Living with Folk Art

Ethnic Styles from around the World

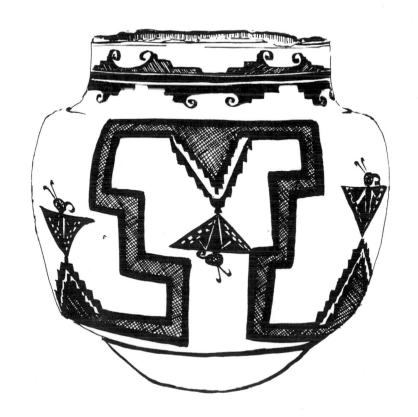

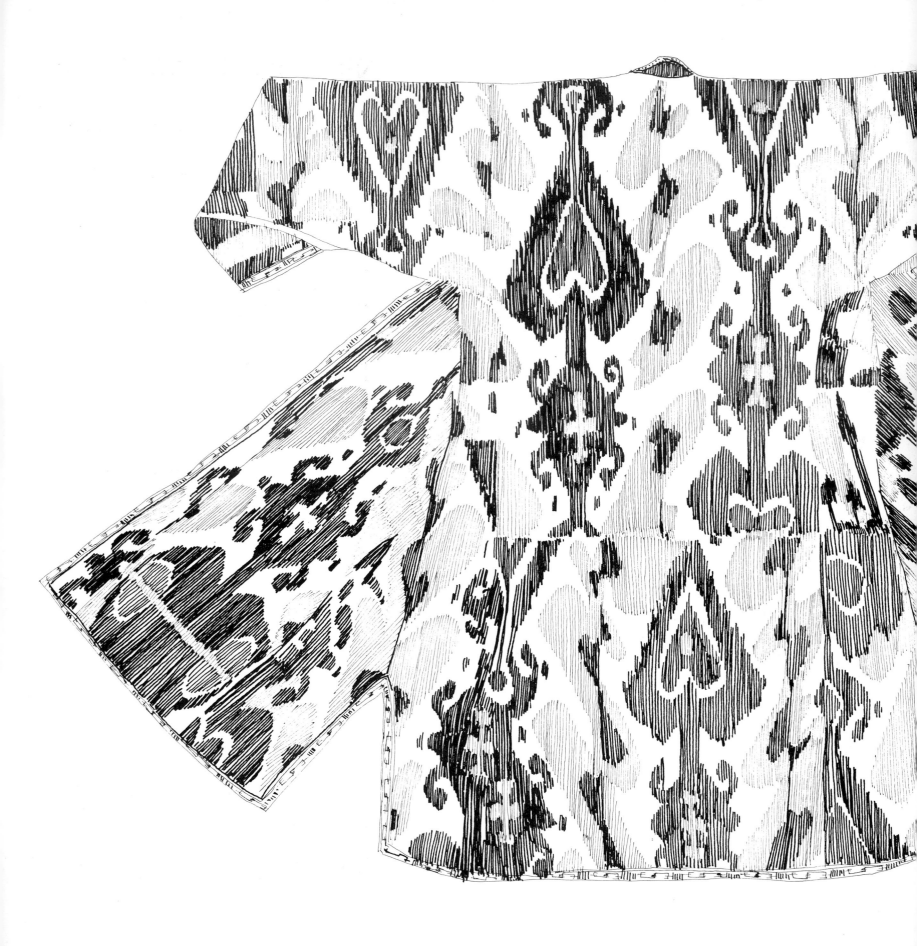

NICHOLAS BARNARD

Photographs by
JAMES MERRELL

Living with Folk Art
Ethnic Styles from around the World

With 253 illustrations, 187 in color

Line Drawings by Miranda MacSwiney

Thames and Hudson

This book is for Lauren

On the half-title page: *A Pueblo Indian pot*
On the title page: *An ikat 'chapan' from Bokhara*

© 1991 Thames and Hudson Ltd, London

Published in paperback in the United States of America in 1998 by Thames and Hudson Inc., 500 Fifth Avenue, New York, New York 10110

Library of Congress Catalog Card Number 93–113284
ISBN 0-500-28021-5

Printed and bound in Slovenia

Acknowledgments

For this book, James Merrell and I have travelled the Americas and Europe, much as the shy explorers of a private world, to photograph the homes of the collectors of tribal and folk art. We were always generously welcomed and assisted with good-humoured forbearance as we cluttered a cherished bedroom or exquisitely decorated drawing room with a tangle of cables and lighting equipment. The colour plates that follow are therefore dedicated to our selfless hostesses and hosts. For our time in California, New Mexico and Mexico we would like to thank Lauren Greene, Tukey Cleveland and Valerie Justin; and it is again to Lauren that we express our gratitude for such splendid hospitality and organizational ingenuity that culminated in a memorable journey through northern New Mexico. The snow-cloaked days in Taos were made possible by the preparatory work of Ron Cooper. In Mexico itself our way was carefully shepherded by the advice of Annette and Sydney Tarr, Susan Tarr and Dr Mark and Cicely Winter; our guide in Oaxaca was Gabriela Vales-Lopez and in San Cristobal de Las Casas, Joan Norris. The black-and-white photographs were supplied by museums and private collectors, among whom my special thanks to Jan Steward (for pp. 45 and 93) and Peter Adler (for p. 11). At the Royal Geographical Society, Rachel Duncan assisted most ably in the procuring of the photographs on pp. 10, 12, 13, 44, 47 and 90, and at the Pitt Rivers Museum in Oxford, Mrs Edwards kindly left me free to enjoy a morning of archive hunting. The results of that quest are to be found on pp. 37, 41, 76, 77 and 157. The photograph on p. 70 is courtesy of the Seaver Centre for Western History Research, Natural History Museum of Los Angeles County. The line drawings are the work of Miranda MacSwiney; for her boundless enthusiasm and diligent penwork we extend our gratitude. Finally, for their support and patient understanding, we thank Jennie and Lucy.

Contents

Introduction

Many years ago I ventured on a pilgrimage to one of the world's least known collections of ethnic art, kept within the musty edifice of the Horniman Museum in London, where the haphazard display of artifacts from faraway lands offered up a bewildering treat. I wandered from cabinet to cabinet, held at frequent intervals by the startling impact of dance masks from Mexico, Papua New Guinea and West Africa, or by the mesmerizing play of shadows cast by puppets from Indonesia and India. I remember that visit as a first stirring of the wonder that the ethnic arts continue to inspire in me.

Living with Folk Art celebrates an appreciation for the creative expression and talent of the men and women of the lands more often referred to as 'less developed', and its limits are not too rigidly circumscribed by the murky areas that surround the semantics of the titles 'folk', 'tribal' or 'primitive'. My own personal taste and the collections that James and I have had the privilege to photograph have clearly had their influence on the scope of this book, which has inevitably meant that some folk traditions have had to be excluded. That apart, the interest and enthusiasm that inspired the collections featured here, and indeed the book itself, have ancient roots. The quest of the more 'civilized' world for the raw materials, artifacts and peoples of the lands beyond the horizon and, indeed, the realms of the imagination, stretch back at least to the days of the Roman Empire, from which time the exotic treasures of the 'primitive' world have proved a lasting source of stimulation to Western wonder and desire. In an age dominated by technology and an ever-accelerating pace of life, these sometimes imperfect and naive arts and crafts provide a feast of creativity, a fount of inspiration and an escape into a world where reason and order are not always the benchmarks of expression. Within this book can be found a rich and colourful introduction to the arts of a world past and present, that is influencing yet again a whole new generation of travellers, collectors, artists and designers.

Chapter One **Through Western Eyes**

Western taste has developed rapidly in many areas over the past hundred years, as is most evident from the radical change in attitude towards the art and artifacts of alien cultures. Until recently, all contact with far-flung societies was motivated by the desire for trade or annexation, or was less commonly the result of the zealous curiosity of bold explorers. The recognition of the creative strength of ethnic objects as artforms in their own right is a twentieth-century phenomenon that has had a profound influence on our own culture.

First Explorations

The first documented trade links between the West and the mysterious lands of the East were forged by the trade of cloth. One of the earliest expeditions is dated at 510 BC, when the Persian Emperor Darius I sent Greek mercenaries to India for the cotton cloth that was so coveted by both the Persians and the Greeks because of its brilliant fast colours. Thenceforth, successive cultures of the Ancient World from within the Mediterranean basin – the Phoenicians, Greeks and Romans – are known to have sent military expeditions, caravans and sailing vessels which spread the net of European civilization from India to West Africa in search of trading commodities and precious metals. The Romans' desire for the exotic and their indulgence in lavish attire and material possessions drew the finest artifacts like a magnet to the imperial outposts on the shores of the eastern and southern Mediterranean. From there, the silks of China, the diaphanous muslins of Bengal, the colourful and colourfast cottons of Gujarat and the spices, gums and resins of East Africa, Arabia and India, were sent to Rome. From and by way of India or Indian traders spices, jewels, exotic animals, cotton and Chinese silk goods and yarn found an eager and rich Mediterranean consumer.

The trading patterns between Europe and the East from the eighth or ninth until the sixteenth century were dominated by the Muslims and Vene-

Wood carving of a war and hunting spirit of the Yimar culture, Papua New Guinea

tians. Muslim traders supplied the European nobility, the Church and the populace with both essentials and luxuries from the East. But of all these goods, it was the knotted carpet that was most cherished and that continues to be displayed as an exotic sign of wealth. Paintings from this era show 'Turkey' carpets gracing altars and tables, and portrayed them prominently as the richly decorative requisite for the floors of the nobility. Other commodities included printed and plain cotton cloth and brilliant coloured silks.

Trade to and from the West African kingdoms during this period was conducted along the coastal sea routes controlled by the Portuguese or, alternatively, by way of the trans-Saharan caravans that linked Egypt, the Orient and the lands of the Moors. Until relatively recently, the exchange of gold, cloth, salt and spices gave the notoriously fierce Tuareg tribes of the west and central lands a livelihood raiding and trading. Some idea of the far-reaching and obscure nature of the trading links at that time may be gleaned from finds such as an English bronze ewer discovered on the shrine of an Ashanti king. Dated at about 1399 and bearing the insignia of King Richard II, the ewer was used as a war fetish and found in the palace at Kumasi, present-day Ghana, in 1896. Such a distinctive shape must have had quite an impact on local metalwork design.

From Portuguese coastal trading to West Africa in the sixteenth century, we can surmise that the Europeans did in fact recognize the quality of indigenous craftsmanship, but had little appreciation for the culture and traditional artforms of the people. From Benin City in Nigeria, and Sherbro Island, Sierra Leone, the Portuguese commissioned artifacts carved in Iberian style: ivory spoons, forks and hunting horns depicting dignitaries, horsemen and coats of arms. These were returned to Europe along with consignments of rice or palm-fibre mats and bags. It would seem, however, that the bronzework and wooden carvings in the palaces of the obas (the Yoruban chiefs) left them unamused; more likely these were considered ugly and unchristian – a double damnation.

By the late fifteenth century, however, advances in European sailing technology had allowed the coastal barques to turn away from their shore-hugging journeys and to venture across the oceans towards uncharted lands. The primary commercial motivation for this expansionism was the value of spice, an essential flavouring and preservative for the meat of both rich and poor. By rounding the Cape of Good Hope the Portuguese were to reap the benefits of their commercial foresight for the next hundred years, and Malabar became the re-export centre for spices from the East Indies. India proved to be a prolific source of luxury and exotic goods. From the west and especially Gujarat came embroideries, printed cloth and indigo, Madras and the south-east provided cottons, Kashmir became legendary for its shawls and Bengal a rich production centre for silks, embroideries and fine muslins.

Panels of Central Asian ikat cloth

The century of Iberian monopoly was to be disturbed by the almost simultaneous arrival of the Dutch and the English in southern Asia, who aimed to break the Portuguese stranglehold on the spice trade. The first Dutch fleet of 1595 ventured straight to the source of this prized commodity, establishing a new colony in Batavia. To avoid drawing upon their precious reserves of silver, the Dutch established a cunning network of trade in which India became a key link because of its inexpensive yet fine textiles – by buying cheap cloth in India, the Dutch could barter for spices in the East Indies. Such a pattern of trade was to be repeated by the English bartering for slaves in West Africa.

The European adventuring eastwards met with a robust and creative network of societies and despite tragic hiatuses in production caused by European trading policies, and coercion to adopt a 'Western' style of economic development, these cultures have continued to cultivate both their traditional and Western-influenced craft skills. By contrast, the consequences of the early sixteenth-century European incursions across the Atlantic to the high plateau and mountain kingdoms of the Aztecs and Incas were immediate, crippling a sophisticated people spiritually, financially, demographically and culturally for evermore. A handful of Spanish conquistadors brought to an end two great kingdoms of lavish wealth, prolific creativity and organizational genius with violence and alacrity. Such ruthless fortune-seekers were not, however, without an appreciation for the culture that they found; they were indeed awestruck by the advanced civilization there and quite amazed at the richness of the lands to confiscate and the quantity of gold for looting. Yet Pizarro's men saw in the Temple of the Sun in Cuzco not the exquisite statuary and magnificent textiles, but a movable feast of treasure. The ignoble annihilation of the South American Indian royalty and the bloody subjugation of the peoples was followed by the wholesale export of the golden treasures; little was preserved intact, for as pagan relics the forms were abhorred and more convenient to ship as bullion. Of the salvaged statuary and ornaments, Albrecht Dürer wrote in his diary in August 1520: 'I saw the things brought to the King [Charles V] out of the new golden land: a whole golden sun, a full yard wide, similarly a whole silver moon, equally big … all sorts of marvellous objects for human use much more beautiful to behold than things spoken of in fairy tales. These things were all so precious that one has appraised them worth 100,000 guilders. And in all the days of my life, I have seen nothing which rejoiced my heart as these things – for I saw among them wondrous artful things and I wondered over the subtle genius of these men in strange countries.' By the end of the sixteenth century the source of such wonder was no more than a slave colony to the new Hispanic landlords.

Magellan's circumnavigation of the globe (1519-22) and the decline of the expeditionary zeal of the over-stretched and war-weary Spanish Empire shifted the focus of European colonial interests to India and the East Indies,

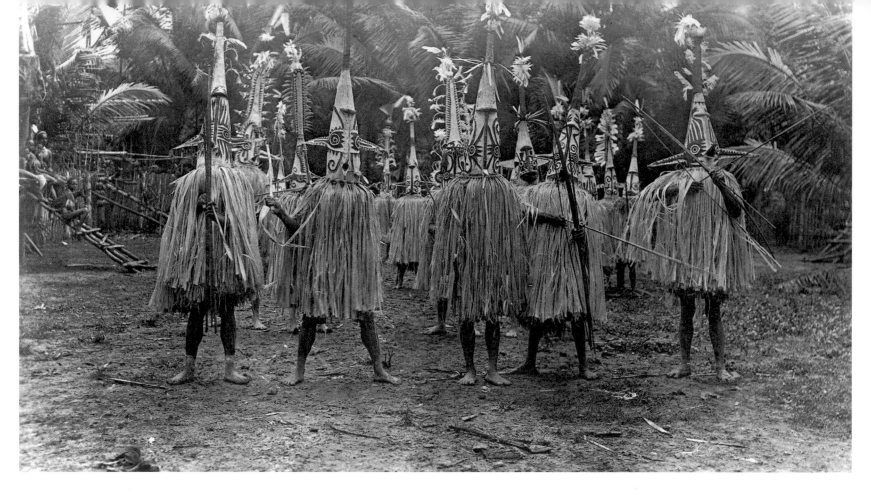

The Kair Kuku ceremony of the Tomipu tribe conducted at the Vailala River in Papua New Guinea, c. 1919-23

and successful annexation followed. To the south, the mysteries of the African continent beyond the coastal belt were to remain secure until the mid-nineteenth century. The items returned from the trading forays were described in a way that indicates the superior contempt the Europeans undoubtedly expressed towards the natives. Such an account appears in the catalogue of the Wieckmann collection of the Ulm Museum near Stuttgart, dated 1659. It concerns a most famous and exciting object, a wooden board of the Yoruba, carved with an array of beasts and men, used then as now for the divination ceremony of the Ife people. The contemporary description is as follows: 'An offering board carved in relief with rare and loathsome devilish images, which the king of Adra, who is a vassal of the king of Benin, together with the greatest officers and important men of the region, are accustomed to employ in fetish customs by making sacrifices on it to their gods.'

As the first well-organized missions of scientific survey to foreign lands (as opposed to a trading or looting foray), the voyages of Captain Cook are outstanding. The three voyages between 1768 and 1779 were a triumph of acquisitiveness. Many men on board wrote detailed diaries, the draughtsmen drew copiously and the scientists dissected and analysed the essentials of the plant and animal world they encountered. The journals of the voyages vary in the level of appreciation for the tribal world they found. James Cook

judged that the figures attached to Tahitian canoes were 'very little inferior [to] work of the kind done by common ship-carvers in England'. Joseph Banks found Tahitian work on the whole in 'so very mean a taste'. It was the Maori art that generally aroused the greatest interest. Banks, finding the New Zealand native canoe carving 'rough', commented perceptively: 'the beauty of all their carvings depended entirely on the design'.

The reports carried home from these missions fired the romantic and sentimental ardour of society in Paris and London for the world of the South Seas; regrettably, however, such enthusiasm extended to the Christian fundamentalist movement whose missionary fervour stretched to purging the natives of their pagan idols; their conflagrations must have consumed great quantities of 'abhorrent' statues and effigies throughout the Dutch East Indies, the Pacific, and the 'dark' continent that so stirred the imagination, Africa. During the eighteenth and early nineteenth centuries, at the height of the slave trade, very few native curiosities were collected from Africa, not even for scientific study. Ironically, the only masks, statues or other perturbing artifacts that were returned to England were sent by missionaries as tangible evidence of heathen souls in need of salvation.

A Nalki Devie dancer, and (right) a Parava Devie dancer, from the tribes of Asia

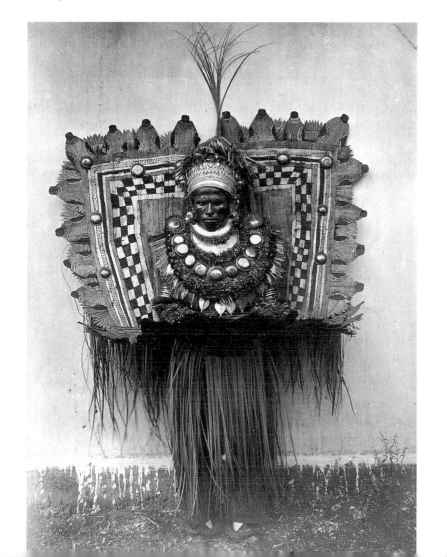

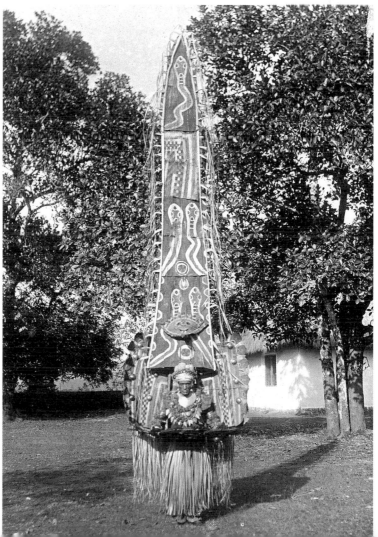

Collections –
Public and Private

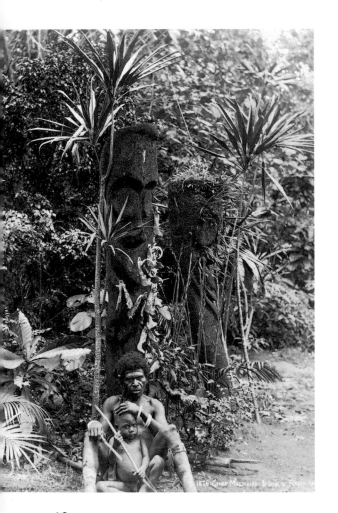

The establishment of museums in which collections of native objects and crafts could be stored for public display was dogged by inauspicious beginnings. Most artifacts were designated curiosities, objects of human ingenuity and marvels of faraway lands. Manmade objects were more often than not mixed with exotic specimens from the natural world. A famous early example of an ethnographic museum of sorts was founded by Sir Ashton Lever. Lever consumed a fortune to establish a museum in London in 1774, for which he purchased a quantity of the artifacts from the Cook voyages. The failure of so daring a venture saw the museum close in 1786 and the collection scattered throughout the world. Much was sold to northern European museums, a sizable proportion remaining within a Berlin institution which later became the Museum für Völkerkunde. For the great public collections of today, we must be thankful to the nineteenth-century combination of international mercantilism and colonial greed. The Godeffroy Company of Hamburg collected ethnic objects as part of its activities, and the scrabble for African territories, culminating in their official division at the Conference of Berlin (1884-85), sent bright young government officials to the continent. For them, collecting was a diversion and often a matter of duty.

Germany led the way in the establishment of ethnographic museums. Between 1850 and 1875 the museums of Hamburg, Leipzig, Dresden and Berlin were founded and in 1885 Leipzig acquired the Godeffroy collection. In 1884 the Pitt Rivers Museum of Oxford, England, was founded. Then, as now, the collection was delightfully arranged, by type and use rather than by region of origin. The result is a cornucopia of wonder and a feast for the senses.

Trade shows and fairs introduced the nineteenth-century European general public to alien cultures. The first international exhibition of 1851, at the Crystal Palace, London, showed the products of the 'exotic' world made by 'natives', and the 1883 international colonial and export trade show in Amsterdam was described by a local writer as 'a continuous colourful cause of thrill'. The first really major impact any collection of tribal artforms had on the public came as a result of the Royal Navy's Benin City punitive expedition of 1897. Immense quantities of bronze castings and ivory carvings were seized that immediately aroused the admiration of writers and observers because of the consummate skill of their execution and artistry in expression. It was indeed fortunate that these bronzes were deemed aesthetic by Westerners, and even by their standards, finely made. The notion that sophisticated techniques could be utilized by 'primitive' man to produce such beauty guided many a Western scholar along an easy progression of thought which ended in the classification of such subjects as 'art'. That these forms remain freshly inspirational was quite evident from the success of the exhibition of art from Benin in London in the early 1970s. No wonder the nineteenth-century scientists and historians were so stimulated,

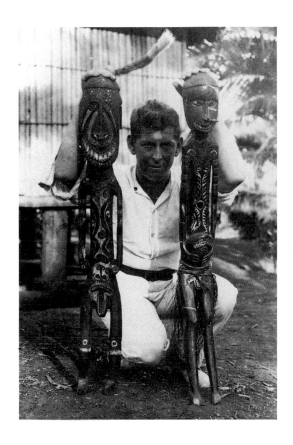

A visitor from the West holds carved figures from the Kikori Delta, Goaribari Island, Papua New Guinea, 1919 23

faced with the challenge of a grand scheme of new questions posed by the plethora of such ethnic objects and tribal practices. Somehow they had to reason a path through the evidence before them that undermined so many of their preconceived ideas concerning religion, art, human history and psychology.

By the turn of the century the expeditions were departing the shores of North America and Europe for Africa to collect more artifacts, and collect they did. Many of these ventures were no more than grand excursions for wealthy sportsmen; some were outstanding feats of scholarship. From the American Museum of Natural History a mammalogist, Herbert Lang, and an assistant ornithologist, James Chapin, set off for the Belgian Congo in 1909 for an expected two-year expedition. They returned in 1915 with fifty-four tons of material that included nine thousand photographs and over four thousand objects, as well as zoological specimens. From Germany, the Berlin expedition of 1912-13 ventured to explore the most forbidding of their colonies, northern New Guinea. They charted the Sepik River Province, surveyed the mineral and economic prospects, and collected artifacts. Richard Thurnwald, a German anthropologist and explorer, travelled to the source of the Sepik and made first contact with the Mountain-Ok people ('ok' means 'water', or 'river'). It is intriguing to learn that the Mountain-Ok christened their visitors 'futmin', meaning 'design-people', undoubtedly as a result of the German interest in their decorated artifacts. The transactions were simple: 'In the evenings the inhabitants of the nearby villages came up and sat together with my carriers ... and bartered things with each other. They offered my carriers arrows and decorative objects, while my carriers made them happy by giving them red calico strips and glass beads. So we finally parted from each other in peace and great friendship.'

As the intrepid charted Africa and island-hopped the Pacific, the continent of the Americas, the lands of the Raj and the Dutch East Indies were continuing to supply the Western market with native artifacts, both functional and purely ornamental. From early days, batiks from Batavia, and shawls and printed furnishing cotton from India had satisfied the whims of English and Dutch society. Soon after the Conquest, the Spanish turned the superlative weaving skills of some of the indentured masses of the Andean Altiplano to good effect, sending home fine cameloid cloth as well as tapestries woven to a European heraldic design. The quality of their execution is breathtaking. Northwards, the American Indians, imprisoned within their allotted reserves, delighted an Anglo-American market with their weaving skills and silversmithing. The Navajo, relative newcomers themselves to the South-West as well as to weaving and jewelry-making, were encouraged by traders to meet market demands by producing rugs rather than blankets while tempering their taste for garish colours. One such trader, John Lorenzo Hubbell of Ganado and Keams Canyon had, in the 1900s, about three

hundred women weaving to order for him. Patterns were largely of a genuine Navajo style and, to encourage their weavers, Hubbell covered the walls of the Ganado Trading Post with paintings of early and classic blankets. A catalogue, for circulation amongst the dealers of the East, was published in 1902 listing prices and styles – an early form of ethnic mail-order.

A Powerful Source of Inspiration

A painting on sago spathe, by the Kambot tribe from Papua New Guinea

As the traders and collectors sought to satisfy the consumers', the anthropologists' and the archaeologists' ever-insatiable appetite for more artifacts and ideas, the artists of Europe were enjoying the 'primitive' as a creative stimulus, and as 'art' in its own right. 'The idol cut by savages in the trunk of a tree is nearer to Michelangelo's Moses than most of the statues in the annual salons,' stated Champfleury in 1869, an opinion which proved to be an early and strident precursor to the turmoil through which the art world was about to be led, unwillingly, and with its hangover of Victorian prudery.

It is the work and activities of Gauguin that are best remembered as the major prelude to a more general recognition of worth for the tribal arts. Despising the classical world of artistic expression, he was impressed by the Aztec sculpture in the 1889 Paris Exposition, and again in 1897 by the art of the Persians, the Cambodians and Egyptians. Gauguin is notorious for his romantically inspired and ultimately tragic journeys to the South Seas; his painting, sculpture and woodcuts of the time are, however, more than observational and often challengingly interpretive.

As the artifacts were amassed by the ethnographic museums there sprung up a breed of dealers and agents in London, Paris and Berlin who catered for these institutions and, increasingly, the private collectors. Of these early twentieth-century 'amateur' private collectors, it was the Paris-based avant-garde group of artists who are largely credited with the historic turn in the evaluation of 'primitive' artforms; the particular source of their inspiration was the primitive art from the French West African colonies. In 1903 or 1904 the Fauvist painter Maurice de Vlaminck found two African figures in a bar, for which he bartered by buying a round of drinks; and his fellow artists and friends, such as Derain and Matisse, also entered into the spirit of collecting with gusto. Derain is said to have been 'speechless' and 'stunned' at the sight of a Fang mask that he subsequently purchased from Vlaminck. Braque recorded that the 'Negro masks . . . opened a new horizon for me'. Picasso, from 1906, formed a collection that directly influenced his work. Of his extraordinary series of paintings of 1907, the large canvas, *Les Demoiselles d'Avignon*, is a tense and powerful expression of the meeting of the Western world with that of the African continent. Picasso's emotional and somewhat covetous sentiments for these newly discovered arts were once described to André Malraux in the following manner: 'People are always talking about the influence the Negroes had on me. What about it? We all loved the fetishes.

Embroidered bedroll decoration from Turkestan

Kwebe tribe wooden mask from the Congo

Van Gogh and his generation had Japanese art – we have the Negroes. Their forms had no more influence on me than on Matisse, or on Derain. But for Matisse and Derain, the masks were sculpture – no more than that. When Matisse showed me his first Negro head, he talked about Egyptian art. But when I went to the Musée de l'Homme, the masks were not just sculpture, not in the least. They were magical objects. Now, the Negroes' sculptures were intercessors against everything – against unknown threatening spirits. I understood what their sculpture did for the Negroes. Why they carved them that way, and not some other way. They were weapons – to keep people from being ruled by spirits, to help them free themselves. Tools. *Les Demoiselles d'Avignon* must have come that day, not because of the forms, but because it was my first canvas of exorcism!'

Der Blaue Reiter and Die Brücke, both German groups of painters, were profoundly affected by their visits to their countries' well-stocked and organized museums, which are still especially strong in Oceanic art. Ernst Kirchner, of Die Brücke, enjoyed his first sight of the arts of the Pacific – including treasures from the Cook voyages – in the Dresden Museum. Emil Nolde and Max Pechstein followed the example of Gauguin by actually departing from the bohemian comfort of their bars and ateliers to travel to the South Seas. The painters were not far ahead of the sculptors of the time. Brancusi carved stone heads and other sculptures that capture the sense of space and serenity of some of the masks of the Guro and Baule tribes of the Ivory Coast. The talent of Epstein was certainly nurtured by the energy of the primitive arts, and he went on to collect avidly throughout his life.

Through the painter and sculptor, the path of newfound appreciation for the primitive led to the art galleries and art collectors themselves. By the First

15

Mask from Papua New Guinea

(Opposite) *Looking out on to the frozen mesa of northern New Mexico from the warm bedroom of his old adobe home, the owner of this collection of Meso-american folk and tribal art can enjoy his arrangement of Mexican artifacts in comfort. The crucifixes were crafted by a Mayan tribe, and the decorative ecclesiastical ironwork fragments from colonial times, along with the pre-Christian household gods and wooden figures, were found in Chiapas State.*

World War the work of the avant-garde artists was being sold in the galleries of Europe and North America displayed alongside the carvings of Africa and Oceania. Soon afterwards, the great contemporary art collectors of the United States followed by matching their Picassos and Duchamps with examples of African and pre-Columbian art.

The great private acquisitions of the century have been made by corporations. Inspired by enlightened senior management and often guided by museum curators acting as consultants, many international corporations have built selective collections on a par with some of the great museums of the world. Many of these collections remain buried within the secret world of a corporation, others are the decorations to the offices of the most senior executives, whereas some, thankfully, are presented to the world as exhibitions. These multi-national corporations, the colonial empires of the twentieth century, have extended their philanthropic horizons to their overseas dominions, funding the establishment of national museums and supporting local craftsmen and artists. Back home their acquisitions are often more efficacious as an asset when presented as the foundation of a collection for a new museum or a public gallery.

There has been no abatement in the tide of general interest in the worlds beyond our shores since the Second World War. On the contrary, the speed and efficiency of air transport has made it easier for ordinary people to travel to the sources of tribal and folk arts. The tourist culture has changed forever the nature of our appreciation for the lives of the tribal craftspeople of the Second and Third Worlds, for now so often a token of a memorable journey is returned to a homeland. Ironically, some of the great European and American merchants and merchant collectors of recent years have been those who wandered the globe in the 'sixties, observing the peoples, their customs and their artforms and often participating in a 'native' lifestyle, albeit at times beguiled by idealism.

Certainly the finest selections of tribal art are within museum, corporate and private collections; what abounds in the galleries and more recently the main street department stores, however, is a plethora of art of ethnic origin. From the startling and disturbing, such as a fetish from the jungles of Central Africa, to the soothing and harmonious, such as a 'designer' kilim from Anatolia, there is an unparalleled quantity of tribal and folk arts available for our enjoyment. We are indeed fortunate that we have been led by the artists, fed by the museums and guided by the anthropologists and archaeologists, to emerge from centuries of ignorance and disrespect for the world of the 'native' to an age of relative enlightenment. What were seen as 'curios' and derided as pagan are now classed as art. Tribal, folk, ethnic, primitive – whatever the label, there is at last a consensus that such tradition-bound creativity may be placed alongside the works of the artists and craftsmen of the Western tradition as outstanding examples of human expression.

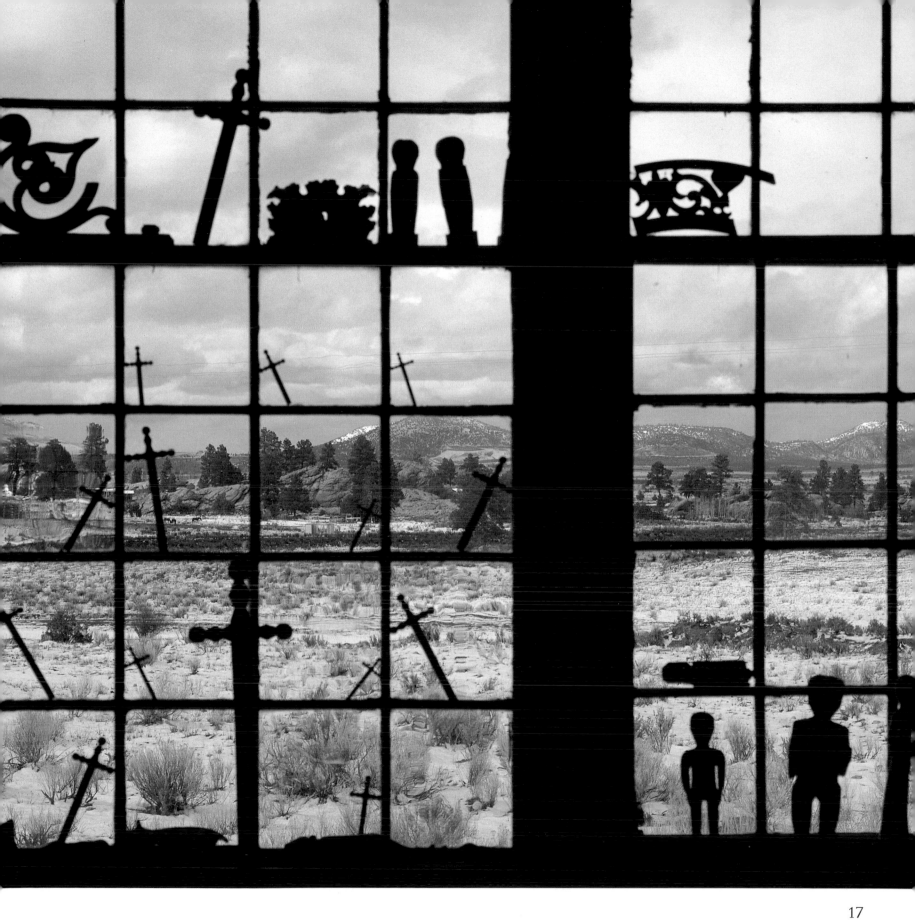

Gujarat, in north-west India, was the original home of these wooden pieces (left). Spread on the floor, the chequered cotton cross forms an empire-wagering game known as 'chaupad', which features in the great epic Hindu poem, the Ramayana. (Below) Dried teasel heads are invaluable as cloth brushes; these particular combs were the everyday tools of an Andean poncho weaver. The other household items assembled here are all from India: a chapati rolling board, a Jonaic pouring vessel, and for that bathtime delight for both young and old, a boat from Varanasi powered by a small spluttering flame. (Opposite) A medley of old wooden chests, opium pourers and spice containers from north-west India. The noblest bird of the Subcontinent, the peacock, cranes above this array in colourful contrast to the simple bronze figure of the serene buddha.

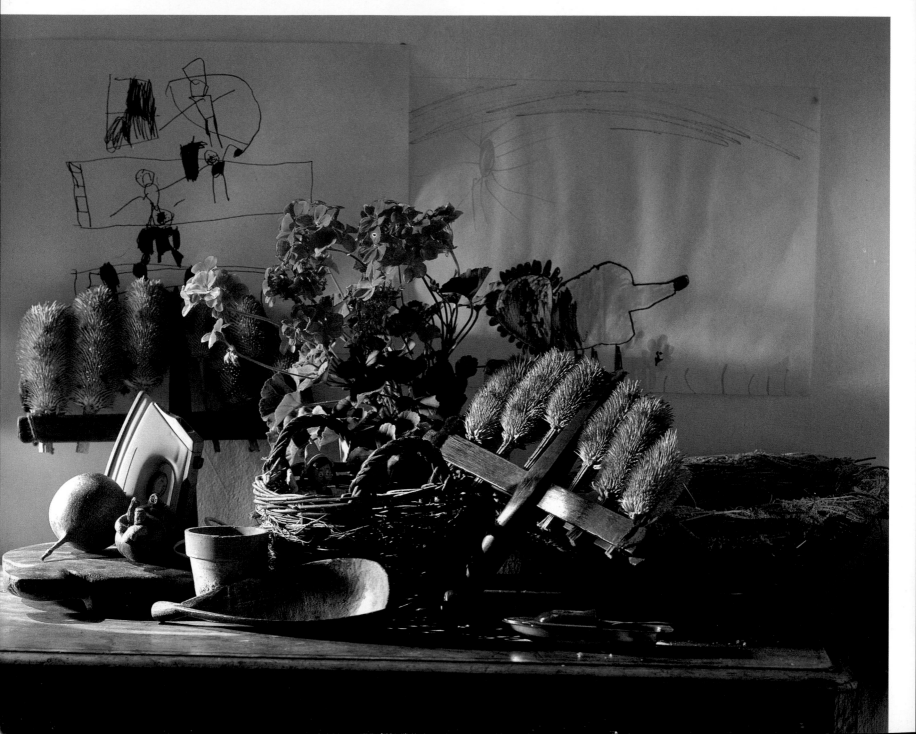

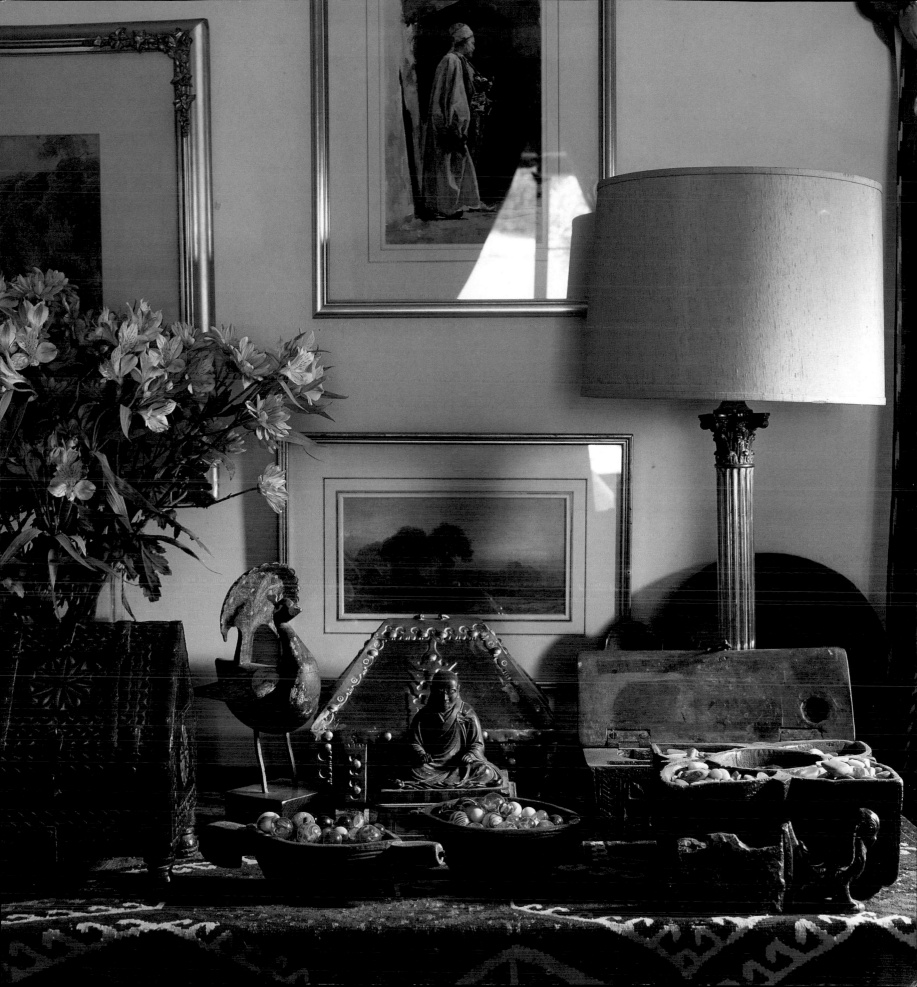

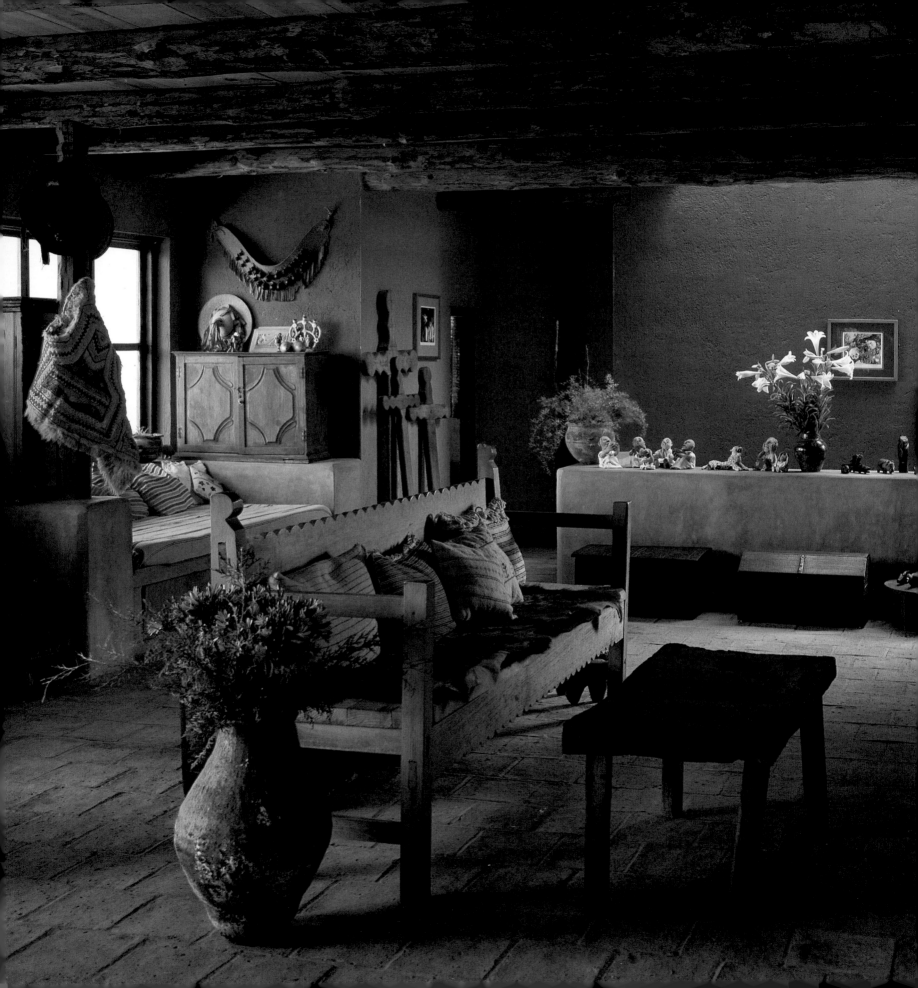

The natural hues of traditional building materials provide a rich backdrop for a collection of Mexican Indian and colonial artifacts, furniture and furnishings (left). On the floor an old Chimula Indian water jar holds a spray of flowers, the knarled table once resided in a local ranch house and the crosses used to mark the sites of sacred springs. (Below) Set off against the soft and subtly coloured Pendleton trading blanket on which it lies, this Tlaquepaque plate conjures up all the images of the leisurely and rhythmical pace of life south of the border. (Right) This house was built within the last four decades, using architectural salvage from the ruins of Mexican monasteries and convents. The objects within range in age from pre-Columbian pottery and colonial cupboards to such recent folk handiwork as the yellow Pátzcuaro lacquer chest.

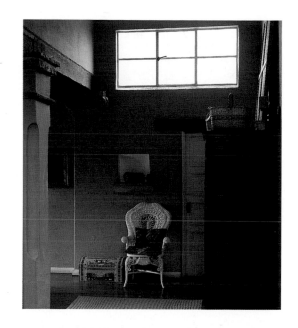

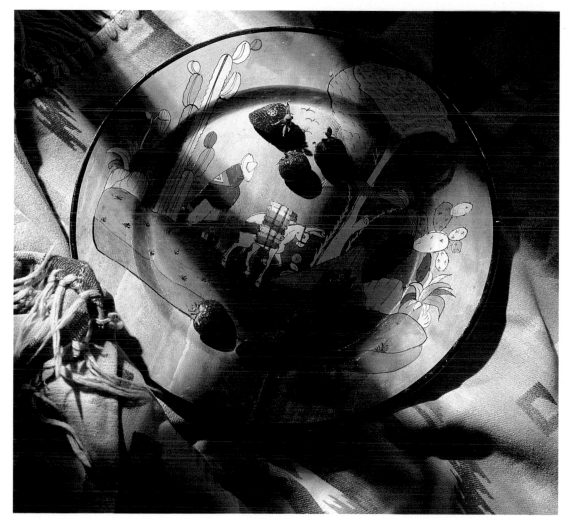

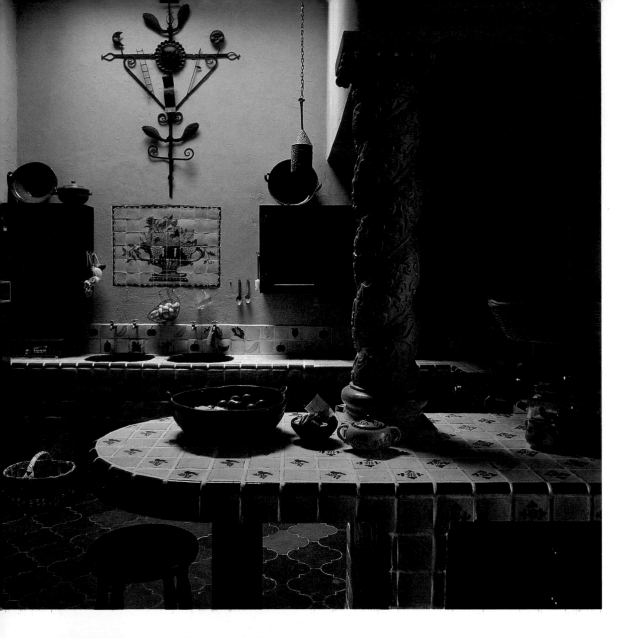

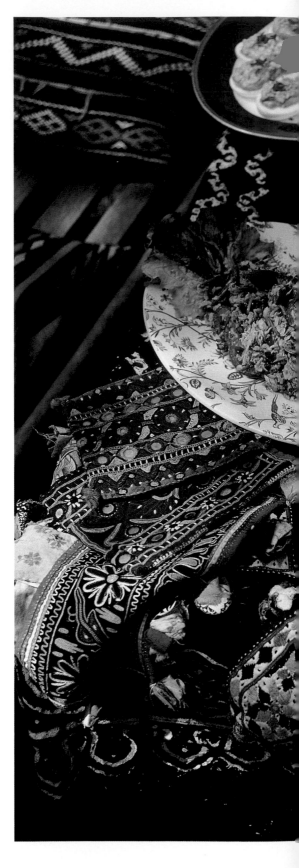

(Above) In the kitchen of an old colonial house on the Mexican-Guatemalan border, the ironware, tiles, bowls and baskets all have a local or regional flavour that fuses pre-Columbian tribal traditions with a veneer of *Western* sensibility.

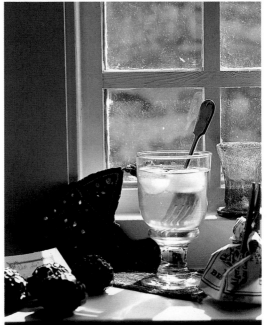

(Left) *A still life to touch upon the gamut of world trade, on an English country window-sill – glassware from Spain and Afghanistan, tea and fruits from the Orient, a cotton and mirrorwork hanging from north-west India, and cooling draught of elderflower cordial from the garden.*

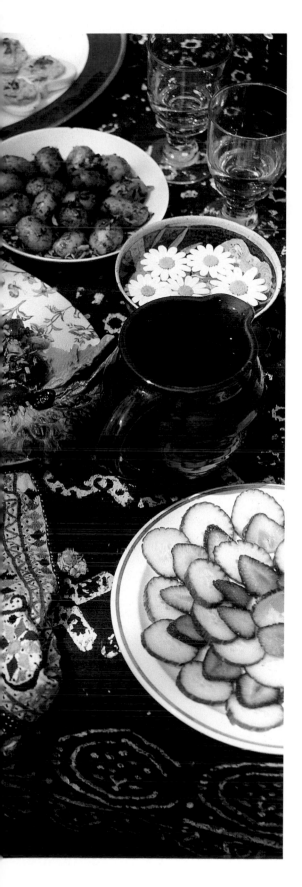

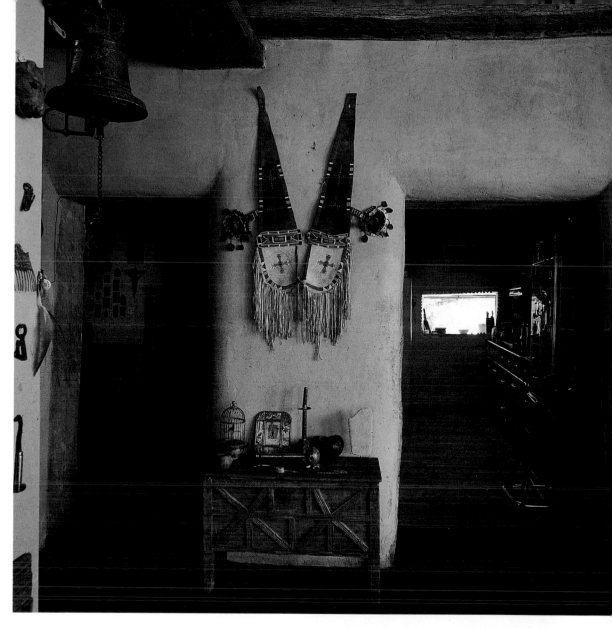

(Above) Hung between doorways in this sturdy adobe hall, a Crow Indian horse crupper looks down upon a New Mexican chest arrayed with a strange collection of curiosities. To the right, on a stand, is a carved foot of a prehistoric south-west Indian tribe, ancestors to the makers of the Pueblo pot and distantly related to the metalworkers who fashioned the tin and silverware in the kitchen.

(Right) Two Chimula Indian boys pose amongst southern Mexican artifacts for this study.

(Left) Prepared for a peckish photographer, a scene of prandial delights is spread on 'ajarakh' material; this colourful tablecloth and the embroideries were collected from the wilds of Saurashtra, north-west India.

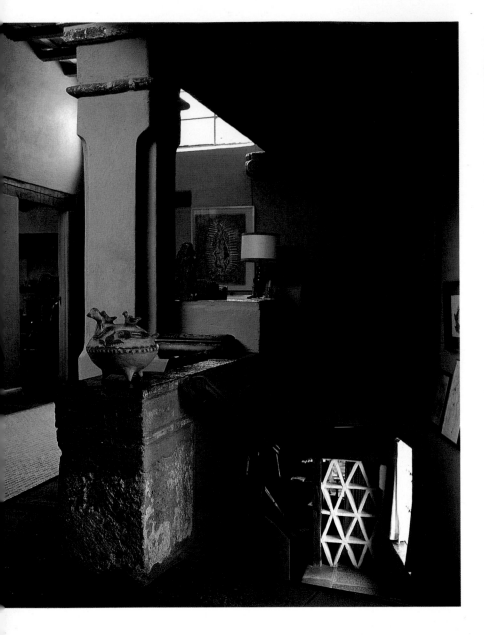

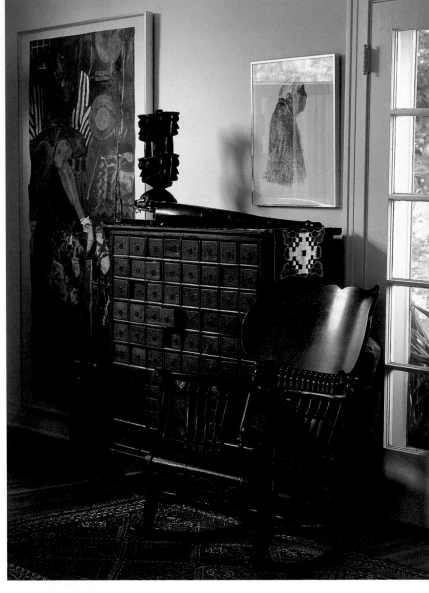

(Above) Paintings and pottery figures of the Virgin of Guadalupe decorate the upper hallway of this Mexico City home. Perching precariously in the foreground is a bird-and-fledgling pot from Oaxaca.

(Right) One glance at the living room of this Santa Fe adobe house will show that floor, furniture and walls are all host to a mixture of folk and tribal art, both old and new, from all over the world. There are textiles from Panama, Arizona, India and Japan, and carvings and pots from West Africa, Ecuador and present-day as well as prehistoric South-West America.

(Above) This Los Angeles home is filled with challenging combinations of tribal and contemporary art whose images and colours startle the senses. On a Japanese chest, an Ibo twelve-faced head-mask from Nigeria watches over all corners of the room.

(Opposite) A seventeenth-century Tiv bronze from Nigeria gazes in wonder from its piano pedestal at this assembly of carvings, beadwork and textiles. From India comes an early cross-cultural trading commodity, the eighteenth-century Palampore chintz that shimmers on the wall, and by the sofa is a Mughal stone 'jali' window.

24

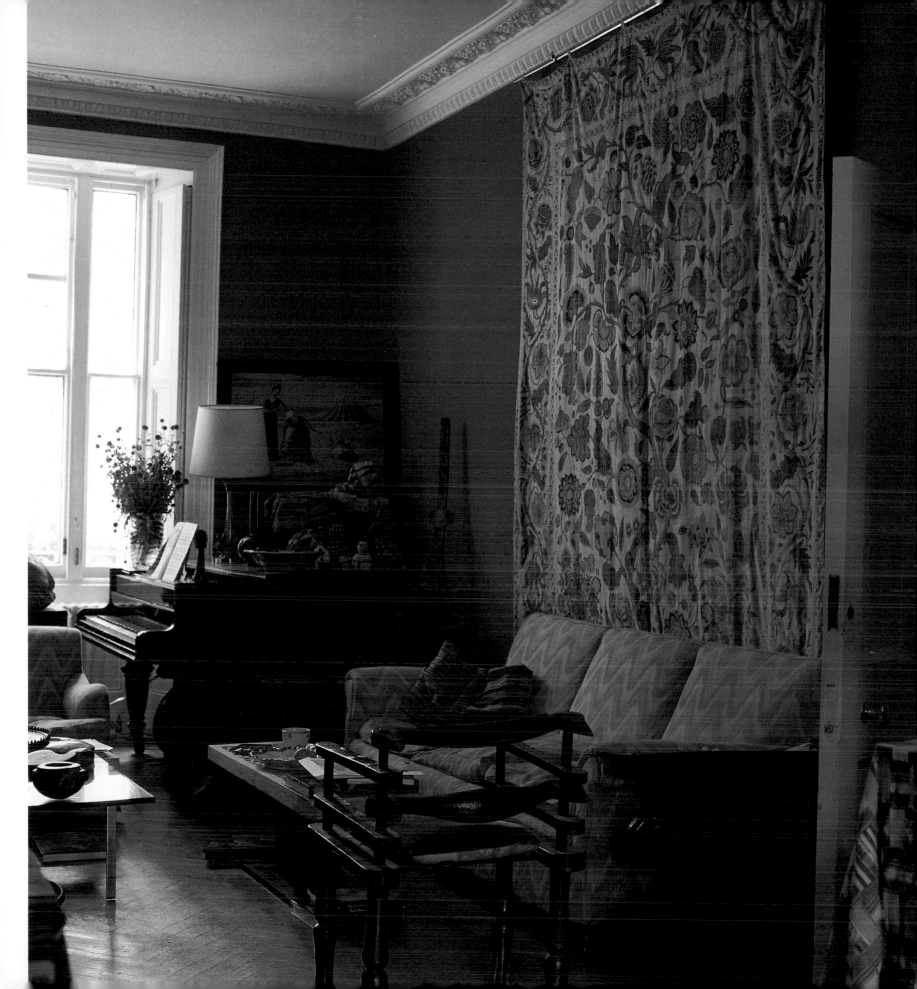

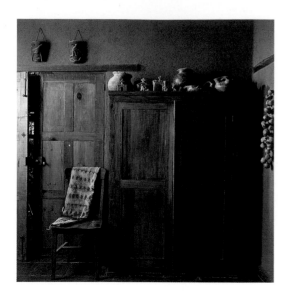

(Left) The unpainted mud walls of this home provide a naturally textured backdrop for a collection of Central American art. On the colonial cupboard sit Zapotec Indian pots; the string of miniature vessels and the wooden masks are of Mixtec origin, and the 'huipil' is dyed with colours obtained from two animal sources – the kermes insect and a variety of Pacific Ocean sea snail.

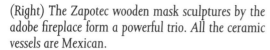

(Right) The Zapotec wooden mask sculptures by the adobe fireplace form a powerful trio. All the ceramic vessels are Mexican.

(Left) Within the niche akin to a Hindu house-shrine and garlanded with paper flowers, an Oaxacan 'retablo' of the Virgin of Guadalupe nestles close to crucifixes made as Day-of-the-Dead graveyard decorations.

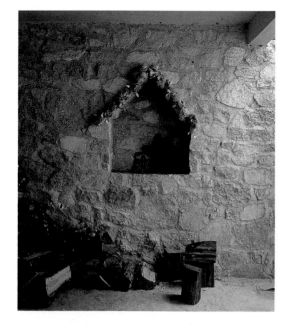

(Opposite) In the courtyard of this Mexico City house, salvaged stone from colonial ruins supports a breeze-cooled and shady dining area. Resting against the wall are the wooden platters for rolling tortillas and an Aztec head snaps at the feet of the unwary.

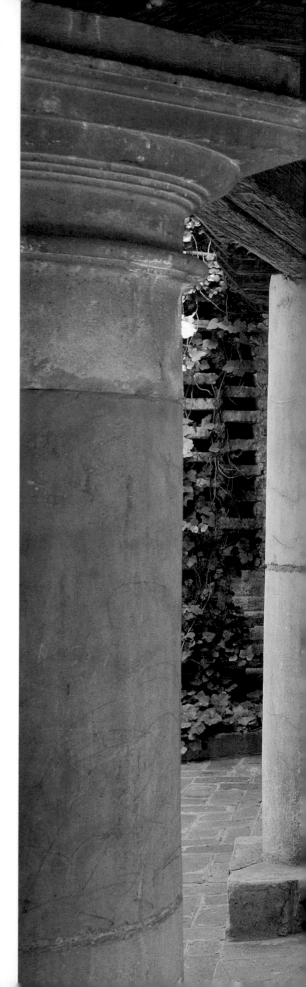

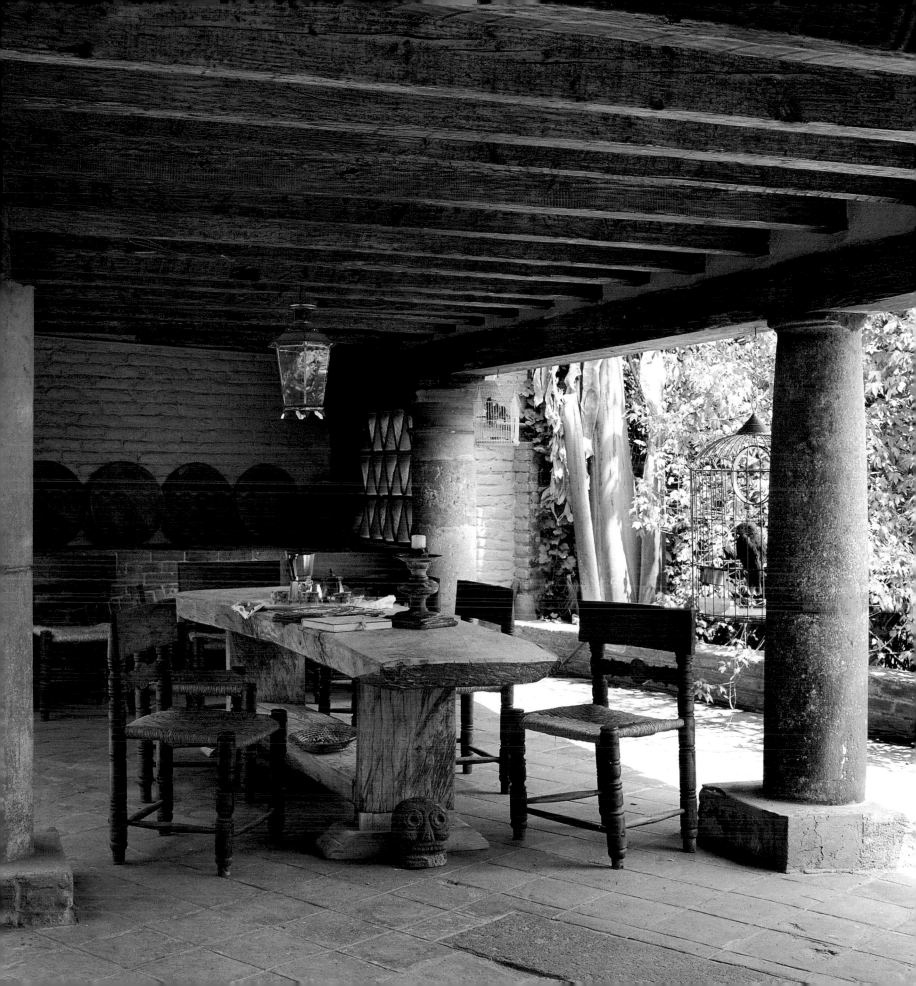

The curvacious form of a Portuguese colonial Brazilian rosewood bedstead (above) is delightfully complemented by the geometric patterns of a West African strip-woven spread. Made by the Ewe of Ghana and Togo, these textiles, and the more colourful work of their Ashanti neighbours, prove ideal as bedcovers and wall-hangings. Light blankets or rugs from the Americas (opposite) also make fine bedclothes. This Mexican Teotitlan example is coloured with cochineal and indigo; the modern kilim on the floor is Anatolian, and the devilishly beghouled chairs are crafted by Zapotec Indians.

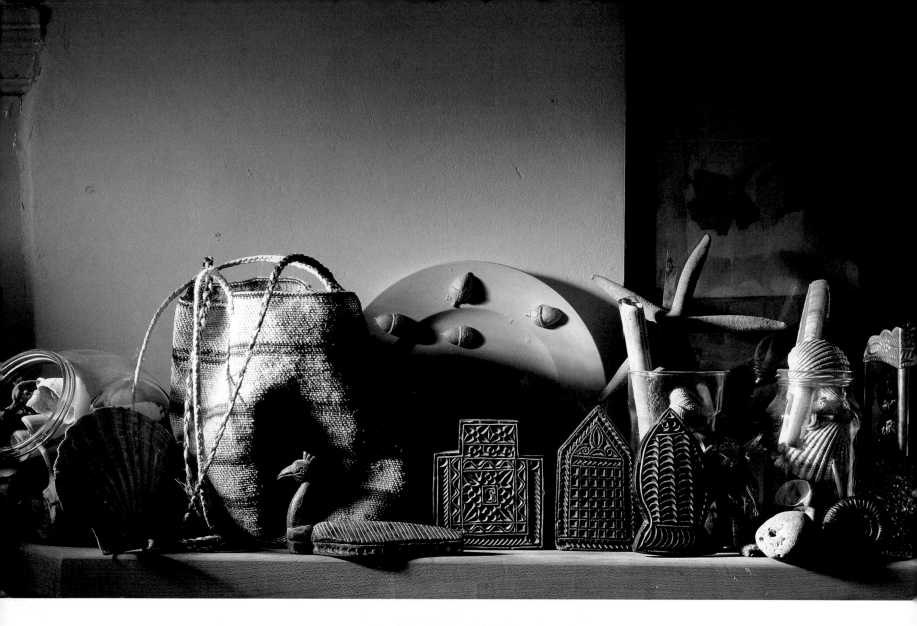

(Above) Mantelpieces give prominence to any display of curiosities such as these, gathered on memorable journeys to unfamiliar lands. Tin treasures abound in Oaxaca, Mexico, the 'shigra' basket from Ecuador is ideal for fruit, and the peacock make-up box an essential accessory for any lady from Gujarat, north-west India. The biscuit stamps for baking, from Bangladesh, make perfect kitchen decorations.

(Right) The view from a bed on to open countryside has been enhanced simply by draping small embroidered hangings from Gujarat over the curtain poles and radiators.

(Opposite) On a desktop spread with an old linen cloth from Spain is a panoply of collectables: a Chinese chest, a silvered vessel from Mexico, and a gessoed orb with a brass incense container – the ecclesiastical accessories from colonial days. On the crowded window-sill sit the jungle beasts and figures of the Lacandón Indians of Chiapas State, the only indigens of Central America unconquered by the Europeans.

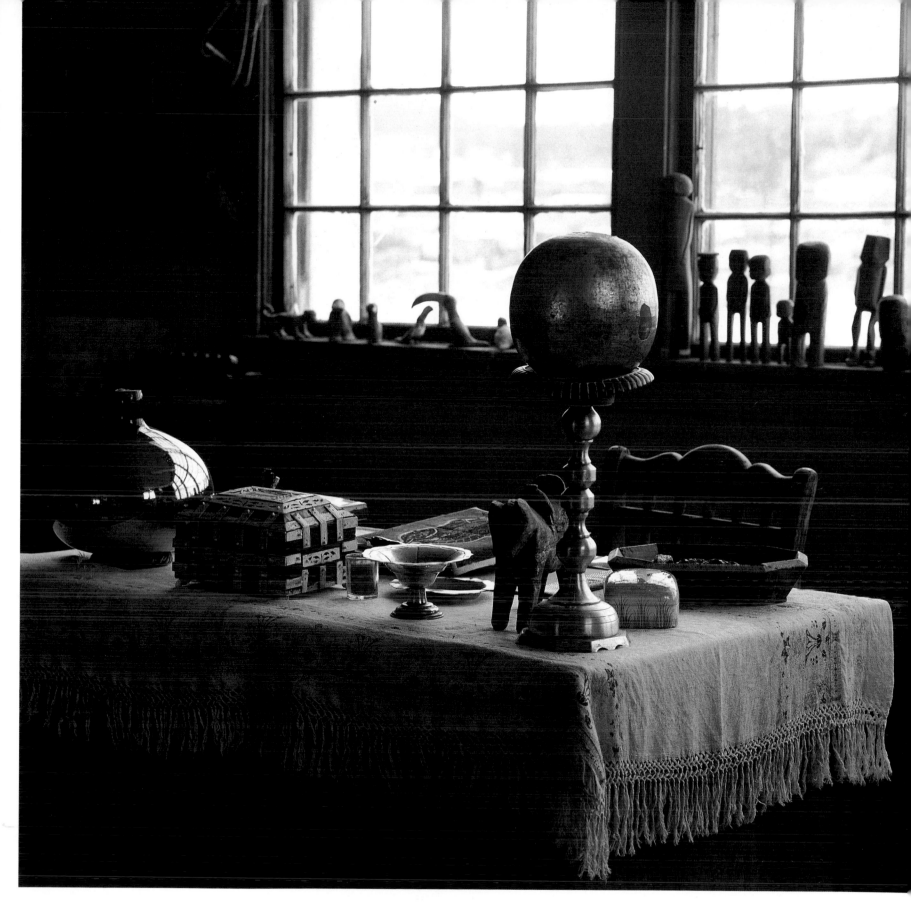

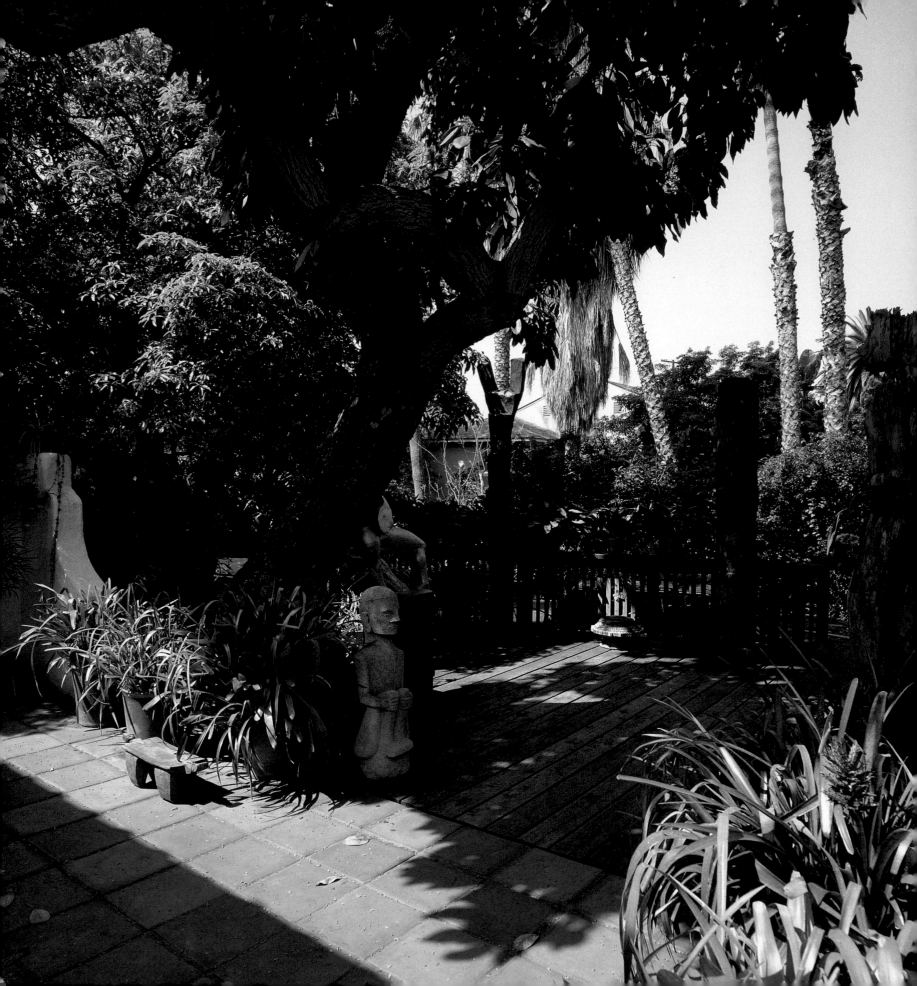

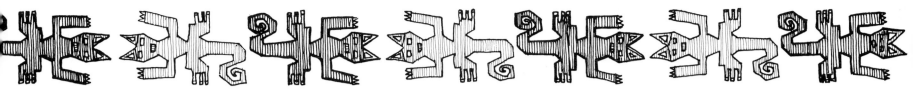

Chapter Two **Traditions of Use and Decoration**

Before the onset of intensive anthropological and archaeological investigations in the twentieth century, explorers and collectors would often retrieve crates of specimens for their Western homelands with little thought for the use, the significance and, often, the exact origin of these objects. The earliest travellers would rarely seek to understand a lifestyle they considered mean, illogical in custom, and bedevilled with pagan practices. More often than not, the booty of an expedition would be returned to Europe as a collection of curios, to rest within cabinets carrying descriptive labels of the most cursory nature. Until very recently the stores of the ethnographic museums of the Western world continued to be filled with artifacts that came to pose more questions than they answered. It is the modern-day anthropologist and archaeologist who is now discovering, by in-depth analysis in the field, many of the possible uses and ritual roles of tribal artifacts brought back to the West many years before.

Increased general interest in tribal artifacts may have been spearheaded by the enthusiasm of artists, but quite apart from its aesthetic appeal, an object carries a labyrinth of anthropological information. For many, the pleasure of viewing and, often, owning a tribal or folk object is more than enough. To the sculptor Henry Moore, primitive art 'makes a straightforward statement, its primary concern is with the elemental, and its simplicity comes from direct and strong feelings ... The most striking quality common to all primitive art is its intense vitality. It is something made by people with a direct and immediate response to life.' The desire to pursue every line of enquiry, then to rationalize and pigeon-hole the facts neatly, would seem, however, to be an inherent tendency in the Western mind. Any attempt to interpret clues in the world of tribal art is particularly fraught with difficulties. To admire the mud-besmirched or highly polished African sculptures within a museum cabinet is to see them out of context, for many masks and statues of Africa are originally daubed with a blaze of painted colours, the loss of which would, in its homeland, often mean an object's immediate

(Opposite) On a southern Californian sun-deck, figures and carvings relish their lush surroundings of palms, exotic flora and year-round warmth. A house-ladder from West Africa, modern American sculpture and the stout stone and weathered wood of the figures from the South Sea islands will last without fear of decay in so equable a clime.

replacement. A mask that to Western eyes powerfully expresses horror or pain might well have been considered comic by the tribe from whence it came. Masks, shields and statuary are stripped of their ritual significance when removed from the panoply of ceremony which involves dance, music and, so often, the heightening of awareness through hallucinogens. Thus wary of the pitfalls of such an endeavour, this chapter attempts to survey the role of tribal and folk artifacts – textiles, carvings, pottery and basketwork – within their society of origin.

Textiles

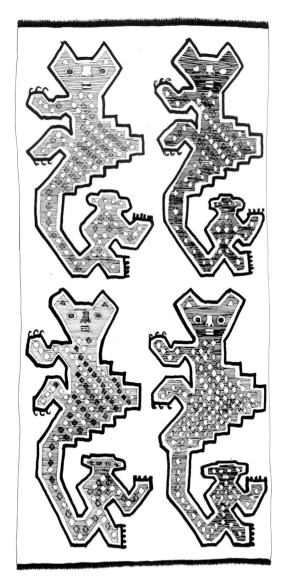

Section of a poncho from the Ica valley in Peru, c. 1000-1450

The handlooming of textiles has ancient origins. Grave sites from India to Siberia and coastal Peru have exhumed sophisticated weavings which date back to the time of Christ and beyond. Ironically, these ancient cultures that developed such advanced methods of textile production are now counted among the more primitive countries of the world. Be they exotic cloths for the elite and wealthy, or mass-produced weaves for export or local everyday attire, textiles, of all the arts and crafts, most effectively combine utility with decoration. Within the pre-Columbian empires in what is now Peru and Bolivia, fine textiles were woven and exotic Amazonian feather raiments were made to the requirements of the political and religious aristocracy. By contrast, in Gujarat, western India, the workshops have resounded to the thump of the textile printing-block on cheap cotton for centuries.

Of all the tribes and peoples of the world alien to Western culture, it is the nomads of the steppes and desert who have developed, by virtue of necessity, highly refined, useful and decorative textiles. Nothing is superfluous in the spartan and far-from-romantic lifestyle of the nomad for, from high summer pasture to winter camp, from well to oasis, the paraphernalia of everyday existence must be easily transported by donkey, ass or camel. The Muslim nomads of Asia and North Africa have woven textiles over the centuries according to a strict code regulating their traditional value and use. Bags, sacks, camel head-dresses, horse and camel saddle-covers and tent bands woven as ropes are made for transportation and to afford some comfort at camp. The tents, whether of barrel-vaulted goat hair, or circular yurts of felt over a green willow frame, are gaily decorated to cheer their otherwise gloomy interior with all the baggage of the caravan: the tent bands dangle tassels of bright wool, the flat-weaves make the earthen floor bearable and the patchwork hangings and embroideries enliven the walls with lurid colours accentuated by strident geometric designs. It is to these wanderers that the great weaving traditions of the Orient most likely owe their origins. Shifting from region to region, driven on by the warring activities of neighbouring nations keen to quell such unruly independents, or looking to find a homeland of a more equable clime and hospitable terrain, the nomads of Central Asia roam the lands from the Levant to the Himalayas. Their village

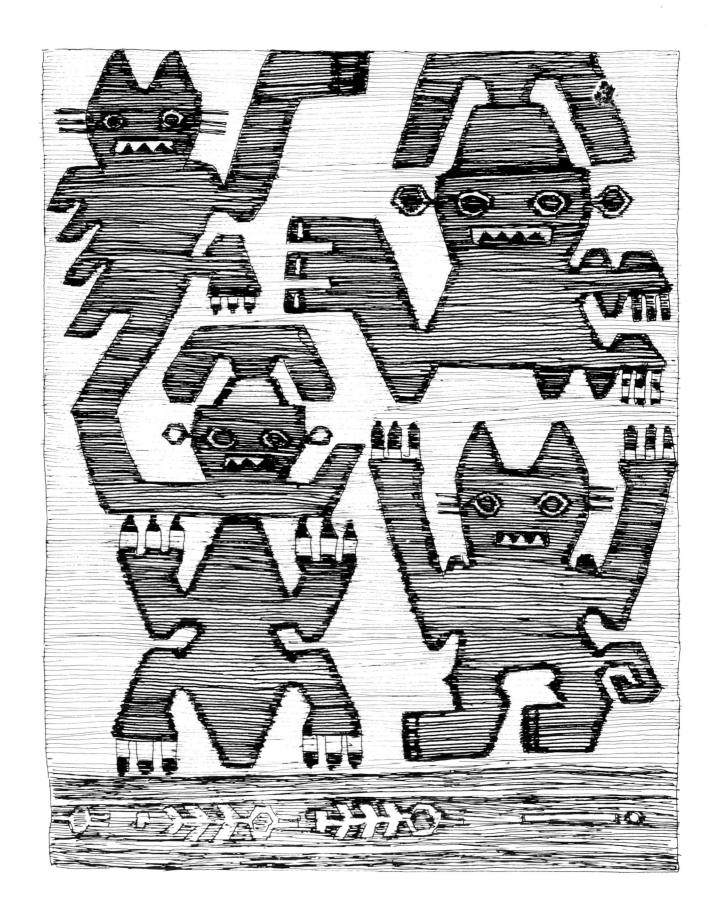

Poncho from the Ica valley

'Kantha' (embroidered quilt) panel from Bangladesh

and encampment weaving tradition is now well known for its prolific production of flat-woven floor rugs, known as 'kilims' or 'gelims' according to either Turkish- or Farsi-speaking origins.

Subject to the all-embracing tenets of Islam, the weavers of North and West Africa, Anatolia, the Levant, Iran, Central Asia, Afghanistan and Pakistan, as well as of India and Indonesia, work into their decorative arts a symbolism that successfully blends their animist past with a statement of the Faith. Islam is a disciplined religion, wherein all words and deeds are seen to be derived from God, so their arts, therefore, are compelled to infuse decoration, form and function with a sense of order. Such ornamental expression pleases the eye, its endless unfolding of geometric, abstract and semi-abstract forms arising from the need to avoid idolatry. The kilims and flat-weaves of the Islamic world are often patterned with floral designs and in north-western Iran one finds the Kurdish 'Senna' work, wherein kilims are tightly woven with small interlocking patterns of flowers. Such fine workmanship is derived from a courtly embroidery tradition of the Safavid era, where appreciation for the delicate balm of colourful roses and carnations finds expression in an often dun and dusty environment. The floral element in Turkic weavings is stylized and abstracted in the 'gul' (meaning 'flower'), and other symbols include the eye, to deflect the gaze of those with evil intent, and the ram's horns – originally a pagan fertility symbol. Hand motifs may be interpreted as representations of the hand of Fatima, or of the 'five pillars of Islam', and the 'tree of life' is a universal source of fascination for symbologists.

The shape and patterning of prayer rugs are certainly symbolic while the rugs themselves serve as a clean and comfortable ground for the five daily prostrations. The orientation of the mat and the central point of the composition is indicated by the 'mihrab' – a representation of the niche on the wall of a mosque that faces Mecca. In mosques from Delhi to Ankara are found tremendously long flat-weaves, with many mihrabs, which can accommodate whole rows of worshippers. The panoply of other symbols within Islamic textiles are, however, the most commonly misinterpreted of all non-Western artforms. Close contact with the Muslim world and the importation of knotted rugs as luxury goods engendered over the centuries the popular idea of the 'mysterious and exotic Orient' that reached a climax of absurdity with the Victorian Orientalist movement and is still manifest today in the trade-dominated manufacture of carpets filled with symbols and motifs tailored to appeal to consumer taste. Strange symbols can all too easily be digested by Western iconography if familiar terms of reference are used to interpret them – a crenellated line is seen as a ladder, and a cross on a squat base a tree of life. For the weavers themselves, however, their work very often consists of the oral and visual inheritance of traditional symbols that have often lost their meaning through centuries of repeated use.

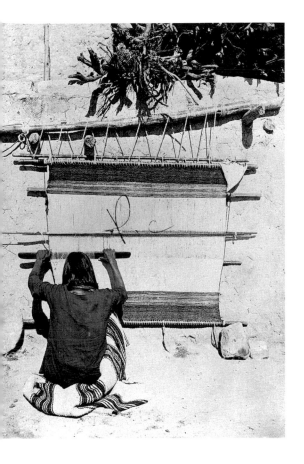

A Hopi Indian weaving a sacred blanket, South-West America, 1879

By contrast to the nomads, tribespeople settled in an urban lifestyle have considerable opportunity to translate their traditional skills into the organized production of trading commodities. It is within the village, away from the workshops of town and city, that weaving is likely to remain an activity in harmony with the day-to-day life of farming, be it smallholding management, herding or indentured labour for a local estate. In the villages of Ghana and Togo the traditional weaving of colourfully patterned robes of fine strip-constructed cloth – the 'kente' work of the Ewe and Ashanti – still survives, and the village menfolk weave commissioned garments on drag looms. In Bali, the ikats considered unfit for ceremonial use are sold without hesitation to the tourists. Entire villages in Central and South America, from Mexico and Guatemala to Ecuador and Peru, have found that their weaving and embroidery skills inherited from their pre-Columbian ancestors are a godsend, for the financial rewards of selling to tourists and meeting export orders, in whatever form required, are a boon to their meagre income from agriculture. In India, certain villages in Orissa, Andhra Pradesh and Kashmir are renowned for their weaving and embroidery skills now nurtured by Government co-operatives, and in Turkey the production of many village carpets and flat-weaves is as likely to be controlled by the orders of a fax machine connected to the trading houses of Frankfurt and London as by local demand. Indeed, by entering traditional rug designs into a government computer, a print-out of a particular carpet design, complete with colour references, can be sent out to a weaver on demand.

The indigenous textile production of non-Western societies primarily serves to meet clothing needs; handloomed cloth and embroidered, appliquéd and quilted textiles are still worn in a traditional style as everyday cloth wraps or stitched garments, but they are now increasingly put aside for ceremonial occasions only, retained as a link with the past. Inevitably, wealth, rank and power is expressed in dress, and such elitism is a well-protected social custom: Ashanti cloths of Ghana remain the finery of chiefs, whereas the vividly patterned and coloured silk robes of the Central Asian oasis towns and cities were once worn according to strict dress codes enforced by local khans, and in Indonesia the right to use certain designs and colours on cloth was controlled by the nobility. Selected Polynesian 'bark cloths' (felted material made of tree bark) are still highly esteemed, especially valued for their painted decoration: the men of Samoa would wrap great lengths around their body, to be unrolled before an audience eager to admire the patterns. Some of these trappings have become legendary – the King of Tonga, who was once on a visit to England, became famous for his various changes of bark-cloth wraps of immense size.

Most textiles of the tribal world are decorated with patterns or colours that signify personal or religious identity and use. Among the cultures of the ancient world without written language, the pre-Columbian empires of the

Chancay, Huari, Nazca and Inca are known to have communicated with symbols. The priests and rulers used painted ceramics and carved stone reliefs as well as woven textiles to reinforce certain religious beliefs: representations of gods and god-like creatures – two-headed snakes, birds of prey, fertility symbols and feline creatures – patterned their exquisitely worked fabrics. It is fortunate that death cults were central to these cultures which valued textiles so highly, for they left archaeologists and grave-robbers thousands of examples of fine and ancient cloth to disinter from their tombs.

For the Indians of Central and South America, the Christian faith of their European conquerors was absorbed and modified to suit a way of life that was geared towards survival within their Altiplano and jungle environment. Here, the seasonal cycles, the movement of the stars and animal and plant life have an overriding influence on day-to-day life and behaviour. Despite the efforts of the Church such concerns still thrive alongside their associated pagan rituals. The Aymara Indians of Bolivia retain a link with traditional worship by means of pre-Columbian-style ceremonial textiles, the 'q'epi'. Handed down from generation to generation, these mantles are now worn by those who preside over Christian festivities! Indian textile motifs throughout the Hispanic Americas are inspired by an animist past, and include the sun, the moon and the stars as well as animals and mythical beasts derived from ancient folklore. The Kuna Indians of the San Blas Islands, Panama, have, by contrast with their more renowned neighbours of the highlands, absorbed Western influences and contrived their own reverse-appliqué technique for decorating clothes. These cut-cotton panels, called 'molas', depict pagan gods, football heroes, Christian saints and political party slogans, and have been adopted by the Kuna as 'tribal' banners to wave in the face of increasing pressure for social and political acculturation from the more 'civilized' world of the Panamanian Republic.

The largely Hindu world of the Indian subcontinent is home to a wealth of weaving, embroidery and appliqué skills, manifest in temple and household decorations as well as in clothing, festival and animal trappings. A dynamically creative religion, Hinduism and its mythology find expression on cloth in vivacious colour and pattern. Colours symbolize mood, ceremony, season and ritual; red is the colour of lovers, saffron the colour of 'sadhus', the holy men who renounce this world, and yellow the colour of spring, of blossom and joyful well-being. Figures from Hindu epics such as the *Mahabharata* mingle with the folkloric images of birds and other wildlife on the embroideries of Gujarat. The wise elephant-headed god Ganesha, son of Siva, is worshipped before any major undertaking, to remove obstacles to happiness, and distinctively shaped shrine embroideries ('Ganesh-tapana'), depicting Ganesha flanked by his two wives Siddhi and Buddhi, are hung in the home on special occasions. The decoration and symbolism of

'Hinggi' ikat from Sumba, Indonesia

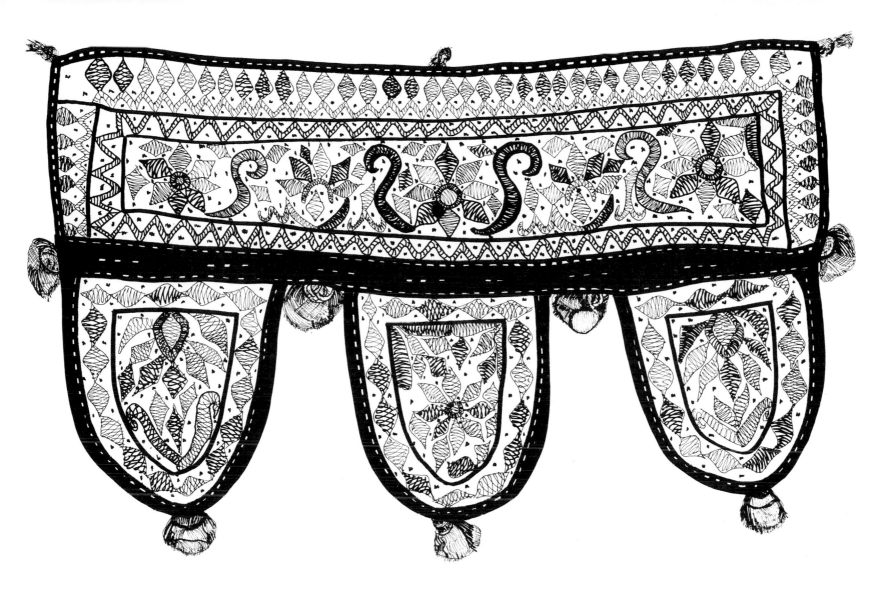

Cotton 'pantoran' from Gujarat, north-west India

these textiles not only demonstrate the vitality of the Hindu religion but are also clear expressions of status within an ancient class system. The style of decoration in the home, of personal attire and animal trappings, and the types of material used, immediately establish the caste of the owner. Fine and antique double-ikat 'patola' cloths purchased from the weaving specialists of Patan would be a ceremonial nicety for high-caste Bombay families, whereas an itinerant snakecharmer would cloak himself against the cold with a simple quilted cotton cloth made by his wife.

Hand-woven textiles are an integral part of traditional Indonesian culture. They are woven by women and are regarded as female objects associated with fertility. For rites of passage, textiles play a vital and unifying symbolic role. The famous double-ikat cloth of Bali, from the village of Tenganan Pageringsingan and known as 'geringsing', would remain uncut from the loom until the ceremonial first haircutting of an infant, and other continuously warped textiles would symbolize the continuity of life and be

evident at birth rites. Within the same archipelago, the islands to the north, such as Sulawesi and Kalimantan, are home to tribespeople of the tropical rainforests, who use textiles as funeral shrouds and ceremonial hangings. Few Western symbologists could faithfully fathom the religious meaning behind the hooks, arrows and fierce zoomorphic creatures which adorn these textiles.

Sculpture

The thud of the axe, the chipping of the adze and the turning blade and chisel on wood are all familiar sounds within tribal village communities. Craftsmen who can create or capture expression, or carve a character for shamanistic purposes, will down their everyday tools and take the time to work on a figure or mask, usually to commission. Masks and representational figures often enjoy a special role in tribal societies, bridging the real and perceived world, the past and present, the known and the feared, and seek to enrich life by encouraging the powers that control man, his harvest and sustenance from the fields, corral, bush or savannah. As such, these objects have a profound spiritual or superstitious significance, as well as being, on many occasions, powerful works of art in their own right. The range of carvings produced extends from the ethereal to the practical, and in many cases, the form and colour of an everyday object such as a cooking vessel, a ghee pot from Tibet or a chapati rolling-board from Rajasthan, can be more satisfying in its humble worldliness than the aesthetic qualities attributed to some effigy decreed to be great 'tribal art'.

The representation of an individual in portraits, busts or statues is a revered artistic institution of the Western world. Within most traditional tribal societies, however, the sculpted or carved figure is created in deference to the accepted mores of the group, ancestors, demi-gods, gods and the shape of spirits and forms to come; any direct association of image creates a ghost-like twin or an ethereal reflection. Decorative trappings often indicate the status and wealth of a character. Wooden grave-markers such as those of southern Madagascar as well as the 'vigangos' of Kenya depict events in the life of the deceased through pictorial narrative in the case of the former and by the subtle expressions of shape, of the incised markings and by daubs of colour in the latter.

The sculpture that we peer at through the musty glass of a museum cabinet offers us a mine of information about its tribal makers, for again, unlike Western creative expression which is essentially self-orientated, ethnic artifacts are produced as part of a collective identity often exclusive to the group. The well-known Kuba royalty figures of Zaire are a simple case in point. To the Western observer the rows of seemingly identical wooden figures ('ndop') appear puzzlingly repetitious, until it is realized that it is the differences in the design on the plinth of the figure that identify the king in a

A child in front of a doorway in Cameroon with carved figures, c. 1925

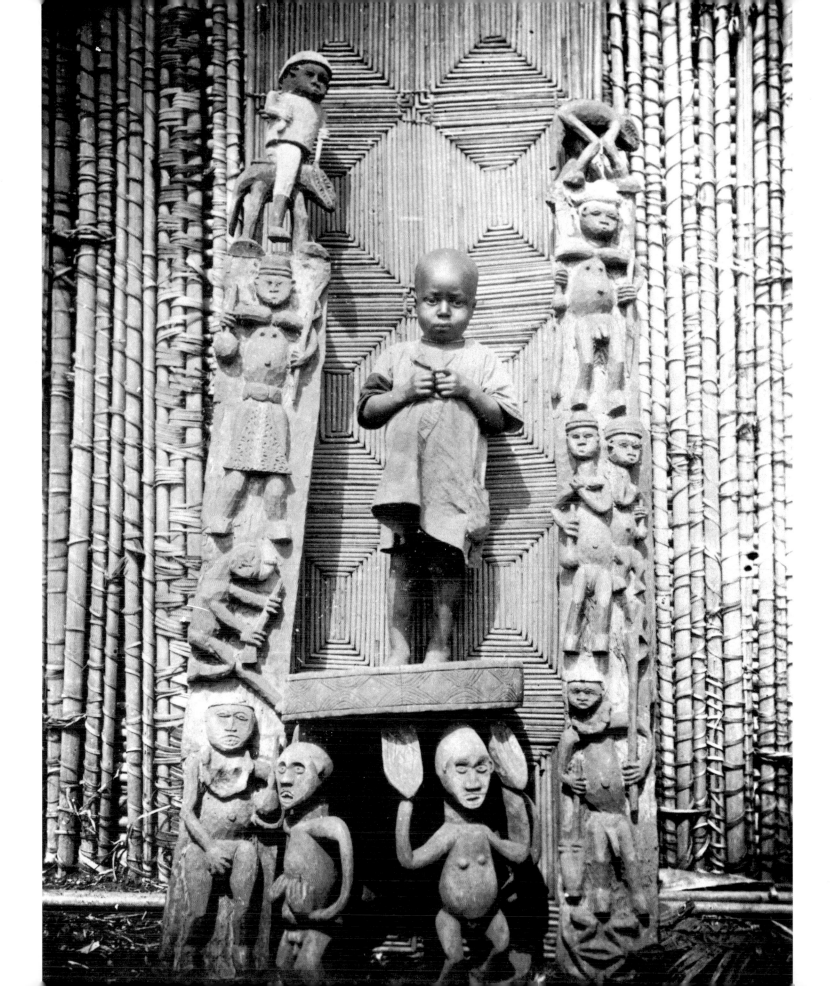

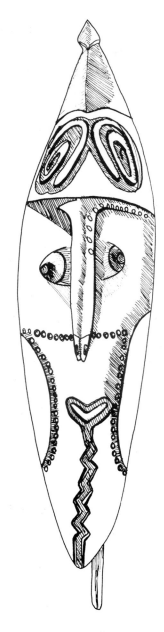

Ceremonial mask of the Yau people from Papua New Guinea

series that extends back to the seventeenth century. The form of the figure is simply not relevant.

The sheer effort involved in carving the wood and the limitations imposed by its place of display, usually a small village room, a roof-top or head-piece, discourages the creation of large items. Exceptions, such as the towering totems of the North-West Coast American Indians, the beach markers ('Bis' poles) of the Asmat of Papua New Guinea and the soft fernwood heads of the Malnaim of the New Hebrides, all associated with ancestral worship, status and hierarchy, are made of easily worked materials. Smaller free-standing statuary and carvings of the particularly prolific African and Oceanic cultures are found in abundance, and are for protection against evil spirits, ancestral worship, deity veneration or forbidding visual aids in the instructional rites that lead adolescents into manhood. Stored or displayed within a sacred house, room or chest, these sculptures and forms are not to be trifled with, but are key elements to the rhythm of life in the community. In most tribal societies sacred sculptures and masks may only be viewed by adult males, and sometimes only by shamans, and between use they are often swathed in cloth or even buried in the ground. If twin infants born to a Yoruban woman die, she will nestle carved images of them, wrapped in a cloth, within a calabash.

The carving, construction and wearing of masks have deep-rooted social and cultural significance in the societies of both the Western world and the tribal peoples. Most masks deliberately hide the everyday identity of the wearer and become part of the regalia of theatrical expression: the costume and the mask become the character portrayed. Complete transformation ensures that there is powerful communication with the group as a whole, constantly reaffirming within the community traditional notions by boys' initiation, funeral or healing rites, agricultural and hunting ceremonies, and presenting stories and legends with messages and images that instruct and edify the village society.

In some initiation or purgative ceremonies masks are regarded as such potent containers of evil or malicious spirits that they are burnt after the ceremony, and the ground where the dance was held is deemed to be dangerous to walk over for a short time thereafter. This practice is common in the Congo basin, upheld by the elders perhaps as part of a myth to maintain the socially cohesive strength of the performance, or else in serious fear of the residual spirits. Certain masking communities of northern Nigeria forbid the viewing of masks by the women, whose delight in travelling to the museum at Jos to view a cabinet full of such secrets must be very great.

Of all sculpted forms, masks have, ironically, the greatest power to beguile the Westerner. So strong or simple is their imagery when divorced from the paraphernalia of costume and ceremony that their apparent purity of form or serene or terrifying expressions often bear no relation at all to their

original character. The mask is but a part, sometimes the least significant element, of the performance. The Western artists who were so excited by ethnic artforms – especially by masks – were seeing what they were able or wanted to see and little more. It is truly unfortunate that masks cannot be displayed in their proper context, where dance, music, costume, atmosphere and wildness of behaviour would awe the imagination of Disney himself.

Ceramics

The manipulation of clays to make figures, masks, pots and vessels for everyday and ceremonial use reaches a high form of artistic expression in certain tribal societies of the world. The shape of the vessel and the decoration painted on its surface are often combined to achieve a perfect, harmonious balance. From the villages of Lombok, Indonesia, to northern Nigeria, delightfully curvaceous vessels are used as jars for water, which still needs to be collected from the cistern and stored within the home in so many communities. The practicality of such handmade clay forms that Westerners now tend to esteem in their own society as art objects is perfectly demonstrated by the tea cups of India. There, the chai wallahs of railway platforms in the north-west will dispense their delicious tea in charmingly irregular, unglazed but fired clay cups that may then be returned to the earth through the open window of the slow-moving train.

Traditional ceramic production within an Indonesian village is integral to the lifestyle of the makers, who form cooking pots, charcoal braziers and water vessels in a style that is simple, unpretentious and pleasingly shaped. From prehistoric times clay forms have been created to combine everyday tasks with the need to satiate propitious spirits. The water vessel ('kendi') occupies a special place in this scheme. Water, as in so many societies, possesses deep spiritual connotations, and so the kendi is made, decorated and treated with great respect. From island to island, the kendi are beautifully executed; in Aceh, north Sumatra, Bali and Lombok they are elegantly slim and often lavishly decorated, in Java are found more austere forms with simple brush-marks that belie the Muslim sentiments of the area.

West African pottery has ancient roots, as the work of the Nok culture of northern Nigeria, more than 2500 years old, proves; and yet the techniques, from moulding to firing processes, remain as 'primitive' as ever. Ceramics are produced wherever the clay is good, and there is a ready market in a local town for the wares: as with most tribal crafts, the production supplements an often meagre income from unreliable harvests. The lack of any technical development in ceramic work is a perfect reflection of the lifestyle of the people: the women make all the ceramic ware by hand, beating and coiling, with no knowledge of vitreous glazing. After being fired in open brush fires at a low temperature, the resultant wares – dye pots, roof finials, lamps,

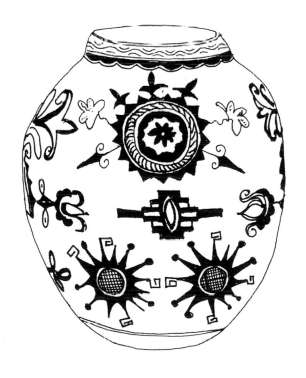

Storage jar made by the Tesuque Indians of New Mexico

spindle whorls, toys, storage jars, cooking pots and floor tiles – are rough and ready but as domestic objects they perform well. The recipe for the clays and sands and the techniques used have been passed down from generation to generation over the centuries to suit the function of the vessel. Cooking pots are so underfired that their 'soft' nature can withstand the intense heat of an open fire, and water jars are made semi-porous to allow for evaporation and the consequent cooling of the contents.

Decorated pots and forms are created for royal or ritual use. Ancestral and spirit cults of the Ibo and Niger delta groups and the Yoruban cults of the gods involve the use of ornamental pots. Water drawn from the river for the Yoruban elders and chiefs is carried by a hip-swaying procession of women balancing ornamental pots on their heads. The inheritance of styles for such pot-making is parochial. A woman will learn the skills as a girl and return to her craft after dispensing with the child-bearing chores. A potter's daughter may well neglect her skills forever when she marries into a community with no history of ceramic production, whereas an unskilled girl marrying into a potting community will be instructed in the craft by her new in-laws. When a girl from one potting family marries into another, her style is dictated by her new husband's traditions, although vestiges remain to create a bewildering complex network of forms and decorated designwork produced within a small area.

Although the African, Indian and Indonesian societies are indeed blessed with a rich legacy of ceramic ware, the potters of the Americas, past and present, produce the most dynamic range of exquisite pots and clay forms. From pre-Hispanic Peru there remains a prodigious quantity of fine ceramics still extant, and complex examples such as the distinctive 'stirrup vessels' as well as bowls, urns and cups have been found in the well-preserved graves of the Chavin, Nazca, Moche and Chimu cultures. Little is known about the iconography and use of the wares, as these societies were without a written language and the Conquistadors were somewhat more interested in the precious metals than the pots and beakers. The research that has been done shows that there was a cross-fertilization of imagery from ceramics to textiles, stone carving and murals. It would seem that the most incongruously shaped vessels, such as the seemingly useless stirrup pots, were for ceremonial use, accompanying their owners to the tomb, and that their surface-painted designs were both representational and symbolic, depicting everyday as well as fantastic images. Chavin pots are decorated with the bird, reptile and cat imagery that owed its inspiration to the rich wildlife of the Amazonian jungle and especially to the jaguar, a big cat of legendary and supernatural powers feared and awed throughout the American tropics. The later work of the Moche is distinctly representational – the living world as seen through the eyes of the artist, rendered in folkish images. The Moche pots and vessels are small and often surprisingly brightly coloured for their

Baloie potters from Zaire with a selection of their work

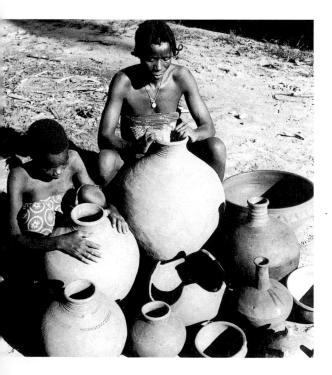

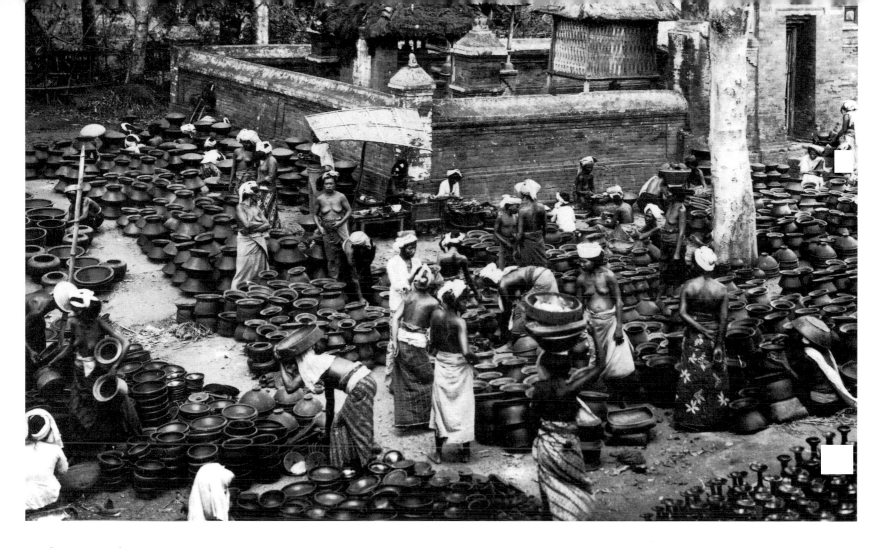

A Balinese pot market, c. 1927

age, thanks to burial techniques and the dryness of the climate. The portrait jars of the Chancay and Moche are particularly expressive and are frequently found moulded to a human pose or decorated with a scene that is associated with the act of offering, especially of cloth. The tribute ('mita') to the essentially malevolent ruling group was a pre-Columbian custom sorely abused by the new Spanish landlords. The pottery traditions of Mexico are equally deep-rooted in prehistoric cultures, but unlike those of Peru, continue to develop in a lively manner sustained by the vast market demand both at home and abroad. Pottery remains from the past are again in abundance; doubtless, ceramic wares performed a range of utilitarian and ceremonial roles within every historic empire and society. A casual stroll through the marketplace in any tourist town or country backwater will clearly illustrate the vitality of the traditional potting craft industry. Before dawn and often on the previous evening the men and women from outlying hamlets and villages will journey to market with their mules, bearing baskets of pots. Others nervously shepherd the unloading of a parcel from the roof of a groaning bus. Spread on the ground and on low tables will be the fruits of their labour,

45

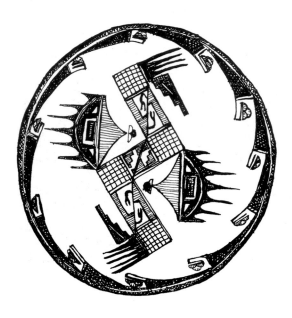

Pottery bowl made by the San Ildefonso Indians, New Mexico

the everyday water jars and cooking vessels, ceremonial items, such as incense burners, and tourist trinkets. The shapes of the cooking vessels, and of course the basic diet, have evolved little over the centuries of Hispanic domination; the items made include the platters for cooking tortillas, jars for storing grain, colanders for washing maize and rough-surfaced bowls for mincing chilli peppers.

Pre-Columbian-style clay statuary and vessels continue to be made and used in the same way as their ancestors amongst the less accessible groups of Indians. Crude zoomorphic statuary and gourd-like bowls are fired in the ashes of an open fire. Towards the Guatemalan border the Lacandón Indian community of the Chiapas rainforest remains in near isolation from the modern world, and holds the fragile record of never having been subjugated by Europeans, nor converted to Roman Catholicism. Their worship of a pantheon of gods continues in temples by way of offerings to clay incense-burners daubed with ash, lime and annatto juice; these depict the faces of various deities.

The pottery tradition of South-West America dates back to before the time of Christ, and developed in style by way of footborne trade that flowed between the peoples of the Anasazi and the later Pueblo communities of the desert and savannah scrub mesas, the tribes living to the south and adjacent to the Pacific. In a land where survival – as a hunter-gatherer, nomad or in a settled community – has never been assured, the sedentary Pueblo peoples were once great traders, supplying the wandering peoples of the plains and desert such as the Apache and Navajo. Nowadays, as ever, their pottery forms are moulded to perform the life-sustaining tasks of water collection, transport and storage, or as cooking and eating utensils, drinking vessels, jugs and mugs. The all-embracing lifestyle prescribed by their religion ensures that whatever its form, decoration or use, the article is infused with creative energy that is ceremonial in origin. Pueblo pots are always made with identical materials and the same time-honoured techniques, but the great commercial success of their work over the centuries to this day is a product of their ability to assimilate shapes and decorations from other Pueblo peoples as well as from outside sources. The inspiration for their work is ever-changing, therefore, but is stoutly based on a rigid attitude towards their place in the universe and a sense of humility in their role as creators. Early pots are dynamically patterned with geometric motifs that often link together to form seemingly zoomorphic or anthropomorphic compositions. The form and decoration of the bulb-shaped water and food storage jars often unite in such perfect harmony that one imagines that they were created as one from the first moulding. Never losing their eye for a new design or form, the Pueblo potters have decorated their pots with flowers, birds and animals from the nineteenth century onwards, and the imported forms of the Europeans are produced alongside traditional ware.

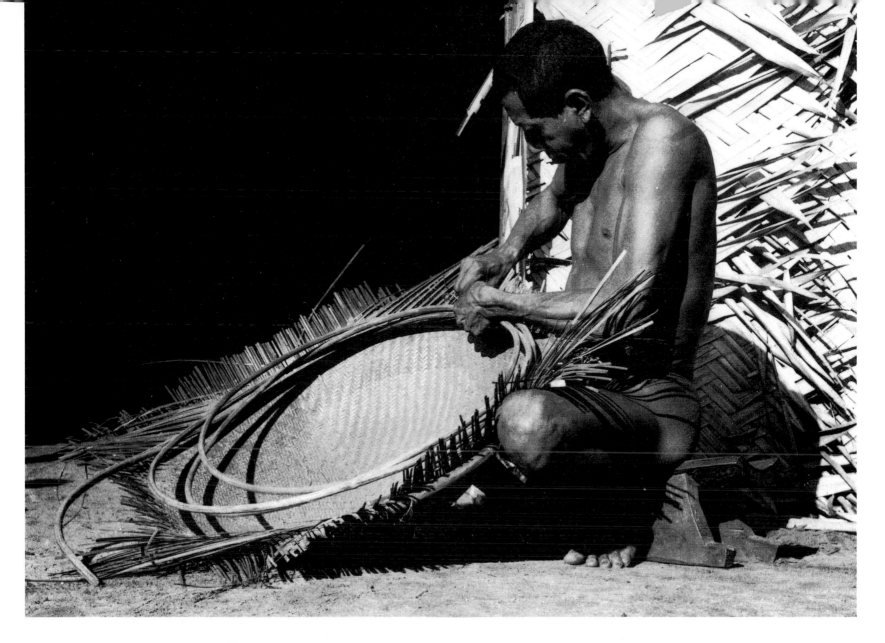

Basketry

A Turkano Indian seated on a wooden stool binding on cane hoops to form the rim of a cassava basket sieve, Colombia, 1960-61

Basket-making pre-dates the craft of weaving and potting by many thousands of years, and yet despite the lengthy construction process most tribal and folk communities continue to make and use baskets, largely for everyday use. Baskets were most commonly made as bowls by the Indians of the South-West. The settled and prolific basket-makers such as the Hopi and Pima Indians as well as the Apache would have used the shallow dishes and bowls for carrying loads and the smaller platters for preparing and serving food. Larger baskets came to be made at the turn of this century in response to demands from the outside world. Design-work is often figurative or of geometric motifs linked together, repeating, or reflecting one another; the Apache women were especially fond of reproducing the animals and birds indigenous to the lands they roamed as a random arrangement of charming figures.

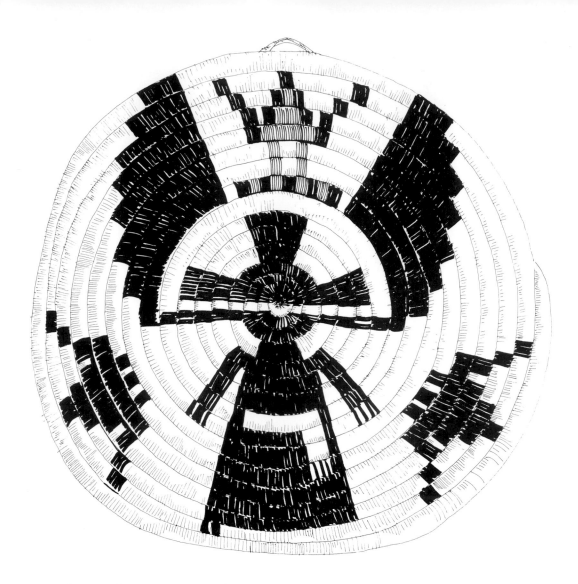

Basketwork of the Hopi Indians of Arizona

(Opposite) This living room is furnished in a comfortable mixture of European and Central American folk and colonial styles. Over the fire are positioned two ceremonial figures, one an early eighteenth-century Christian saint, the other a seated effigy from the ancient culture of the Mayan Indians. Floor rugs from Morocco and Mexico rest happily side by side.

Basket-making traditions flourish throughout Central America, West and south-Central Africa and the southern and eastern states of the Subcontinent, but it is in Indonesia that baskets transcend everyday use to become part of ceremonial life. The lush forests serve to provide the basket-makers with raw materials. Flayed bamboo may be sliced into paper-thin strips and plaited into baskets to make food containers, and when lined with a tar-like substance can be used to carry water. Exceptionally strong carrying baskets are made from larger-sized bamboo strips. The lontar palm is a remarkable source of plant fibre useful to the Indonesians; the leaves are used for water and palm-wine carriers, umbrellas, woven baskets, sacks and cigarette papers. The wine is extracted from the inflorescences of the female palm. Baskets and mats perform an important role as ceremonial and ritual accessories as well as necessities in Indonesian households. They are used to carry betrothal and wedding gifts for the bride and the bride's family, to hold sacred heirlooms and to carry ritual objects. Shape, colour and decoration designate the function of each.

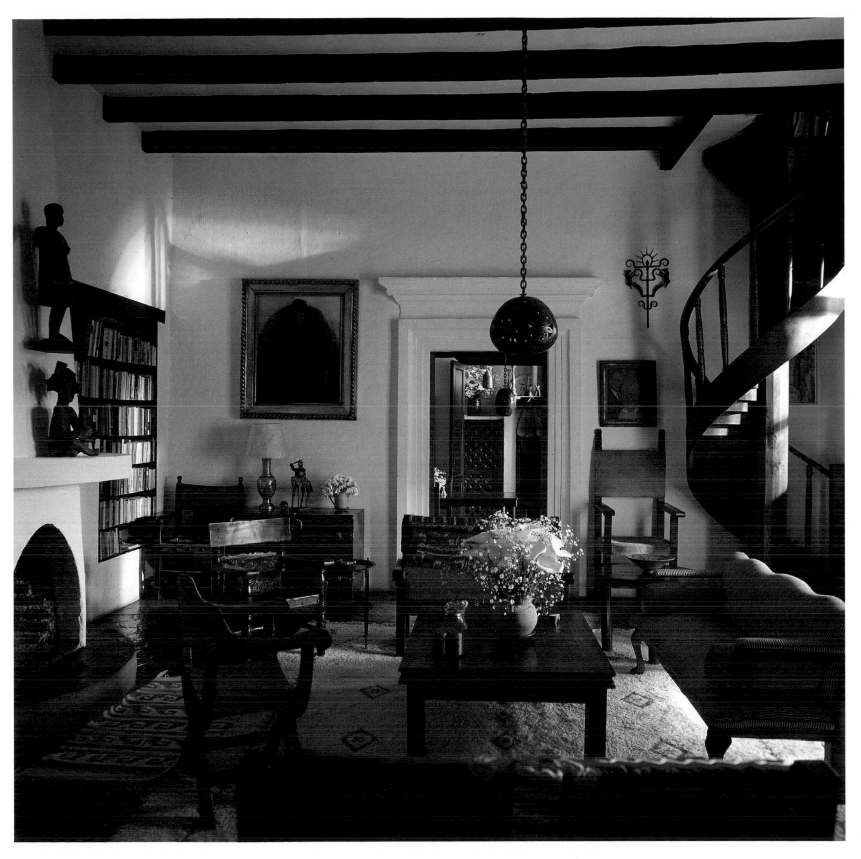

Curvilinear and tactile forms abound on this chest top (below). The wooden 'lota' is from Rajasthan, the painted deer from Orissa, and the Indian egg-shaped box is probably for cosmetics. Amidst this ethnic scene are found an English oak frieze and inscribed shell, which rests alongside its counterpart – a shell carved from the wood of the tropical shorelines of Indonesia. (Opposite) On the oak panelling an 'Arabi' kilim from Afghanistan is the backdrop to a strange assortment of decorative objects. From Bali come the brightly painted balsa fruit, from Italy the seventeenth-century painting, from India the merchant's chest and house shrine, and from Afghanistan the platter-like wooden bowl. Over the table a large kilim from Anatolia completes the richness of this scene.

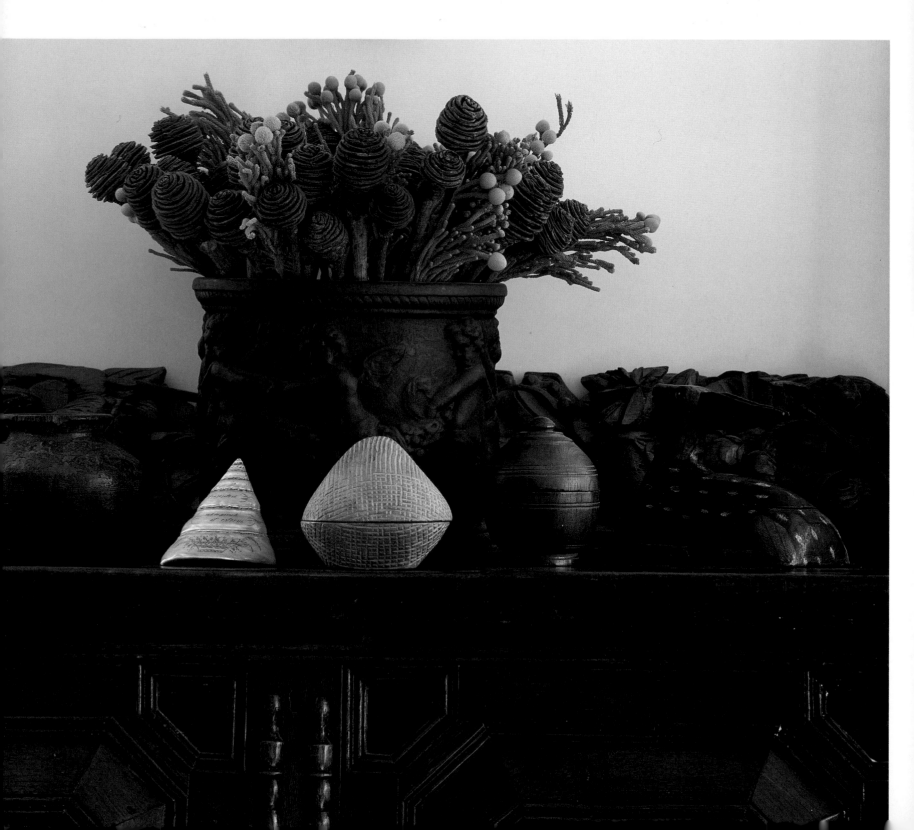

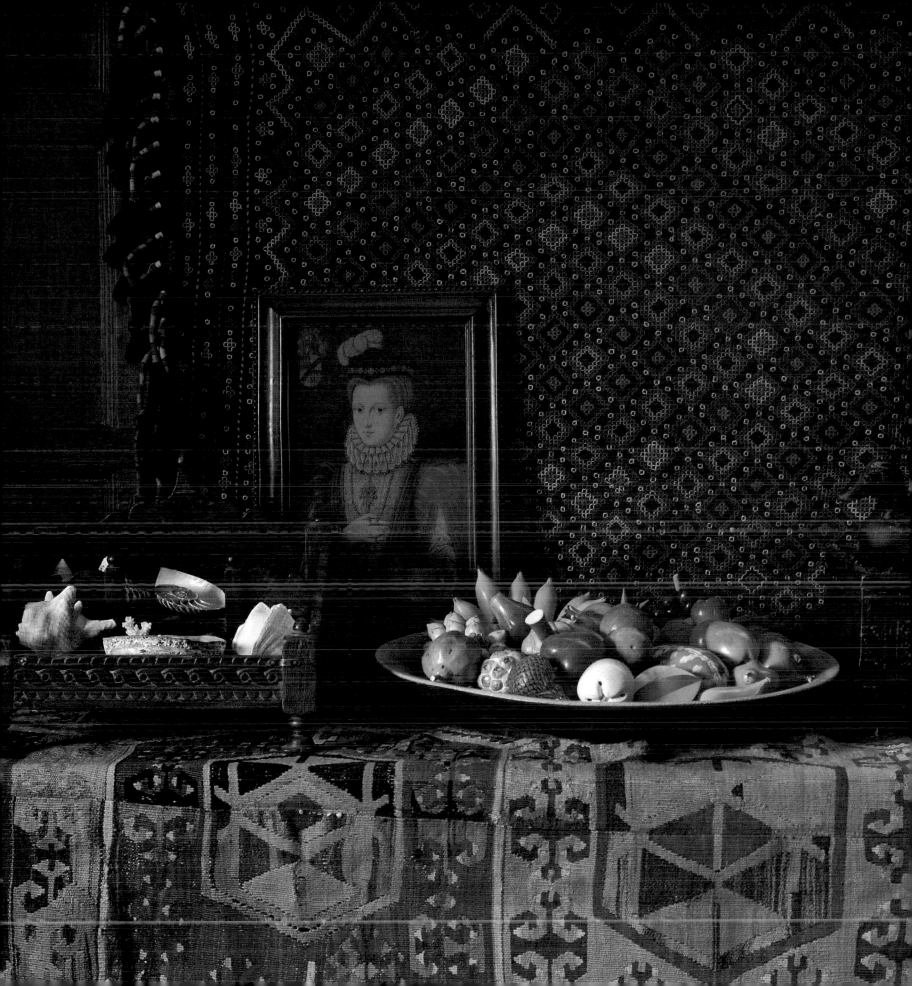

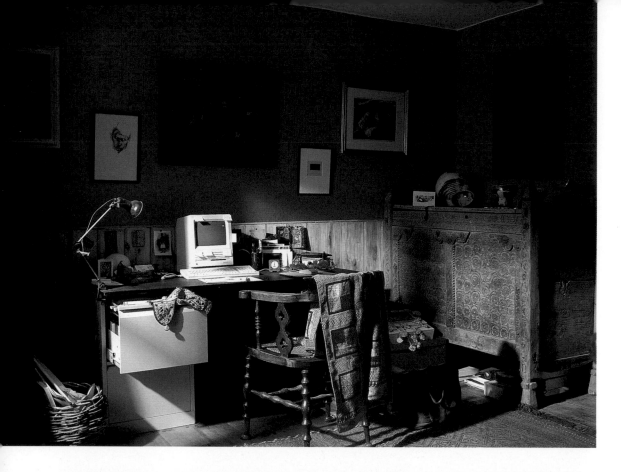

(Left) *A glimpse of the private world of a study reveals the clutter of favourite paintings, pots and folk as well as tribal artifacts. Beautiful yet functional, the carved Swati chest and kilim were collected from Central Asia, and the covers for the computer and printer, keyboard and stereo system are embroideries from India.*

(Opposite) This is the office of a Los Angeles furniture-maker who delights in the arts and crafts of the peoples south of the border. Unusual combinations of bottle tops, hub caps and thrift-store paintings are formed into figures, decorations and furniture to amuse and to please the eye.

(Below) Within an artist's studio lie the secrets of the inspiration of the moment – here, the visual relationship between pre-Columbian stone carvings and twentieth-century Huichol embroidery.

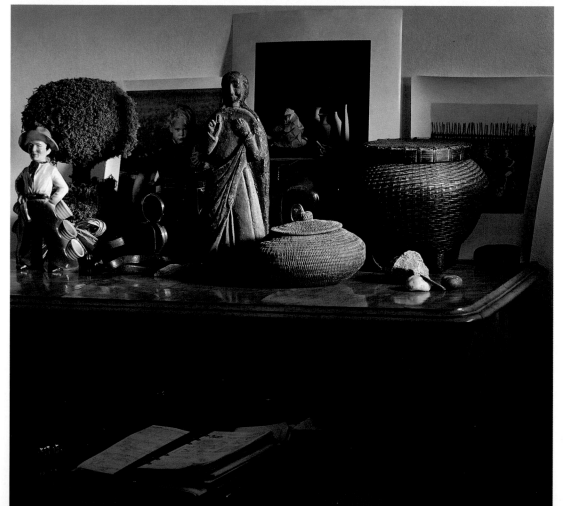

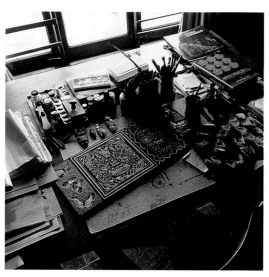

(Left) This wooden ecclesiastical carving hides ancient cultural roots, for it was found in south-west India where St Thomas landed to establish Christianity during the first century AD. The fine baskets originate from the tropical islands of Indonesia, whereas the swollen filofax is an essential aid for a somewhat more hectic Western lifestyle.

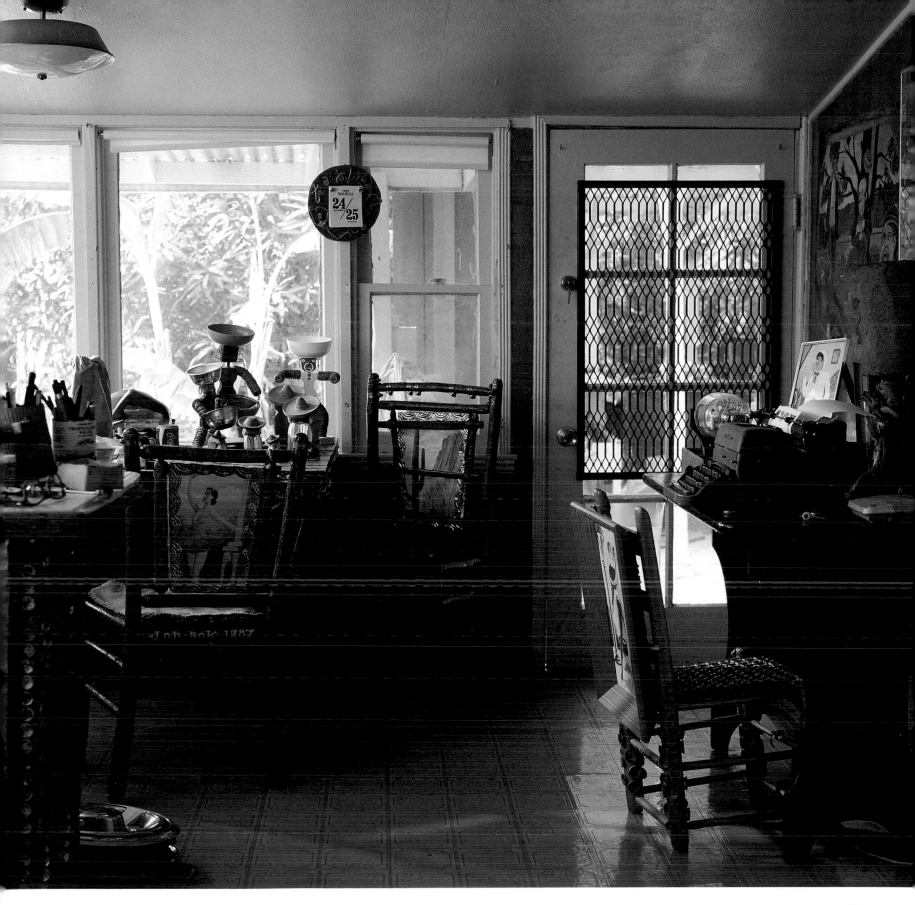

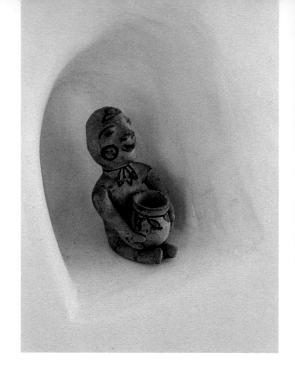

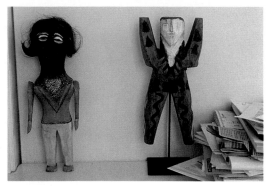

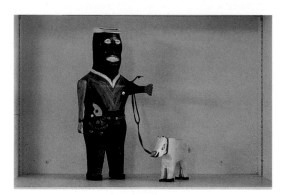

This house, set amidst the piñon and mountain-juniper landscape of the South-West, is the home of an avid collector of American folk art. The collection of four thousand objects overspills around the traditional American Indian fireplace, on and amidst books and bookshelves, within cupboards and in every room – the result of a lifetime's passion. This selection from the collection (above and left) reveals a little of the wide-ranging nature of American folk art, from native work (the Navajo birds and blackware pots, and Hopi 'kachina' dolls), to the tramp and naive art of the European Americans. Look out for Idi Amin and his hound.

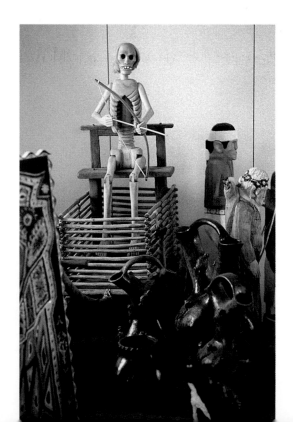

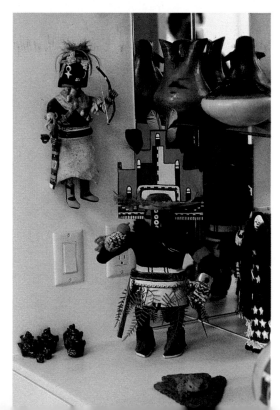

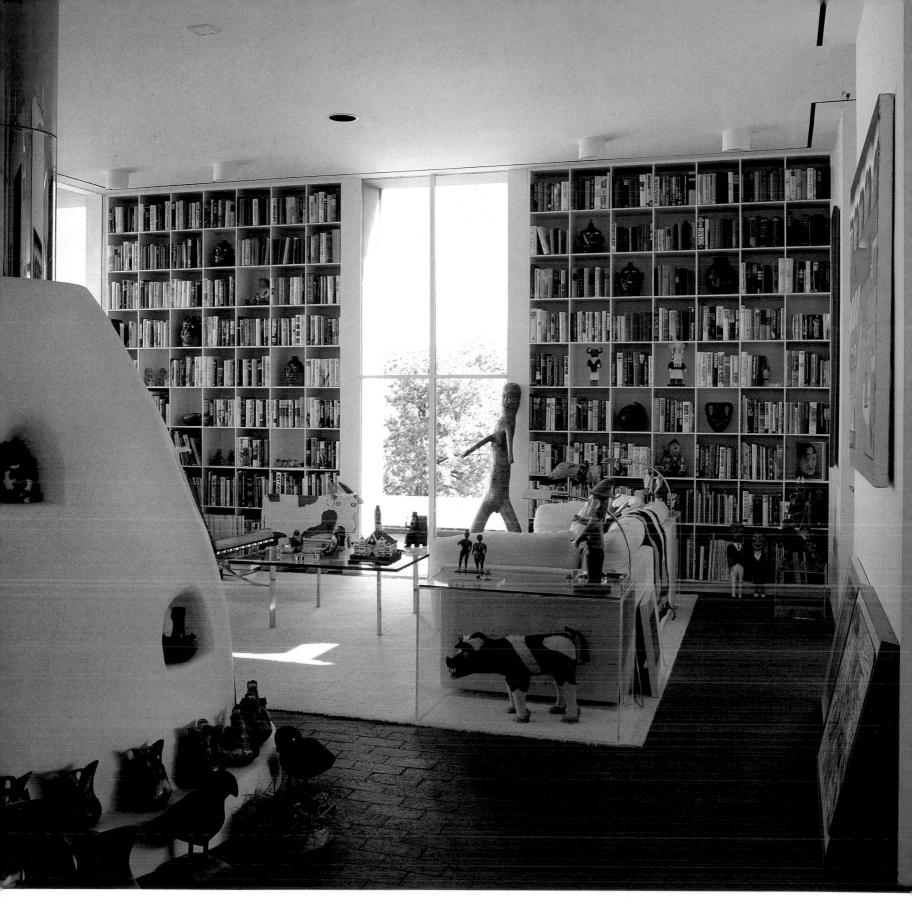

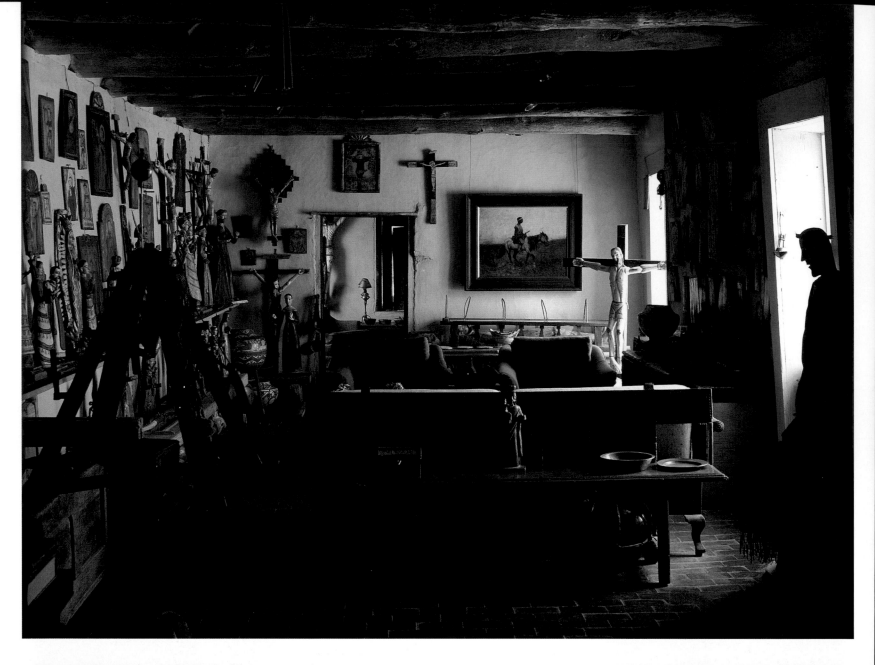

Within this nineteenth-century adobe home is a magnificent collection of Hispanic ecclesiastical artifacts and native American arts. (Opposite) Grouped around a 'bulto' of Christ is a halo of 'cristos', or crucifixes. The desktop is decked with Pueblo Indian shrine gods and a strikingly decorated Pueblo pitcher. (Above) This is the central room and original meeting area of the building, now decorated with effigies of New Mexican saints and a church candlestand of impressive dimensions. (Left and right) Almost every shelf and wall within the house is reserved for the collection and the kitchen is no exception.

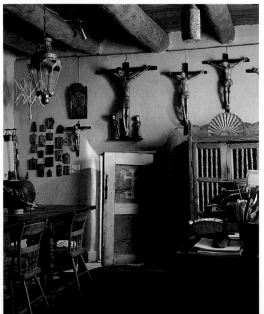

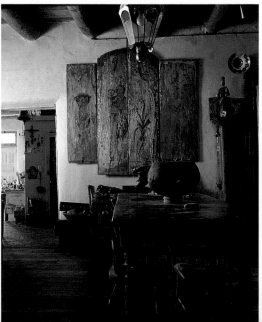

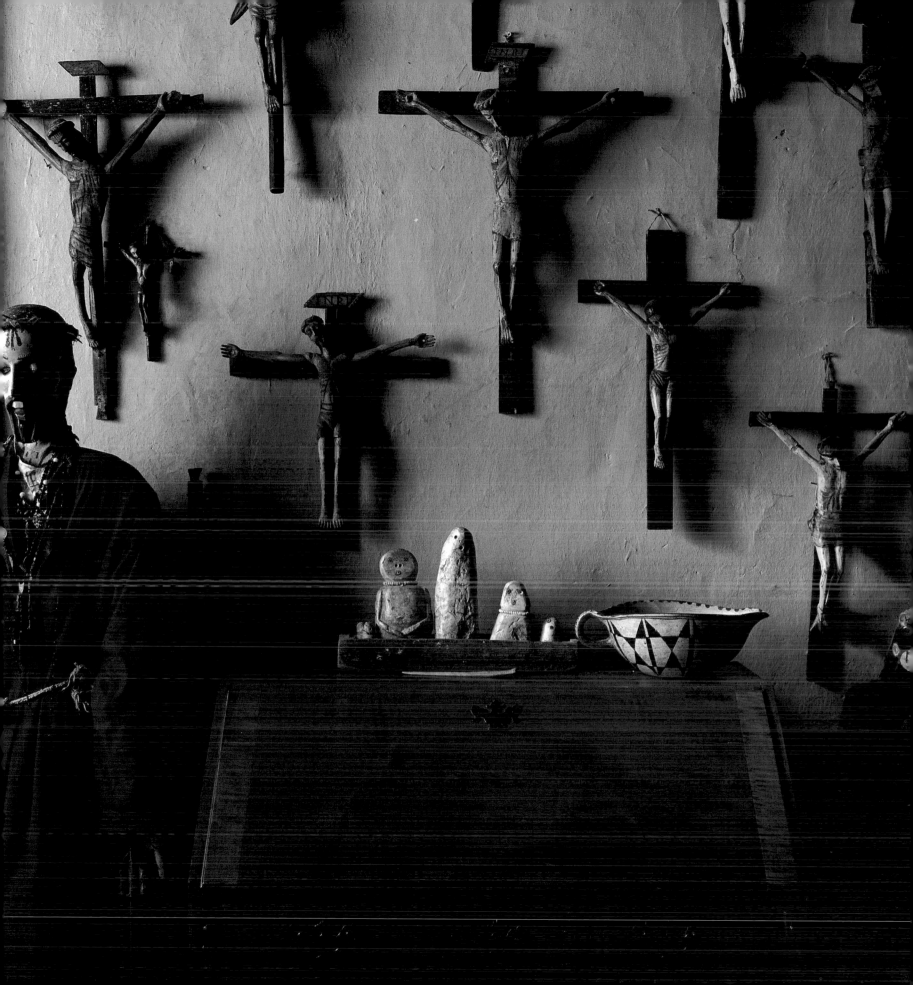

(Left) Inspired by the saffron tones of the desert lands of north-west India, this guest bedroom has been painted and decorated with the colours and artifacts of Rajasthan and Gujarat; on the wall is a hardwood 'jali' shutter and laid over the bed an erstwhile ceiling-hanging of appliqué and embroidery.

(Right) On this bedroom chest artforms of many different ages and origins are grouped together. From Italy – a wooden seventeenth-century head of St Francis; from India – a Gupta female head; and from a Han tomb of China – an object some two thousand years old.

(Below) For some, the passion to collect exceeds all available space, and so here, on the landing, a Sumban ikat cloth has been draped over a rail purely for the passing pleasure of its look and feel.

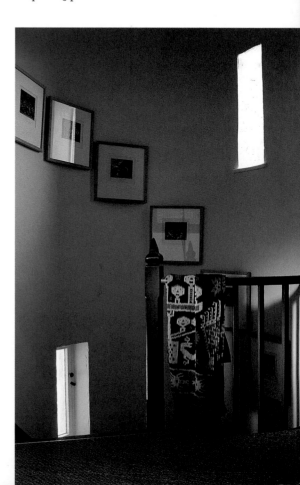

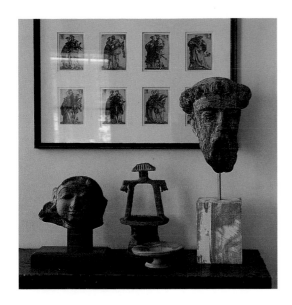

(Right) This is the living-room of a textile designer who derives her inspiration from her passion for tribal and folk form, texture and colour; a shawl from Bolivia is a backdrop to colonial silver plate, hats from the Altiplano deck the walls and even the cactus has an American Indian basket to cover its pot.

(Below) The walls of this room have been decorated with a painted border taken from a kilim motif, and the effect unifies the assortment of decorative objects within. Here a European Bible box, a wooden fish and a rice mould from Indonesia sit on the window-sill in the company of another small chest for precious goods – a dowry casket from north west India.

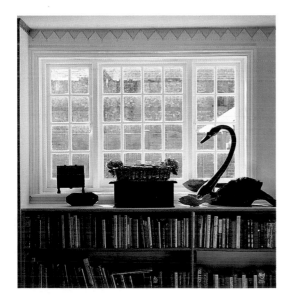

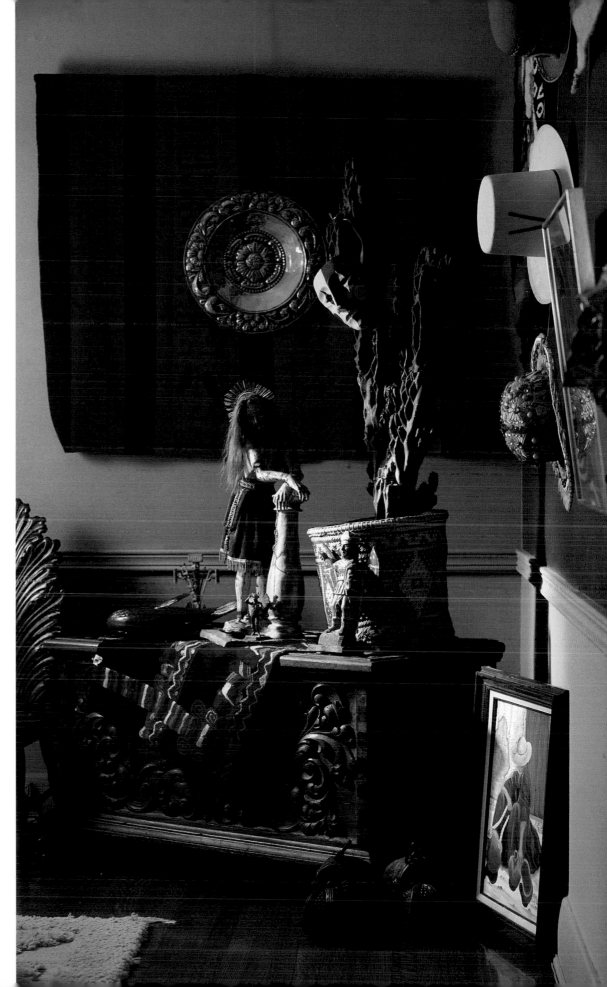

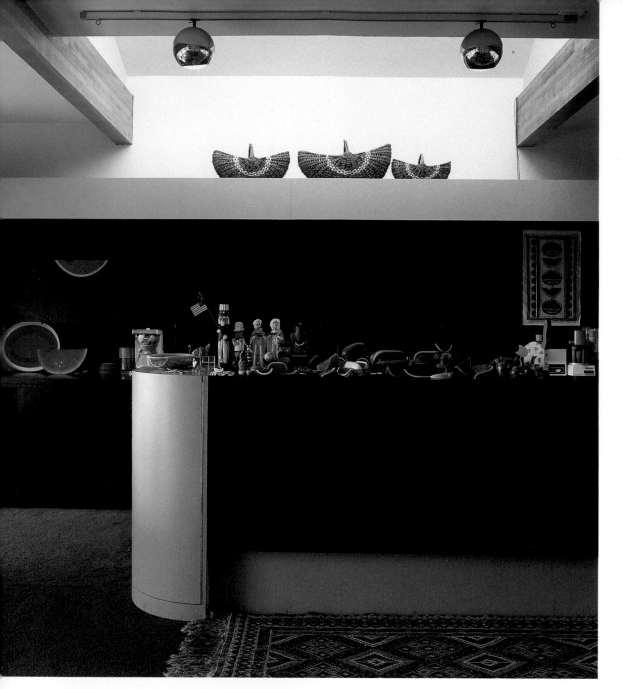

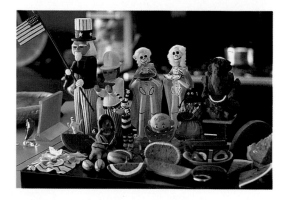

There is no doubt as to the central theme of this collector's passion: here we find baskets and pots made in the shape of water-melons, and water-melons on trays and tea towels, in the hands of figures and even skeletons consuming the fruit. From Japan to Russia, Mexico to the Philippines, the roving eye knows no bounds.

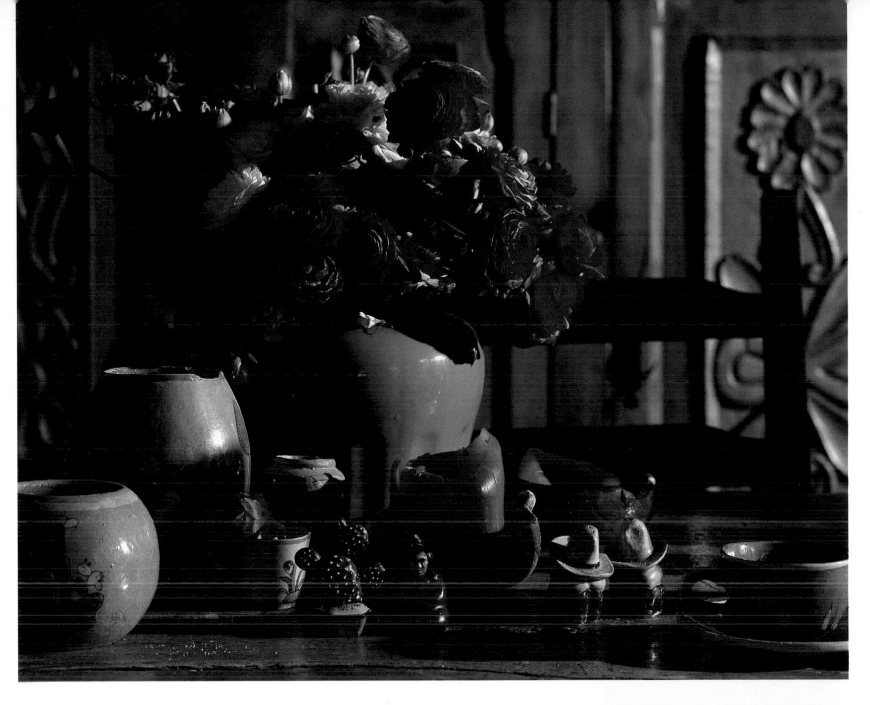

The dining room within the home of a Californian passionately involved with contemporary Mexican folk craftsmen and musicians. Vivacious colour radiates from the wall-hanging – a silk and wool 'sarape' and around the picture rail as well as on the table is displayed a fine collection of Tlaquepaque pottery – the post-revolution celebrationary wares of a small town near Guadalajara.

(Opposite) Designed as an external fire-lit room open to the fine, yet often chill, northern New Mexican evenings, this annexe contains a small selection of Midwestern American folk art.

(Right) This New Mexican dining room houses part of a fine American folk and tribal art collection. The scantily clad lady from Nashville looks askance at the row of Navajo Indian preventative and healing ceremony masks.

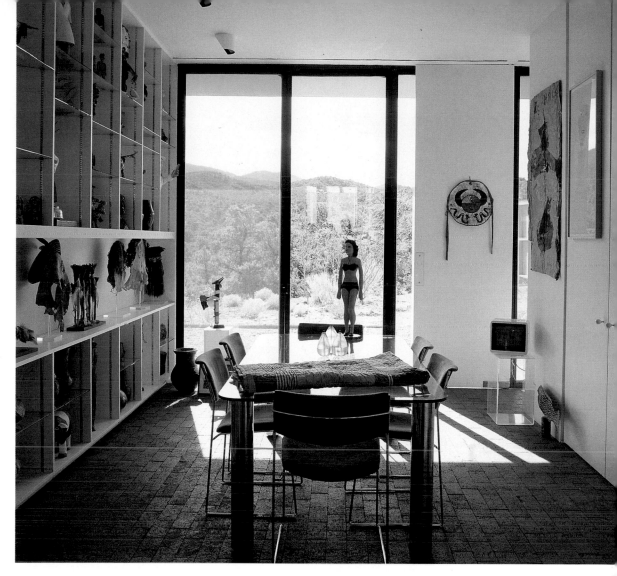

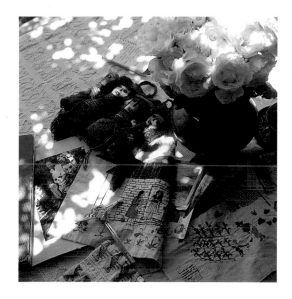

(Above) A still life of Central American arts: in the shade of a tree, the weaves of Zapotec and Mixtec Indians and the grave dolls of Peru can be closely examined and admired at leisure.

(Right) The furnishings and decorations of this home are a tribute to the simplicity of expression in much American folk art; the Shaker cupboard and the quilts strike a satisfying balance between form, decoration and function.

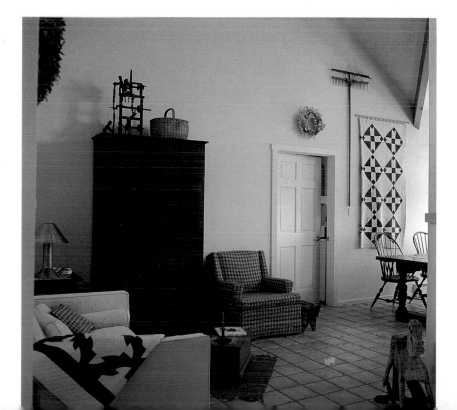

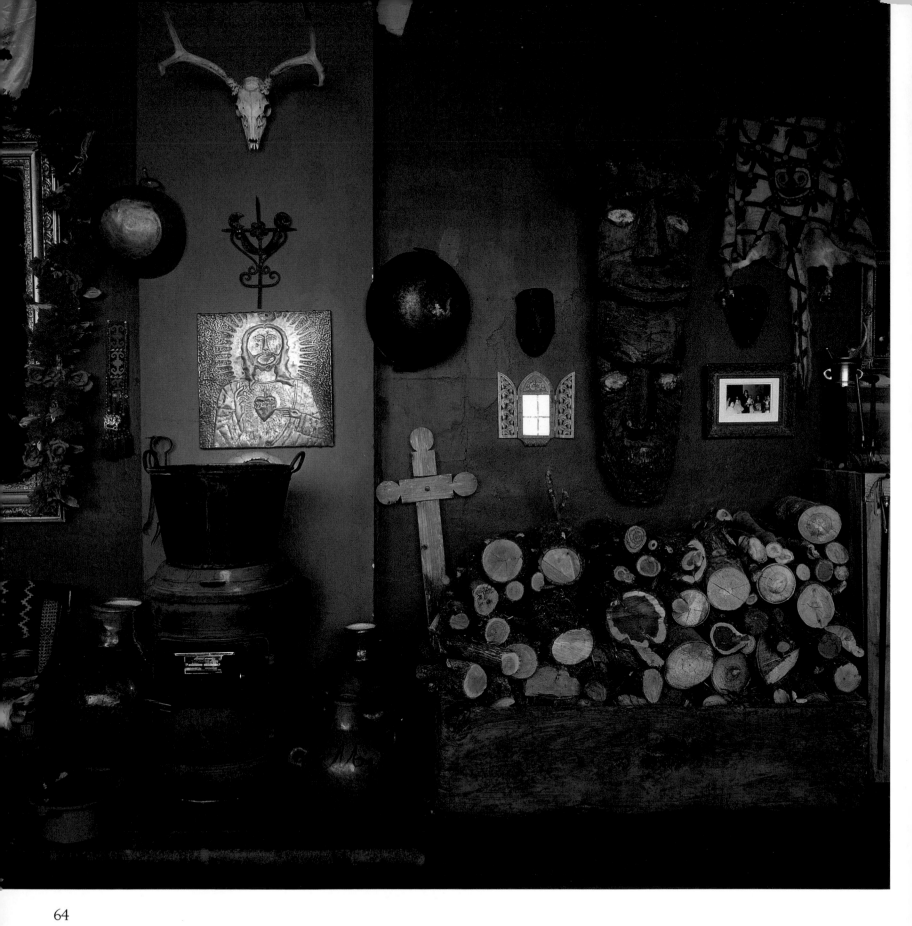

Chapter Three **The Sources**

When the collector takes time to visit an ethnographic museum, or attends a private view of a tribal art exhibition at a culture centre or gallery, sipping wine amongst fellow guests, he or she is surrounded by the wonders of a world now extinct or near-extinct, and will have cause to dwell upon what has now been lost in the tides of acculturation. The tribal communities of the world have suffered from Western interference in so many ways, through 'modernization', 'civilization', or conversion to some sanctioned and organized world religion, and because of this, enthusiasm for tribal and folk art must necessarily be tinged with lament. Some attempt is now being made to revitalize skills by educational and cooperative commercial schemes, but these, ironically, might prove in time to be yet another meddlesome incursion of the developed world into a society ill-understood and ill-served by Western evangelism throughout the centuries.

It may be that the tribal arts are running headlong on a course towards final extinction — at this stage it is impossible to say. Whatever their ultimate fate, however, many artifacts still remain to be enjoyed by the Westerner; what follows is a survey of ethnic arts past and present, intended as a general introduction to the wide variety of items available in the hope that this might stimulate a deeper interest in and appreciation of the peoples and their creative energies.

(Opposite) Surrounding this wood-burning stove that warms an old adobe schoolroom high up on a New Mexican mesa is an inspiring collection of Mexican artifacts. The double-headed wooden carving is of twentieth-century Mixtec Indian origin, representing the god of confession, to be addressed once a year before the eager ears of the whole village.

The Americas

What Columbus discovered when he reached the western hemisphere was not the India he had been sent to find, but a continent that ran from the Arctic Ocean to the wilds of Patagonia. It is to Columbus' error that the natives of this land owe their name 'Indians'. The most culturally diverse groups inhabited the western mountains and plateaus that form the spine of the Americas, running from the North-West Coast, through the deserts of the South-West, into the highlands and jungle realms of the Central American isthmus and down the southern continent. Within these lands lived

various tribes who, despite trading with their neighbours on the coasts, the lowland plains or the jungles below, developed an often parochial yet dynamic style of art and craftwork. From the golden objects that bewitched the Conquistadors to the hand-smoothed ceramics of the subsistence farming communities of the Pueblos that are made and collected to this day, the range of the tribal and folk arts of the Americas is a bewildering delight.

North America

The North-West Unlike their relations of the plateau lands to the east or the sea-mammal hunters to the north, who carve in bone and soapstone, the artistic tradition of the Indians of the North-West Coast is based on a rich supply of timber and a surplus of production which allows the commissioning of luxury craft goods. Warmed by the Japan Current, the coastlands are humid and draped in a cloak of rainforest. Supplies of fish and game were once in abundance, and the Tlingit, Haida, Tsimshian, Bella Coola and Bellabella, essentially fishermen, enjoyed a sedentary and ritualized existence living in large clan or kindred houses. Their lives were regulated by complex social organization, with a marked class distinction between the hereditary nobility – who, not surprisingly, sought to improve their lot by the accumulation of wealth and status – the commoners, and the slaves. The quiet winter months afforded them time to indulge in lavish potlatch feasts involving singing, dancing, drama and present-giving, for which heraldic and ceremonial artifacts were commissioned by the elite from professional artists. The tribes are best known for their painting and wood-engraving tradition as well as for their basketry. Governed by extremely complex traditional design rules, the North-West Coast style is unmistakable in its clarity. The quality of work reached its zenith in the late nineteenth century when styles of engraving and painting, on wood as well as metal, were a conglomeration of the representational, stylized and the symbolic. An engraved and painted wooden chest used for storage would bear decorative crests representing the rights of certain kinship groups. Designs of human forms and their facial features, birds mythical and real, the killer whale and small indigenous animals such as beavers are commonly found and by a visual 'flattening' of the image are spread over the pictorial area of the object in an ambiguous harmony. Graphic reduction, the dislocation of reality and the split-representation of objects are the hallmarks of North-West Coast art, which now appear in an array of compositions on wooden chests, animal skins, metal, basketry, mats and blankets that vary from the strikingly realistic to the surreal.

The South-West This region is dominated by rocky deserts, mountainous outcrops and scrubland that afford little sustenance to humankind,

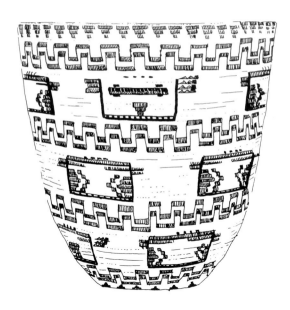

Hopi Indian basket

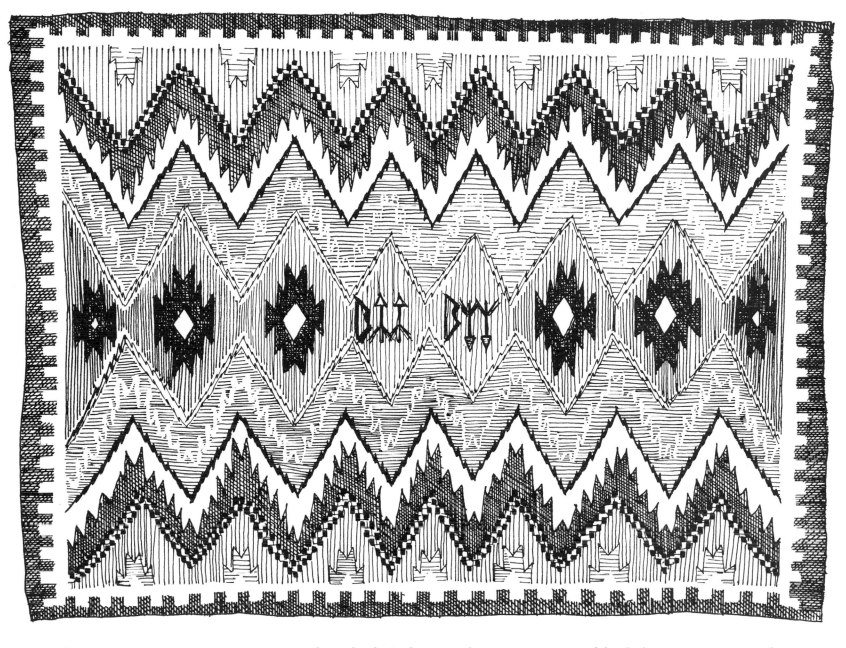

Navajo rug from Teec Nos Pos, Arizona

and until relatively recently its most successful inhabitants were game hunters, gatherers and raiding tribes. The tribes who settled, at first in simple dwellings and then in the well-known multi-storey Pueblo complexes, comprise three groups, the Mogollon of Arizona and New Mexico, the Anasazi of the northern South-West, and the Hohokam of the southern desert. Their sedentary lives were made tenable by hunting and gathering, and by irrigation systems that nurtured their crop of maize and, later, beans and squash. Their methods of pottery and textile production seem to have been adopted from sources to the south, and these simple cultures eked out a precarious existence on the borderline between famine and subsistence for hundreds

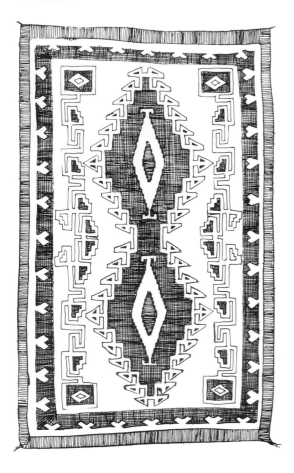

Navajo rug

of years, until the arrival in the fourteenth and sixteenth centuries of two warring groups, hunter-gatherer American Indians from the north and foreigners from across the ocean to the east.

The Navajo and the Apache are Athapaskan-speaking tribes who journeyed south into Pueblo lands to establish a relationship with the natives that swung from cordial trading to raiding and pillaging. These were followed by the rapacious Spaniards, who travelled north into the South-West in search of yet more gold. The relatively impoverished tribes and lands they found must have been a source of both frustration and hardship to the European invaders, who saw no harm, nevertheless, in raising the Spanish standard and subjugating the locals. The arrival of an alien religion and a regime of forced labour gave the Pueblo peoples sheep, horses, treadle looms, new dyestuffs – and a desire to revolt. The successful insurrection was to last from 1680 to 1692, after which Hispanic rule resumed and then endured until the area was won by the Union in 1848. Despite the proselytizing of the Spaniards, the traditional arts and crafts of the Pueblo Indians and their fast-learning Apache and Navajo companions survived and flourished (in quantity if not always in quality), spurred on, from the late nineteenth century to the present day, by the American-European demand for native American decorative artifacts.

The pottery of the pre-Pueblo and Pueblo groups of the South-West is of the highest technical and imaginative order and continues to be made in quantity to this day. Early influences on prehistoric Hohokam and Mogollon pottery undoubtedly came from the southern lands of what is now Mexico, developing from plainwares to both abstract and representational decorative forms. The Anasazi were the perpetrators of a wonderfully ornate style from about AD 900 onwards, which comprised black designs painted on a white slip, a form of decoration which reaches a level of excellence with Mimbres ware. Fine compositions balancing a white background with solid black and hatched areas create separate positive and negative dimensions within the patterns; Mimbres ware also includes representations of living forms within the geometrical structure. Black-and-white painted patterning was supplanted by polychromatic designs from about AD 1300 onwards, when figurative forms began to appear in Anasazi work.

The contact with the Spanish had led, by the early nineteenth century, to a decline in quality that was also partly due to the importation of other ceramic tradeware from outside the region. The tourist boom that followed the opening of the Santa Fe railroad led to an increase in output and a lowering of standards made good again in the twentieth century when prices for pots that were now seen as 'art' rather than ephemera soared. Hopi pottery almost faded to extinction until the discovery by archaeologists of the outstandingly patterned Sikyati prehistoric ware. Produced in Hopi country, the original highly stylized black, orange and white ware inspired a renaissance

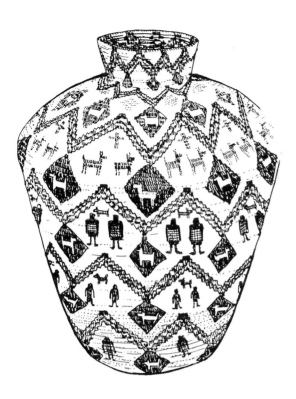

Apache 'olla', or storage jar

in production centred on the village of Hano. Today the Pueblo potters of the South-West continue vigorous production of traditionally designed polychromatic pots.

Ancient basket-making traditions flourish amongst the Pueblo Indians of the South-West to this day. Yucca or sotol leaves are used in the lengthy plaiting and coiling processes, with structural decoration achieved by twilling. The Hopi manufacture of baskets is renowned for its superb quality, imaginatively embellished with geometric and figurative forms. Birds, people and 'kachina' dancers are commonly found on upright shapes, whereas the rounded weaving of shallow-bowled baskets invites curvilinear patterns set against rectilinear blocks derived from the straight warps. As with the Navajo adoption of rug- and blanket-weaving techniques, the other Indian late arrivals on the scene, the Apache, took to learning basket-making from the Pueblo indigens with zeal. The Apache were the superlative basket-makers of the American South-West although they were renowned more for their raiding habits than for their homely craft skills. Apache women twined and close-coiled decorated baskets with stunning workmanship and creative integrity. The tub-like storage baskets known as 'ollas' are a marvel of patiently executed close coiling, each taking as long as a year or more to make. Materials used included willows and cottonwood and the dark designwork was executed either in black extracted from the seed-pod of the devil's claw or in the reddish brown from the yucca root. That their work is no more than a century old in tradition matters not, for the Apache baskets are spangled with lively designs of people, deer and horses against a backdrop of zigzags and banded patterns. The most coveted examples of antique native American baskets are the nineteenth-century work of the Washo of Nevada and California. Finely coiled baskets are patterned with small traditional designs that run in a series of spirals from neck to base.

Wood sculpture really had no place in the craftwork of South-Western Indians until the advent of the nineteenth-century market for kachina dolls. Kachinas are masked dancers who depict by way of myriad costumes a range of supernatural beings, and the dolls in their image were originally made by the Zuni and Hopi Pueblo Indians as fertility symbols for women and instructional tools for children. Older dolls are characterized by a simplicity of form, detail and expression, the modern work, sadly, by elaborate painted decoration, a striving for realism and poses which mimic movement.

The Christian folk art for which New Mexico is well known originates with the Hispanic groups of the region. What began in the eighteenth century as the work of priests and lay artisans for the decoration of churches – the carving of wooden altarpieces, painted panels ('retablos'), figurines ('bultos'), effigies of saints ('santos'), Christ figures and crucifixes ('cristos') – extended to many a household and turned into a flourishing folk crafts tradition of the nineteenth century. Artists began to sign their work and

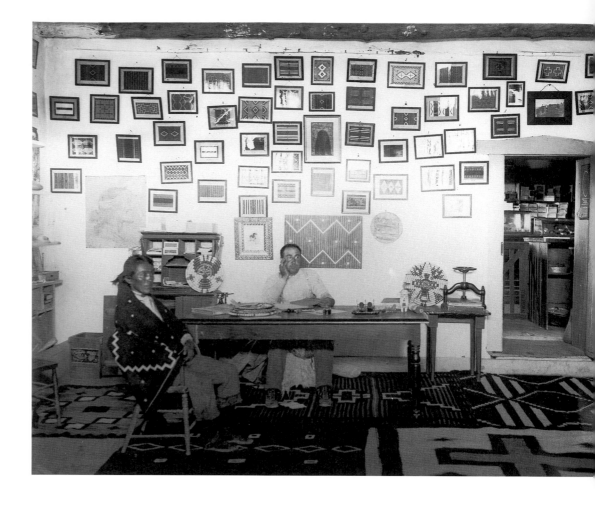

The Ganado Trading Post, Arizona, in 1904, established in 1878 by John Lorenzo Hubbell. Hubbell provided inspiration for the Navajo weavers working to his commissions by hanging colour plates of traditional Indian sarapes and blankets on his office wall.

workshops were established to train apprentices in religious statuary carving. By the early years of this century the practice was in decline, superseded by the mass-production of imports from the American East. This wood-carving tradition may be detected in the work of New Mexican folk artists of Hispanic origin and found on display in that gallery-town, Santa Fe.

Although the native Americans have been weaving with plant and animal fibres for many thousands of years, it was the introduction of sheep and imported dyed trade yarn by the Spanish that triggered off a craft industry that continues to flourish. At that time, the Pueblo Indians were weaving cotton textiles on vertical looms like those still used by the Navajo today. Faced with the demand for a new type of textile and new rules of dress, the Pueblo weavers produced 'sarapes', the cloak-like cloths with patterns of simple yet elegant weft stripes. The future of South-Western weaving was irrevocably altered following the Pueblo revolt, for many then moved to settle amongst the Navajo. Navajo women were quick to learn these new weaving skills and with the Spanish-imported indigo- and red-coloured yarn unravelled from trade cloth, began to supplant the Pueblo work with imita-

tions of their sarapes that, with the added influence of weaves imported from Old Mexico, developed into 'chief blankets'. Chief blankets progressed in style from banded work to striped and diamond compositions from the mid-nineteenth to the beginning of the twentieth century. These textiles, along with the earlier sarapes, constitute the most sought-after and valuable collections of textiles in the world.

By the late nineteenth century, the European trading posts of the South-West were directing the Navajo weavers towards a consumer-orientated production, and thus the era of the Navajo floor rug began. Patterns and compositions were taken from Oriental rugs and these, combined with soft colours, were the most popular decorative styles listed in department-store catalogues. Today the traditional vertical looms of the Navajo continue to produce blankets, mats and rugs for an easily pleased market of American Europeans. Some of the more darkly humorous compositions are without peer.

Central America

Mexico The varied landscape of Mexico, from south of the northern deserts to coastal jungles and up to highland plateaus, has been the home of both overlapping and successive Indian civilizations. These were cultures with a strongly creative temperament, whose empires stretched back to at least 1500 BC, but ended with the arrival of the Spanish in the early sixteenth century. The sight of one of the giant Olmec heads from the southern coastlands of the Gulf of Mexico fired the enthusiasm of the sculptor Henry Moore; the remains of the great Zapotec, Mixtec and central highland cities such as Teotihuacan continue to awe the imagination of every visitor; and the mysterious disappearance of the greatest early culture, the Maya, still bemuses academics. The infamous work of a band of Spanish adventurers in dispatching the last and short-lived Indian empire of the Aztecs paved the way for a new overlay of religious, cultural and human influences to add to the cornucopia of the past. Intermarriage between Indian and Spaniard has created a vast mestizo class over the centuries, and yet there remains over sixty Indian groups dotted over the land, comprising some fifteen per cent of the population. The mixture of traditional crafts of the Indians and the folkish objects from the mestizo artists has given Mexico the reputation for being the most productive folk culture of the world, rivalled only by India. Crafts in Mexico are part of a dynamic and vibrant tradition and any visitor cannot help but notice, despite the preponderance of ruins, how the atmosphere is charged with an enthusiasm for living, each day at a time.

Mexican craftwork revolves around the production of time-honoured traditional goods such as pots, baskets, textiles, masks and statuary, their inspiration deriving from blatantly pagan to Christian symbolism. Mestizo

artifacts – metalware, pots and other decorative ceramic forms, statuary, masks, toys and trinkets – are devotional and often full of the motifs of youthful nationalism, yet often a sense of exuberant delight is manifest in the craftsman's approach to his country's obsession with death. Skulls, skeletons, beasts of the night and nightmares are immensely popular and find good use at the festival of the Day of the Dead, 2 November.

The Indian weavers of Mexico are primarily concerned with making clothing. The village women continue to use the backstrap loom of their ancestors to weave and embellish colourful lengths of cloth that make up the yardage for both everyday and ceremonial garb. Pre-Columbian women's garments included the open and tubed skirt complete with sash, the sleeveless tunic (the 'huipil') and the enclosed shoulder-cape (the 'quechquemitl'). Dating back to the sixteenth century, the 'rebozo', or shawl, is a most popular accessory worn by Indian and often mestizo women. Many hand-loomed cloths are practical in design, for they provide the everyday means for an Indian woman to carry loads; some also serve as head-covers, or to protect them from the sun or rain. Men sport more European garb than ever before and only in the isolated communities will they wear their traditional tunics, sashes and near-invisible short trousers.

Just as the women work the backstrap loom, so the men make their contribution to the family with their income from the workshop production of sarapes, rugs, ponchos and fancy goods for the tourist market – their treadle-loom is a more efficient, semi-mechanized Spanish import. Skilfully woven to traditional patterns, their textiles can be of the highest technical and compositional merit. The eighteenth- and nineteenth-century sarapes of northern Mexico, especially the classic Saltillo compositions, are highly prized, and good work also continues amongst the Tarahumara, Mayo and Yaqui who now emulate most successfully the compositions and floor-rug designs of their relations over the border. Further south, the Zapotec weavers of Oaxaca are renowned for their skills as copyists. The Mexican revival of their ethnic arts in the 1920s produced weavings that borrowed directly from the geometric architectural motifs of chiefly Mixtec ruins. This pre-Columbian influence has been followed by the weaving of rugs and hangings that replicate the work of the Western moderns, including compositions by Miró, Matisse and Escher.

Many other lively folk crafts are endemic to Mexico. Besides the food and water storage jars and traditional cooking ware, the painted ceramic forms are also immensely popular with the home market, visitor and exporter alike. Some fuse pre-Columbian imagery with that of the Old World; the result – fantastic candelabra depicting festive scenes such as the Nativity, strung with tresses of wired birds, animals and flowers, and bowls shaped or adorned with plant and animal forms, from Puebla; and from Jalisco, gaily painted scenes – of the Ark, with jungle animals, and of village life, with

festivities and churches packed with devotees. Metepec, near Mexico City, is a town renowned for its ambitious and visionary potters who mould mythical beasts and fabulous animals, often on a grand scale, a particular favourite being the guitar-playing mermaid. The giant tree-of-life candelabra are also from this town. The potters' ability to match ever-changing Western tastes is legion; there is no knowing what popular comic heroes will dangle from a candelabra on one's next visit.

The most fantastic of all clay forms are the tiny skeletons from Oaxaca. Visions from the wildest Hadean and Dantesque scenes are formed and gaily painted as children's toys for the Day-of-the-Dead festivities. Equally nightmarish statuary and sculpture is made elsewhere in Mexico. Brightly painted papier-mâché dragon-like creatures, skulls and skeletons are manufactured in Mexico City itself; this work, as with many inspired modern Mexican folk arts, was originally the creation of a particular individual and his family group which, when successful, is inevitably copied to create artifacts in the same style.

The tinware of Oaxaca is well known. Sheets of tin are cut and soldered to form ornate, punched or plain mirror and picture frames, wall sconces and free-standing candleholders formed behind the frontage of a gaily painted tin church. Tin cut-outs of hearts, animals and flowers abound; brightly painted, punched for textural effect and pierced to hang, glittering Oaxacan tinware of sharks, cacti, dancing Aztecs, mermaids and skeletons (to name but a few designs available) make refreshing alternatives to conventional Western Christmas-tree decorations. Other metal folk artforms are associated with the Faith. 'Milagros', tin representations of parts of the anatomy, are pinned to the robes of popular saints as votive offerings, and retablos are sometimes hand-painted on tin, recording the details of a miracle.

Religious festivals are dominated by dances, where masking plays a crucial role. Made of paper, wood, leather, cloth, gourds and wax, most are realistically painted to depict a character clearly. Pre-Columbian ceremonial rites for the protection of crops and the safety of the tribe are most probably echoed in the dances of the modern-day rural peoples, which involve real and mythical animals, from tigers and jaguars to goats and bulls. Pro-Hispanic dances enacting the defeat of the Moors, as well as the conquest of the Aztecs, are immensely popular, and the pale-faced masks representing the Iberians are especially disturbing.

South America

Peru and Bolivia The works of the Indian and mestizo groups of modern-day Peru and Bolivia pall in comparison to the rich contemporary folk culture of Mexico. Amongst collectors, however, these Central Andean lands are well known and revered for their prehistoric and antique textiles,

Small yoke from the Olmec culture of Mexico, c. 800-600 BC

73

and for the ceramics of their Altiplano and coastal desert kingdoms. Ancient textiles and ceramics have been unearthed in fine condition and in prodigious quantities. The combination of two factors, a series of civilizations centred around death cults, and the dry climate of the coastal desert, has ensured the preservation of the magnificent treasures that form the basis of the region's weaving and ceramic history, which can now be charted over three thousand years. The lands of the ancient coastal cultures such as the Paracas, Nazca, Moche, Huari, Chancay and Chimu, and the highland civilizations of the Chavin and Tiahuanaco were united all-too-briefly by the Incan Empire from *c.* AD 1352 until the arrival of the Conquistadors in 1532. The coastal tribes were skilled at metal-working, pottery and weaving, representing in painted wares and the befeathered, embroidered, slit-woven and tie-and-dyed cloths their preoccupation with the collecting of trophy heads, with feline spirit beings and supernatural deities. Almost all the techniques of textile decoration known to the present-day weaver were utilized by these cultures.

In Peru and Bolivia today, weaving and pottery continue in circumstances little affected by the pace or technological developments of the modern world. Backstrap looms are worked by the women to produce belts, ceremonial wraps and mantles, ponchos and ponchitos, and despite the keen adoption of dyed synthetic yarn (for its ease of use), the truly traditional cameloid fibres of llama, alpaca and, rarely, the wild vicuna, continue to be harvested and spun for yarn. Peruvian workshop treadle-weaving, a male occupation, is famous throughout the region because of the sheer quantity of tourist rugs and hangings produced. The most pleasing of all recent weaves originate from the Aymara Indians of the Lake Titicaca borderlands. Woven exclusively on backstrap looms, the ceremonial head-dresses, mantles and tunics of alpaca are patterned with bands of rich colours that are a study in simplicity through reverence; no wonder that these cloths were carefully stored and passed from generation to generation: for the Aymara, they represent a tangible link with their pre-Christian past.

The potters of Peru continue many of their traditions by producing items little changed in form or purpose over the centuries. Lamentable practices were encouraged by the discoveries of the prehistoric pots during the nineteenth and early twentieth centuries – Moche, Chimu, Nazca and Wari graves were looted as soon as it became known that articles coveted by Western museums and collectors had been newly unearthed by an archaeologists' dig. Forgeries and reconstructed originals abound. More recent examples of decorated Peruvian ceramics are orientated towards the tourist and export trade, and new forms painted with compositions inspired by pre-Columbian art are widely available. Painted and coarse clay whistles and pipes in the shapes of birds and animals are popular and clear imitations of Moche stirrup vessels signed by the artist are also produced.

Clay bottle made by the Wari culture of Tiahuanaco on the south coast of Peru, c. 600-1000

Africa

Africa has produced, over the past century, quantities of distinctively 'primitive' tribal art which looks resplendent in many a museum or private collection. Sculpture in bronze, masks and wood statuary, plain and painted pottery forms and fine textiles of palm and cotton fibres continue to be produced from a swathe of coastal and rivurine settlements that skirts the Sahara Desert to the north and south and stretches into the depths of the Congo basin. Africa is primarily a continent of the land, of exotic animal and bird life, and despite all the efforts of man to tame the vast deserts, savannah plains, rainforests, high mountains and racing rivers, the atmosphere is charged with the pulsating rhythms of natural vitality in all its forms, benign and evil. Scattered tribes scratch at the surface of the land and take what they can from the dwindling herds. Despite the patient efforts of the missionaries, the arts and crafts of the people are intended to reinforce, illustrate, illuminate and represent, through function and decorative symbolism, the group values of a young culture uneasily coexisting within such an old land.

North Africa

Scattered along the narrow coastal plain or lost amidst the scrublands of the Atlas mountains are tribal groups who are the descendants of a complex and wonderful range of cultures that began with the Phoenician, the Carthaginian, Roman and Vandal incursions and continued on through the Byzantine, Ottoman, Arab, Berber, Spanish and French. The resultant mixture of influences is a constant source of wonder and delight. Indigenous craftsmen of the region are most noted for their sophisticated textiles, which date back to the ancient Coptic weaves of Egypt, and their decorated pottery; pot and cloth production is centred on the scattered Berber peoples of central-western North Africa.

Coptic textiles originate from the adoption of Christianity in Egypt from AD 380 and are tapestry weaves of the finest order. The Copts buried their dead fully clothed in linen and wool garments that were decorated with panels of slit-weave tapestry depicting birds, classical human forms and animals in a style that is unmistakably Christian yet strongly influenced by the East. The colours glow, and the skill with which the weavers turned the wefts along curves to create life-like imagery is breathtaking. An enormous quantity of Coptic textiles exist, unearthed from the desiccated graves of the Nile River Valley by museum expeditions and robbers.

The Berber nomads of the Atlas mountains of present-day Tunisia, Algeria and Morocco have for centuries sought fresh pasture for their flocks by moving from the plains into the mountains following the cycle of the seasons; thus their need was for readily transportable covers that would provide insulation from the changes in temperature. On the horizontal and vertical looms of Berber women, therefore, wool and goat-hair tent cloths,

Dance mask from the Ngounie region of Gabon

capes and floor covers have been woven, and then decorated with the geometric compositions enforced by Islamic regulations and the technical limitations of the flat-weaving process. The Tunisian and Moroccan flat-weaves are well known, particularly the floor rugs or blankets ('hanbels'). Tunisian textiles, especially from Gafsa and Kairouan, can be identified by their brightly coloured slit-weave work cheerfully depicting animals, flowers and geometric designs. The High and Middle Atlas mountains of Morocco are home to the most prolific of the Berber weavers of the region. Tribes such as the Zaer, Beni M'guild and the Zemmour use the wool and hair from their flocks and herds to weave hanbels, capes, saddlebags and shawls. The hanbel blankets and rugs are woven with bands of plain red alternating with bands of very intricate weft-faced patterning. These textiles, about ten feet by five feet in size, are tightly woven yet often pliable, and thus ideal for family blankets. A visit to a Moroccan market will instantly show that the traditional hand-looms of the Berber are productive as never before, supplying textiles to countries far beyond their own world.

The Berber ceramics of Algeria are made by the Kabyle peoples of the Djurdjura range of the Atlas. Primarily agriculturalists, and well known for their silver jewelry, the Kabyle hand-mould pots whose form and decoration is directly descended from a style introduced from the eastern Mediterranean some two thousand years before Christ. The shapes and patterning of even the late twentieth-century white and red styles of water vessels, pots, plates and serving bowls certainly have a distinctly antiquarian feel. How much longer this four-thousand-year tradition will survive amidst the frenetic pace of social and cultural changes of the modern Algerian state remains to be seen.

West Africa

The savannah lands that fringe the Sahara Desert and the rainforest country that extends to the ocean are home to a multitude of tribes whose wood masks and statuary and fine strip-woven cloths play an important part in their daily lives. Wooden artifacts are usually carved from a single block with an adze, and their statuary is normally undecorated, merely patinated by the application of oils, woodsmoke and a generous amount of handling. Masks and head-wear for ceremonial dancing are often painted, and painted again before each use. Wood carvings have a limited life-span in the climates of West and Central Africa, and although the work of a well-known carver would be highly valued and appreciated, as soon as the ravages of time or the termite disturbed the shape of the mask or figure, it would be discarded and another ordered. The masks and statues are functional, embodying spiritual powers, and so Western reverence for the antiquity of artifacts knows no place in their world.

The loom of a professional Ashanti weaver from Ghana, c. 1925, the warp of which is held taut by being anchored down. Strips of narrow cloth are created on this apparatus which are then sewn together to form a robe.

The most famous tribes of the savannah lands of Mali, Burkino Fasso and the northern Ivory Coast are the Bambara, Dogon and Senufo. Their wooden sculptures of the human form and masks of animal and human imagery play a key role in initiation ceremonies, agricultural and funeral rites. Such artforms are often carved by the blacksmiths, a separate caste who are seen in mythological terms to be descendants of the primordial Maker. Dogon figure sculpture is confined to the communities along the Bandiagara cliffs, their carved grain-store and house doors depicting human forms beseeching the skies for ever-needed rain.

The highly stylized and graceful antelope head-dress sculptures of the Bambara are always distinctive; the head-dress is attached to a basketwork cap so the dancer appears half-man, half-antelope. At planting and harvest festivals, pairs of antelope dancers, a male and a female, would perform to ensure the continued fertility of the earth (the antelope, in Bambara lore, taught mankind the skills of cultivation). Bambara men passed from childhood to maturity through a series of six initiation societies, and masks were made to symbolize each stage; one human, the others of zoomorphic forms, each had an instructional significance. Senufo masks and figures are of great spiritual and magical importance and are made by the blacksmith caste. Stored in secret sacred groves, the carvings are brought out for initiation, funeral and agricultural ceremonies. The function of the Senufo figurines is akin to that of Christian images of saints – to provide possible material and spiritual aid.

Along the latitude of the Equator lie the modern-day nations of the Guinea Coast. From Guinea Bissau, through Guinea, Sierra Leone, Liberia and the Ivory Coast, to Ghana, Togo, Benin and Nigeria runs a band of rainforest, forest and savannah, which is inhabited by a wide variety of tribes that carve distinctive masks and figures and weave with skill. The 'Poro', or secret society, masks of the Dan-Ngere group and the Mende and Loma tribes of Sierra Leone, Guinea and Liberia are carved from wood and worn to initiate all men ('Sande') and women ('Bundu') into their social, religious and professional roles for the good of the community as a whole. Old Dan Poro masks are highly prized by collectors for their thin, smooth and dark patinated surface and ovoid shape. Smaller palm-sized examples of a similar style were carried by the adult males as 'portrait' or 'passport' masks. The Bundu masks of the female initiation society are perhaps the most well known of the Sierra Leone wood sculptures; their helmet-like structure, complete with carved hair, is most distinctive. The work of the Baule tribe of the southern Ivory Coast is appreciated amongst Western observers for its fine standard of workmanship and serene composition in both the masks and statuary. Figures with calm expressions, heavy limbs and smooth sexless torsos were the inspirational models for many early twentieth-century European painters and sculptors.

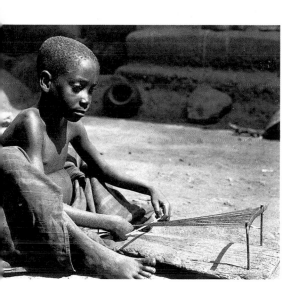

Ashanti child of Ghana learning to weave on a miniature loom, c. 1925

Lamp by the Biba Nupe tribe, Nigeria

Along the coast, in Ghana and Togo, live the Ashanti and Ewe tribes. The military federation of the Ashanti, established in the seventeenth century, brought great wealth and power to the region in the form of gold and slaves, two commodities precious to the Europeans. Found in abundance in the shallow rivers and on the shore, gold was cast by the lost-wax process to form small masks, heads and animals, fashion accessories for the king and court notables. Gold was measured against other cast miniatures proved by the royal treasury for their precision – the well-known brass gold weights that depict human, animal and plant forms in lively detail as well as a panoply of objects used in everyday life. The gold weights were also used as jewelry and as charms by storytellers. The most important chiefs of the Ashanti clans sat in state on wooden stools, each carved specifically and exclusively to suit the owner; other royal regalia included the powerfully individual clan staffs and umbrella finial decorations, and these are still carried at ceremonial rites, when the fine strip-woven cloth is worn. This is made by professional male weavers who inhabit the lands from the Senegal River in the west to Lake Chad in the east. For many, strip-weaving on narrow-heddled drag-looms is a full-time occupation, and cloths are commissioned to a strict code of patterning by the Ashanti, according to royal patronage; Ewe cloths are of the highest quality the client can afford. Certainly, the Ewe and Ashanti 'kente' cloths are the finest examples of a West African strip-weaving tradition. Ashanti cloths are unashamedly luxurious, patterned by bands of bright colours and shiny yarn. The seventeenth-century kingdom sent caravans across the Sahara to France and Italy for waste silk to weave into superb 'asasia' cloths and, although the looms of Bonwire are now in relative decline, fine work continues to be produced, using the brightest coloured rayon fibres imaginable.

The soils of Nigeria have perhaps yielded the most impressive evidence of cultural development by way of prehistoric sculptures in the whole of Africa. In Nok, northern Nigeria, were found terracotta heads and fragments dating from 500 BC, and the naturalistic heads of the Ife and Benin kingdoms chart the progress of their creative and technical sophistication in bronze casting (for which they are now famous). The tradition of sculpting persists amongst the urban Yoruba people of western Nigeria and neighbouring Benin. A numerous people, the Yoruba are the descendants of the Ife, and countless artists continue the strongly creative tradition of their ancestors with their wood, brass, iron, bead and weaving work. Yoruba sculpture can be identified by its stylized naturalism, especially visible in the portrayal of the human figure in realistic poses. Their pantheon of deities hints at the complexity of their religion. Each god has a separate cult, for which ritual masks and shrine furniture are carved, and the ingenuity and humour of the craftsman is tested by the construction of colourful masking head-wear often complete with images of human forms and their moving parts. Tex-

tiles are dyed by the Yoruba using an imaginative range of techniques. Yarn is bound for the resist-dyeing technique known internationally as 'ikating' and when untied, woven to yield cloth with gentle and irregular variations in colour and pattern. Other plain cloths are dyed by the simple techniques of folding and resist-tying; dyed in indigo vats the resultant 'adire' cloth is patterned by circles both large and small, often on a geometric background. From northern Nigeria the Muslim Hausa people are known for their embroidered robes of perfect blue. Their territory forms the crossroads of trans-Saharan trade routes, so it comes as little surprise that these textiles display a fine fusion of Islamic and African tribal motifs. Plain indigo-dyed strip-woven cloth is cut to form a generous poncho-like robe, and the neck-line to the breast pocket is embroidered with fine white cotton stitchery.

Central Africa

The art of essentially Nigerian tribes can also be found in Cameroon. The rolling plains of the Cameroon grasslands are known for their prolific production of wood, brass, clay and bead artifacts centred on royal patronage and worship: much Cameroon art comprises effigies of kings, past and present, portrayed as divine rulers. Royal ancestor figures, portals with high relief sculpture, carved and beaded thrones and vessels, drinking horns, brass and clay pipes and oliphants have been created by guild artists as ceremonial symbols of a ruler's authority. Of the grassland tribes, the expressive figurative work of the Bangwa and the Bamileke is outstanding by all African standards.

The wooden sculpture of the Fang of Gabon to the south inspired Modigliani, Derain, Vlaminck and Matisse. The white-faced Fang mask sold by Vlaminck to Derain has itself almost become a symbol of the African influence on modern art! Late arrivals to the region from further east, the Fang were a ferocious people; their raw energy is evident in their statuary, an elegant group of serene styles centred on the worship of skulls and skeletal remains of ancestors. Their celebrated masks are, as with many of the area, white-faced and simply patterned, highlighted by the use of black, red and ochre pigment.

The great mass of Central Africa is drained by the Congo River and its tributaries. Beneath overhanging branches lie savannah grasslands; to the north, dense equatorial rainforest. The pygmies of the forest produce no prized arts and crafts, unlike the peoples of the savannah, who enjoy an organized tribal lifestyle under regal rule. The land is dotted with the 'empires' of the Kongo, Kuba, Luba, Pende, Songe and Lele tribes; these groups traded right across the Continent, as well as with each other. Under royal control, their sculpture and textile manufacture became highly specialized. The Kuba effigy-figures of kings are well known, as are the Congolese

Mask made by the Bateke tribe of Central Africa, owned by André Derain

Skirt panels of the Kuba tribe from Zaire

figures with over-detailed body features. These fetishes have either been annointed with magical substances or contain them within a hollowed section; such concoctions may either protect or harm by the release of spirits. The nail-riven figures of the Kongo and others are a memorable sight and are not recommended as bedroom decoration for the faint-hearted.

The raffia textiles from the Congo are a form of wealth and their highly decorative motifs are symbolic and personal; the finest cloths are worn as dance skirts and as a mark of respect at funerals. Of the Kuba people it is the Shoowa tribe who are rightly famous for their raffia textiles. The Shoowa cover all their craftwork with geometric and rectilinear forms. Wooden drums, chests, torsos, masks, heads and cups are carved and scarified with interconnecting geometric motifs in loosely ordered patterns. While West African textile production is professionally orientated, the Shoowa men and women weave and decorate raffia cloth as an integral part of their lives as farmers and part-time hunter-gatherers. Limited by the length of the leaf fibres, the men weave squares of three to four feet, as well as sections of skirts and wraps, in a balanced plain-weave on a vertical or angled loom, and the women then decorate the textile with appliquéd shapes or embroider the surface in a similar fashion with either a velvet or an overstitch technique. Worked upon at leisure, the panels may take months to complete and when finished are then joined together to form a dance skirt sixteen feet

long, which is wrapped around the torso and waist and hitched up with a length of cord. The appliqué technique is said to have arisen out of the necessity to patch tears and holes in a cherished garment with raffia strips, roundels and small squares. Such repair-work has developed into a method of textile decoration that, when the skirt is unravelled and full in view, forms steadily and naturally developing sections of abstract designs.

In contrast, the small overstitched or velvet-worked panels are regimented in composition, with strong motifs that are often unsettling to the eye. Thought to be items of currency and to signify wealth, the textiles are covered with geometric and rectilinear designs which have names such as 'tortoise', 'forest vine' and 'eyebrows'. Yet here, the seemingly naive and spontaneous compositions of these decorated raffia panels are in fact brilliant transmutations of recurring geometric forms by reduction and distortion. These and other Shoowa panels were to inspire painters such as Klee and Matisse.

Cut-pile raffia panel of the Shoowa tribe of Zaire

Asia

Asia Minor to Central Asia

The Muslim peoples that inhabit the lands from the shores of the Mediterranean to the High Pamirs have developed, over the centuries since their conversion, a highly stylized form of ornamental art. Without exception, such art has evolved over the years from pagan forms now sanctioned by the Islamic principles that are all-embracing in life and work. The mix is an entirely happy one, and can be seen most clearly in their kilims and other flat-woven textiles, the near-historic examples of which may still be collected today, inexpensively and with relative ease.

Anatolia The population of this mountainous land is a mixture of Greek, Kurdish, Armenian, Assyrian and Turkic peoples, the vestiges of past invaders and rulers. Turkic kilims are plentiful, made by the descendants of the conquering tribes from Central Asia. Although proud of their name 'Yoruk', meaning 'we who roam', most are now village people. Today, Turkey leads the rug-producing world in its effort to reinstate pre-Western traditions of village weavers in answer to the demands of a growing and more discerning marketplace.

Anatolian kilims vary greatly from region to region. Balikesir kilims are made in an area in west Anatolia by the population of semi-nomadic Yoruk peoples. Antique Balikesir rugs have distinctive compositions of a simple yet visually complex interlocking grid of blue and red patterns. The town of Aydin, near the Aegean coast, produces kilims that have small patterns and that are often woven in two halves and joined together. In central Anatolia, kilims named after the town of Konya are made in its surrounding villages. These are woollen, often sizable and tapestry-woven, with large slit-weave work, and their compositions comprise strong Turkic medallions on a white or cream ground. Further to the east, Malatya, in Kurdish country, provides a plentiful supply of kilims woven by Turkic and Kurdish peoples. East of Sivas there is a proliferation of flat-woven prayer rugs and towards the Caucasus, the old kilims from around Erzurum are well known for their ochre colouring and tiered central mihrabs surrounded by stylized floral designs. The remote and mountainous Lake Van area is home to many Kurdish people who weave high-quality woollen kilims that are again made in two pieces. The compositions of these rugs are confusingly similar to Kurdish work from across the borders in the Caucasus and north-west Iran.

The Caucasus The Soviet states of Azerbijan, Armenia and Georgia bridge the Middle East and west-Central Asia. The people of this region have undergone subjugation by many cultures through the years and, as a consequence, Greeks, Persians, Arabs, Turks and Tartars have all left behind isolated tribal groups, who speak various languages and enjoy a reputation, now historic,

Kurdish kilim from eastern Anatolia

Qashqai kilim from southern Iran

for weaving energetically patterned fine kilims. The rugs most coveted by collectors are those of the nineteenth century, the golden era of Caucasian weaving, when temporary stability was brought to the region by Imperial Russia and trans-Asian trade increased. Tightly spun woollen kilims were woven until the 1920s and 1930s, and are categorized by the rug trade as either Kuba or Shirvan. The large field of Kuba kilims is patterned with very colourful and bold geometric designs, bounded by a single, often crenellated, border. Shirvan flat-weaves are less rare and their simple compositions are distinctive – bold geometric medallions set in bands on a borderless ground. A harmonious use of colour and the highest quality of slit-weaving characterize Caucasian work.

Iran Iran's scattered minority of Turkic, Kurdish, Arabic and Balouch tribal groups are well known for their weaving of charismatic and colourful kilims. Many of these peoples are descendants of invaders from Greece, Arabia and the frontiers with China. Under the Pahlavi regimes and latterly, the Islamic fundamentalist government, the non-Iranian tribes have suffered territorial and cultural restrictions which curb their independence. These political factors have combined with economic incentives to alter the lifestyle of the semi- and fully nomadic peoples such as the Qashqai and the Bakhtiari forever; the traditional skills of nomadic near self-sufficiency, such as flat-weaving, are in decline.

Kilims from in or around Sanandaj (formerly Senna), the capital of Iranian Kurdistan, are floral in composition. Inspired originally by the brocades and embroideries of the Safavid era, 'Senna' kilims are small and woven of the very finest slit tapestry depicting interlocking clusters of tiny flowers that are more characteristic of knotted carpet patterning. South and east of Tehran, the region around the caravan trading towns of Garmsar and Veramin is famed for its distinctive kilims. Large and heavily woven with cotton and dark wool, these kilims are decorated with bands of diagonally arranged motifs or fields of interlocking designs coloured with brilliant reds, blues and, unusually, greens and yellows. In southern Iran the pastoral nomads of the Zagros mountains are the Turkic Qashqai. Their kilims are highly prized because of their ancient Turkic motifs within parochial compositions, which give rise to marvellous combinations of strong designs balanced with subtle colours.

Afghanistan and Turkestan Afghanistan is a country of sharp physical and demographic contrasts, from frozen peak to arid plain. The people, too, are widely varied, some Hellenistic, others raven-haired and dark skinned. Their textiles are equally diverse, and, in general, rarely collected or appreciated. Tribes of Balouch and Uzbek, Tadjik and Turkic extraction specialize in the weaving of distinctive kilims. Afghanistan may be simply divided into

two weaving regions, that of the so-called Balouch kilims to the south and west, and of the kilims of the Turkic and Uzbek peoples to the north and, historically speaking, over the border into Turkestan, now a Soviet republic. The Balouch of west Afghanistan and Khorasan in Iran are the Rukhshani people, a semi- and fully nomadic group who are famous for their dark tightly woven kilims constructed on simple, portable, narrow ground-looms. The largest are the dowry rugs, often made in two sections and joined at the selvedge. Prayer mats, eating cloths, bags, camel decorations and tent runners are decorated with compositions of small white motifs on a dark ground, woven with the finest weft-faced patterning.

By way of a counterbalance, the kilims from the north are predominantly slit-woven with medallion patterning and bright colours. The town of Maimana has lent its name to a variety of kilims produced on a large scale, mostly by Uzbeks, on vertical continuous-warp looms. The Uzbek Tartars weave large runners with a double-interlocking technique which can be recognized by their crisp motifs on a field of 'eight-legged spider' medallions in bright blues and reds. Uzbek nomads are well known for their strip-woven rugs and horse-covers. Made on tiny ground looms that are easy to transport, the tent bands of warp-face patterned work may be cut and sewn together to make a cover of any size. The tinkers and gypsies of Central Asia are the Koochi, who weave kilims known as 'Mukkur', large runners with strong geometric patterning, made of coarsely spun wool with selvedge and elaborate fringe decorations of beads, shells and coins.

North of Afghanistan the region of Uzbekistan is famous for its highly decorative embroideries and ikat work of the nineteenth and early twentieth centuries. The colourful ikat cloth is known descriptively as 'abr', a Persian word meaning 'cloud'. These beautiful resist-dyed textiles of either silk or silk warps and cotton wefts were used as clothing, tablecloths, curtains, bedcovers and hangings, and to this day the traditional ikat coats continue to be worn in north Afghanistan and the use of printed cloth with ikat designs is common in Soviet Central Asia. In nineteenth-century Turkestan, the wearing of such luxury garb was strictly controlled to maintain the social hierarchy, wherein the upper classes would display their wealth and nobility by way of the finest silk robes, worn in layers. Patterned with medallions, stylized flowers and animals, and coloured with vivid reds, blues, greens and yellows, the ikat clothing was a dazzling sight in the dusty streets and drab landscape of Turkestan.

The textiles of the nomadic Turkomen made as tent or animal decorations are colourful and distinctive. Embroideries packed with brightly coloured, archaic geometric designs of stylized eagles and ram's horns are attributed to the Uzbek Lakai sub-tribe and their small bags, fringed bedding decorations and square panels are embroidered miniature masterpieces. Larger tent hangings and animal trappings exist, made with appliqué and

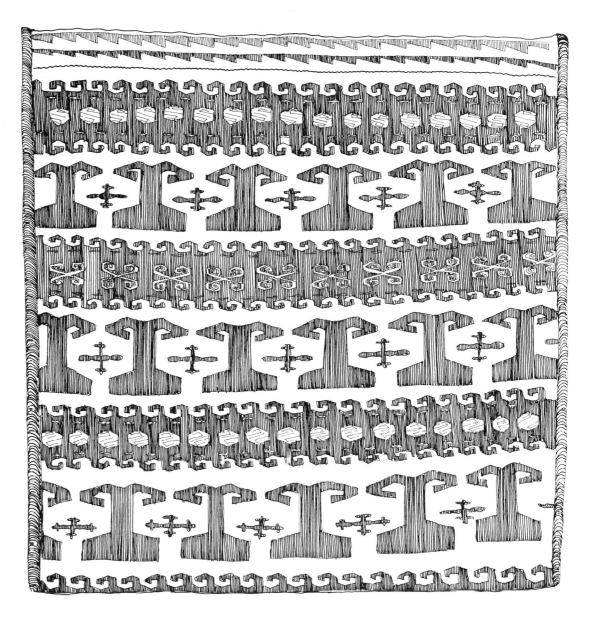

Kilim-work bag of the Balouchi people of Afghanistan

patchwork, wherein fragments of fine silk ikat are incongruously mixed with panels of printed Russian cottons and plain fabrics. The resulting geometric mêlée of different textured cloth is most original.

The Indian Subcontinent

India's handicrafts seem inexhaustible in supply and the variety as wide ranging. The Subcontinent has undergone more religious and political revolutions than any other country: the Scythian, Greek, Saracen, Afghan, Mongol and Maratha invaders came by land, the Portuguese, Dutch, English, French and Danish by sea, bringing to the craftsmen influences that they have taken in their stride as part of the impulses of creativity that are layered

over a three-thousand-year continuum of folk traditions. The sight, sounds and aromas of the crafts of weaving and embroidery, metal work, potting, wood carving and basketmaking make any journey through the villages and small towns of the Subcontinent unforgettable.

Weaving is central to the cultural heritage of the Indian subcontinent. For centuries the loom has played an integral role in the livelihood of a people whose highly complex social and cultural organization has developed through an exchange of influences with the Orient, the Levant and, more recently, Europe. The varying extent to which this southern Asian culture nurtures, disseminates and continues its own traditional practices amidst an influx of foreign creative and spiritual energy is reflected in the wide variety of textiles available, both regionally and inter-communally. The weaving of diaphanous muslins is a world apart from the coarse cotton production of tribal villages and it is by virtue of these extremes that so rich a textile culture has developed, and is developing, to this day.

A distinction has always existed between the organized production from the looms of the professional (often male) weavers for export, temple, and special castes and the simpler work, hand- or loom-spun for domestic and personal use. The former continues to be exported and to supply local demand for fashion clothing and furnishing materials, while the latter, the family and domestic work, is on the wane, under pressure from economic and cultural modernization. Ceremonial family textiles are still made and the lower castes weave and embroider much as before, whereas the more socially and economically mobile middle classes now tend to prefer a dowry exchange of money, jewelry or consumer durables to a trousseau of hand-made and painstakingly worked embroideries and textiles.

The country's complicated caste system and the religious differences within the region have contributed much to the variety of textile production. A system in which the individual remains throughout life a member of a clearly defined community has clear advantages for cloth-making, both at a workshop and family level. Different castes specialize in different processes indicative of their status, and within the same caste each member of a family group will contribute a separate element to the production process. Most communities involved in the manufacture of textiles are of lower castes and, generally speaking, the coarser the cloth the lower the stratum; highly specialized weavers and decorators of silk and fine cloth enjoy the highest status possible.

Of the raw materials cotton remains the most predominant natural fibre. Textiles from the region are highly decorated, using a variety of techniques often on a pre-woven ground, or by pattern dyeing the yarn before weaving. Most textiles are made as clothing and animal trappings and as ceremonial hangings for house and temple. Three kinds of technique are featured here: flat-weaving; decoration of a plain ground with embroidery, appliqué and

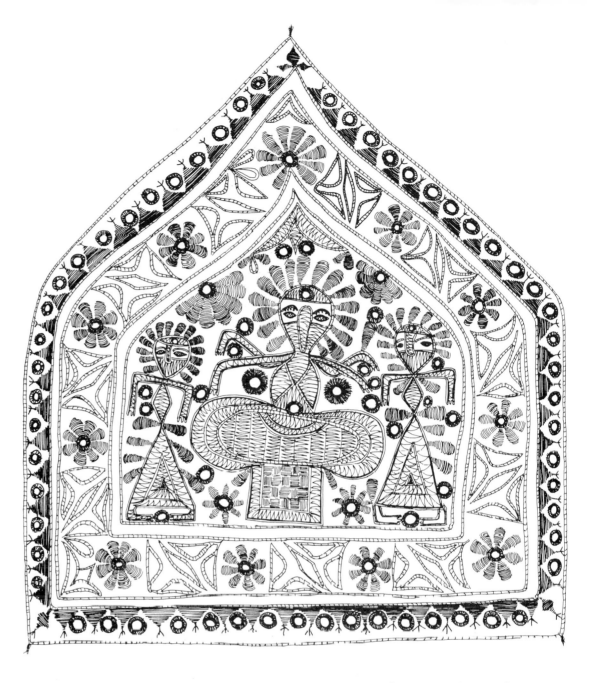

'Ganeshtapana' from Gujarat, north-west India

quilting; and finally, decoration and weaving using the resist-dye techniques.

Latterly, flat-woven cotton floor rugs have become a major export. Known as 'dhurries', these textiles are made on relatively simple ground looms and used throughout India. Important centres of manufacture include Bikaner, Marwar and Jodhpur in Rajasthan, Agra and Fatehpur Sikri in Uttar Pradesh, Patna and Obra in Bihar, Warangal in Andhra Pradesh and Tibgan in Madhya Pradesh. The weave is weft-faced and decorative techniques, as in kilim weaving, include slit work, dovetailing, double interlocking, eccentric wefts and weft-float patterning. Patterns can vary from nineteenth-century floral work inspired by Persian and Anatolian carpet

motifs, to simple bands and blocks of colour. Dhurries are still often laid on the floor under carpets in the houses and palaces of the wealthy, the largest being commissioned for palace decoration, possibly extending to over eighty feet in length and twenty-five feet in width. Dhurries for smaller rooms are common, as are prayer dhurries with single or multiple niches. Bed dhurries are about six feet by three feet in size and are spread over a wooden-framed bed, under the mattress and bedding.

The hand-embroidered ornamentation of woven cloth is an ancient tradition in the Subcontinent and is particularly associated with the tribes and peoples of the North-West Frontier, the Sind desert of Pakistan and the Indian states of Gujarat, Rajasthan and the Punjab. Predominantly the work of village women for personal and family use, the embroidered skirts, blouses, veils, household and shrine hangings and animal trappings are colourfully patterned with a mixture of ancient and modern motifs. It is quite usual for the embroidered work to cover the plain cotton ground almost entirely, in a range of figurative, floral and geometric patterns according to the regulations of their religion. Mirrorwork is common and colours that may seem harsh on their own are skilfully and harmoniously combined on panels. Each member of a caste or religious group proclaims his or her identity and status by way of dress. Colour, pattern and the richness of cloth from humble wool to finest silk all contribute to the social labelling of the individual. The multiplicity of the caste system ensures that any gathering of people from these regions is a brilliantly colourful affair, especially so at the time of a festival or marriage, when animals, courtyards and houses are caparisoned and tented cities are created of embroidered and decorated awnings and panels.

Appliqué and quilted work, generally associated with village embroidery traditions, are also practised further to the east in Bengal and Orissa. The appliqué technique entails the addition of pieces of cloth, sometimes along with other decorative objects, to a plain ground. Quilting is the joining together of layers of cloth with running stitches to make a padded fabric. Both ancient methods of ornamentation, these techniques are often found used in conjunction with decorative embroidery stitches and appliqué in particular is used to greatest effect in large, many-panelled ceremonial hangings and animal trappings such as ox-covers. Gujarat is justifiably famous for the appliqué work of its covers, hangings, trappings and household decorations and the combinations of materials and motifs used may latterly vary from the charming to the truly bizarre.

The resist-dyeing techniques known in India as 'bandhani' and 'bandha' elsewhere enjoy the more familiar titles of tie-and-dye (or 'plangi'), and 'ikat' work respectively. The decorating work of the bandhani technique is relatively simple, but in the case of the bandha, it is immensely complicated and time-consuming. To tie and dye, selected parts of the plain-coloured

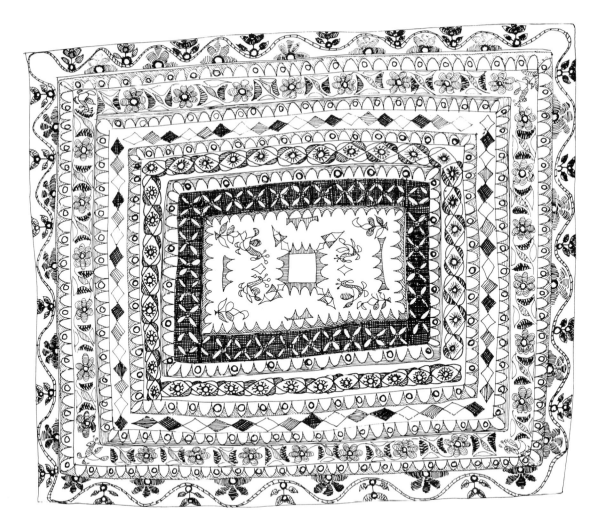

Bed quilt from Kathiawar, in Gujarat, India

cloth, often folded once or twice to save time, are lifted and tied with wrapping thread and impermeable material in a selected pattern. The tied cloth is then dyed, and the tie-and-dye process repeated again should more colours and patterns be needed. When the threads are removed the areas protected from the dye (or series of different coloured dyes) will appear as circles, pin-pricks, square patterns, rosettes and palmettes; the quality of decorative effect and cloth used varies from simple colour associations on coarse wool to the finest silks adorned with delicate floral motifs. Bandhana textiles are prized as veil cloths, saris, shoulder cloths and turbans. Tie-and-dye work is found throughout India, especially in Gujarat, Rajasthan, Orissa and Andhra Pradesh and is the monopoly of the Hindu and Muslim communities of professional weavers, dyers and printers.

Metalcrafting is an ancient Indian profession; a bronze figure of a dancing girl found at Mohenjo-daro dates from some five thousand years ago. Metalware plays an important role in the daily religious and communal life of the people and most common and of the greatest variety are the water vessels, cooking pots, serving dishes and containers made of brass or copper. Form

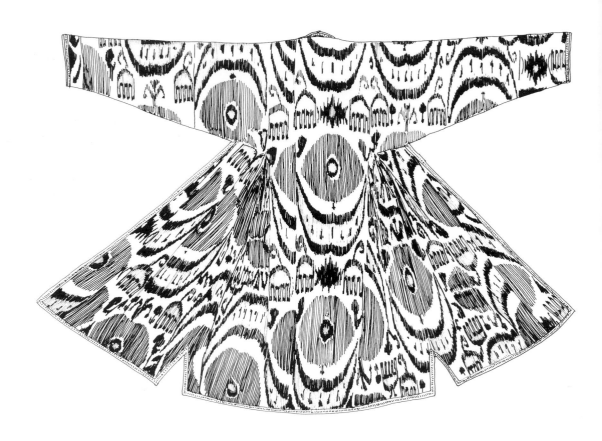

Ikat 'chapan' from Bokhara

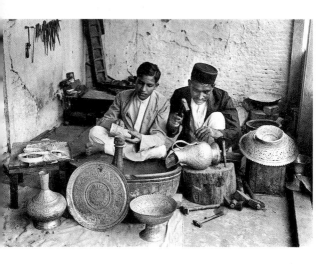

Metalcrafters working in brass, Delhi

and function is married in the shape of the 'lota', the small round-bottomed vessel used to pour water, and throughout India local demand for such domestic wares is supplied by the village and town craftsmen known as 'karmaras', who cut and cast metals to time-honoured specifications. South India is known for its cast lamps and bells, and the temple towns of Madurai and Nagercoil especially for their ceremonial bells of exquisite beauty and tone. Engraved brassware is popular with Muslims and visitors alike and the Oriental-style coffee pots and wine jugs are made in Jaipur and Moradabad. 'Traditional' bronzes in the medieval Indian traditional 'chola' style that originally came from Madurai, Madras and Karnataka are now replicated with skill in industrial cities such as Bangalore. The tribes of Bihar, West Bengal, Orissa and Madhya Pradesh use the lost-wax process to form striking ancestral and votive icons, masks, animal figures, oil lamps, containers and bowls. Itinerant metalworkers, 'dhokras', continue to move from village to village selling their wares forged within their portable foundries carried on bullock carts.

The wood-carver, the 'sutardar', is primarily concerned with the creation of household objects, furniture and architectural items. As ever, such work is not without religious content and in many houses the carved door-frames that welcome the guests conform to the recommendation in the *Matsya Purana*. Carved wooden frames, screens, balconies, brackets, beams and

house posts are much in evidence throughout India, created with the simplest of tools. The palaces and 'havelis', the country houses of Rajasthan, Gujarat and Madhya Pradesh, are magnificently endowed with such work. Each region has developed distinctive styles and thus the vale of Kashmir, so rich in hardwood forests, is famous for its wooden houses, mosques, houseboats and places of pilgrimage constructed and decorated to suit Islamic sensibilities. Wooden toys, boxes, small chests, masks, dolls, animals and trinkets for the tourist and foreign markets are now important craft industries in India. The lacquerware of Rajasthan and Kashmir is now found on sale worldwide and the carving and painting of solid wood animals such as elephants, lions and tigers in classical Indian poses is highly skilled in Rajasthan. The wood-carvers of that extraordinary seaside temple town, Puri, in Orissa, produce a great variety of colourful masks used at one time by itinerant actors playing characters from the *Ramayana* and *Mahabharata*. Indeed, Orissa has a tremendous reputation for its production of finely crafted wooden toys.

Basket-making is another vigorous folk craft of India and the peoples of the hills, forests and jungle of Tripura, Assam, Bengal, Bihar, Orissa, Kerala and the Nilgiris coil and plait leaves of bamboo, cane, grasses, reeds, date and coconut palm to make carrying and storage artifacts. Kashmir and Jammu peoples weave fine willow baskets and in these foothills of the Himalayas, wheat, rice and maize straw is used as raw material. Terracotta crafts are also a cornerstone of many an Indian village community. The potter is associated with God, for out of nothing he creates water pitchers, bowls, toys and divinities for every household and temple. Figures of traditional local deities are less commonly produced, replaced by those of national religious figures appealing to a wider international audience. What have not changed over the millennia, however, are the style, techniques and patterning of everyday water storage jars and those wonderful disposable tea cups.

Indonesia

The modern state of Indonesia is a collection of islands that are spread over three-and-a-half thousand miles of ocean and sea from Malaysia to close by Australia. These tropical islands have, from ancient times, been enriched and often overrun by the overflow of peoples, commodities and religions from mainland Asia. Like the Indian subcontinent, the Indonesian archipelago is alive with the interactions of hundreds of ethnic groups, which have developed rich craft cultures over the centuries that are a constantly developing blend of ritual and commerce. From the fifteenth century onwards, Indonesia exported spices, rare and scented woods and dyestuffs, especially indigo. Textiles from mainland Asia were used by the Portuguese, Arab and Indian coastal traders as goods for barter, so bringing Islam to the

islands, and the influence of weaving patterns and designs from the subcontinent of India.

The islands of Indonesia are a rich source of all types of crafts; from baskets to pottery, wood carvings to puppets, they seem to have adapted to the advent of the tourist trade on a grand scale, especially in Bali, balancing commercial gain with creativity most successfully. The ceramics of the area vary from traditional village artifacts such as the earthenware cooking stoves and undecorated clay storage jars to a proliferation throughout the region of the water carafes, 'kendis', that are often tall-necked and spouted, or formed of complete animal shapes, much like zoomorphic tea pots. The potters of Kasongan, central Java, Pejaten in Bali and Takalar, south Sulawesi, are part of a new trend for the hand-production of fancy goods for the tourist and export market; expressive shapes and decorated wares depicting men and beasts, legends and phantasms are most popular.

Mats and baskets plaited from vegetable fibres are made throughout the villages of Indonesia. Mat- and basket-making is traditionally a part-time occupation; the larger items are made by the men, and the raw materials invariably grow wild near the village itself. Their imaginative use of the palm-tree fibre was once documented by an intrepid explorer: 'The Rotinese and Sawunese are fed, equipped, attired, buried, and remembered after their decease by the products of their palms.' The leaves and trunks of the grasses are split and woven into food and clothing storage baskets and knapsack-like carrying baskets, as well as fighting-cock portable baskets. Sea Dayaks of east Kalimantan weave rattan carrying baskets of great beauty and strength. Dyed red and black, fibres are interwoven with the natural tan strands to create a variety of stripes, checks, zigzags, hooks and spiral patterns that reflect the Dayaks' world perspective.

The abundant source of tropical wood in the region has resulted in a rich tradition of carving and of late, the production of colourful folk forms. Older carvings are inspired by religious belief and the Dayak statuary is no exception. Collectively called 'hampatong', the wooden figures represent tribesfolk and their ancestors, animals and demons. Small carvings act as talismans whereas the larger forms feature in funeral ceremonies and are planted in the ground to protect the village. Their exposure to the tropical elements explains the heavily weathered nature of the sculpture. The work of other tribes in the region such as the Asmat of Irian Jaya, the Toraja of south Sulawesi and the Niasans off the west coast of Sumatra is associated with ancestor worship, and wood carvings decorate houses and canoes as well as domestic utensils.

The wood carvings of Bali have developed with alacrity over the past sixty years. The tourists of the 1930s brought trade to the island paradise, and the craftsmen took no time in adapting their skills to produce souvenirs and art for the visitors without damaging their own traditional sentiments. Hard and

Buffalo-hide 'wayang kulit' tiger puppet made in Indonesia

soft woods are carved into animals, mirror frames with floral and animal embellishments, easy-to-assemble wooden flowers, coconut palms and banana trees, and creatures of a Balinese fantasy world. Coloured with acrylic paints, the sculptures are highly decorative and well made and have proved an immensely popular export. The well-known duck carver of Bali and his seventy-five assistants produce an average of two thousand each month. More traditional painted wood carvings of theatrical masks, for the performance of Hindu epics, are made in Bali and Java; such stories are also played out by the shadow puppets of painted buffalo hide ('wayang kulit') and painted, costumed wooden forms ('wayang golek') that are crafted in central and western Java respectively. Dressed in the court finery – batik cloth sarongs, velvet waistcoats and ornate headwear – the wayang golek are supported by a central wooden shaft and the jointed arms are moved by finer stakes. The wayang kulit enactment of the *Mahabharata* by shadow play is a night-long performance of music and epic action. The preparation of the characters by the puppet-maker is a ceremonial affair, for each character has specific marks and colours that may be punched out from the hide and painted at certain times of the day or night. In this manner, with the help of prayer and fasting, the puppet-maker lets the energy of life flow into his offspring.

Weavers have produced textiles on simple backstrap looms throughout many of the islands since ancient times; such primitive looms are still used to weave warp-ikat cloth for sacred rituals. Apart from their function as items of exchange and as signs of wealth it is their ritual significance that predominates. The preparation of the yarn and the dyestuffs and the weaving of the cloth are a woman's occupation and the textiles are regarded, symbolically, as female. The finest are central ceremonial elements at rites of passage such as birth, circumcision, first haircutting, marriage and death. There are strict codes for the manufacture of these ritual textiles, which regulate the types of dyestuffs, colours and patterning to be used.

Costume is the area in which ritual associations, the display of prestige and wealth and everyday wear come together. Fine ikats and other textiles would be collected by the elite to wrap and bury a corpse in a final show of earthly prestige and religious ritual. The traditional costume suits the tropical climate of the region by being flexible in use, light in weight yet filled with designs and colours that show at a glance the wearer's status, stage in life and community of origin. The backstrap looms are worked to produce rectangular cloths, which are intended to be draped or wrapped over the body in a variety of ways that show the patterns to good effect. Smaller cloths are used as belts, and as breast and head wrappers, the larger cloths as sarongs and shoulder mantles.

The most decorative ways of colouring and patterning cloth in Indonesia are by ikat weaving and by using supplementary weft techniques. The work-

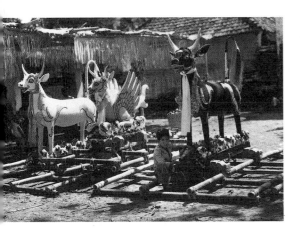

Carved religious effigies assembled for a funeral pyre, Bali, c. 1927

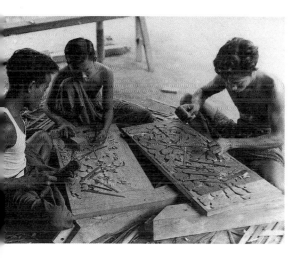

Balinese wood-carvers at work, c. 1927

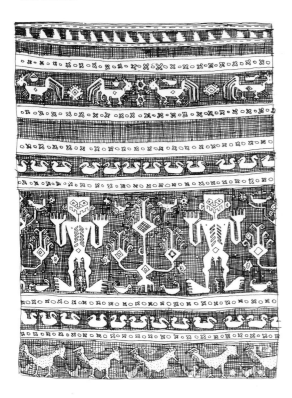

Ikat sarong from Indonesia

ing of fine designs on to plain cloth by the weft-patterning process was at its most accomplished in nineteenth-century Sumatra. The variety of textiles from this large island matches the mix of Indian, Chinese, Javanese, Arabic, Portuguese and Dutch peoples which inhabit it. South Sumatra is famous for two types of surface decorated textiles, the richly embroidered women's sarongs known as 'tapis' and the so-called 'ship cloths'. (The skills that were used to make the tapis and the ship cloths have been lost for over three-quarters of a century.) The banner-shaped 'palepai' and 'tatibin' and the square 'tampan' panels are weft-decorated with sombre images of boats with arching bow and stern, filled with people, houses, animals, shrines and banners. The cloths would be hung for such ceremonial rites of passage as first haircutting and marriage.

Java produces magnificent batik-decorated cloth and to the east the ikat tradition continues in eastern Bali with the double-ikated cloth, known as 'geringsing', from the village of Tenganan Pageringsingan. Inspired in composition, it is thought, by Indian 'patola' cloths imported over the past four hundred years, these natural tan cotton cloths are resist dyed to create fine figurative motifs that, when seen from a distance, link in geometric harmony; colours are deep tones of earthen red, purple and black. These valuable cloths are traded for differing ritual uses throughout the island. The coastal district of eastern Sumba is famous for the men's mantle cloths. Ikat patterned and known as 'hinggi', the cloths are made in pairs, and worn over the hips and shoulder. Sumban ikat patterns are often large and visually engaging – the finest work of the past comprises complex horizontal bands of both large and small motifs – coloured with strong blue and red dyes. The ancient practice of displaying severed heads now finds its place in textile design with ikat patterns of skull trees. Other subjects include deer, fish, shrimps and well-endowed male figures.

Flores, an island studded with volcanoes, is known for its regional textile production. To the west the Manggarai women weave indigo-dyed plain sarongs that are colourfully decorated with supplementary weft-work. An area of banded motifs forms a centre to the tubular sarong, with other star-shaped motifs scattered within the plain field of the cloth. Elsewhere, warp-ikat work predominates. The Lio peoples weave patola-like textiles featuring tiny light-coloured human figures, insects and dogs on deep blue, brown or black grounds. Again to the east, the Atoni people of the island of Timor are known for their unusually bright-coloured hip cloths made up of warp bands. Plain strips of blue, yellow and red cloth alternate with warp ikat and supplementary decorative techniques. Northwards, within the Sulawesi (Celebes) island group, the Toradja people's most decorative weaves are the striking warp-ikat funeral shrouds filled with interlinking images of hooks and arrows.

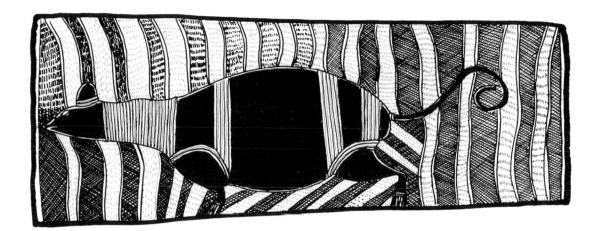

Bark painting of an opossum against a background of tide-marked sand hills, from north-east Arnhem Land

Oceania

Across the Pacific Ocean from Indonesia to the Easter Islands are scattered the island groups of Oceania. North of Australia lies Melanesia with Micronesia beyond, and Polynesia stretches away into the expanses of the Pacific to the east. By now-submerged land-bridges and by heroic navigation across the seas in dug-out canoes, the inhabitants of the islands spread throughout the region in sporadic bursts over the millennia from the continent of Asia. Long periods of isolation succeeded eras of immigration, during which times cultures developed their own characteristics; and although their technologies were based on the use of simple tools, from these societies has emerged a range of extraordinary artforms that is dominated by the powerfully expressive sculptural talents of the craftsmen. European expansion into such a fragile collection of cultures from the eighteenth century onwards has, however, destroyed their idyll forever.

Polynesia For eighteenth-century Europeans the arrival of Polynesian art by way of the voyages of Wallis and Cook was of great significance. The sculptures of the 'noble savage' were admired for their technical accomplishment and good taste, indeed they largely conformed to the stylistic requirements of Western society at the time. These were the earliest of the world's tribal arts to be appreciated by the West and their notoriety in combination with the popular accounts of the early explorers sent boatloads of evangelical missionaries to save the souls of the 'good children of nature'. The hiatus in interest that followed, on the realization that not all savages were noble in the face of alien encroachment, was only ended by the works of Gauguin and succeeding modern artists' curiosity regarding objects tribal.

Polynesian societies were hierarchical, and governed by two great spiritual forces, 'tabu' and 'mana'. 'Tabu' was forbidden, a negative force, and what was tabu was determined by the priests, whereas 'mana' was an energy

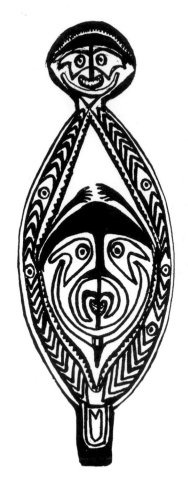

Papua New Guinea spirit board for ceremonial use

(Opposite) Of prime historical importance in the collection contained within this London drawing room is the Punu tribe mask from Gabon that rests on the mantelpiece, for it once belonged to and inspired the creative genius of Matisse. The cerebral form on the table is none other than a piece of Barbadian coral and the mounted brass disc on top of the Ashanti priest's stool is a stance-improving dance anklet of the Ibo tribe.

of supernatural origin that might exist in both animate and inanimate objects. Amongst men, mana was hereditary and bore its owners near divine status. Not surprisingly, royalty and chiefs as well as the artists of the society were holders of mana. Polynesian wood sculpture is almost entirely utilitarian and at times is simplified in form to the point of abstraction. Surface decoration is limited to geometric incisions. From Fiji and Tonga there are the stocky figures with over-large heads and simple bodies, from Hawaii statuary with fiercely contorted facial expressions, and from Easter Island emaciated male ancestor beings, part-man, part-reptile. Maori art from New Zealand was, from the beginning, appreciated above all for its quality and decorative nature. Their wooden houses, giant canoes, weapons and domestic artifacts were all carved with immaculate scroll-work.

Melanesia By comparison with Polynesia, Melanesia is less explored and exploited by visitors from Europe. The island of New Guinea, for instance (now Irian Jaya and Papua New Guinea) is one of the last refuges of tribal peoples to be investigated by the rational and analytical Western mind. The bewildering range of peoples and languages spread over hostile terrain would tax any attempt at observation and understanding. The landscape and sheer size of the island has allowed tribes to develop their arts and crafts and religions in relative isolation. The Asmat of south-west coastal Irian Jaya are remembered for their towering funeral posts and their canoe prows most provocatively carved with phallic forms. Inland and to the north-east, the distinctive carvings of the Sepik River tribes have been well documented. Long-nosed masks come from the Middle Sepik Iatmul tribe, 'hook' figures from the Karawari River area and ancestral figures from the Abelam.

Melanesian societies were generally classless and men rose to power through the familiar route of wealth and personality. Their artforms were associated with their religions, centred on special ceremonial houses in which sacred objects were stored. Ancestor cults and worship of spirits embodying the forces of nature predominate; for good measure, this religious recipe includes head-hunting and cannibalism. Such was the inspiration for their carved and painted wooden masks, figures, shields, house boards and houses. New Hebridean society was male-dominated and advancement centred round the acquisition and sacrifice of pigs. The large commemorative sculptures were carved from tree fern, and puppets, masks and enormous slit gongs were extensively painted for ceremonial use. New Caledonian carving concentrates on the decoration of architectural forms with human faces of a menacing nature and the north-western New Irelanders are renowned for their huge range of masks and sculptures known as 'malanggan' used for initiation and funeral rites and then left to rot. Finely painted in red, black, yellow and white they are instantly recognizable by their openwork carving.

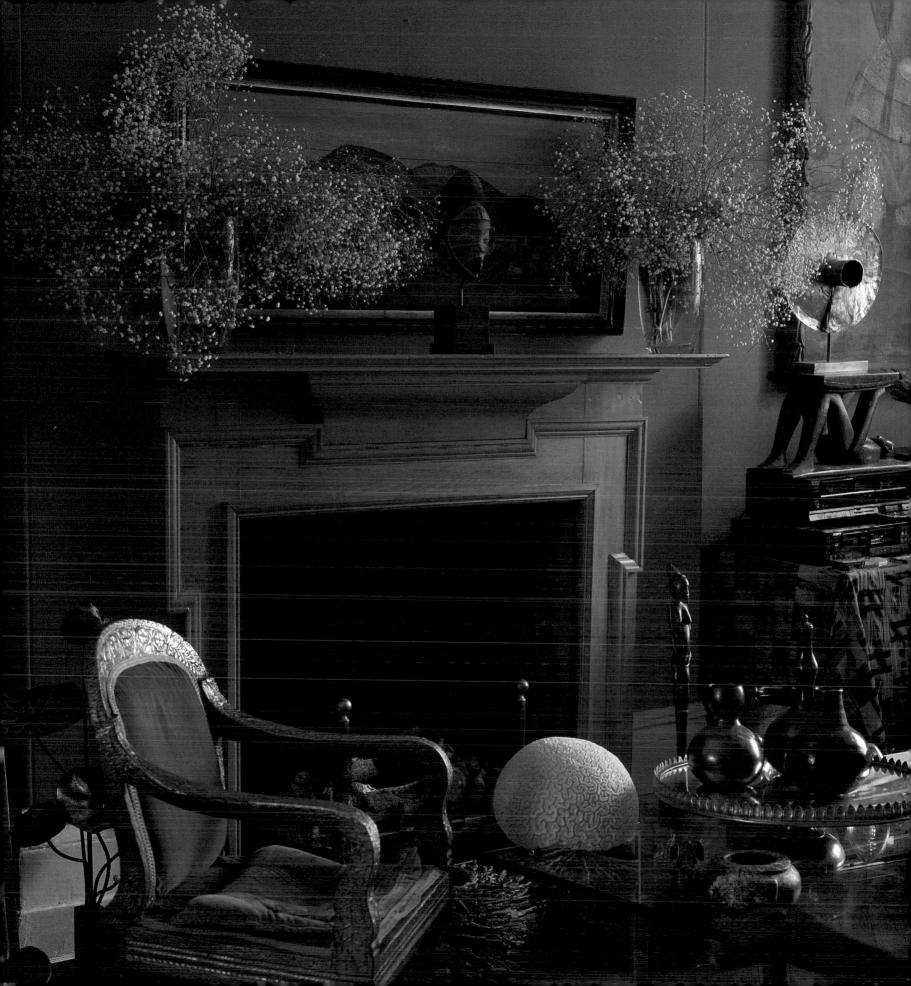

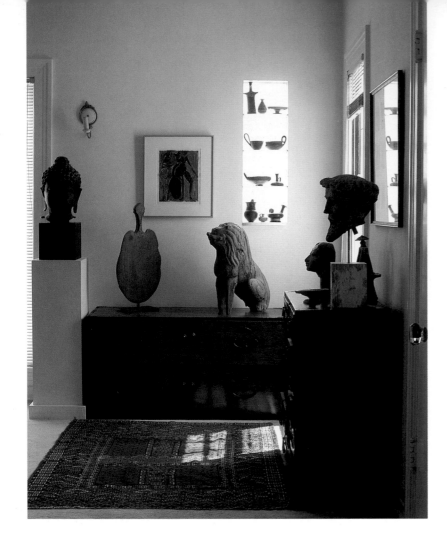

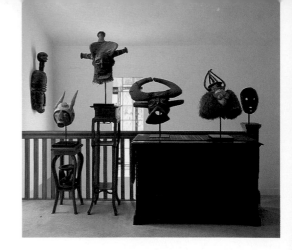

(Above) A bright burst of Californian spring sunshine illuminates the powerful buffalo imagery of a mask displayed alongside a Bobo head-piece from Burkino Fasso.

(Left) On entering the bedroom, the unwary are greeted by a party of statues and artifacts, large and small. Most benign is the Thai head of Buddha in bronze; most strange, the wooden tray from Kerala, which is used for preparing bread.

(Opposite) This is the storeroom of a collector of tribal arts, packed with curiosities from the world over. The appliquéd initiation costume from the Ibo tribe stands guard over the room; crowded together on the dresser are a Yoruban hat with cowries and mirrors, beadwork from southern Africa, dolls from the pre-Columbian Chancay kingdom and on high an unworldly Baining mask from New Britain.

(Below) This shadowy scene echoes the ethereal nature of many eroded wooden statues from the rainforested lands of Borneo.

(Below) Flanking a self-portrait are two masks, mounted on stands placed on pedestals for heightened impact and visibility. To the left is a Susu wooden head-mask from Guinea, and the diminutive figure overshadowed by the bull's horn is a stranger from another continent – a terracotta Quimbaya effigy from Colombia.

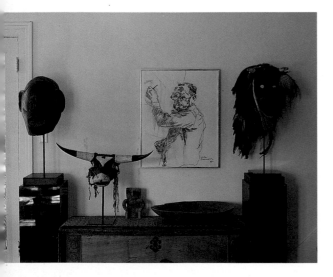

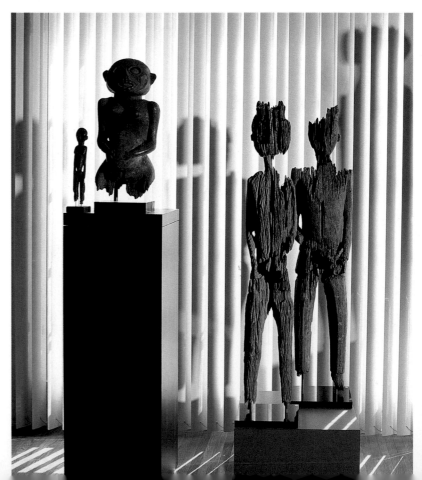

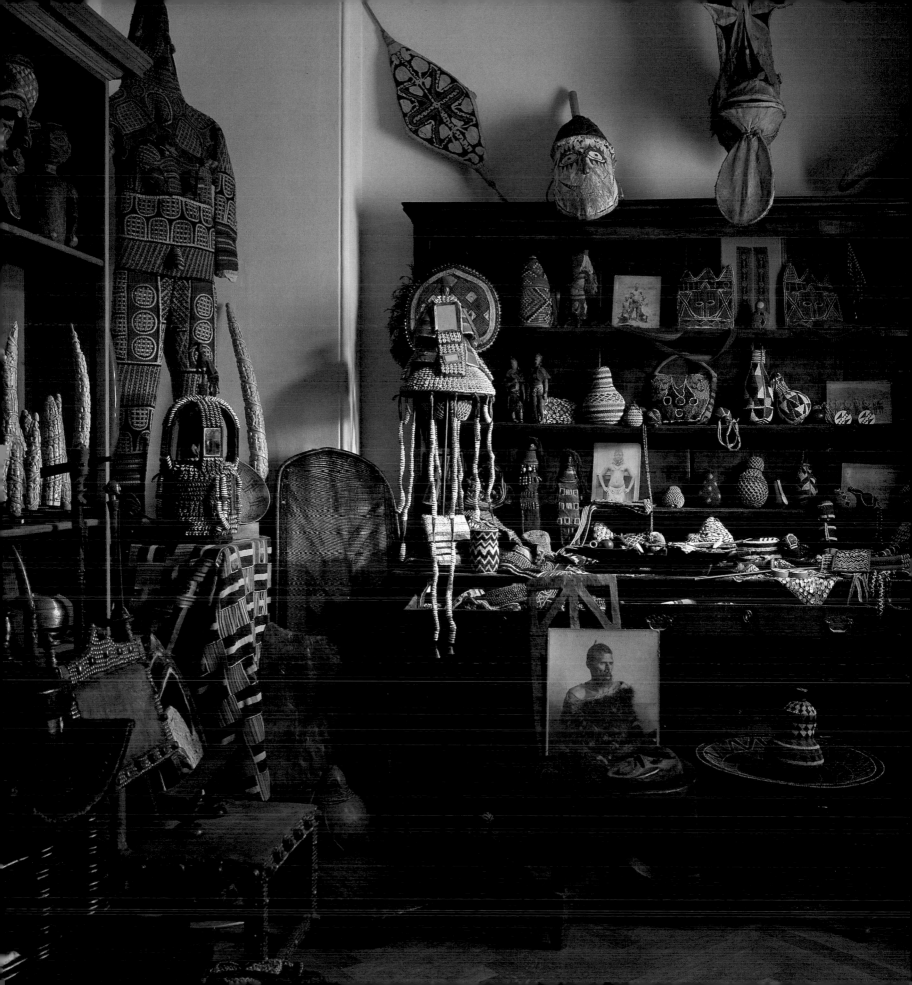

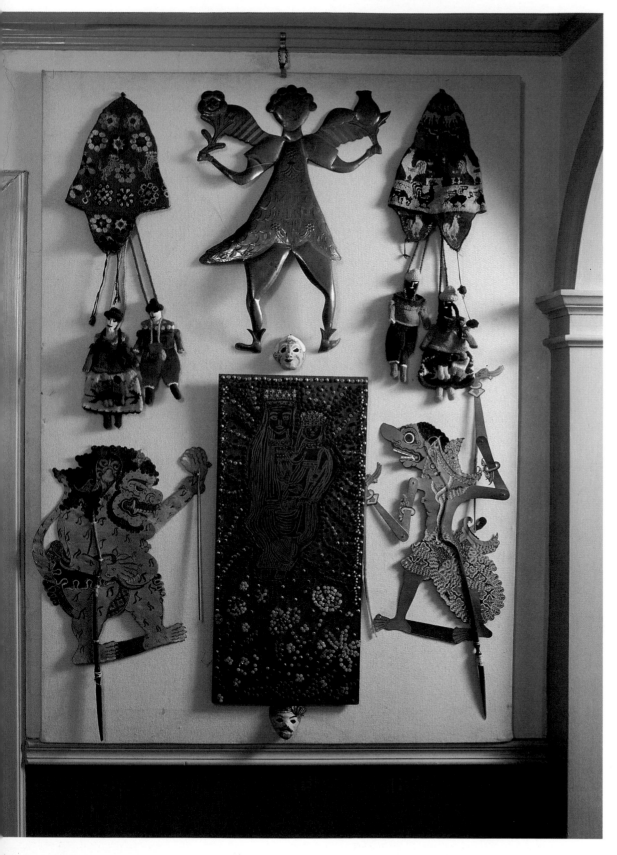

(Left) By stretching white cotton over a pinboard, an ideal surface is created to mount, hang or rearrange with ease a collection of folk and tribal art. The Bolivian Aymara Indian hats and dolls colourfully flank a tin angel from Mexico, the masks are from a festival of miniatures held in La Paz every January and the American pin panel separates a pair of warring buffalo-hide shadow puppets from Java.

(Below) On the gallery of a famous artist's former London studio there is a rich assortment of Oriental textiles. Two small tables topped by family photographs and matching lamps are covered by embroideries of differing origin yet connected histories. To the right, the Bokharan susani is from Central Asia, matched by an embroidery from the north-west of the Indian subcontinent – at one time part of the Mughal Empire.

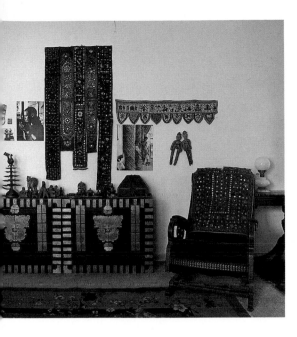

(*Above*) The living-room wall of an artist and devotee of the Subcontinent tells so many personal stories of travel and discovered treasures – memories captured on film and locked within the mind. The mirrored *toran* is suspended above the newly wedded couple of the *Ahir* herding caste; also from Gujarat are the clay votive figures, whereas the small chest for dowry trinkets originates from Kerala.

(*Right*) The stairway wall of this architect-designed house is an ideal site for a collection of 'wayang golek' puppets from Indonesia, each wrapped in a sarong of finely patterned batik.

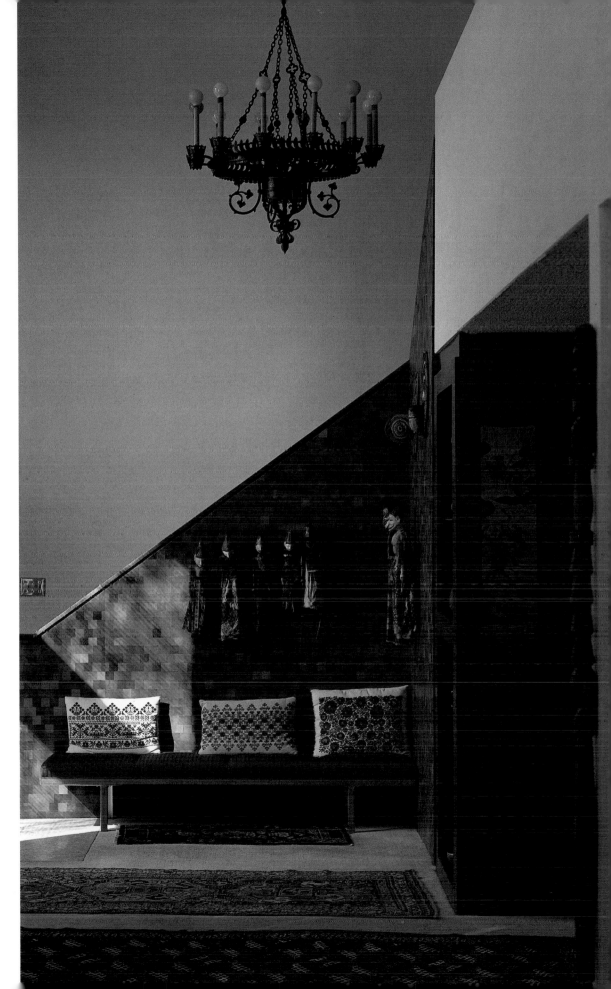

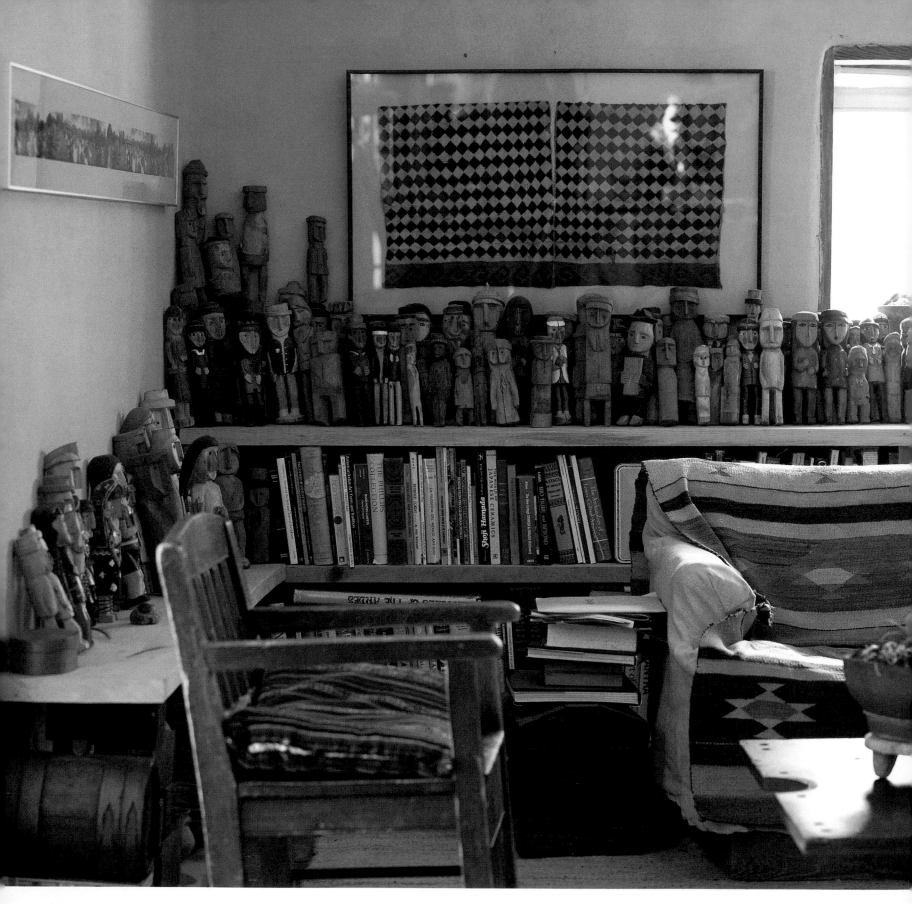

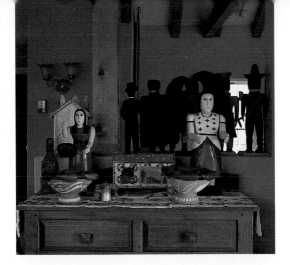

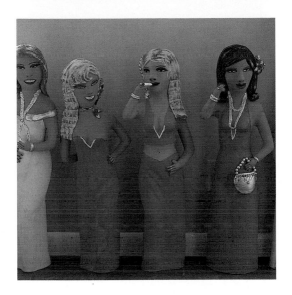

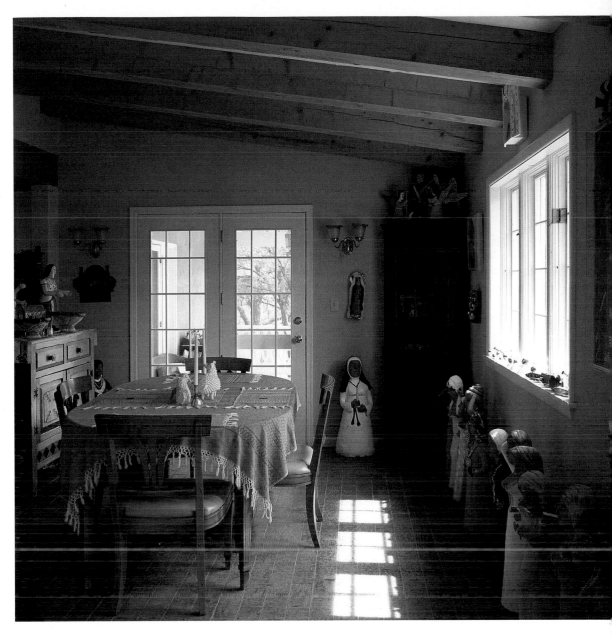

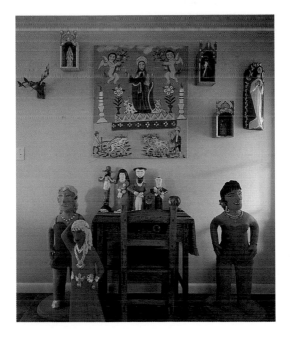

This Santa Fe adobe house (above and left) is decorated in lively style by the carved wooden characters and paintings of the folk craftsmen of Central and South America. Lining the dining-room wall and in the hallway to welcome guests are the gaily attired ladies of the street, from Oaxaca, Mexico.

(Opposite) Preserved safely behind glass and hung on a shaded wall, this section of an Incan soldier's or official's tunic is a study in geometric orderliness. By contrast, the Kuna Indians of the Panamanian Caribbean have carved the jumble of shapes and personal array of village folk as effigies, known as 'nuchas', for curative rites.

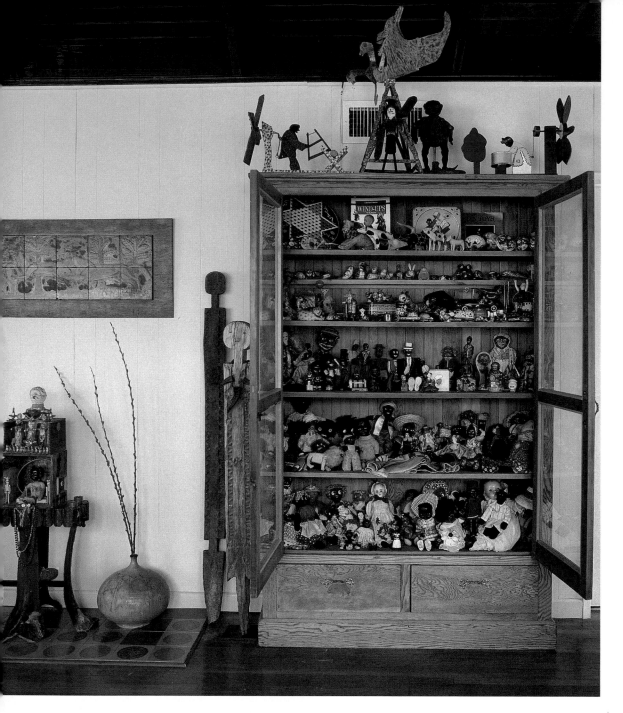

(Left) *A cabinet of children's delights is open for all to enjoy. Dolls and toys from Africa, the Caribbean and Mexico nestle together, and above, the whirligigs from American folk craftsmen rest forever from their exertions in the wind.*

(Opposite) *A trio of memorial effigies from Kenya grace this collection of African art with quiet dignity. Erected to honour important members of a male secret society, these 'vigangos' express through form and markings the personality of the deceased.*

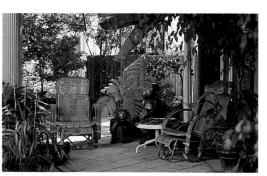

The veranda, gateway and door portal are all welcoming areas of the home, and can be cheered and enlivened by arrangements of folk and tribal art. Gay birds (above, right) and benign guard-dogs greet the visitor, and a quiet reading area overlooking the garden need only be shared with the Thai monkeys, a Swati chair and cloth from Guatemala.

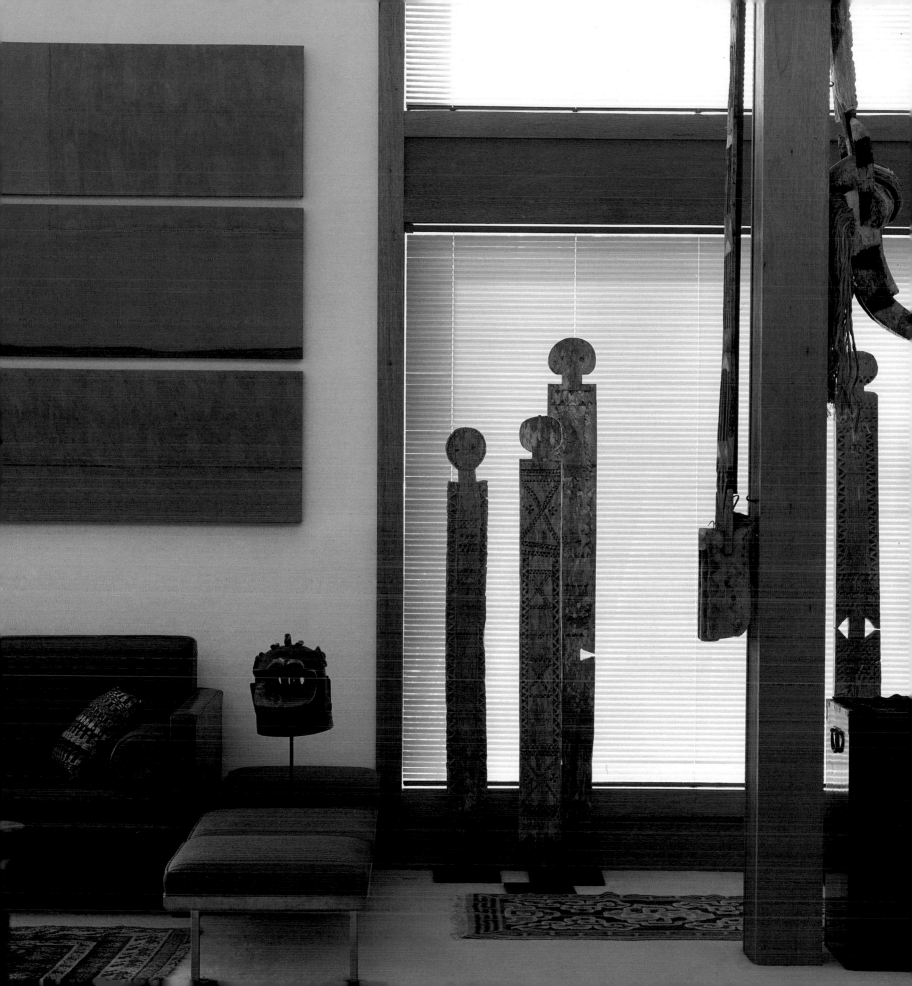

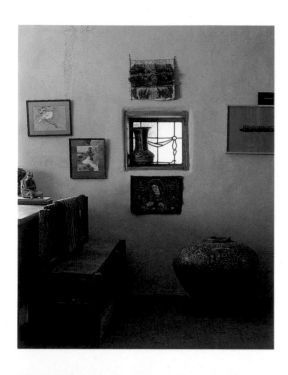

(Left) A feather pouch from the Amazon provides a spot of colour on an adobe wall. Framed both for preservation and presentation is a row of humming-birds woven as a fringe for a pre-Columbian Chancay shawl, and an unusual Navajo child's 'chief' blanket is draped over the bench. The appliquéd 'mola', and the burial pot made and decorated some seventeen hundred years past, are Panamanian.

(Right) This collection of native and Central American folk and tribal art holds a bewildering array of reli-gious icons, both pagan and Christian. The cushions on the bench were once 'pantelhos'.

(Below) On the flagstone floor, a dark Afghan kilim woven by a Balouch tribe is a subtle backdrop to a gay profusion of other colours and patterns. From India comes furnishing yardage – the ikat upholstery cloth and the embroidered curtains – and from eastern Tur-key, the modern kilim thrown over the back of the sofa.

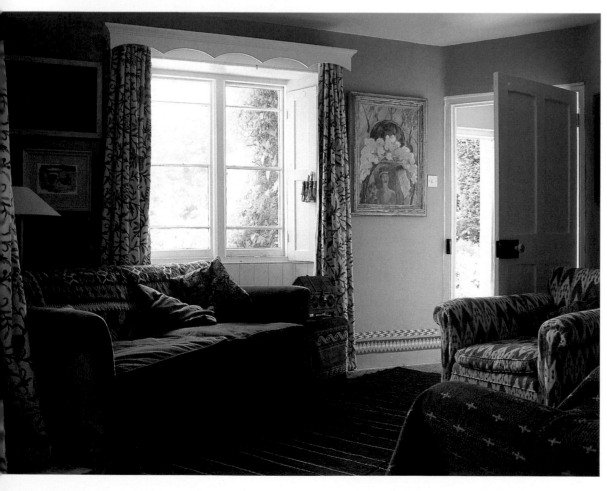

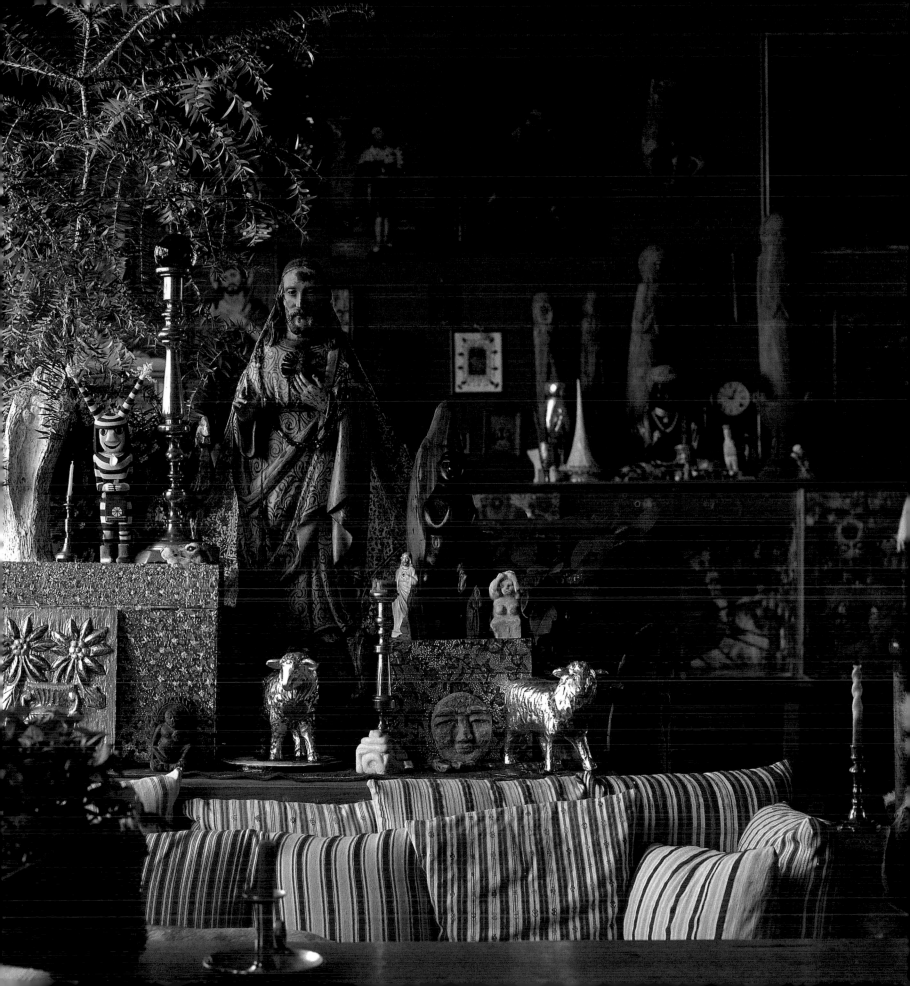

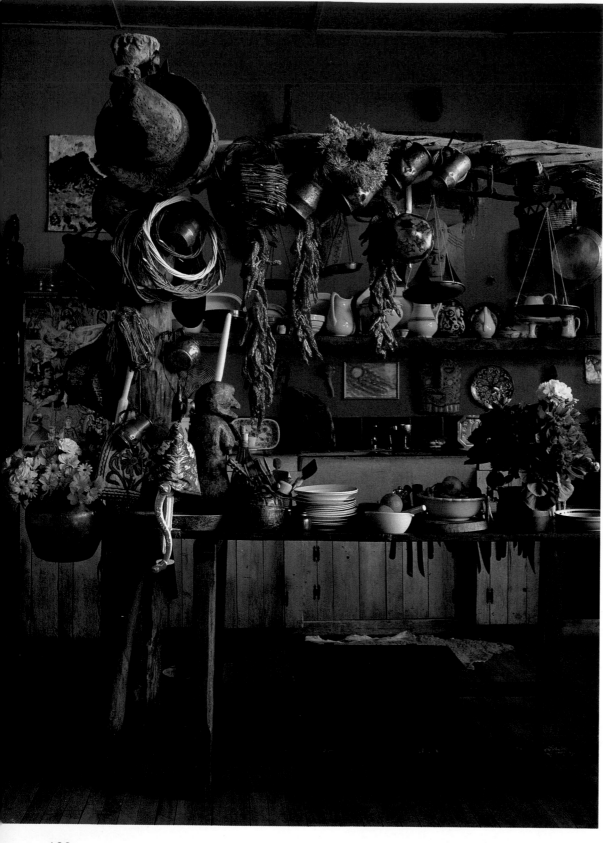

The kitchens of collectors of folk and tribal art can range from the almost familiar to the truly exotic . . .

(Above) A tobacco-rolling tray from Mexico now holds a chilli or two in readiness for a flavoursome repast.

(Left) The wooden sombrero hangs amidst copper pots and pans in a world far removed from its original environment, where it was used as a Mixtec ceremonial dance-piece, its brim laden with flowers and candles.

(Opposite) Starting from a green-field site, the owner has been able to build into his house choice pieces of carved wood from Asia. Here in the kitchen, the lintel over the Aga stove was originally at home in a village window- or door-frame in Gujarat, India. The iron candlestand is from India as well, the 'brod' box from Scandinavia.

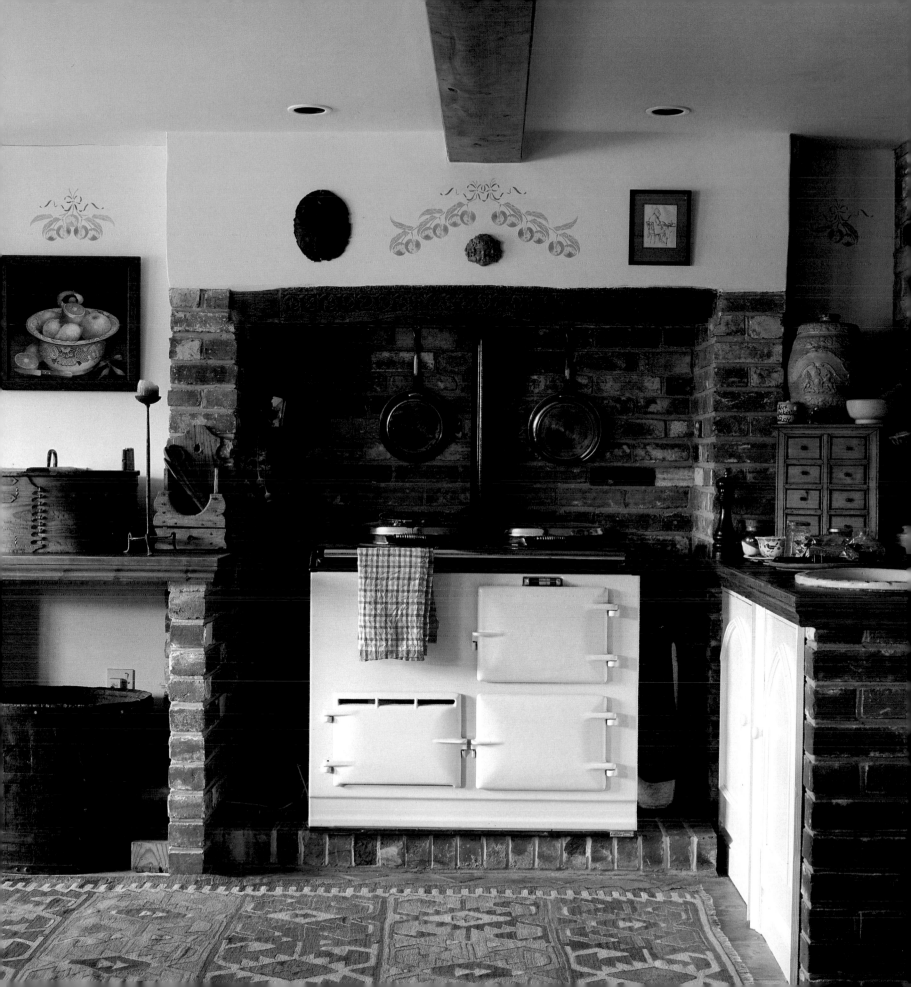

(Left) The memorabilia of journeys past, and the wherewithal for planning future expeditions within the South-West and across the border to the sleepy lands of rural Mexico, are unfolded and spread over a table softened by a woollen 'sarape'.

(Above) A traffic-jam of camionetas, cars and trucks from Colombia and Mexico deck this old pie cabinet in the hallway.

(Left) Bottle tops, screw caps, carved and painted wood rattle at the slightest movement of this friendly snake from New Mexico.

(Opposite) A shaded sun-deck built in Japanese style is a serene setting in which to admire a collection of embroideries. The look and feel of cloths from Bhutan, Gujarat, the Punjab, Turkestan and Guatemala evoke memories of journeys to lands rich in textile culture.

Chapter Four

At Home Today – Decorating with Tribal and Folk Art

From the museums and galleries of New York, Paris and London, to the main street department stores in cities all over the Western world, the creative ingenuity and artifacts of tribal and folk craftsmen are now enjoyed and collected as never before. Their appeal, within the context of home decoration, first came to prominence with the nineteenth-century fascination for the Orient. For the better off, the Persian or Turkish carpet was the essential exotic decorative accessory for the floor or wall, and was also used as a rich upholstery material. Onwards into the twentieth century, it was the artists of the time who placed African statuary and masks on display in their Parisian studios and smashed the traditions of the romantic era with their savage coloured canvases; Matisse himself covered sofas with kilims from Persian Kurdistan and the many paintings which hung on his walls were interspersed with cut-pile raffia cloth panels from the Belgian Congo. From among European traders and Government staff of the colonial era, on duty in dusty lands such as the Sudan, the Hindu Kush or the lush tropics of South-East Asia, few households were without the artifacts of the peoples within their area of control. In the attic, musty chests reveal their treasures: photographs of soldiers and tribesmen, holidays on Dal Lake houseboats and the moth-savaged shawls from a sojourn to the cool of Kashmir.

Despite the travels of the colonials, early tourist ventures to exotic lands and the keen collecting of artists and a few amateur enthusiasts, the majority of people adopted a close-minded attitude to the arts of the tribal and folk world. Flat-weaves such as kilims and dhurries were regarded merely as excellent dog bedding, and masks and statuary were too alien to be acceptable as ornaments. Consequently, many of the artifacts of the tribal and folk world were ignored, and only traditional luxury trade goods were sought after. What a contrast to today – for the late twentieth century has seen an explosion of interest in these arts and crafts as decorative objects in their own right. Colourful appliquéd ox-covers from Gujarat, India, brightly painted metal rickshaw panels from Bangladesh, tin toys from Mexico and

(Opposite) A study in simplicity in blue. The folk arts of North America are here complemented by a Peruvian floor rug patterned with pre-Columbian motifs.

nail-studded masks from Central Africa – all are now finding a place in the homes of the West. These artifacts add that vital edge of the unfamiliar, which is coupled with a sense of the traditional yet dynamic creativity that – paradoxically – our own society has suppressed, and therefore made precious, on its goose-stepping march of progress.

The conventions of Western home decoration sanctify as comfortingly 'normal' the watercolour hung on the wall and the china ornament on the shelf or mantelpiece. What fresh and challenging opportunities exist when these familiar trappings are exchanged for folk accessories; and yet so broad is the choice of artifacts available that a whole manner of visual effects may still be achieved, from the shock of a disturbingly 'pagan' mask to the serenity of a finely worked floral batik.

There are varied and manifold reasons which prompt one to buy a piece of tribal or folk art such as an ebony-coloured wooden statue from the Gold Coast of Africa or a figuratively decorated basket from the American South-West. What delight it is to yield to the mischievous and impulsive desire to own and admire such expressive artistry; but again, what painstaking patience one must have to seek out an object of just the right shape, size and colour – be it a textile or a carving – to perfect a scheme for the ideal living space. This chapter is intended to assist those needing inspiration, the meticulous planners as well as the fellow feckless-at-heart.

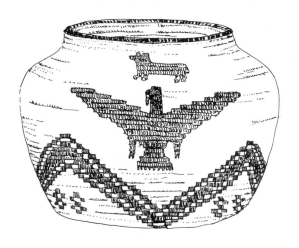

Basketry of the Havasupai tribe of Arizona

Size and Shape

Of all the tribal and folk arts, textiles used as wall-hangings offer the greatest variety in this respect. With decorations ranging from temple paintings thirty feet long that are found in north-west India to crumbling fragments of Coptic fabric unearthed from Egyptian burial sites, a wall may, at one extreme, be swamped with the rich colours and patterns of a single textile or, at the other, be dotted with picture frames containing a collection of small cloths mounted in traditional style.

The prehistoric textiles of worlds old and new need special care when framed and hung. Textile fragments unearthed, for example, from the pre-Columbian grave sites of coastal Peru, or from the excavations at Fostat, will best be preserved and presented when sewn to a suitably coloured cotton cloth backing and either mounted behind glass or stretched over a wooden frame in the fashion of a painter's canvas. Such treatment will suit any small or fragile textile, whether it is an embroidered purse, or a 'toran' from Gujarat, a beadwork talisman of the Zulu or a Lakai Uzbek embroidered bedding or yurt decoration.

Flat-woven rugs and blankets – such as kilims from Anatolia, Iran and Central Asia, the hanbels of North Africa, dhurries from the Indian subcontinent, and the weaves of the Navajo as well as the tribespeople and villagers of

Central and Southern America – have to be easily transportable, and are usually six to seven by three to four feet in size. Islamic prayer rugs make fine hangings, the 'mihrab' that orientates the direction of supplication providing a focal point. From Indonesia there are the sarong lengths and skirt tubes woven with detailed ikat and supplementary thread work; from India come wall-hangings such as the colourful 'chaklas' and 'rumals'; and throughout the Andean region are found the ceremonial capes and mantles, the most pleasing of which are made by the Aymara of Bolivia.

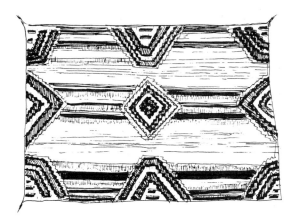

Navajo blanket

Larger textiles look spectacular on a wall. Certainly, such textiles need a good deal of space surrounding them and in front of them, so that the onlooker may step back to view the entire composition from a distance. At Bombay Airport the seething crowds and fearful clamour are made bearable at the sight of a Pabuji par scroll that is mounted to run full length across a terminal wall. Long and narrow yet lightweight painted cloths, such as a par, the appliquéd and embroidered raffia skirt cloths of the Kuba, and saris and sashes of India, are best sewn to a backcloth mounted on a wooden stretcher when hung on a wall. The largest textiles are more than likely to have once been used for ceremonial purposes, as well as to display wealth – such as the wedding kilims of north-west Afghanistan and the festival appliqués of Rajasthan and Gujarat, for example. Other textiles of grand dimensions may include the dhurries of north-west India, the kilims of Anatolia and the West African strip-woven cloths. For tapestry-woven rugs and hangings, the dimensions of a textile are restricted by the size of the house within which the loom must be set. The technical constraints of maintaining an even tension in the weave mitigates against the creation of a cloth wider than fifteen feet. With loom-woven textiles, lengths in excess of thirty feet are theoretically possible on a continuous warped vertical loom, and strip-woven textiles such as the Uzbek 'ghujeri' work and the 'kente' cloths of Ghana and Togo may be formed to any size, which is determined by their traditional function and the strength of the raw materials used.

In the realm of the tribal and folk art world, unusually shaped cloths abound. The Hausa robes of northern Nigeria, embroidered with white on an indigo ground, and voluminous when worn, will make a striking centrepiece to a large area of wall. Horse-covers from Central Asia and southern Iran are often U-shaped and woven with either a strip-weave technique or in a combination of styles, such as pile and brocade work, on the same textile. Heavy cotton skirts, densely embroidered with motifs of parrots and flowers, are found in the Rann of Kutch, Gujarat; these, along with other articles of clothing – including hats – will make unusual hangings, especially when grouped to form a collection from a particular tribe or locale.

Fixed to the wall, or placed on a pedestal, mantelpiece or shelf, the carvings, ceramics or baskets of the tribal and folk world offer an array of decorative possibilities and effects. Carved forms such as masks, for both

theatrical and ceremonial display, differ drastically in size. From Mali comes the skyscraping dance mask of the Dogon. Such a mask, with a twenty-foot appendage, evidently needs a wall or stairwell of suitably impressive dimensions, but if displayed by itself it can exacerbate the height of a space which then detracts from its own power. The dance masks of the villages of Bali are carved, painted and caparisoned with hair and trappings to create the characters of Hindu epics such as the *Ramayana* and the *Mahabharata*. Boar, beast and mythical bird masks can be large and when mounted on the wall will need a good deal of room on all sides to take the froth of hair, cut buffalo-hide or feathers as well as any protruding snouts, beaks and tusks.

The largest carvings suitable as an adornment for a soundly constructed wall will be the shutters, doors and panels of the Indian subcontinent and South-East Asia. Ornately carved and riotously painted temple doors, screens and panels from Bali can be arrayed across a wall to good effect. From the ruined or looted 'havelis' of Rajasthan come windows braced with twisted ironwork and 'jali' screens of fretted wood from the women's quarters which are to be looked out of, not into. Many fretted screens benefit from a backing of mirrored glass; the reflected light and disturbed images give a sense of depth, as if the onlooker is seeing both out and through the wall at the same time.

There are certainly many tribal precedents for hanging carvings on the wall. The exterior doorway walls of village houses in Papua New Guinea are bedecked with carved wooden boards depicting zoomorphic figures. These panels and the shields of the head-hunting menfolk are dynamically decorated with what a Westerner would interpret as 'modern' designs.

Aside from groups of smaller artifacts such as masks, bowls or dish-shaped baskets displayed on the wall, the most obvious way to give prominence to collections of items is as pride of place on a mantelpiece, pedestal or chest top. The carved wood statuary and masks of the West African tribes and the terracotta faces from pre-Columbian times may often be purchased ready-mounted on a plinth. These, depending on their character, may demand an entire well-lit shelf to set them off most dramatically. Larger figures, such as the eroded wooden statuary of the Dayaks of Borneo, the face and body masks of the Admiralty Islands and storage baskets or chests of the Tlingit American Indians from the north-west coast, will need a pedestal or platform to themselves. The most fragile of artifacts should be boxed in with Plexiglas for safety and preservation.

Ornamental objects too large or awkward for the shelf or mantelpiece can be grouped or positioned to form impressive floor displays. From the region of the Indian subcontinent come the Hindustani temple and house carvings of mythical beasts, mustachioed soldiers and animals; such gaily painted figures are copied with alacrity in Rajasthan for a hungry tourist and export market. Unusually shaped artifacts more appropriate for the floor

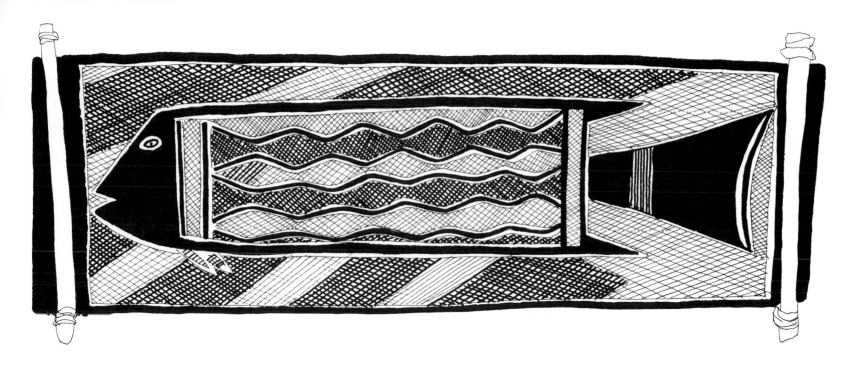

Bark painting of a kingfish from north-east Arnhem Land

include camel and horse saddles from Rajasthan and the Tuareg of North Africa. From the island of Lombok in Indonesia come the large earthenware open-necked water pots and the finely made food baskets that would look good as a group of similar shapes varying in size, as well as doubling up as waste-paper baskets or laundry stores.

Scale

The size of display area available will evidently bear on one's choice of ornament. An expanse of wall, large or small, when covered almost entirely by a textile, bark cloth or a series of interconnecting painted panels, for instance, would dominate anything in close proximity to it, if not the entire room. Rather than cover an area, it may be best to divide it. A long and narrow textile could be hung at eye level to halve the wall space, or several items of the same origin can be used to diffuse it still more. Banners hung vertically, sets of spears and paddles from Oceania, or Kenyan grave markers, can be fixed to a wall to portion an area longitudinally – their suitability for a turret or stairwell is an obvious thought. The orientation of objects will appear to alter the dimensions of a room; rectangular artifacts hung portrait-format will seem to heighten the ceiling or shorten the room, whereas textiles or panels hung landscape will lengthen a corridor or wall. Unusually shaped objects, perhaps a fierce-looking theatrical mask from Mexico or Bali, or a doorway embroidery from Gujarat, will distract the eye away from large and overbearing expanses of wall; likewise, the grouping of many artifacts chosen for their similarity of size – say a collection of dance masks from all over the world – will break up such an area most successfully.

'Mola', or blouse piece, made by the Kuna Indians of Panama

Wooden toy horse from Orissa, eastern India

Small objects such as Mexican Day-of-the-Dead tin and ceramic toys, fragments of statuary and masks from the prehistoric grave sites of Central and South America, modern cast-bronze animals from Bali, gold weights from the Ashanti of Ghana, and the bulky jewelry of the Turkomen of Central Asia may best be shown by building a display cabinet or set of shelves against a wall. In this way special compartments can be created for specific groups of objects or single artifacts. A series of bookshelves stretching across a wall would safely display a prize collection – maybe comprising Pueblo Indian painted pots. Be absolutely sure the fixings into the wall are strong enough; the noise of breaking pots may be awesome, but the anguish will be unbearable.

Colour and Pattern

It was the strident range of colours, strange forms and unnerving patterns that shocked and astonished explorers, missionaries and colonial staff in times past. But what was once seen as alien and suitable for either the bonfire or the curio cabinet and museum store is now finding pride of place in so many homes and private collections. Brightly coloured artifacts abound. From Mexico there are the extraordinary papier-mâché skeleton figures and fantasy creatures of the Mexico City folk artist Linares and his family, and from the villages surrounding Oaxaca come painted tin and ceramic toys as well as the garish statuary of ladies of the street. Guatemala is well known for its fluorescently coloured shawls and blouses. The Kuna Indians of the San Blas Islands reverse appliqué blouse fronts, 'molas', humorously and with a superb sense for strident colour. The Ewe and Ashanti peoples of Africa produce the vividly coloured and patterned strip-woven kente cloths, and the modern flat-weaves of Tunisia, Algeria and Morocco are known for their lurid use of bright synthetic dyes and lurex thread; 'bsats', the flat-weaves of Mesopotamia, are worked with bright oranges and reds. The modern kilim weavers and dyers of Anatolia, Iran and Afghanistan established a reputation, repudiated only recently, for a less than sensitive use of chemically based yellow and orange dyestuffs. From India there are the gold-threaded and sharp-coloured sari lengths, the unsophisticated appliqué work of Orissa and the shawls of the north-eastern tribal states, some of whose colours seem to glow in the dark. The masks of Indonesia and especially the theatrical and ceremonial examples from Bali are gaily painted to shock, terrify and amuse the audience. The blurred patterns of ikat cloth can take bright dye well, as can be seen from the old silks of Samarkand, Tashkent and Bokhara as well as with the Sumban hinggi and the modern machine-loomed yardage of Andhra Pradesh.

Whereas bright coloured and patterned artifacts will dominate a room, subtler textiles and patinated wood will tend to blend or harmonize. Statu-

Ancestral painting of the Gope tribe on a wooden board, from Wapo Creek, Papua New Guinea

ary from the West African tribes and the Kenyan grave-markers have often lost their paintwork through handling or exposure to the elements, revealing the true nature of the wood beneath. Dark hardwoods and ebony glow with a patina of age, soft and light-coloured woods often have a coarse grain and look as though they ought to be painted. From Polynesia there are the dark palmwood carved clubs that have a 'pointillist' end grain, and the hardwood bowls and concave dishes are masterfully carved from large hunks of wood; the great weight and strength of such timber is astonishing. Predominantly plain and yet pleasingly dyed cloth with irregular colour movement makes fine hangings: the undecorated camel-hair fields of some Balouch and Qashqai kilims are a study in tone, and the indigo dyed robes and striped cloths from West Africa are deeply alluring.

Just as an object's colour will determine its strength of presence in a room, so its pattern and design will either arrest or soothe the eye. Strong patterns will dominate, especially if seen from a distance; this will be particularly evident when mounting Papua New Guinea houseboards on the wall and then standing back to view the dazzling zoomorphic and seemingly abstract designs painted on the wood. Brightly painted shields, large carved panels, textiles with a strong central pattern, an arrangement of unusually shaped baskets – all will have a strident effect. Subtlety of design and pictorial representation will obviously tend to blend much more easily. Painted miniatures taken from Hindu epics and the courtly life of Mughal times will need to be framed to allow closer examination; the fine work of Coptic textile fragments also demands detailed scrutiny to be properly appreciated, and the painted stirrup vessels from the pre-Columbian Moche culture of Peru are, again, fine examples of workmanship on a small scale. No matter what medium of expression, by means of shape, colour and patterning, tribal and folk art may attract and challenge the eye, soothe, or unnerve the senses.

Style

Just as Western paintings and sculpture can either be arranged in the style of a spacious museum or gallery, or, alternatively, grouped on the wall, floor and shelf in the dynamically haphazard jumble that is found within many an artist's studio or home, so the artifacts of the tribal and folk world can be arranged formally or informally.

Formal style can be arrived at by isolating an object on the wall, shelf or pedestal and by highlighting it with floods or spotlights. Encasing an object within a glass or perspex cabinet, or framing a textile, produces a similar effect. This semi-clinical display of the tribal and folk arts is the subject of much contention, for some argue that by removing the artifact from any possible reference to its original setting – its association with ceremony such as song and dance, or its architectural and decorative purpose – it is relegated

to just another 'collectable', 'rationalized' to suit the Western audience. It cannot be denied, however, that there are few sights more awe-inspiring than an array of African sculpture – perhaps a full Bundu head-mask of the women's secret society of Sierra Leone placed alongside the statuary of the Fang of southern Cameroon – on stands or platforms within a minimilist setting, and lit with devastating effect by well-placed low voltage lights. Pedestals of differing heights to suit the stature and shape of figures and sculpture will create layers and levels of focal interest. In the same vein, a line of identically sized museum-style frames containing scraps of eleventh-century Indian printed cotton cloth exhumed from the rubbish tip of the ancient Egyptian city of Fostat, hung at the same height along a hallway, will certainly be gallery-like and seem very formal. A pair of shields hung within an alcove or on either side of a fireplace will be dramatic, as will a single mask hung centrally on a chimney breast with a wash or spot of artificial light.

Informal styles are not difficult to achieve, and can sometimes create themselves. Objects amassed in groups may give the impression of seemingly haphazard clutter, and it is often a surprise to discover just how well ethnic arts from all over the world, whether textiles, ceramics or carvings, mix and come to accord in an informal style. A window-sill bearing carved lions from India and Indonesia, a tray, bowl or basket of gaily painted wooden tropical fruit from Bali, a floor area set aside for various wooden chests from Asia, a shelf of dolls from the Kuna Indians of Panama, or an alcove cluttered with an array of retablos from Mexico – the possibilities are limitless. Jewelry of the tribal world is often unwearable, except at the time of wayward swings of Western fashion, and is often most impressive when hung in glittering groups over a fireplace or within a glazed and internally lit wall cabinet.

A pedestal topped by a dark wood statue of seemingly fierce disposition will seem less startling when draped with a colourful cloth from the same region, or from a neighbouring tribe. The strip-woven cloths of the Ewe and Ashanti look especially good used in this way. On table-tops clusters of small figures attract the eye, especially the ghoulish Mexican figurines associated with the Day-of-the-Dead festivities. An old plate cabinet or purpose-built glass-fronted cupboard filled with dolls or rows of prehistoric stone statuary, oil lamps and vessels, will create an effect that may range from a throwback to a Victorian trove of curiosities to a valuable museum display. A favourite location for strange and wonderful objects is the top of a kitchen cabinet or cupboard, as long as no one baulks at the prospect of being peered down upon by Mexican papier-mâché dragon beasts or nail-punctured nkisi fetishes from the Congo. For those seeking a dream-inducing decoration to a bedroom, shine a light on to the shadow puppets of Bali and Java mounted one or two inches away from a wall, and cast fantastic images of beasts and men locked in a never-ending struggle with the forces of good and evil, evil and good.

(Opposite) Such pleasure can be derived from collecting even the most trivial of folk and tribal crafts: a child's toy-horse box, a padded representation of a parrot to hang over a cradle, and an example of ecclesiastical salvage from a ruined church on the Arabian Sea coast are all from India.

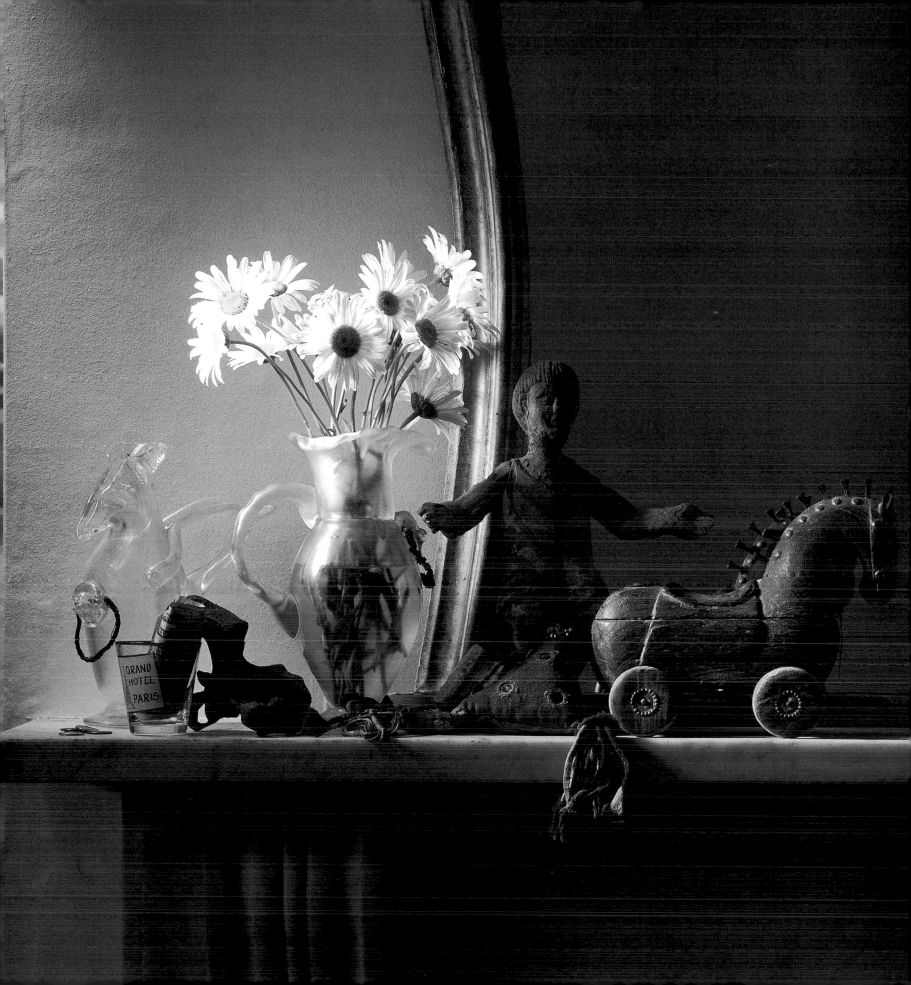

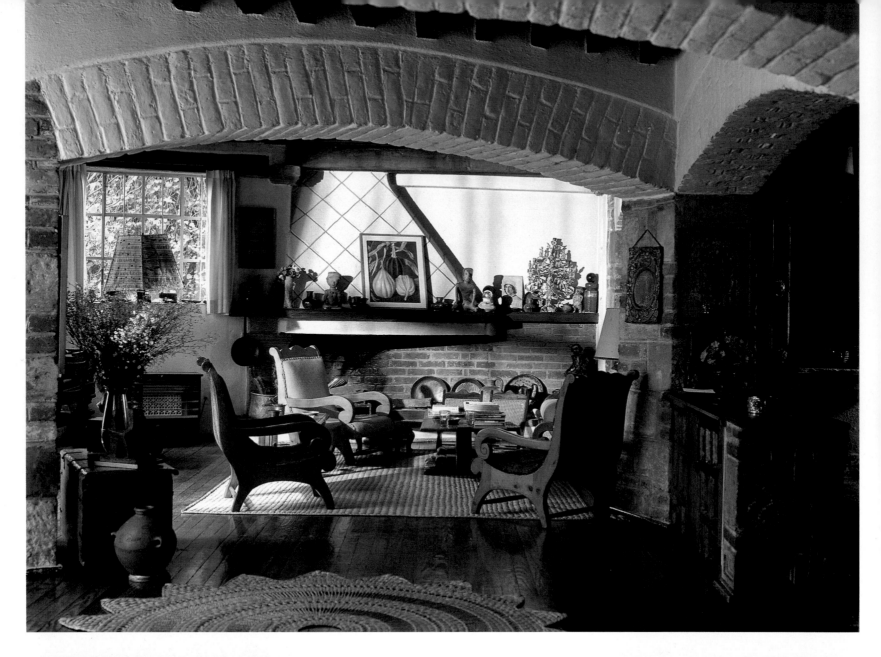

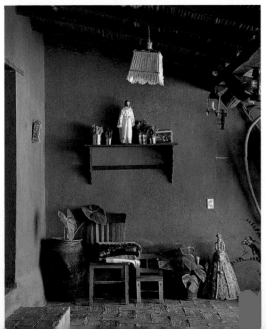

Fragile ceramics are comparatively safe on the mantelpiece (above). Here, pre-Columbian figures from Nayarit and Veracruz look on to this attractive and comfortable living room. (Left and right) The ceramic image of the Virgin Mary on this Mexican veranda was fashioned by Zapotec villagers, while local Oaxacan artists turned the wooden hats and pieced together the speeding cyclist. (Opposite) Mexican hand-woven cloth and Navajo rug fragments add comfort and colour as cushions in this breakfast room.

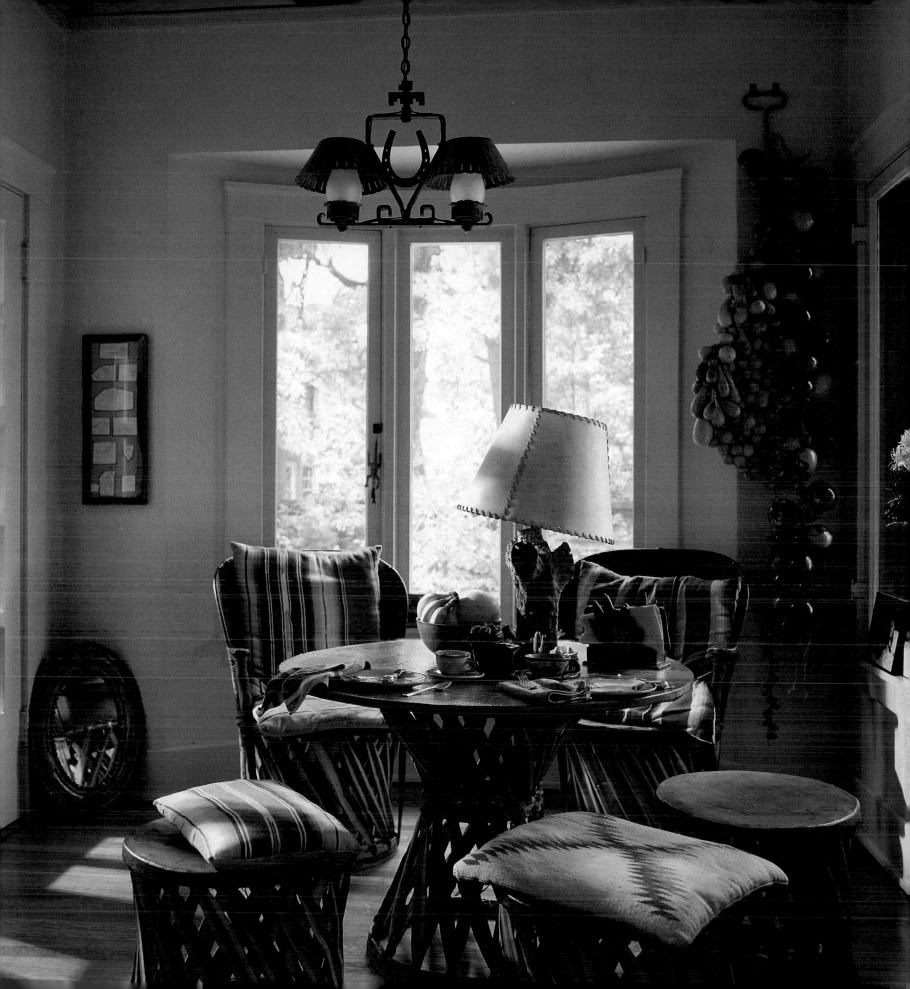

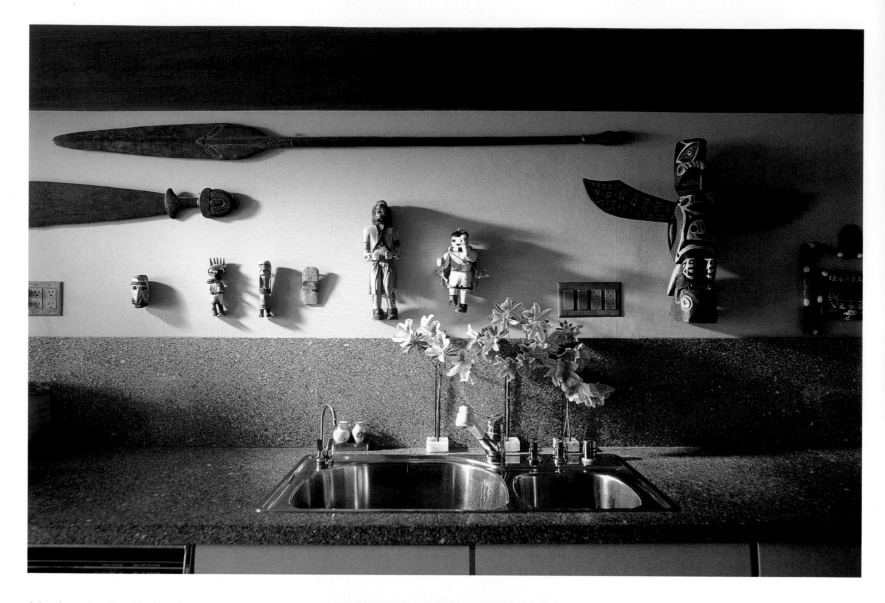

(Above) With only a blank wall to look at, washing the dishes is a tedious chore, and so here have been hung a selection of folk and tribal objects that allow the mind to wander. From the South Seas the spear and club provide linear form whereas the dolls and totem from the American Indian tribes offer the imagination a more figurative and colourful stimulus.

(Opposite and left) The kitchen of an interior designer living in Santa Fe, where modern styles of furniture mix with folk arts to good effect. Cupboard doors have panels of fashioned New Mexican tin and every available surface is crowded with dolls from Mexico and the tribes of the South-West and South America. Charming hand-painted tin 'retablos' depicting local miracles hang above the cupboards.

124

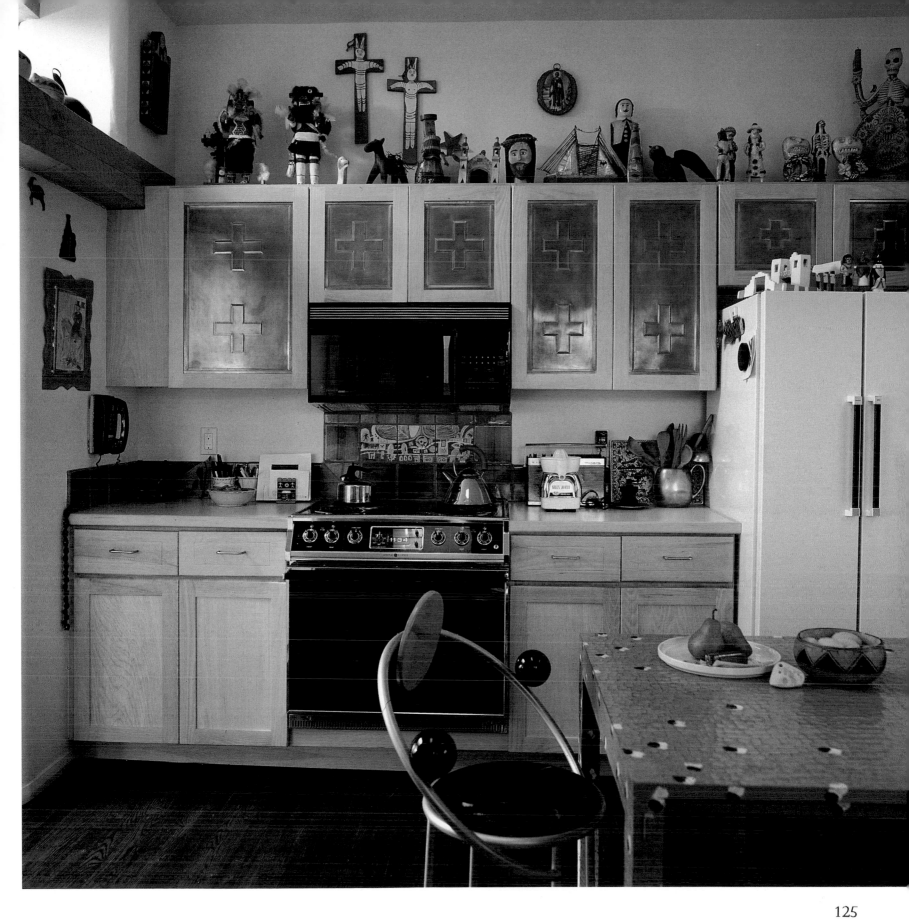

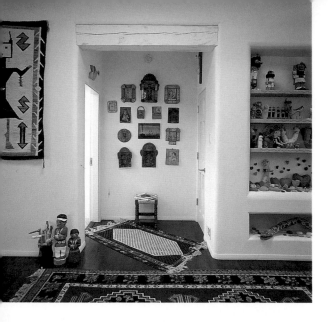

(Left) The bright colours and geometric patterns of the Persian kilims on the floor contrast with the natural wool colours of the Navajo pictorial hanging, and the wall between the bedrooms is crowded with a fine selection of folk icons from Central and South-West America.

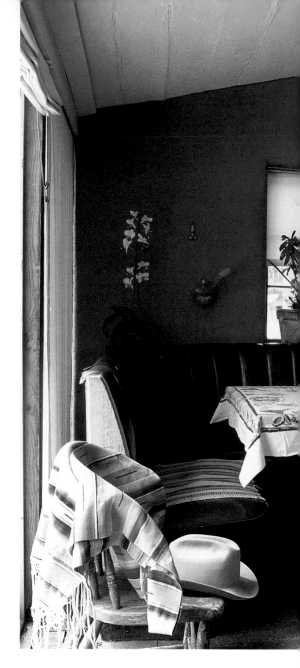

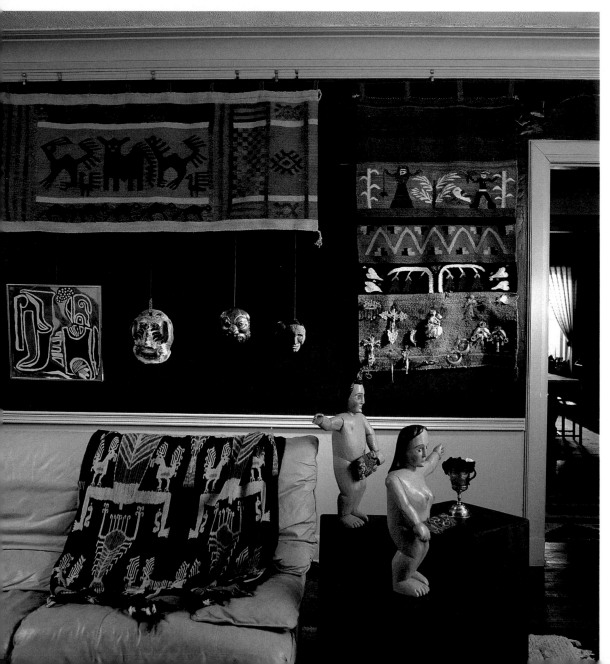

(Left) The background wall of deep claret contrasts well with the collage of textiles, jewelry and masks. Pinned to a Bolivian Aymara Indian shawl is a collection of silver church decorations, earrings and mantle pins of the country's colonial occupants. Wool loops have been sewn to the textiles so that they may easily be hung from a rod or picture rail. Over the sofa is draped an ikat wrap from the island of Sumba, Indonesia, and the robust painted wooden figures come from Mexico.

(Right) Contemporary Navajo rugs with patriotic designs have been sewn on to cloth-covered board to decorate this hallway.

(Below) St Simon is a popular hero amongst the Guatemalan down-and-outs, and this life-size dummy comes complete with a hole in his mouth ready to take the proffered cigarette and a generous glass of beer. The Miró designs have transferred most successfully to a floor rug composition – this example is Mexican.

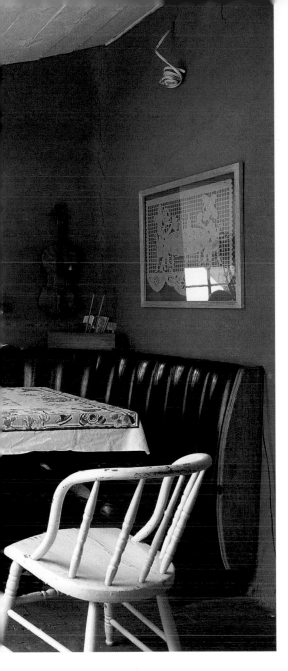

(Above) Rescued from a derelict coffee shop, these benches provide the perfect seating area in this breakfast room looking out on to a garden. The fragile and deliberately ephemeral paper cut-out from Mexico has been framed to preserve the ghoulish scene of two skeletons enjoying their own fare.

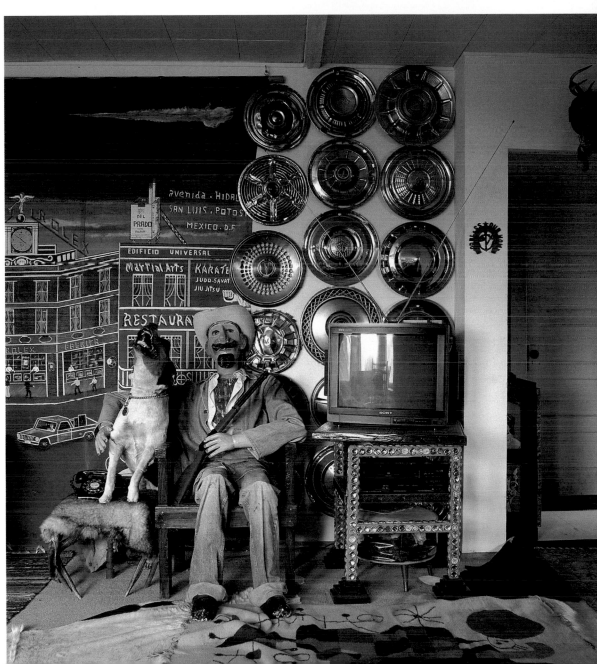

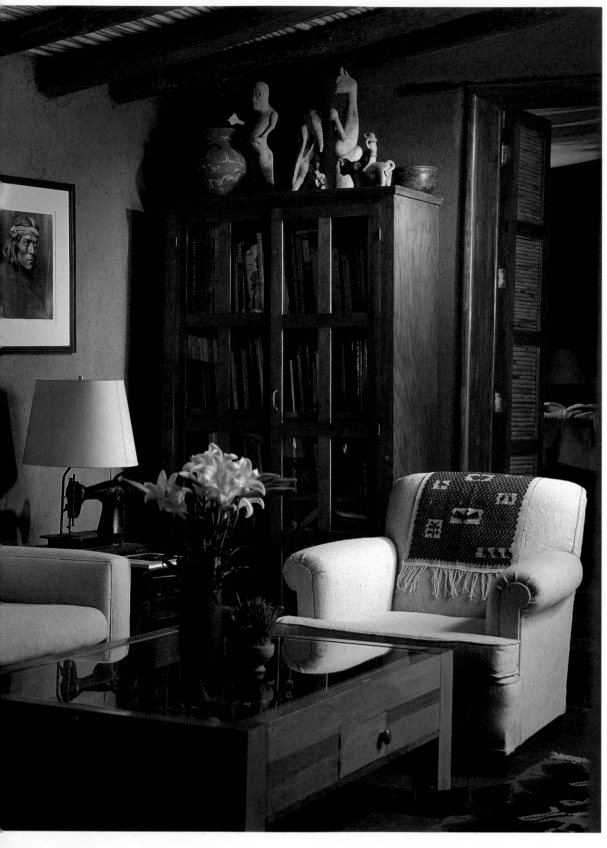

(*Above*) An indigo-dyed and embroidered sarong from Flores proves a subtle background to this study of a carved wooden food-bowl from the South Seas.

(Left) Textile sashes and bands of Central America make fine antimacassars and loosely draped covers for chairs. This one depicts cranes, alligators and fish and is the work of Huave Indian fishermen weavers.

(Opposite) *A fishy affair.* On the mantelpiece a palm-leaf duckling from Bali nestles within the knurled vine-twig basket from the Philippines. The bronze fish is from Indonesia, the painting European.

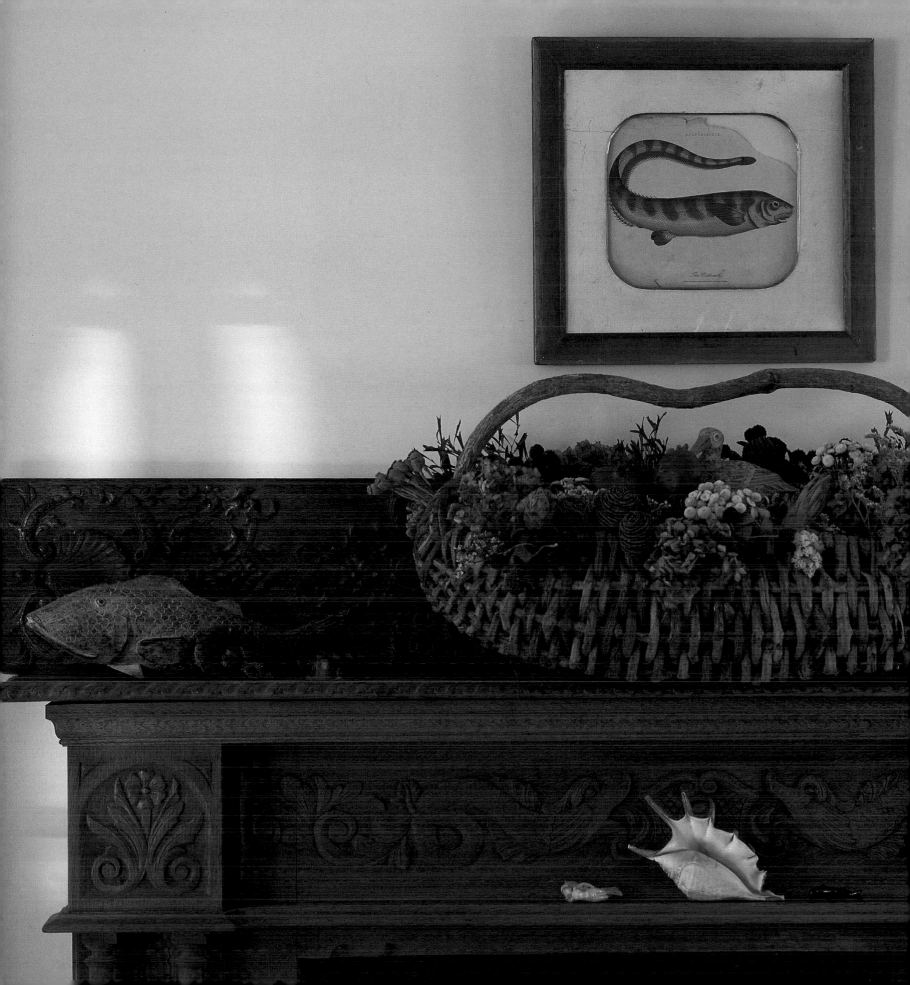

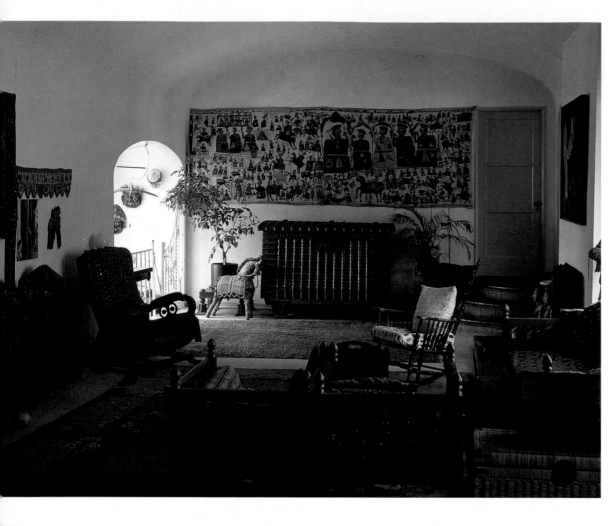

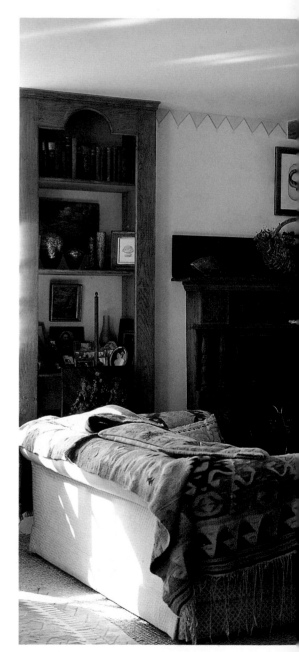

(Below) In this English country house textiles, carvings and metal sculptures from East and West coexist happily. Sofas are decorated with *Anatolian* kilims, the coffee table is set with wooden and bronze figures and bowls from *Afghanistan* and *Indonesia*, while the *European* needlepoint vies for attention with the cushions covered with *Indian* embroideries.

(Above) Not many walls are large enough for a Pabuji par – a vast scroll from Rajasthan that tells the story of the legendary hero Pabuji. The metal-clad chest, a 'pataro', is a common sight in the 'havelis', the country houses of Gujarat, and the Indian embroidery-covered horse results from an imaginative idea of the designer Charles Eames, who reasoned that traditional sewing skills could be supported by the marketing of such toys upholstered to suit Western taste.

(Left) From their barred outlook on to the farmyard, a pride of big cats from *Africa, India* and *England* snarl and pant in the heat of the late summer sun.

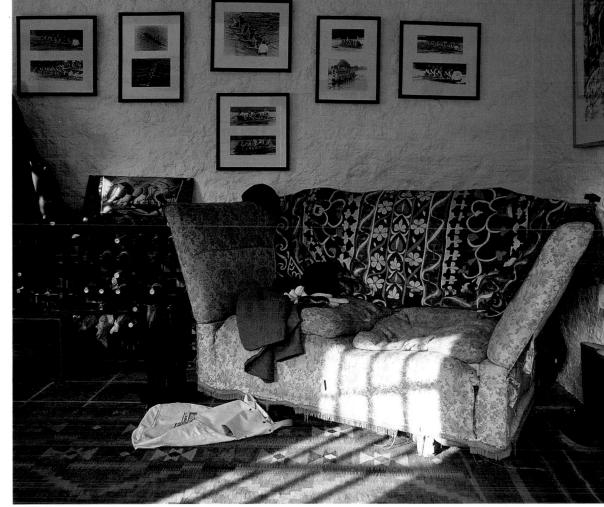

(Above) Once the pride of a drawing room, this Knoll sofa now serves as a luxurious dog bed and is gaily backed by an appliquéd ox-cover from India. The tin painted panel is a cycle decoration from the city of tricycles, Dacca.

(Right) Two painted Indian figures from Rajasthan guard over a Wellington chest in a spare bedroom. The kilim fragment that has been made into a colourful seat cushion comes from Turkey.

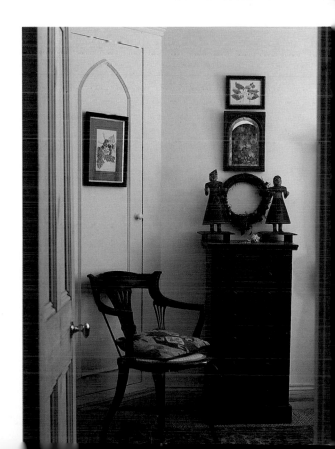

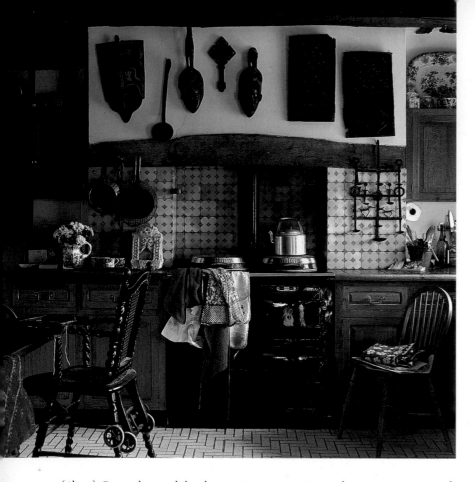

(Above and below) A Mexican kitchen table, set for refreshments at the end of the day. The chest was made by the Chimula Indians to store their ceremonial clothes, and the candlestick depicts a parochial Oaxacan devil grimacing at the bitter-sharp tastes at his feet.

(Above) Grouped around the glowing *Aga* stove are sixteenth-century pew-seat ends from *England*, masks from *West Africa*, an iron ladle from *Afghanistan*, an oil-lamp frame as well as textiles and a stone house shrine from the *Indian* subcontinent. (Opposite) The interior of a restored sixteenth-century merchant's house is subtly enhanced with an *Anatolian* textile. From that time onwards, Turkish and Syrian textiles were much in demand by the ascendant merchant classes of Europe. (Below) Turbans and tent bands are difficult to display; on a bedroom window-sill are provocative glimpses of the dazzling colours and patterns within. Glass from *Afghanistan* and a tapa-beater of palmwood from *Polynesia* complete this exotic scene.

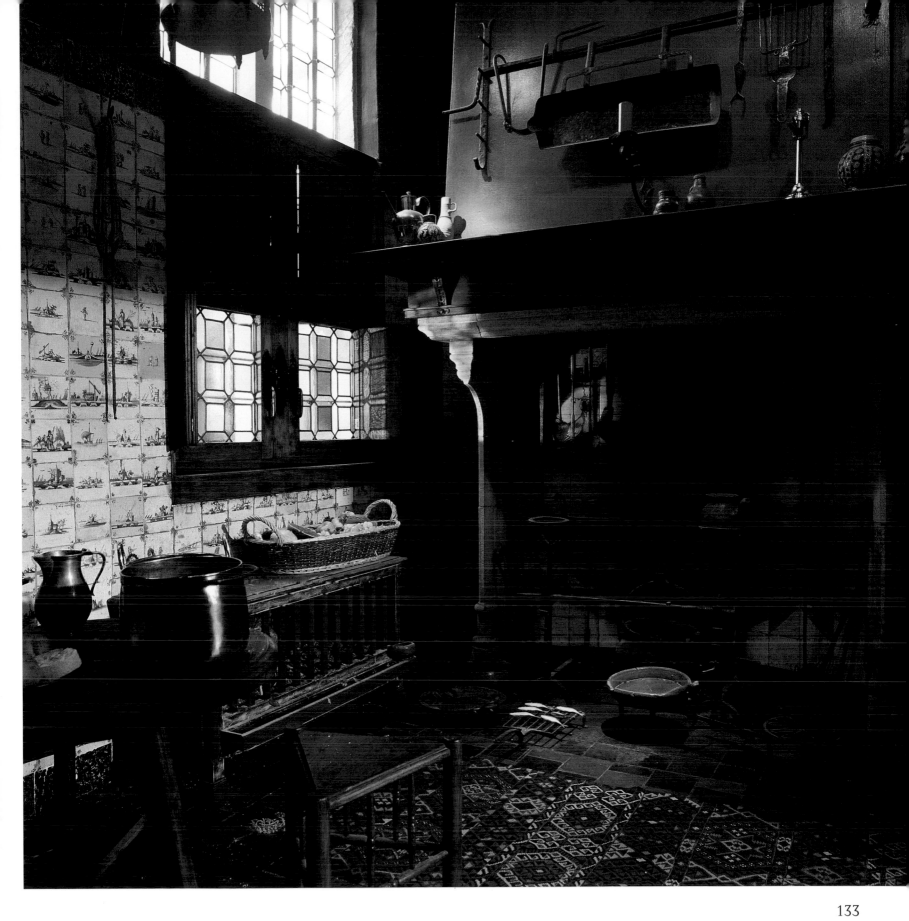

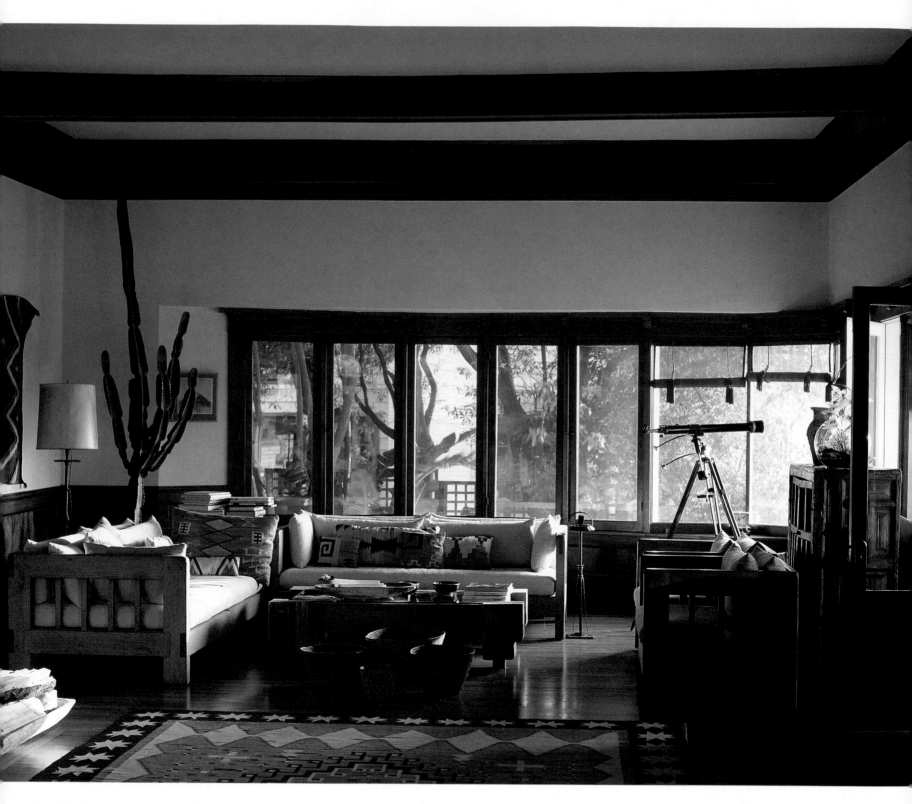

(Above) Navajo rugs and Pueblo Indian baskets add a perfect balance of tribal pattern and colour to this well-lit living room overlooking the Pacific Ocean.

(Opposite) A cool and comfortable room of a house in the central southern highlands of Mexico. The decorations within reflect the skilled handiwork of the local

Indians: a naturally dyed skirt length of Mixtec origin runs along the back of a sofa and a cushion is covered by cloth woven of undyed cotton.

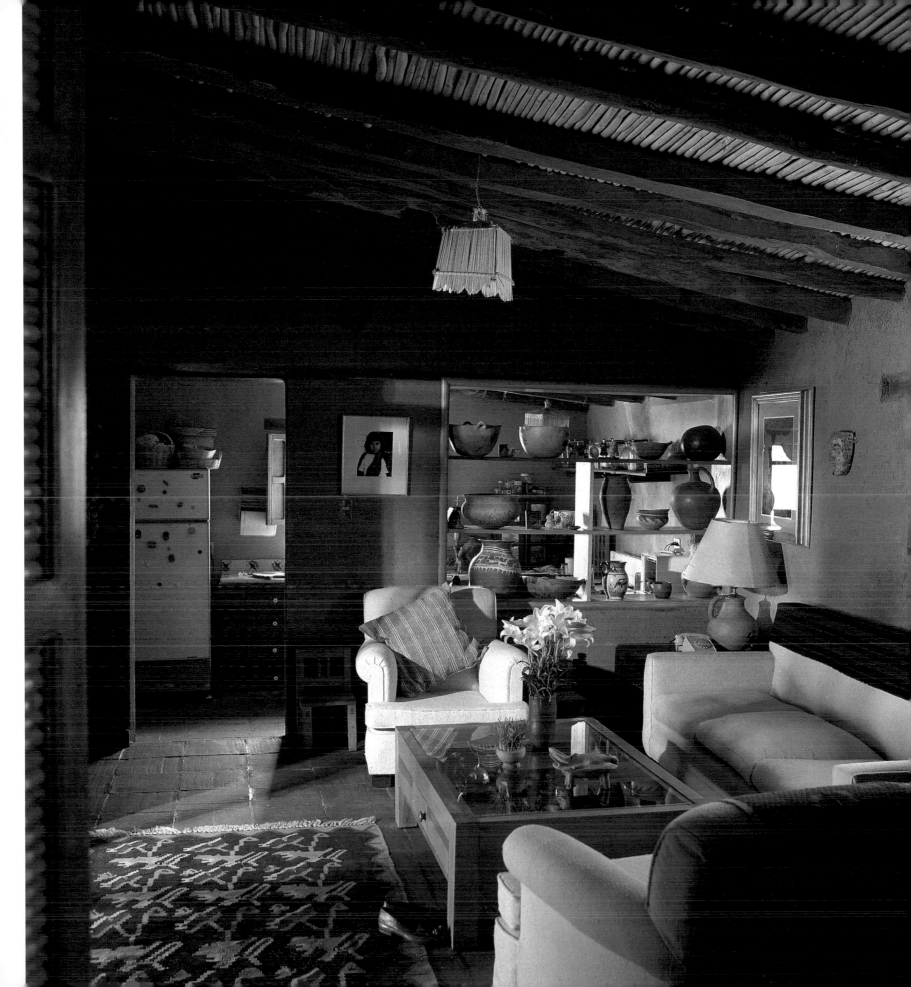

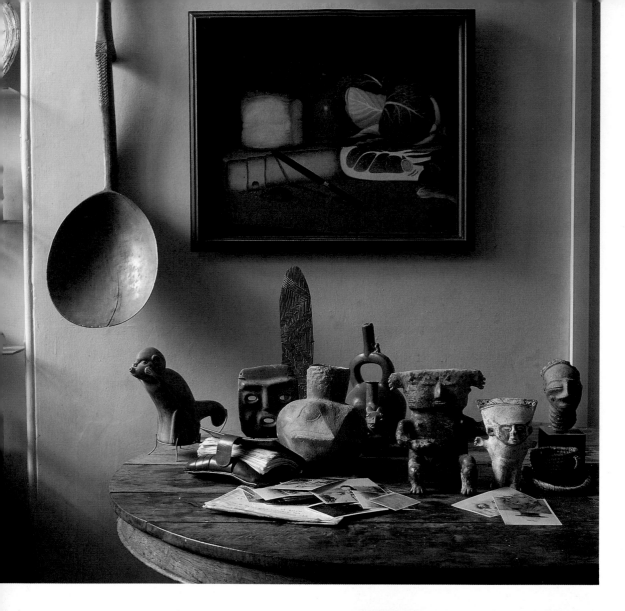

(Opposite) This room, once a New Mexican chapel, still retains its sepulchral feel. The Pueblo Indian storage jar is a reminder of the past skills of the indigen potter, partly lost when overwhelmed by the forces of acculturation.

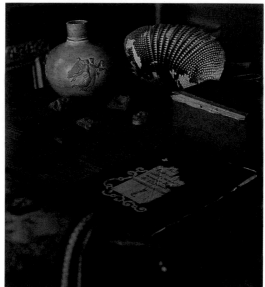

(Above) A scenario found in few kitchens: 'primitive' treasures are arrayed beneath an English Primitivist painting; masks, figures and animals of all forms are of pre-Columbian origin whereas the dark stele, a 'charinga', is as unassuming as its *Australian Aborigine* maker.

(Above and left) On a studio desktop the collectables of an artist are carefully arranged for maximum effect. Pueblo Indian books of sacred prayers and the shell of an armadillo lie among the archaeological trinkets from Mayan and Greek tombs.

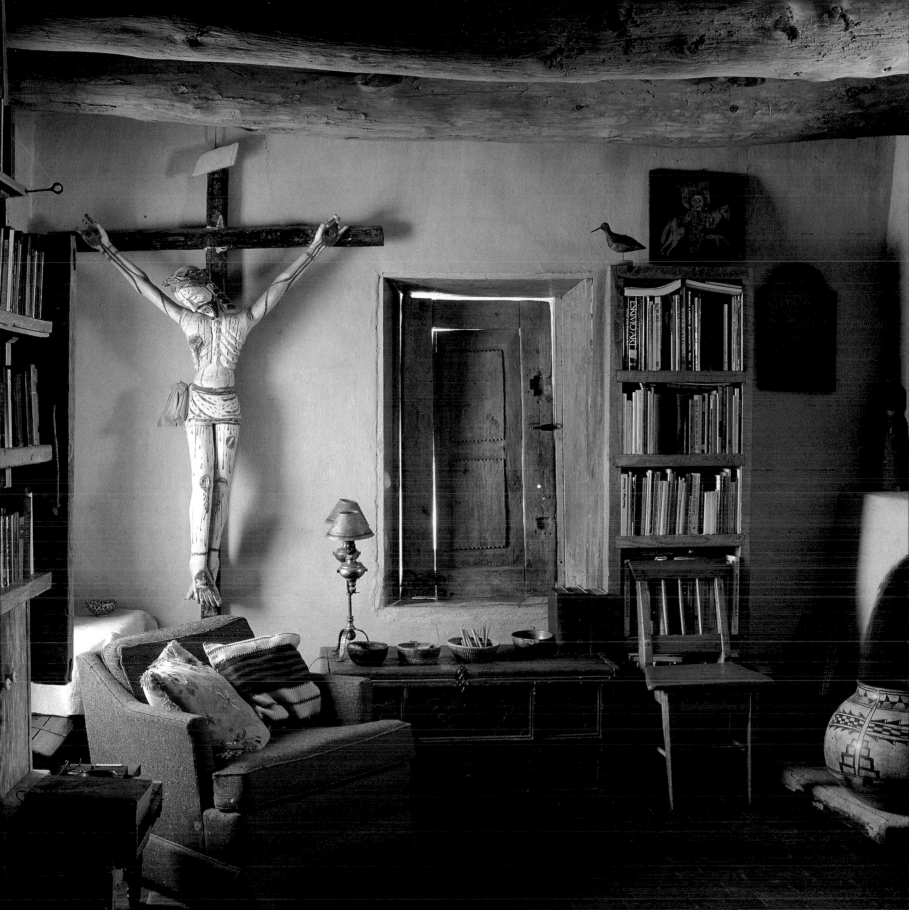

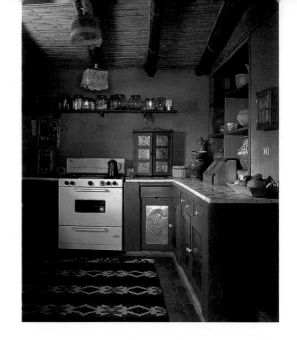

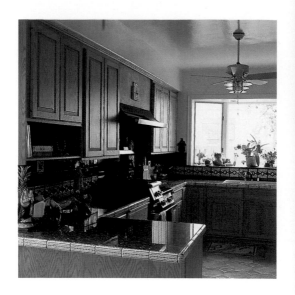

The kitchen is a suitable home for an inexpensive and cheerful rug, and here a Teotitlan flat-weave (left) looks good on the terracotta floor. (Below) Strong kilims from *Afghanistan* are also ideal and this example from Labijar in the north of the country lies on rubberized underlay for comfort, safety and for its own protection.

(Above and below) The clean, architectural lines of this beautifully finished kitchen are softened by a collection of Mexican ceramic and wooden folk art – on the shining marble worksurface mermaids swim amidst Madonnas and angels.

(Opposite) A turn-of-the-century American wood stove warms a peaceful companion, while at the top of a Pueblo Indian ladder sits a pair of Navajo fire-dance hats, worn in simulation of that evocative beast of the plains, the buffalo.

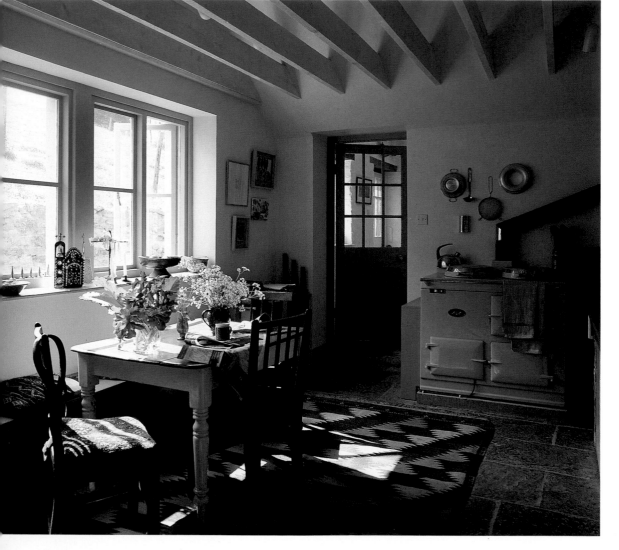

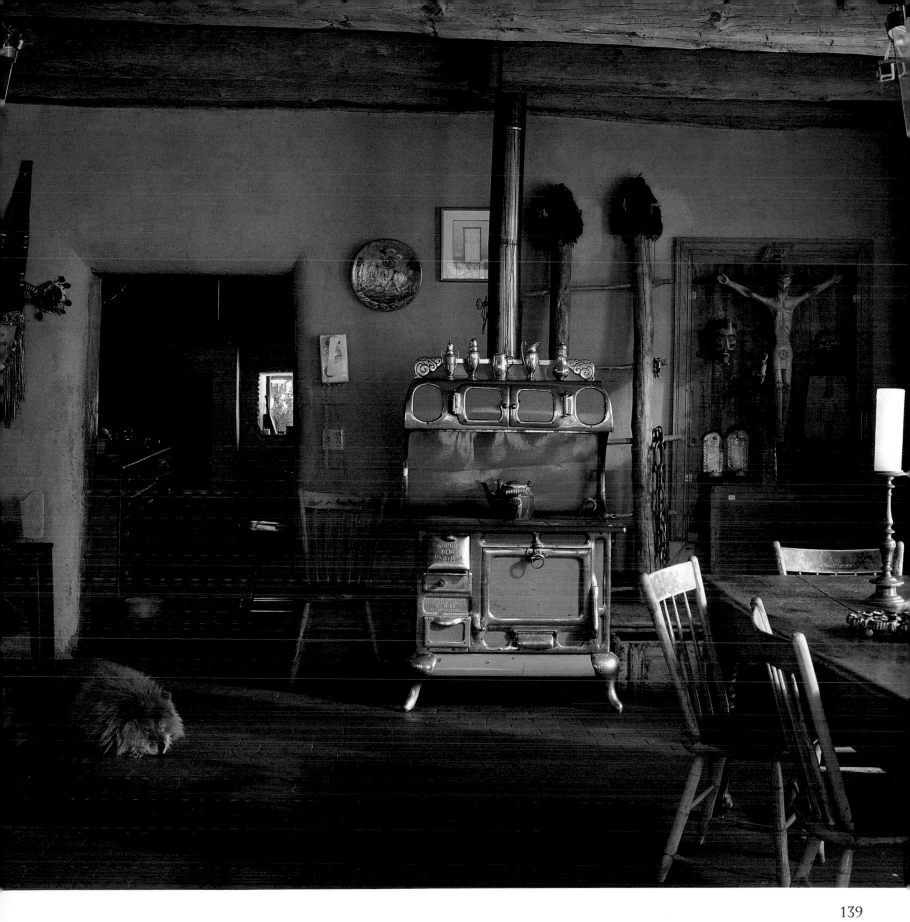

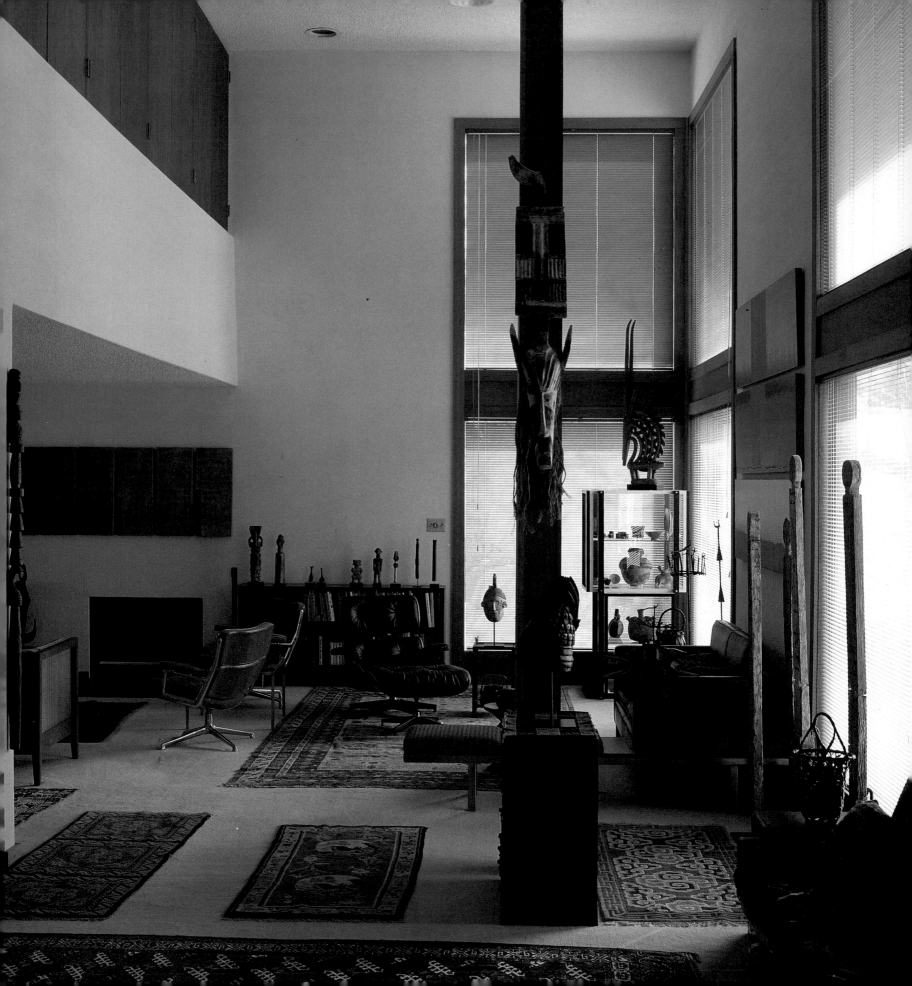

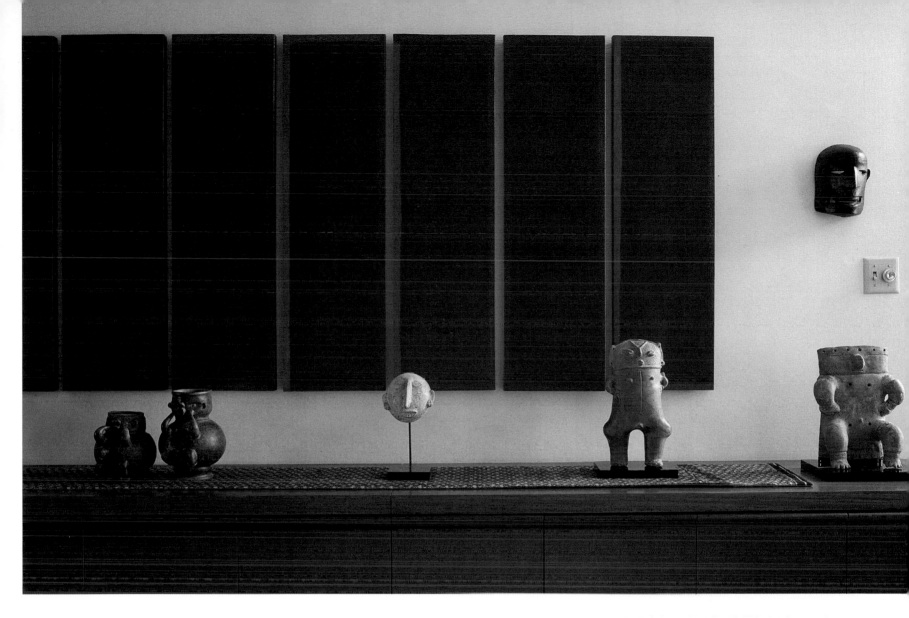

(Opposite) The generous ceiling heights of new houses in America and the controllable flood of natural lighting help to create an ideal living and display area. The strong impact of African sculptural art is particularly effective in this very Western environment. A woman's head-mask of the Bundu clan of Sierra Leone stands on a pedestal in the foreground, a buckish Bambara head-decoration on a cabinet in the distance.

(Above) An extraordinary selection of pre-Columbian pottery vessels and figures from Central and South America grace this sideboard covered with a Berber flat-weave.

(Right) Simple furniture and furnishings mix well with powerful sculpture. Adjacent to a framed Kuba raffia-pile cloth is a magnificently ornate West African Yoruba house post.

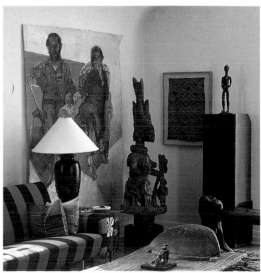

141

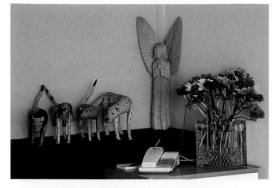

The office in the home of a film producer is dominated by a selection of carved wood and papier-mâché figures from Mexico. Second only to the craftsmen of the Indian subcontinent in sheer quantity of output, the makers of Mexican folk art are inspired by the cross-fertilization allowed between religious and festival art and personal creativity, and motivated by the thriving tourist market there. In this study, papier-mâché Day-of-the-Dead skeletons mingle with dragons, carved wood snakes and mythical beasts.

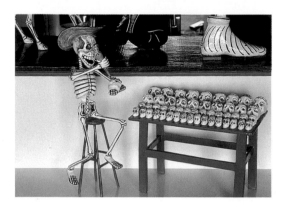

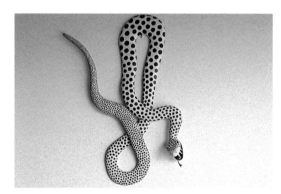

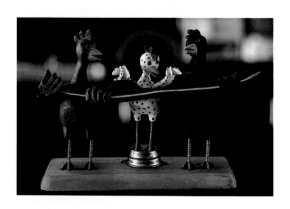

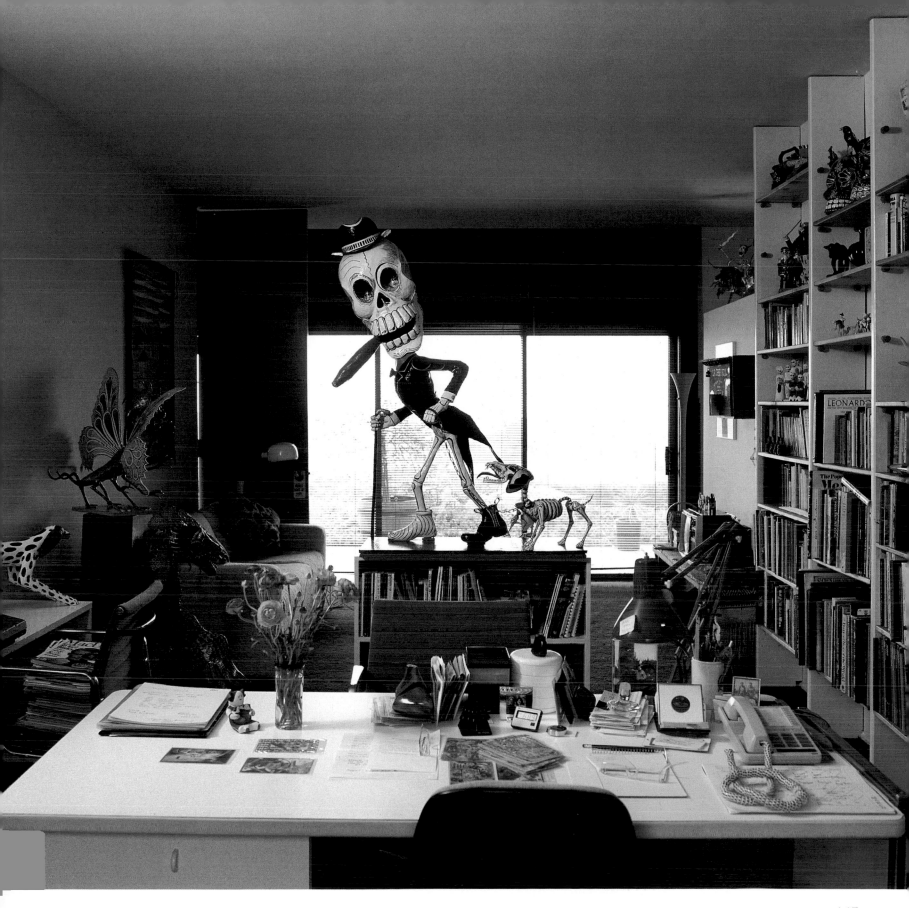

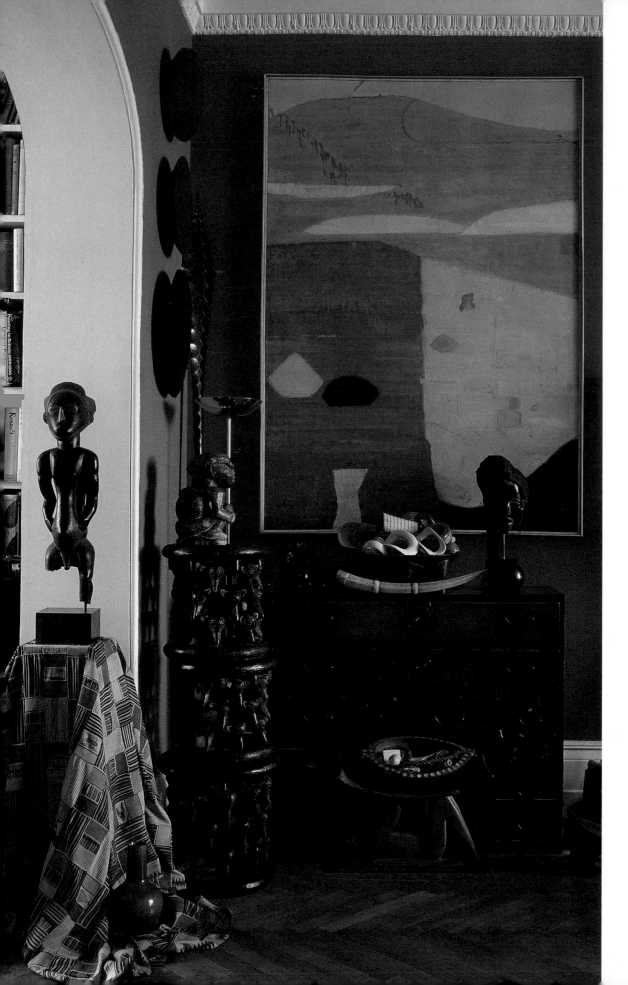

(Left) Cloth draped over a pedestal softens the look of this austere African sculpture. A Luba-hemba ancestor figure stands on an Ewe strip-woven cloth, and stacked to the side is a trio of stools from the Cameroon grasslands forming a tower of carved bats' heads. The rufous discs on the wall are none other than the outlandish head-gear of married Zulu women.

(Opposite) The view from a colonial house over the town of San Cristobal de las Casas, Chiapas State, home of the Lacandón Indians. Their livelihood has never been subjugated by European military supremacy, but rather by the more insidious effects of extensive logging and inevitable acculturation.

(Below) This is the country studio and workshop of a batik artist who revels in collecting textiles from all over the world that share a harmonious balance of soft, clear colours. Scattered on the sofas and the seats of the chairs are many appliquéd and embroidered Indian cushion covers, and on the floor is spread a subtle 'eye-dazzler' kilim from Anatolia.

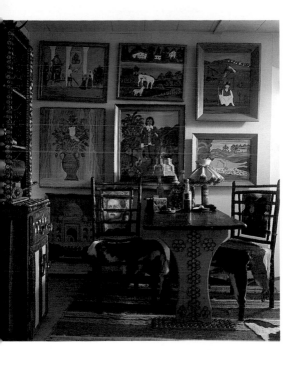

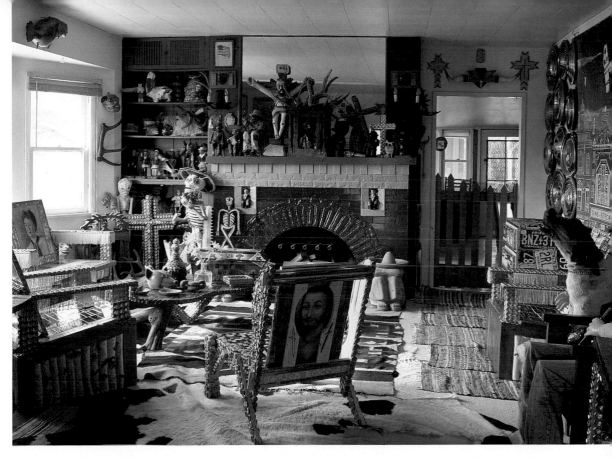

Fired by many journeys to Guatemala and Mexico, a maker of folkish furniture has decorated this Los Angeles bungalow in a wild and individual style. Mexican dance masks grotesquely leer at papier-mâché skulls and skeletons from Mexico City. Furniture decked with coffee tins and number plates stands before a Guatemalan photographer's backdrop of a Mexico City scene, proving that the idea is often more pleasing than the actuality.

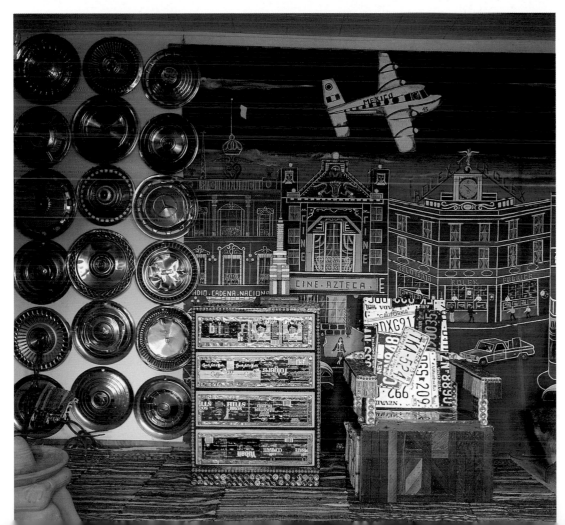

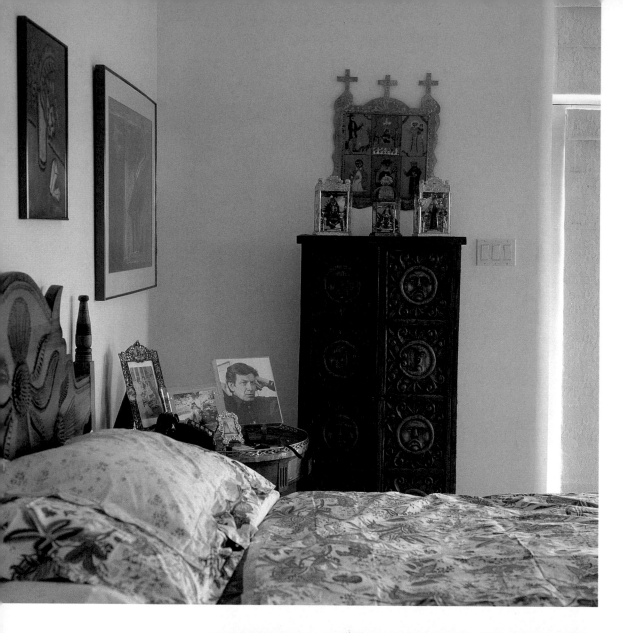

(Left) Solar and lunar faces in a grumpy mood greet the awakening guest; loftier thoughts may be evoked by the trio of tin-encased Virgins of Guadalupe from Oaxaca.

(Opposite) Tucked away in the corner of a bedroom is one of the more elemental artforms of the Mexican Indians: astride a cupboard, enclosed by two Mayan Indian men's blankets sewn together, kneels a Mixtec birth goddess.

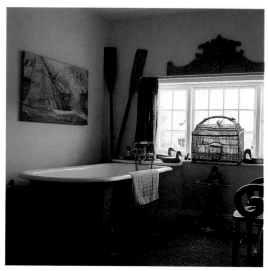

(Above) Over the nautical umbrella-stand that commemorates the victory at Trafalgar rests a Philippino bird-cage complete with silent canaries. Wooden ducks from England and a brass child's toy from India complete this ornithological scene.

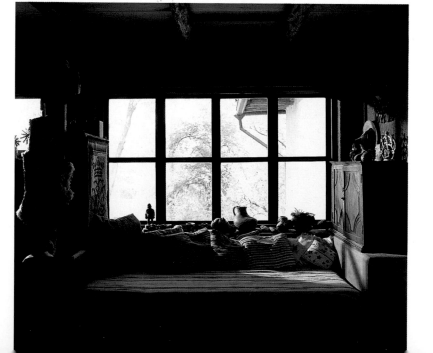

(Left) Pottery of the Lacandón Indians lines the window-sill behind this comfortable setting of tortilla-bag cushions; from this seat the view of the tropical garden complete with exotic flowers and dipping humming birds will be remembered forever.

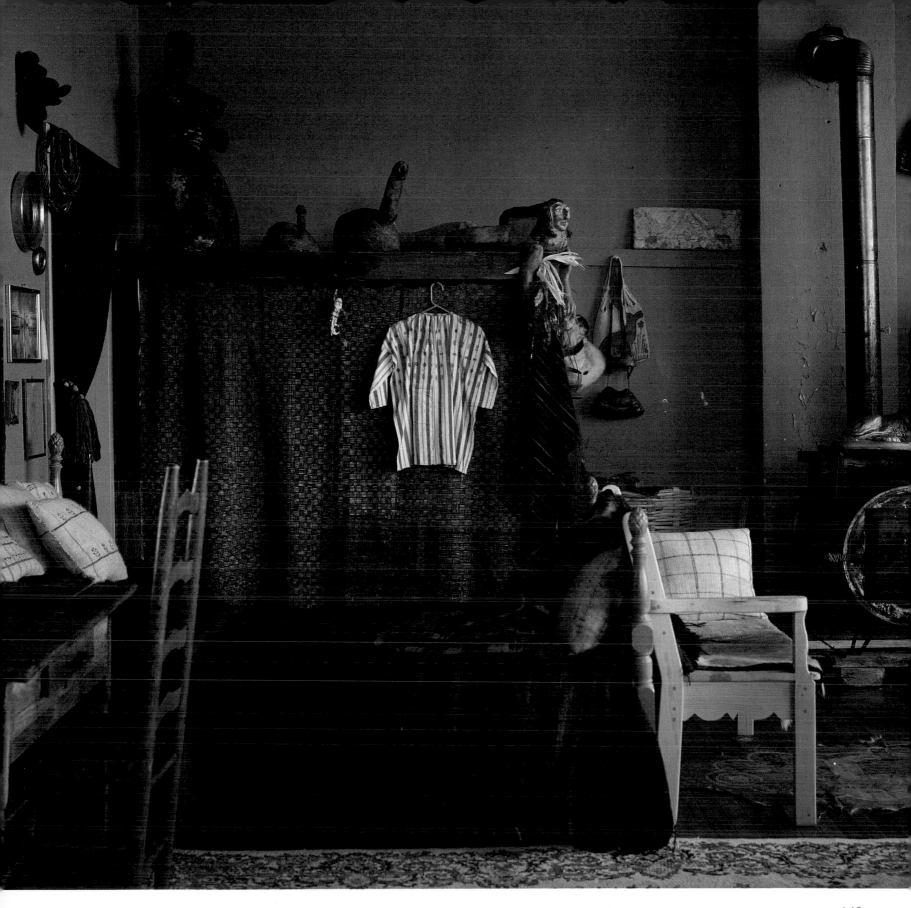

(Right) The versatile kilim may be found in combinations of colour and pattern to match any mood or style. A thoroughly unusual idea is found on the sofa, where Guatemalan embroidered waistcoats have been mounted as cushion covers.

(Below) The entrance to many an adobe home of Sante Fe is trimmed with hangings of firey-red chilli 'ristras', here in the company of two figures from New Mexico.

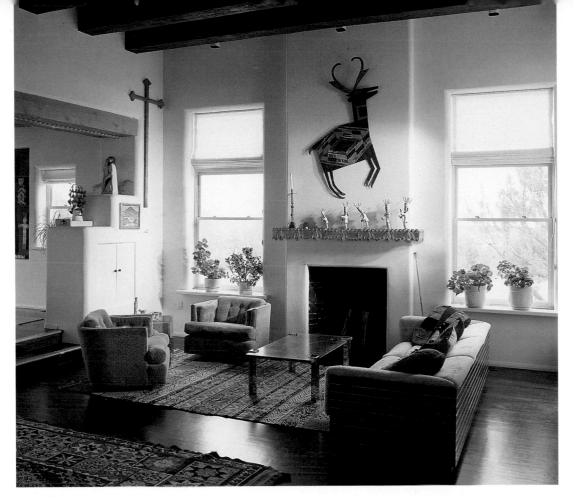

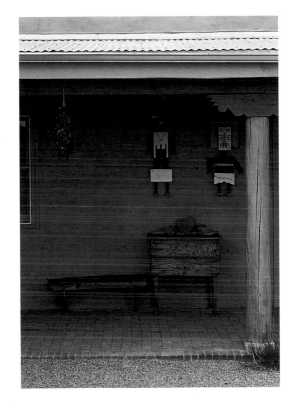

(Opposite and right) The distressed furniture and architectural fittings of the Spanish colonial era are the ideal companions for a clutter of folk and tribal art. Look for the hanging Crow Indian quirt that would fire up any sleepy pony and marvel at the form of Navajo bone weaving-combs set on miniature pedestals.

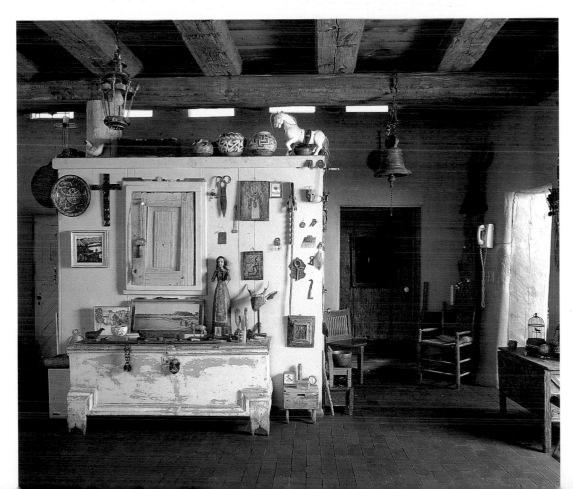

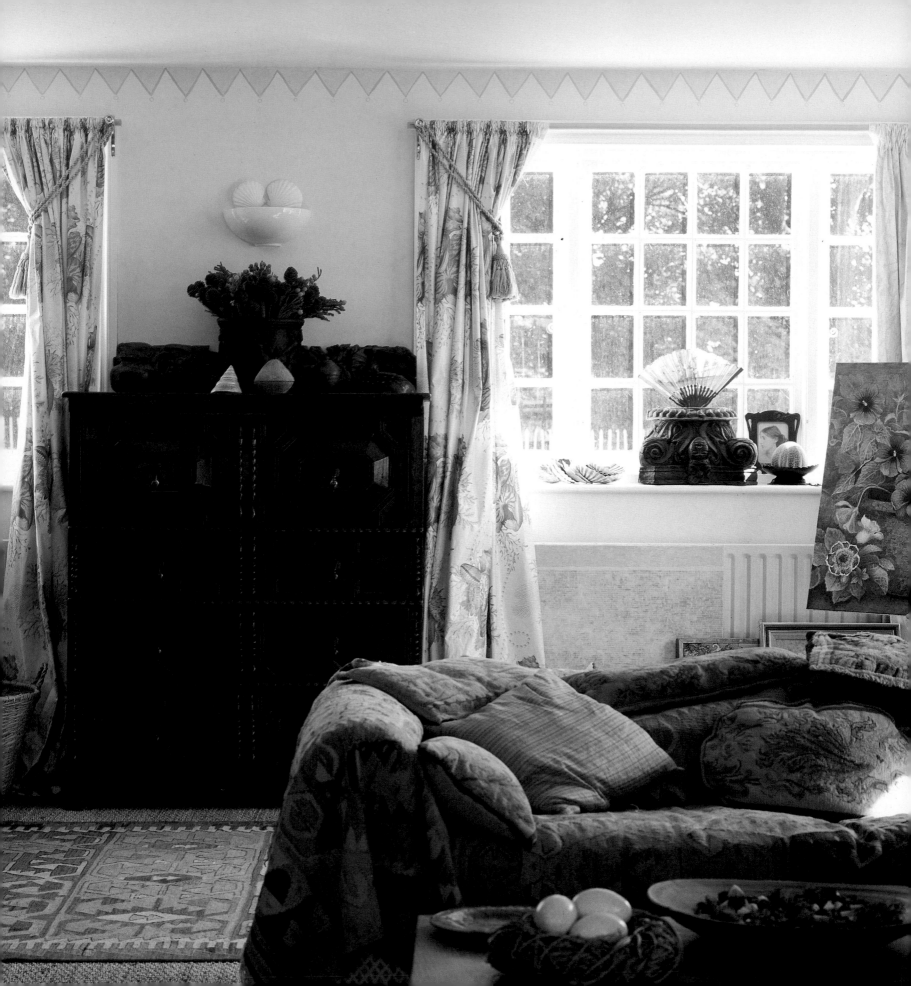

Chapter Five

At Home Today – Using Tribal and Folk Art

Most carvings, ceramics or textiles made outside Western society were intended for a traditional and particular use, but often the purpose of an object, which would usually have determined its shape, and the significance of its decoration, have been obscured by time; in many cases lack of documentary evidence further confounds the issue. Sometimes, however, the original role of a particular item – a flat-woven prayer mat or low wooden prayer platform of Muslim Central Asia, for example – is obvious. Both textile and carving balance utility and aesthetic sensitivity with a simplicity that is so refreshing in a modern world where function, form and decoration have been manipulated and confused by fashion and industry, and driven down a path of endless obsolescence and further consumption. Although a Western interior strips ethnic artifacts of their original context, they can still be functional within the home, especially as covers, supports, or containers. What follows is a summary of the various types of flat-woven floor rugs available, a range of ideas for the use of carved wood as architectural fittings and a brief outline of some possible uses for original furniture. Textiles as furnishings are also discussed, as well as an assortment of useful containers, vessels and pots.

Floor Rugs

Flat-woven textiles that are tough enough for the floor originate in the lands of the cotton growers and the sheep and cameloid herders. From the High Pamirs to the Andes, flat-weave rugs are woven both to ancient and more recent traditions. The high plateau encampments of the Central Asian nomads are thought to be one of the original centres of weaving, where the custom has been maintained by their descendants and associated tribes of Afghanistan, Iran and Anatolia to this day. Whereas kilim production is very old in origin, the floor-rug manufacture of the indigenous tribes of North and South America is a nineteenth century phenomenon, inspired by the

(Opposite) In a living room rich with the colour and texture of Turkish flat-weaves, a seventeenth-century chest supports a collection of English, Indonesian and Indian carvings. On the window-sill, a Rajasthani wooden capitol is the sturdy base for an elegant Chinese fan.

market demands of the consumer, especially the tourist. What follows is a consideration of the sizes and shapes, as well as colours and patterns, of the various types of flat-weaves available, and the best places to display them within different areas of the house.

All kilims and flat-weaves are suitable for the floor as long as one is aware of how hardwearing they are, their degree of colour-fastness and the need to prevent the rugs from slipping and sliding underfoot. Advice on how to clean and prolong the life of a rug, and how to secure it on all types of floor surfaces, is given in Chapter Six.

Size and Shape The largest flat-weaves are undoubtedly the cotton and woollen rugs of Afghanistan and northern India. 'Jail' dhurries commissioned for the palaces of the maharajas of Rajasthan are commonly over twenty feet in length, and the wedding kilims of the Uzbek weavers in the vicinity of Maimana are praised far and wide for their awesome size. Far too large for the rooms of a village house within the foothills of the Hindu Kush, such rugs, fit for a palace, signify wealth and are laid outside on the earth within a shady mulberry grove. These rugs welcome distinguished guests, are displayed at festivals and ceremonies or spread on the roof of a house for the comfort of those enjoying the cool of a night breeze.

Those seeking a custom-made flat-weave of a particular size should look to the dhurrie production of the Indian subcontinent, kilims from Anatolia and flat-woven rugs from Mexico. The weavers take their inspiration from patterns and diagrams drawn up in the design studios of the West, tempering their work to the requirements of local merchants who demand approximate copies of bestselling flat-weaves the world over. It comes as no surprise, therefore, to learn that there are kilims woven by the Kurds of eastern Anatolia that emulate the colours and designs of Thracian textiles from the Mediterranean coastal lands to the west. Dhurries woven to resemble kilims, Navajo blankets and even abstract modern European paintings are common; the weavers of Oaxaca, Mexico, also make fine copies of American Indian rugs of the nineteenth century. Flat-weaves less than nine feet in length are commonly found throughout weaving communities world-wide and all rugs tend to be rectangular in shape for ease of construction on the loom. Square kilims are found in Afghanistan and Khorasan, Iran, from the eight-by-eight-feet Maimana work to the four-feet-square (or sometimes less) rukorsis of the Afshar and Balouch tribespeoples.

Colour and Pattern The visual impact of a textile hung on the wall will be much stronger than that of a floor rug or carpet, proved by the fact that some flat-weaves that look very fine on the wall may seem inconsequential when laid on the floor. The patterns and colours of some compositions need to be seen at right angles to be truly appreciated. This is especially true of rugs with

Raffia cloth of the Shoowa tribe from the Karai river, Zaire

a central motif or motifs, and a formal arrangement of borders. 'Eye-dazzler' Navajo rugs, Herati medallion Senna kilims and Kurdish Malatya kilims from Anatolia are all brightly coloured and patterned and will make a fine centrepiece for a floor.

Flat-weaves with bands of patterning will tend to blend in and look good on most floor surfaces. With no central pattern to catch the eye, these banded textiles are visually soothing. Such textiles are said to have 'movement'. The hanbels of North Africa, the strip-weaves of Iran and Afghanistan, old rugs and blankets from the Navajo and the kilims of the Caucasus as well as the Balouch of Central Asia all tend to display this quality, and blend well with all sorts of decorative schemes, regardless of the strength of their colour.

Flat-weavers of the Islamic world are renowned for their mastery of geometric design, creating attractive combinations of seemingly abstract and ornamental compositions. Nomads on the fringes of the Muslim world often decorate their weaves with folkish representations of animals such as goats and camels as well as flags and groups of people. More well known of late are the rugs of Afghanistan and Pakistan bearing their disturbing images

of the paraphernalia of bitter guerilla warfare. No doubt these will become prized collectors' pieces and a historic expression of this era.

Figurative designs are less common in flat-weaves, no matter what the religious sentiments of the weavers may be. The flat-weaving technique results in stepped patterns of diagonals or straight lines and makes it hard to reproduce the curves of nature. For woven representations of animals and birds, there are the modern weaves of the Americas and the dhurrie work of India. The weavers of Iranian Kurdistan manage to turn curves and bend the rules with their intensely floral kilims that are more akin to the tapestries of the seventeenth-century court workshops from which they take their inspiration.

Durability　A flat-woven rug will survive well on the floor if one takes into account how it was originally made, its age, the amount of wear already received, and the type of underlay needed, before deciding its ultimate destination. Old rugs, or rugs that have endured a hard life in their country of origin, should be treated with respect and laid to retire in a quiet corner of a bedroom or study. By contrast, some of the tightly woven woollen rugs of north-west Afghanistan can take a good deal of abuse under tables or on hallway floors. A fair idea of the durability of a flat-weave can be gleaned by simply feeling its texture and by holding the material up to the light to check for slit-weave work, and to spot areas of weakness and holes.

Placing furniture on a robust kilim is not a problem in itself, but the harsh movement of chair legs or the constant weight of a heavy item damages a rug. It is obviously not wise to lay a prize textile under a dining table; guests are often not as appreciative as an owner. Flat-weaves under cabinets, chests or tables that tend to remain undisturbed should have the weight on them moved regularly to spread the wear, and plastic or wooden cups should be used under castors or the feet of the furniture. If your dining room is badly in need of a rug to lie under the table, only the strongest kilims and dhurries should be considered. The rug should be large enough to take the table and the movements of the diners and their chairs without the selvedge or fringe being repeatedly caught. It cannot be stressed too much that a thorough examination of a rug at least once a year, perhaps by giving the textile a good shake or a beating outside, should warn of any need of repair or change of location to a quieter area where the potential wear and tear is reduced.

The least used and most private rooms in the home are normally the bedroom and the study. The bedroom is perfect for the enjoyment and preservation of flat-woven rugs. The softest weaves may be used as bed-covers, and small kilims, tent runners or prayer mats may be laid at the foot of a bed, or if a pair, each side of the bed. Within the very personal world of a study, the rugs most appreciated by their owner can be spread on the floor without fear of offending anyone else's taste.

The bathroom, kitchen, playroom, dining room, living room and hallway are all much-used areas that will be made more comfortable, welcome and interesting when a strongly individual and hard-wearing flat-weave is laid on the floor. The bathroom and kitchen are areas where the least valuable flat-weaves should be used, because of the inevitable spillage of liquids. The damp atmosphere of a bathroom also cautions the use of all but the most robust and colour-fast weaves that even then must be aired and dried with regularity.

The kitchen is often the most lived-in area of the house and any flat-weave rug on the floor must withstand daily punishment. For safety's sake, the rug must lie flat and be secured by some form of underlay. Likewise the hallway, which will have to endure a stream of foot traffic from outdoors; here, too, a flat-weave will need to be colour-fast and strong. To prolong the life and colours of the weave it is best to have the rug stain-proofed by a proprietary product; spills and dirt are then more easy to remove. The upstairs landing is the best place for a rug, and this is one of the few areas of a house where valuable flat-weaves may be placed on the floor for many to enjoy.

Within a child's playroom, a flat-weave must be strong, yet comfortable enough to romp around on. Underlay is therefore essential on all but a carpeted floor surface, the colours must be fast and the rug is – naturally – best selected for its bright and amusing patterns and cheapness rather than as a long-term collectable.

Architectural Fittings

From the Indian subcontinent and Afghanistan comes a wealth of wooden architectural fittings that have been collected from the villages of the Hindu Kush and the fringes of the Thar desert. The areas of Nuristan, Swat and Rajasthan have a well-developed tradition of wood carving, crafting house posts, beams, doors, shutters and screens. For many, a complete carved mountain-oak 'jali' window or a triple archway from a mosque some twenty feet long would be impossible to place; more readily assimilated for most of us are humble accessories, such as small beams, shutters and doorways. Shutters and window frames may be imaginatively used to open on to or hold in place mirrored glass.

Those about to rebuild or extend their home and who are able to work with a tolerant and friendly builder will have the opportunity to incorporate carved wood in parts of the new structure. The lintel of a fireplace or alcove for a stove can be made with a Rajasthani carved house beam, and an elaborately worked wooden upright from a Nuristani dwelling looks most striking when set into a wall, seemingly to support a ceiling or cross beam. A most unusual idea takes its inspiration from the doorways of northern India. There, a 'gokh' (a small shrine made of soft stone) is set into the wall on

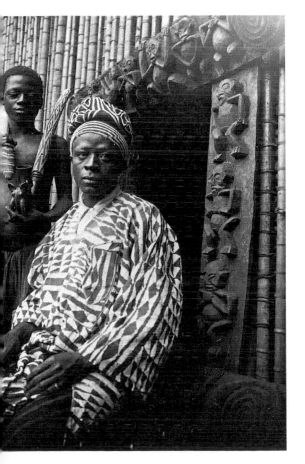

The chief of the Basoa tribe, c. 1925. The doorway behind him represents the sorrows of the population before the consolidation of the chiefdom

157

either side of the main entrance. Such a shrine can be embedded in a wall of a Western-style house, forming a miniature alcove for a flickering candle. For the more adventurous, a gokh can be let into an external wall to make space for a small fountain or to accommodate a bell-pull.

Furniture and Furnishings

Only the elite of tribal and folk societies who have time for rest and relaxation, or who have the personal space, can afford the luxury of furniture. In Nuristan and the kingdom of Swat the low carved wooden chairs are made that are surprisingly comfortable to sit on cross-legged. Beds from the same region and from northern Hindustan include rope-bound, wooden-framed 'charpoys', solid wood swinging platforms suspended from the ceiling by delightfully patterned wrought or cast links and chains of iron or brass. Rajasthan still produces much wooden furniture, and original iron-barred and jali-work windows are often found mounted horizontally on new legs to make coffee tables. The more traditional low tables are less convenient, but suitable, perhaps, for a bedroom, or any minimalist decorative setting. The chests make ideal storage units, especially for a jumble of children's toys or a collection of textiles preserved in a fragrant atmosphere of mothballs. Small upright chests and cabinets from north-west India, often painted with floral imagery or scenes from Mughal times, are useful as jewelry cabinets or many-drawered units for spices in the kitchen. From West Africa there are found chiefs' head-rests, stools and low beds, with a built-in ridge of wood as a pillow. Such beds, naturally, make fine coffee tables.

The lands that have endured colonial subjugation were once home to many Europeans who inspired or commissioned the manufacture of furniture to suit their alien style of life. Made by the local carpenters and craftsmen, such furniture is quite obviously a crossover of Western and tribal or folk influences. From the Spanish colonies of Central and South America there are the much-sought-after beds and bedheads, cupboards, formal dining tables and chairs that have a strange Iberian flavour which is tempered with the handiwork of a native craftsman, whose own pedigree would have been rooted in an ancient culture such as the Olmec or Paracas.

Indian European-style furniture has a very British feel and is often of a robust nineteenth-century pattern; more interesting is the carpentry of the south-western coastal towns and especially of the erstwhile Portuguese enclaves such as Goa, Damman and Diu as well as the old ports of Cochin and Trivandurum. The warm climate and the genteel lifestyle of the expatriates of the past are reflected in the architecture of the spacious low houses and in their cane furniture, planters' reclining chairs, four-poster beds and dining chairs with rattan seats. The Dutch East Indies colonials generated a similar style of furniture with a definite feel of the Low Countries.

Wooden sea-swallow canoe decoration carved by Truk Islanders

Textiles of the tribal and folk world are often ideal furnishing fabrics. Some weaves may be used with no more than minor modifications. Small bags and pockets may be stuffed with a pad to use as a cushion. Larger grain storage sacks, animal pannier-bags and tent hangings may be draped over a banister and used as a laundry bag or to store unused clothing. A feather or foam pad stuffed inside creates a striking and comfortable floor cushion. Textiles can also be used as upholstery, although this often necessitates drastic modifications to their original structure, more often than not a complete dismembering. Whatever one's convictions as regards this controversial issue, the covering of chairs, boxes, stools and seats with tribal textiles as fitted upholstery can be effective and as in times past, such practice ensures the survival of these fragments. (Most of the scraps of old and antique tribal weaves preserved in Europe and North America endured by virtue of their use as fitted upholstery.) Textiles need not always be cut to make upholstery. A scruffy living-room chair will be improved by draping a soft yet strong flat-weave or textile over the entire piece. In order to prevent it riding off, the loose-fitting cloth will have to more-than-envelop the structure, and must be strong enough to withstand the impact and weight of the seated. The best use for less robust textiles, such as Indian appliqués, fine Anatolian kilims or Kashmir shawls, Navajo blankets and Aymara mantles, is as modern antimacassars, laid over the back of a sofa or chair.

Neck rest from Santa Cruz Island

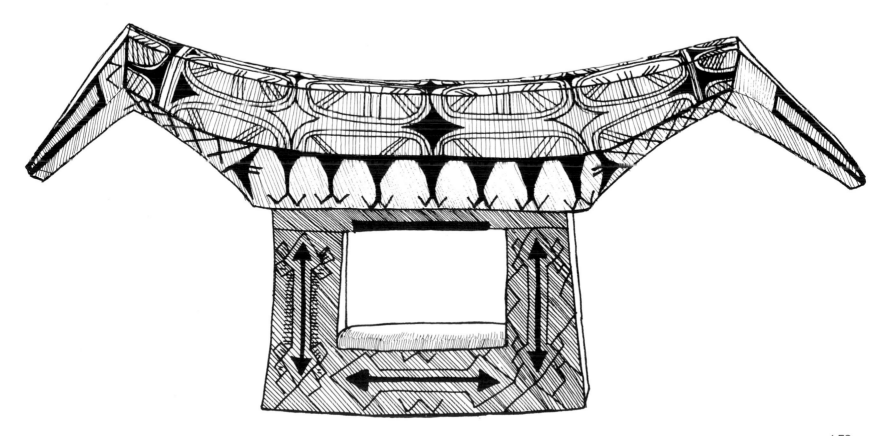

159

The folk cultures of India and Central America are prolific sources of traditional cloths and old- and new-style yardage that will serve very adequately as furniture covers throughout the house. From India the large appliqués of the north-west that are there used as ceiling decorations, wedding canopies and animal covers make ideal bedcovers, as well as bedside tablecloths. Small hangings from the same region such as 'chaklas' and 'torans' make useful covers for objects as diverse as a computer printer and curtain pelmet. Clothing and furnishing yardage from the Indian subcontinent and the Americas may be cut to make tablecloths and napkins as well as fitted furniture fabric, and amongst others, the weavers of Andhra Pradesh and Guatemala have entered this new furnishing market by successfully copying and adapting their own ikat designs, and others from sources as distant as Tashkent and Japan, to create the most pleasing cotton covering material.

Accessories

The usefulness of small baskets, ceramic and wooden bowls and plates, earthenware pots and jars as well as utensils for cooking is limited only by the scope of an individual's imagination. When travelling in remote lands, it is always with these most useful yet least transportable implements that one seeks to return. Huge earthenware jars with their bellies full of cooling water, market baskets stirring with a load of fowl, simple palm-leaf brushes fragrant with sap, tin toys too sharp for children's small fingers, tapa-beating clubs of palmwood from Polynesia, Andean combs of dried teasel heads for raising the nap on cloth and wooden spikes for piercing the nose of a camel – this is the flavour of marketplace paraphernalia. More portable and often available in the West are the fripperies of folk and tribal cultures such as tin-painted Christmas-tree decorations, Day-of-the-Dead skeletons to hang on the car rear-view mirror, and picture frames, all from Oaxaca, Mexico. From Central America there are the pottery candlesticks and candelabras, ceramic pots and bowls of every size. Bali is well-known for its softwood brightly painted mirror and picture frames and for its figurative and animal-shaped containers. From elsewhere in the same archipelago come the betel-nut cutters and baskets of every size and description that are useful for storing foodstuffs or even laundry. From India there are the opium-pouring bowls, opium retort stands that make striking candle-holders and for those with a well or pond, or for the more energetically minded, wooden laundry beaters. The wooden platters and containers from the region are well known – the paraths, spice boxes, make-up containers, chapati rolling boards and pins are usually found in Gujarat and Rajasthan and from Swat and Afghanistan there are the highly scented ghee vessels and a range of exquisite blue glassware made in Herat.

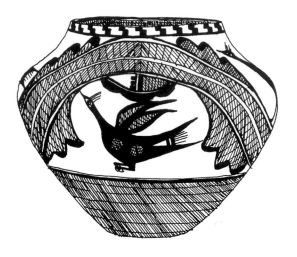

'Olla' made by the Zia Indians of New Mexico

(Opposite) *India's textile traditions run deep: here is a marvellously subtle, sewn and quilted blanket, made by the wife of an itinerant snakecharmer of the Sind region. An Indonesian man would wear with pride the girdle of a batik or ikat sarong, complete with ceremonial 'keris', and on disrobing the knife would be laid to rest on pegs once set into this Javanese wooden board engraved with images of shadow puppets.*

160

(Above) Paper flowers from a church altar bedeck this bedroom and the embroidered Iraqi rug proves more useful as a blanket than a floor cover. (Opposite) Facing the brass bed hangs a near-two-hundred-year-old Pueblo buffalo-hide shield depicting a meandering snake and the warming rays of the sun. Mugs on the dresser, that appear to be 'modern' in form and decoration, prove to be thirteenth-century American Indian ware.

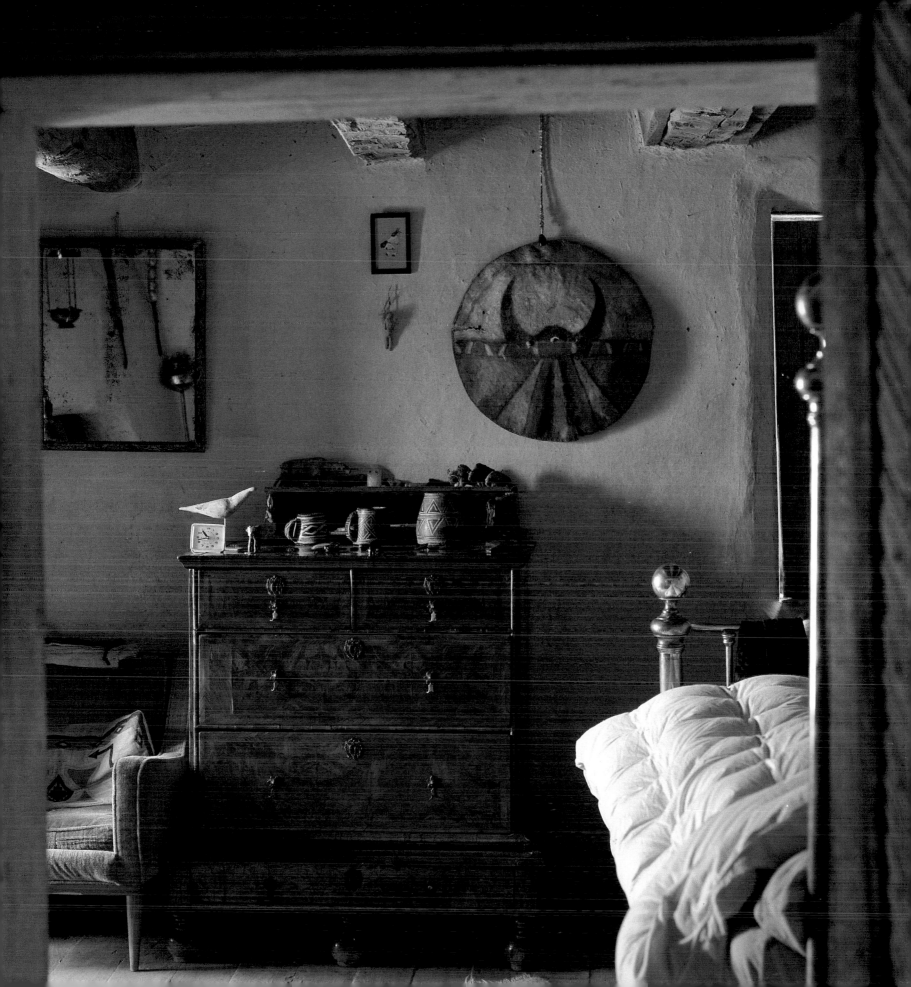

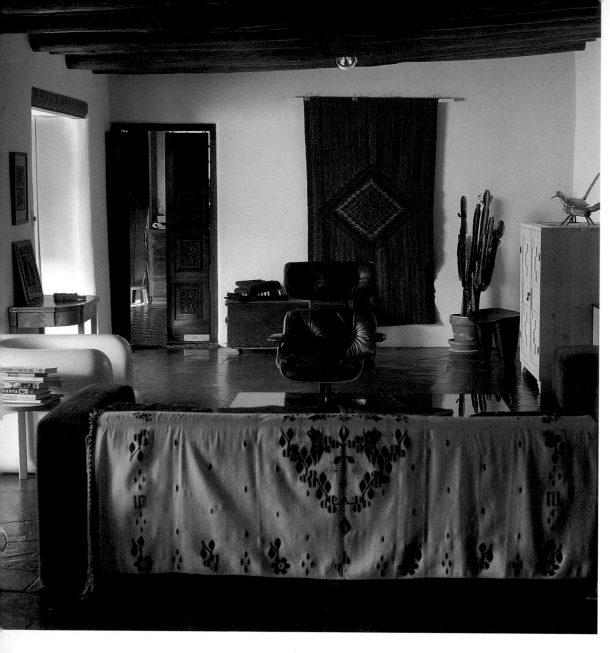

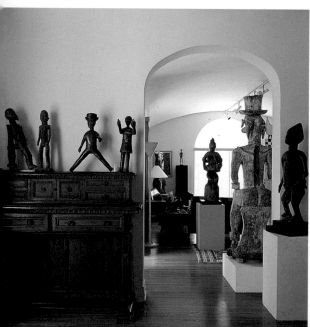

(*Above*) Hanging from a rail and fastened with clips for easy removal, this seventeenth-century Saltillo 'sarape' is exquisitely worked, vivaciously coloured and dramatically patterned – the hallmarks of many an old or antique textile sought after by the collector.

(Left) African sculpture that is appreciated for its fine patina may well have lost bright paintwork over time; here, Ewe shrine-figures from Togo, West Africa, stand akimbo and beckoning on this chest, both complete with original paint.

(Opposite) A tribal chief's wooden bed serves as an unusual coffee table in this living room dominated by West African art. The dramatic, fringed 'plank mask' is from the Bwa of Burkino Fasso.

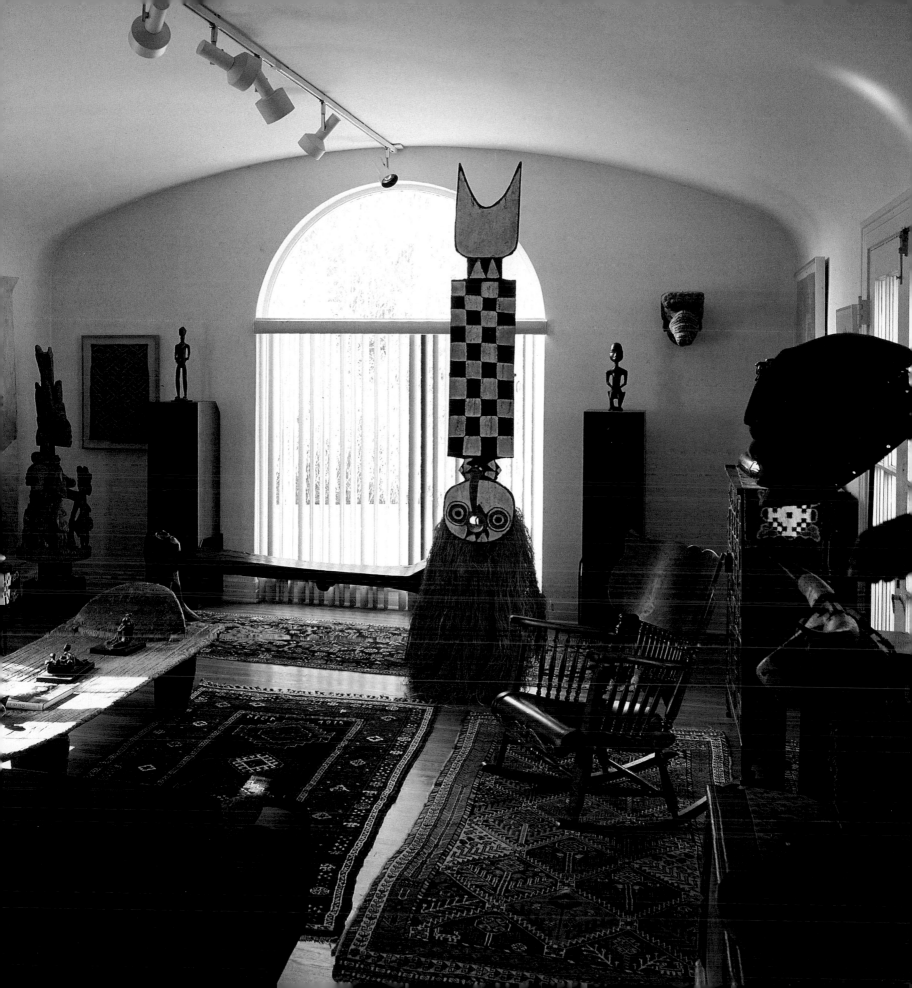

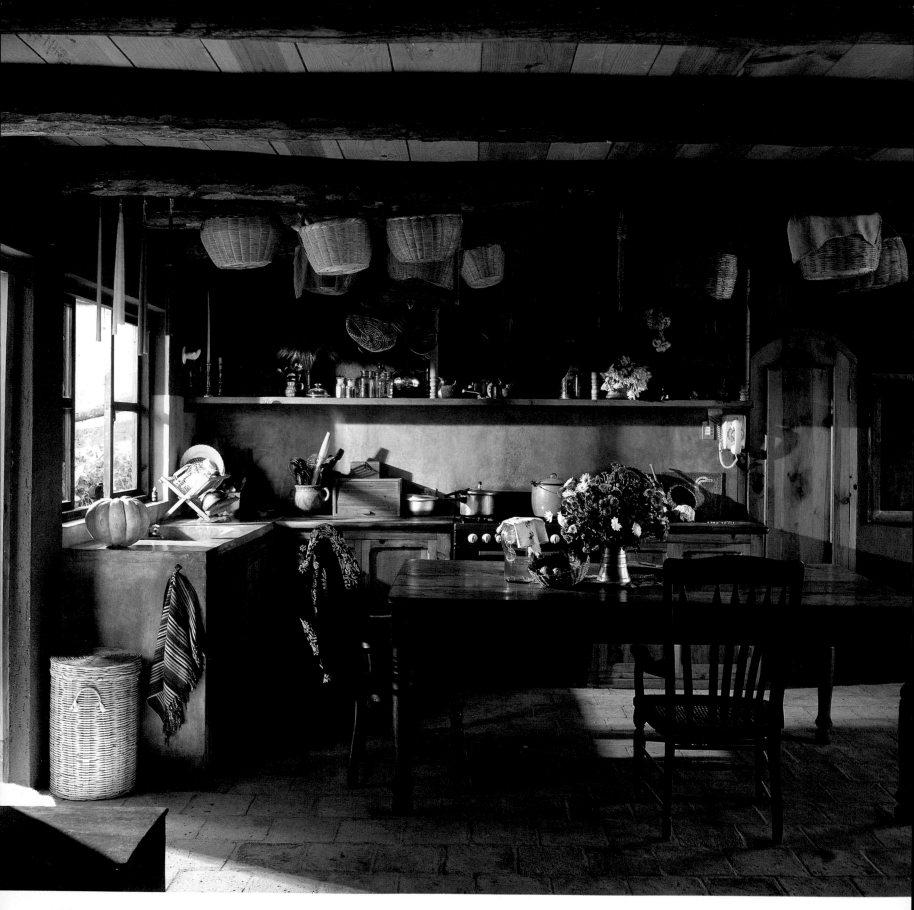

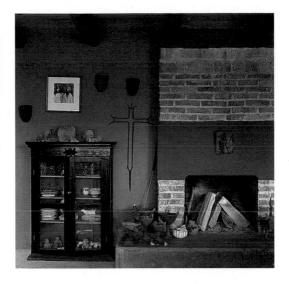

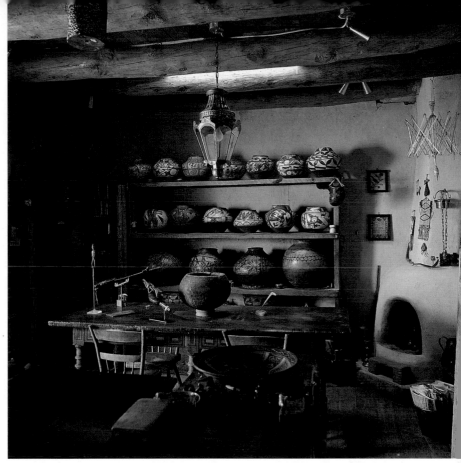

(Above) Lacandón Indians gaze down on an array of their own ceramic wares, and are equally familiar with the iron cross that decorates the apexes of many of the roofs of their local town.

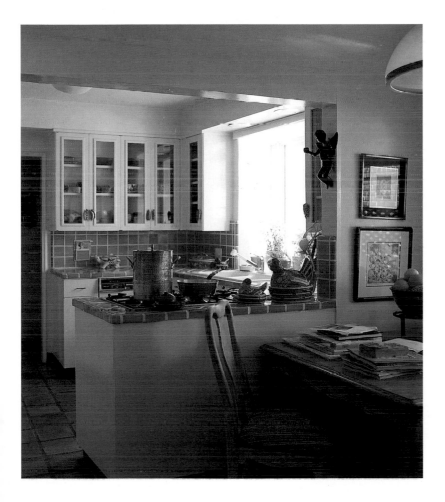

(Above) A sight to gasp at: the diners will have little need for conversation when seated before such a wondrous collection of Pueblo Indian grain and water jars.

(Left) The Tlaquepaque pottery of the 'thirties matches the mood of this kitchen within a Spanish revival-style bungalow in southern California.

(Opposite and below) The rough free-plastered walls belie the adobe construction of this home. The local village and folk crafts within are utilized to the full – from handmade striped dish cloths to a pan hanger that once yoked an ox.

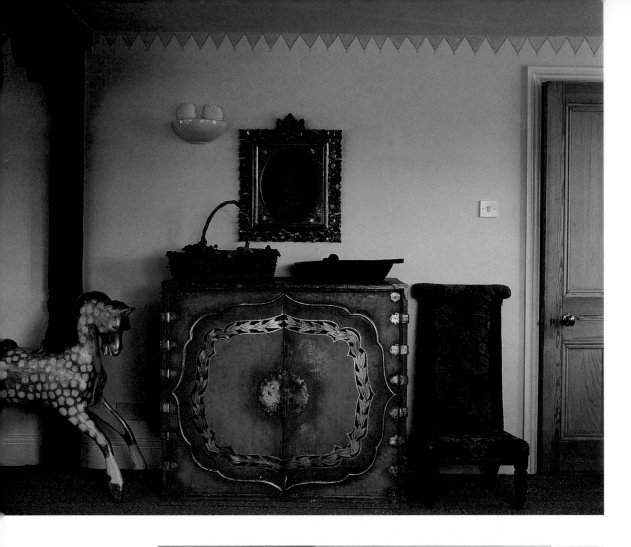

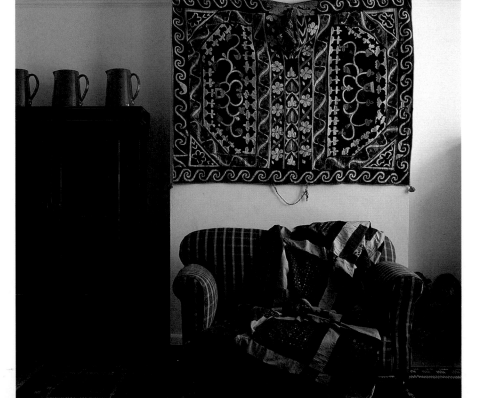

(Above) On a fourteenth-century European chest, a wide oak bowl from *Afghanistan* fills the room with the fragrance of pot-pourri, much reminiscent of the heady aromas of Central Asia.

(Above, left) The building of his new home, on the site of an old farmhouse, presented the owner with the opportunity to incorporate architectural wood from *Asia* within its structure. In the living room, the tie beam is supported by a carved oak house-pillar from Swat, North-West Frontier Province. On the extraordinary gilt and gesso chest sits an Indian 'parath', which would have once contained unleavened bread or a mound of rice, now filled with pot-pourri.

(Left) The hanging sack on this appliqué pinned to the wall gives away its original use: it was once a Brahmin bull-cover of north-west India. The unusually patterned kilim is from the Russian borderlands of *Afghanistan*.

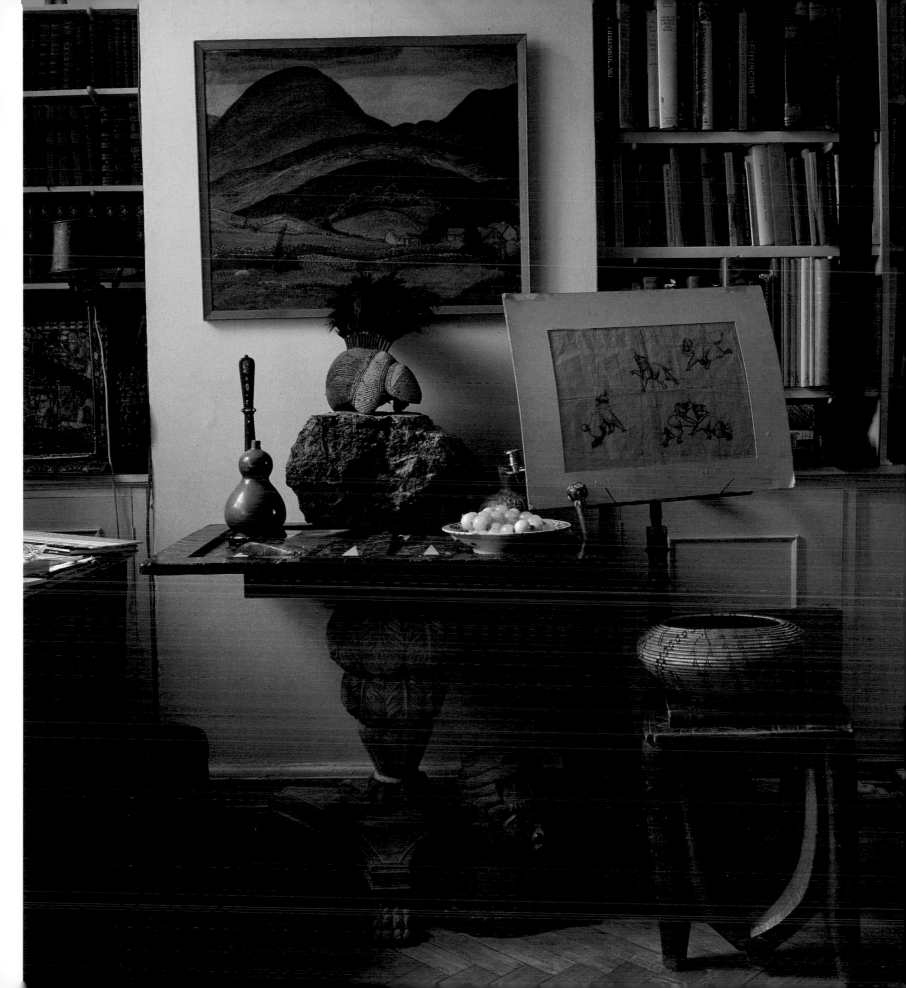

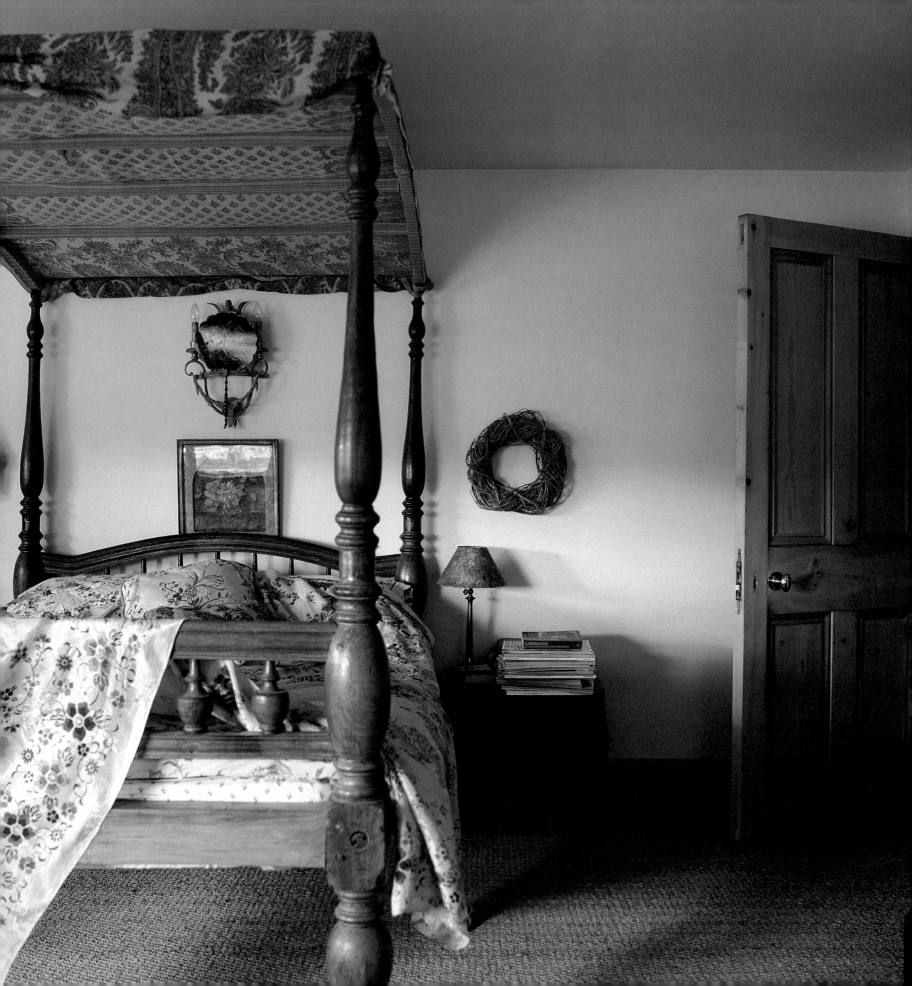

(Above) Most probably from Orissa, in eastern India, these gessoed and painted lions smile at the spaciousness of this old English bath.

(Opposite) A prize acquisition is this nineteenth-century East Indies bed, made of teak by local craftsmen and betraying a mixture of traditional and Western influences. Befitting, then, is such a diverse selection of textiles to adorn it, from the Paisley shawl canopy – most probably a copy of a Kashmir original – to a Chinese wrap and an English appliquéd quilt.

(Right) Few little girls will be so lucky as to play with an adobe dolls' house within a bedroom decorated with the joyously colourful weaves of the Americas.

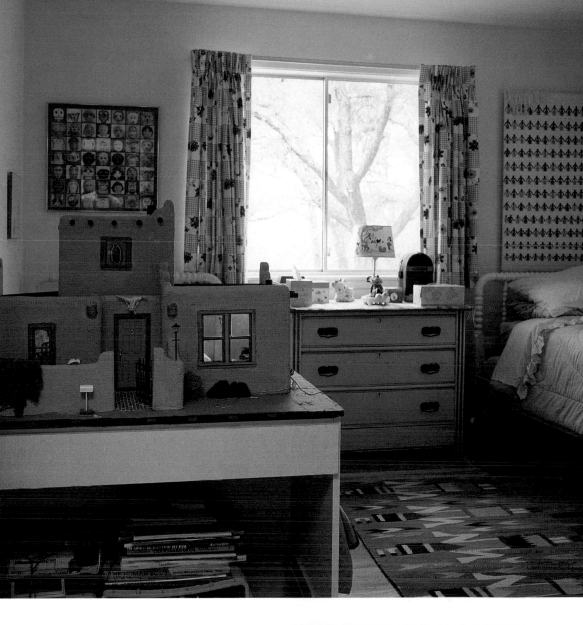

(Left) From backstrap-woven textiles in abundance to palm-fronds woven together for Easter festivals, the rich Mexican folk tradition is well represented in this bedroom.

(Right) Inspired by a well-known book on ethnic textiles, these stencils were cut to represent a fusion of symbols and motifs from African, American Indian and Islamic weaves. An indigo-dyed cotton Ewe cloth makes a fine-looking bedcover.

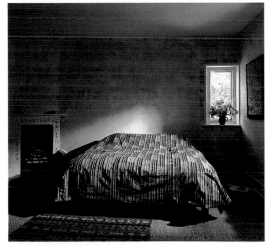

171

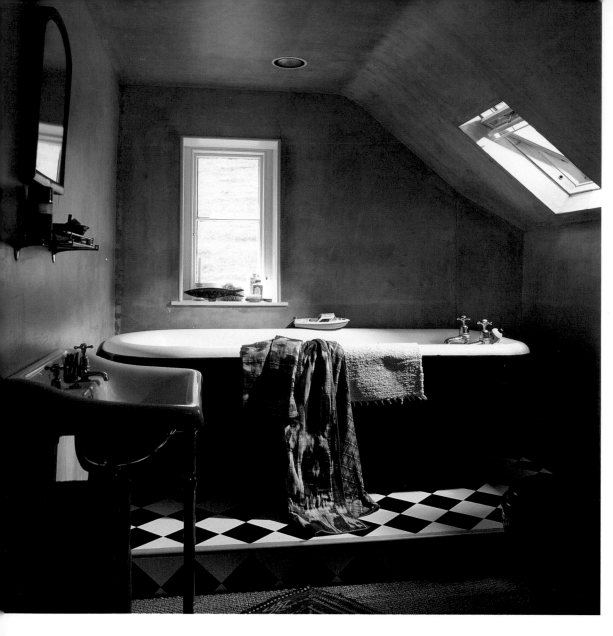

(Above) Raised on a platform reinforced by a steel girder, this huge bath is a reminder of turn-of-the-century British opulence. The wooden fish from Indonesia looks on with envy.

(Right) *A raiment that once filled the streets of Samarkand and Tashkent with shimmering colour, this silk ikat 'chapan' now gives good service as a dressing gown.*

(Left) The simplest and cheapest folk artifacts can transform a room. Beaten tin is manipulated by Mexican and New Mexican craftsmen to stunning effect.

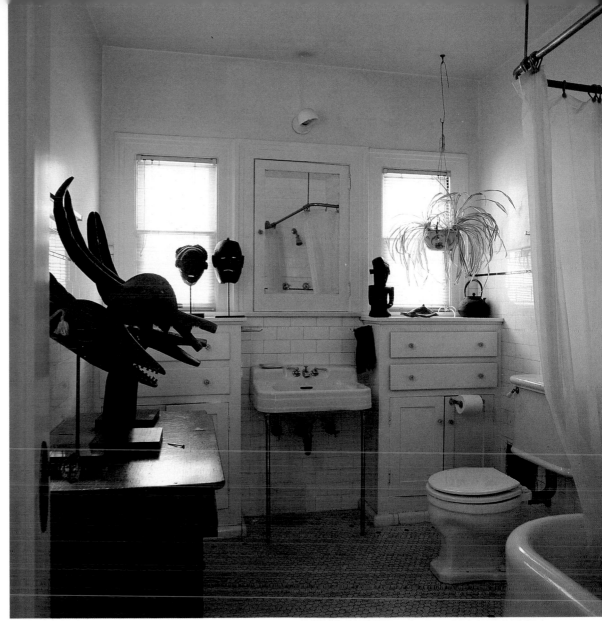

(*Above*) No bathroom is complete without such a gathering of onlookers from out of the darkness of the Congo, Nigeria, the Ivory Coast and the spice kingdom of Sumatra.

(Right) Let into the garden wall of this English country manor-house is a 'gokh' from north-west India. Carved from sandstone, a pair of these shrines would be found throughout Hindustan on the outside walls of houses, flanking the front door. Originally the receptacle for a devotional flame or offering, here the theme of reincarnation is continued by an ever-circling fountain of clear water.

(Right) This Californian house is home to a textile artist with a lively and inspired interest in the folk and tribal arts of the world. The gilded phoenix chair from Europe is a centrepiece to a wonderful collection – from mermaids (tin and pottery figures from Mexico) to textiles made by Bolivian Aymara Indians loosely draped over chairs, and a mantelpiece dominated by a pottery altarpiece from Michoacán, Mexico. From the Indonesian archipelago comes a wooden mortar and pestle, a low ornate chest and colourful ikat cotton yardage that makes a fine fitted cover for an armchair.

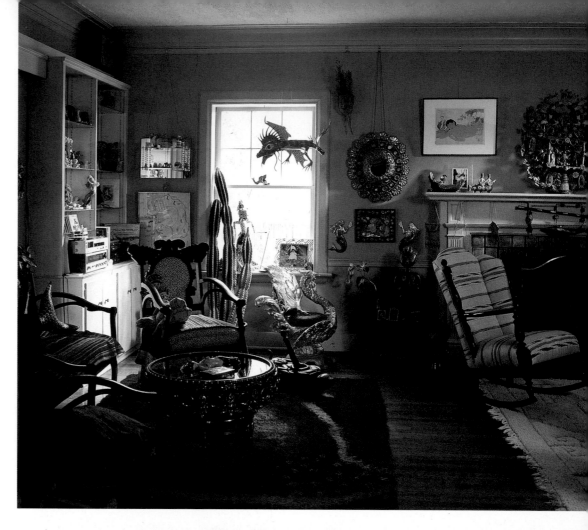

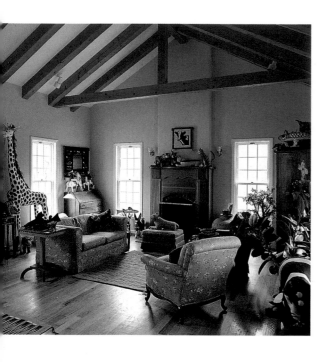

(Above and opposite) This is the home of an author in Santa Fe devoted to the contemporary arts and crafts of Old and New Mexico. Giraffes from the mesa lands of the South-West stand beside Navajo rugs depicting a less sound form of transport than the trusty pony – the motor car.

(Right) A scene of English summertime, to recollect when waiting nine hours for a fully laden train on a mosquito-ridden platform in Gujarat during the monsoon season.

174

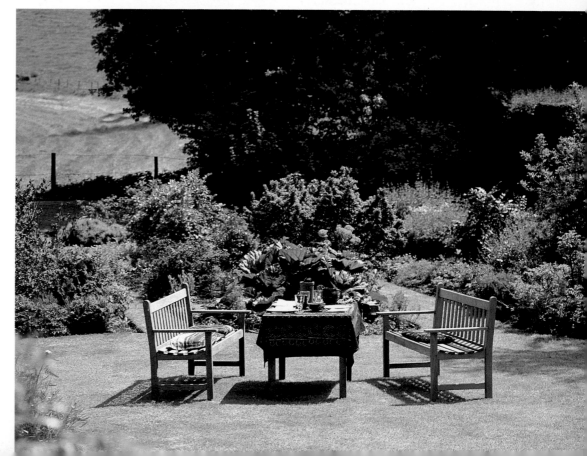

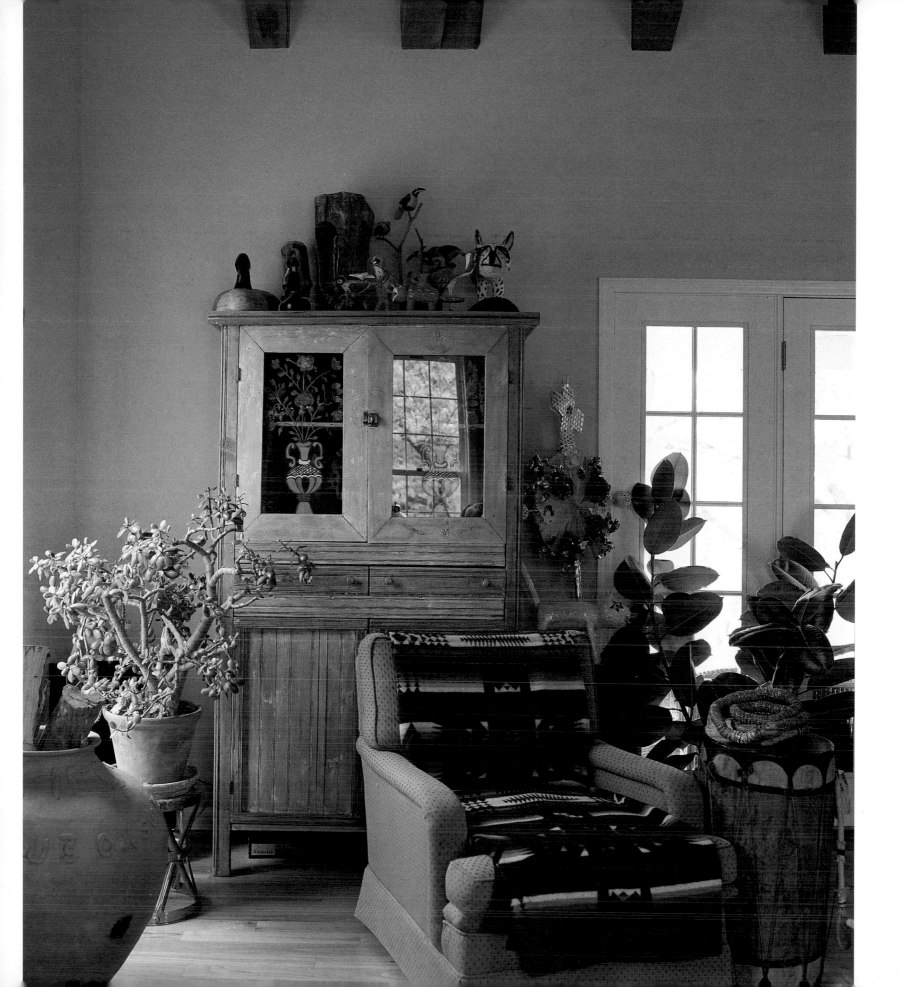

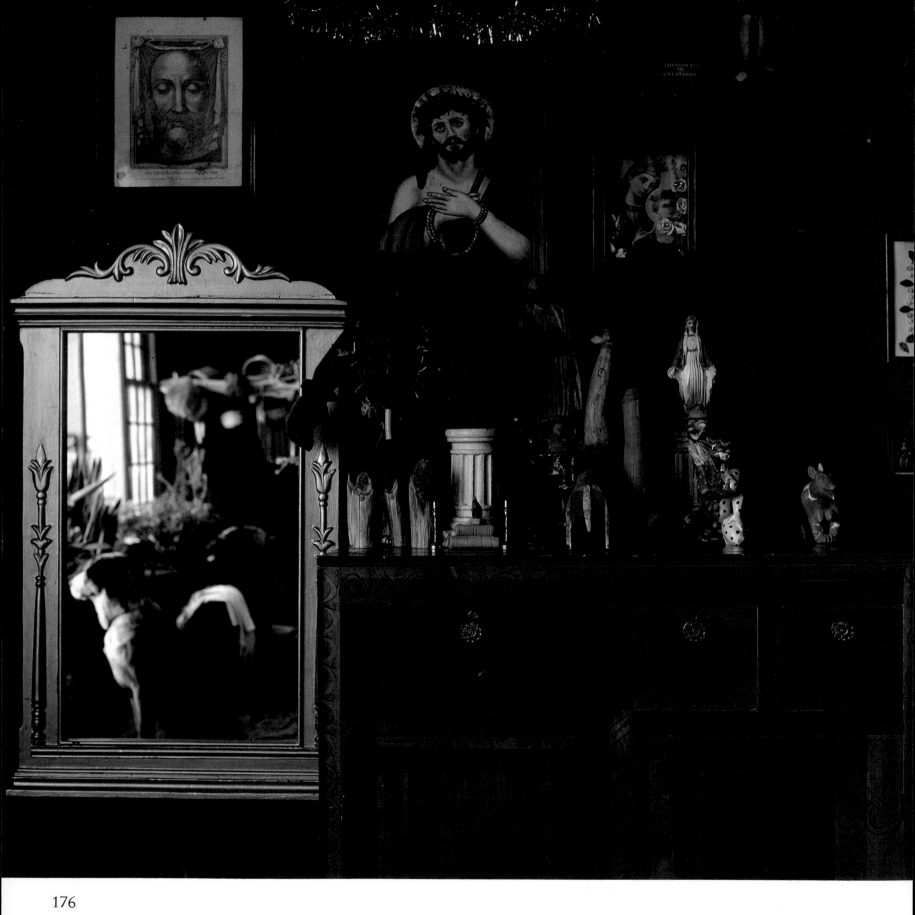

Chapter Six **Guide to Sources and Services**

Collecting Tribal and Folk Art

Over the past twenty years, the collecting of tribal and folk art has developed into a highly specialized and hierarchical affair. Business between dealers, museums and private and corporate buyers ensures that, as in the fine art world, the netting of the finest works at the highest prices is almost always achieved. The ethnic market does differ from the fine art circus, however, in that the individual is able, even these days, to participate without unreasonable expense. For the price of a new dishwasher, one may buy a collection of Mexican dance masks. A holiday in the Seychelles would pay for a wonderful antique blue Hausa robe from northern Nigeria.

By comparison with other highly lauded and traditionally 'acceptable' art forms, the old, antique and ancient artifacts of the ethnic world are absurdly undervalued. For investment purposes, there is no doubt that the oldest, finest or rarest examples will increase most in value. Needless to say, however, not all old artifacts are wonderful, for not all weavers, carvers and potters of the past were great masters or mistresses of their craft.

When buying for your home, for decoration or for a specific purpose, you must assess the likely wear and tear an item might receive, and its requirements as far as lighting and safety are concerned, before making your choice. Thus armed with such knowledge, and with accurate measurements, one must then embark on fact-finding missions to as many reputable dealers as possible, where prices and qualities can be compared. The golden rule is to buy what you like, but always be sure that you know what it is you are buying.

Buying, Selling and Valuation

The best way to buy is to travel: journeys to foreign lands are the surest means to appreciate alien cultures and their creative traditions. It is unlikely, however, that you will find a native artifact of any great rarity, as these will probably have been destroyed through use or, if of tribal, national or ceremonial value, will not be – or should not be – for sale. Most major cities of countries with a tribal and folk art tradition have a network of local merchants who gather interesting artifacts to sell in a gallery, hotel or airport shop. What you will find on your travels, however, are commoner items, both old and new, at reasonable prices. Remember that there will be shipping and handling costs if you send the goods home independently, and possible export and import duties.

Buying from a dealer or retailer at home should hold its rewards for both parties, and it is often a wise move to get to know these people on a personal basis. Specialized dealers the world over will usually supply prospective buyers with high-quality photographs of particular items, and will also give a money-back guarantee (after expenses) if your purchase proves unsuitable after all. Less specialized suppliers are now to be found in most towns and cities throughout the Western world, and inexpensive and relatively new artifacts can now be purchased from some department stores.

Bidding for an artifact at auction can prove both enjoyable and exciting, for there are many provincial auction houses who will sell objects amid a general sale with little idea of their identi-

Opposite: Hey Boy sits watchful over a New Mexican house made homely with a vast collection of pagan and Christian Mexican art.

ty or value. The best way to sell is through an established auction house or through a specialist dealer on commission. Some idea of the true value of your object can be gleaned from that of equivalent items featured in specialist magazines or auction catalogues. Valuation should also be carried out for insurance purposes, for which a photographic record of each item should be made as well. Having established the country of origin of a particular item or collection, one can find an appropriate specialist from magazine listings, who will make a charge which is usually a percentage of the valuation. A complete valuation certificate should also specify the dimensions, place of origin and age of an artifact.

Care and Storage

Precious artifacts ought to be catalogued, perhaps using coded cotton or paper tape, by any system which the owner deems most suitable – date of purchase, tribe of origin, age, or even place of display. These codes should then cross-reference with a log-book listing price, date and place of purchase, value, dimensions, and any information one may have on its origins.

Remember that all artifacts made from plant or animal products are vulnerable to insects, and that any wild fluctuations in temperature and humidity are likely to accelerate ageing processes. A domestic humidifier is a must in a dry environment or in a house heated by desiccating wood-burning stoves, and artifacts must not be displayed close to a direct source of heat – near an open fire or above a radiator. It is the abrupt fluctuations of temperature and humidity that are most damaging to wooden objects. New wooden artifacts returned from tropical parts will tend to split in a temperate and, especially, a desert clime, but if purchased from a dealer or auction in the West, they will more than likely have adjusted to local conditions many years ago.

Wooden carvings and baskets will need to be kept away from destructive and pesky insects, whether these are termites of the African bush, giant wood-boring beetles of the Hindu Kush or the common woodworm of a suburban house. Textiles are especially prone to insect attack. Moth proofing by spraying should be carried out at least twice a year, and mothballs hung close by in muslin bags. A common-sense attitude towards the raw material of the artifact should prevail; again, if in doubt, seek professional advice. To store, textiles should be rolled on to acid-free paper wrapped around cardboard tubes and kept in the dark, in a chest, cupboard or room where extremes of temperature and humidity are unlikely. Damage by insects, especially moth, may be avoided by proofing the textiles with suitable insect repellent and by examination for possible infestation at least twice a year, especially at the end of winter. Muslin bags containing solid insect repellent should be placed above but not touching the textiles.

Underlay will be needed to prevent rugs from sliding on shiny floors and fitted carpets with a deep pile (which tend to become a cushioning layer on which the rug will float about). The right underlay will add comfort, safety and durability. To be hidden under the rug, the underlay should be cut, overall, about one inch smaller than the flat-weave. Many underlays are available in rolls that are often four feet wide and so single-sided tape will be needed to join the strips together to go underneath a large rug or wide runner.

Cushioning underlay suitable for wood, stone and tile floors will not only prevent movement but prolong the life of the weave. The fibres of the rug are in danger from the abrasive action of dust and grit underfoot and the underlay acts as a cushioning pad between such particles and the floor. Minor imperfections in a rug, such as rucking or small creases, will also tend to be absorbed by an underlay. Most will not need to be attached to the rug itself or to the floor, and unless guaranteed by the manufacturer not to leave a residue on the floor or weave, but to be suitable for repeated lifting, double-sided tape used as a securing agent is to be avoided. Rugs, placed on looped pile carpet, sisal, coir or seagrass matting, do not need underlay, except, perhaps, for comfort underfoot.

Repair and Cleaning

Professional advice must be sought for all but the simplest of repairs, and there is a selection of specialists listed at the end of this chapter. Articles, such as recently made wooden sculpture or modern textiles without great financial or personal value, that have received minor damage, should be repaired or temporarily made good with common-sense DIY. If it is wooden then glue it, if it is a textile, take up your needle and thread.

All artifacts in use or on display will require cleaning from time to time. Rugs on the floor will receive the hardest wear and will need the greatest maintenance, and should be hoovered carefully, shaken or beaten over a line at frequent intervals to prevent the accumulation of fibre-grinding dirt and grit. The floor underneath a rug will need to be cleaned as well. Textiles draped over sofas, chairs, tables or beds will be easy to remove and shake clean. Free-hanging textiles on the wall should be taken down and the dust shaken off once or twice a year and this will be an opportune moment to check for the dreaded moth.

Many restorers and conservationists are adamant that the wet or specialist dry cleaning of textiles should be left to the professionals. If in doubt it is better to have a grubby textile than a textile ruined by colour run; colour fastness may be ascertained by rubbing gently each and every different colour area of a textile with a slightly damp white cotton cloth. If any of the colours appear on the white cloth the textile will have to be professionally cleaned. If the colours seem to be fast then proceed to wash with caution. Cold water, very mild detergent such as good quality washing-up liquid and repeated rinsing in clean water will remove most dirt. Stubborn stains may be teased with a soft nailbrush and oil or grease worked on with small quantities of hand-cleanser such as motor mechanics use. Textiles should be dried flat, away from excessive heat and all sunlight; many flat-weaves will need to be stretched slightly and pinned to prevent wrinkling. The spillage of liquids or foodstuffs on to a textile should be dabbed or shaken off the weave immediately and if necessary the floor underneath covered with newspaper to absorb the residual damp and possible colour run. Large-scale saturation will mean cleaning and drying the whole textile.

International Collections

There are some museums and galleries world-wide that are solely given over to the preservation of rare or otherwise important tribal and folk artifacts. Many display other kinds of art as well. Those listed here are likely to have ethnic arts on show to the public at all times. Particular examples or collections may have to be seen by appointment.

Australia

Australian Museum
6-8 College Street, Sydney, New South Wales 2000

Australian National Gallery
Canberra, ACT 2601

National Museum of Victoria
258-321 Russell Street, Melbourne, Victoria 3000

University Museum
James Cook University, Townsville, Queensland 4811

Austria

Museum of Applied Art
Stubenring 5, A-1010 Vienna

Ethnological Museum
Ringstrassentrakt, Neue Burg, A-1014 Vienna

Museum für Völkerkunde
Heldenplatz 3, Neue Hofburg, A-1010 Vienna

Bangladesh

National Museum
Dacca

Belgium

Musées Royaux d'Art et d'Histoire
Avenue J.F. Kennedy, 1040 Brussels

Canada

Museum of Fine Arts
1379 Sherbrooke Street West, Montreal

National Museum of Man
Victoria & Metcalfe Streets, Ottawa, Ontario K1A 0M8

Royal Ontario Museum
100 Queens Park, Toronto, Ontario M5S 2C6

Textile Museum
585 Bloor Street West, Toronto, Ontario M6G 1K5

Denmark

Nationalmuseet
Fredericksholms Kanal 12, 1220 Copenhagen

Fiji

Fiji Museum
Government Buildings, POB 2023, Suva

France

Foundation Dapper
50 Avenue Victor Hugo, 75116 Paris

Musée de l'Homme
Palais de Chaillot, Place de Trocadéro, 75016 Paris

Musée des Arts Décoratifs
Pavillon de Marsan, 107-109 Rue de Rivoli, 75001 Paris

Musée Historique des Tissus
34 Rue de Charité, 69001 Lyons

Musée National des Arts Africains et Océaniens
293 Avenue Daumesnil, 75012 Paris

Germany

Hamburgisches Museum für Völkerkunde
Rothenbaumchausee 64, Hamburg 13

Islamische Museum
Staatliche Museen zu Berlin, 102 Bodenstrasse 1/3, Berlin

Kestner-Museum
Trammplatz 3, Hanover

Linden Museum of Ethnology
Hegelplatz 1, 7000 Stuttgart, Baden-Württemberg

Museum für Islamische Kunst
Staatliche Museen Preussischer Kulturbesitz, Stauffenbergstrasse 41, Berlin 30

Museum of Ethnography
Schaumainkai 29, 6000 Frankfurt, Hessen

Museum für Völkerkunde
Arnimallee 23-27, 1000 Berlin 33

Rautenstrauch-Joest-Museum
Ubierring 45, 5000 Cologne, Nordrhein-Westfalen

Roemer-Pelizaeus Museum
Am Steine 1, 3200 Hildsheim, Niedersachen

Staatliches Museum für Völkerkunde
Maximilianstrasse 42, 8000 Munich 22, Bavaria

Hawaii

Bernice Pauahi Bishop Museum
1355 Kalihi Street, Honolulu, HI 96819

Hungary

Museum of Ethnography
Konyves Kalman Korut 40, Budapest VIII

India

Calico Museum
Ahmedabad, Gujarat

Madansinghji Museum
The Palace, Bhuj, Gujarat

Indonesia

Municipal Museum
Palembang, Sumatra

Provincial Museum
Mataram, Lombok, Nusa Tenggara Barat

Textile Museum
Jakarta

Italy

International Museum of Ceramics
Via Campidori 1, 48018 Faenza

Museo Preistorico Etnographico Luigi Pigorini
Via Lincoln 1, 00187 Rome

Japan

Kanebo Museum of Textiles
5-102 Tomobuchi-Cho, 1-Chome, Mijakojima-Ku, Osaka

National Museum of Ethnology
23-17 Yamadaogawa, Suita-Shi, Osaka

Mexico

Museo Nacional de Antropologia
Chapultepec Park, Mexico D.F.

Regional Museum of Oaxaca
Ex-convent of Santo Domingo de Guzman, Macedonio Alcala Block 5, Oaxaca, Oaxaca 68000

Rufino Tamayo Museum
Avenida Morelos 503, Oaxaca, Oaxaca 68000

Netherlands

Ethnographical Museum
Agathaplein 4, 2611 HR, Delft

Museum of Geography & Ethnography
Willemskade 25, 3016 DM, Rotterdam

Museum of the Tropics
Linnaeusstraat 2, 1092 AD, Amsterdam

National Museum of Ethnography
Steenstraat 1, 2300 AE, Leiden

New Caledonia

Musée de Nouvelle Calédonie, Nouméa

New Zealand

Auckland Institute and Museum
The Domain, Auckland 1

Canterbury Museum
Rolleston Avenue, Christchurch 1

National Museum
Buckle Street, Wellington

Otago Museum
Great King Street, Dunedin

Papua New Guinea

National Museum and Art Gallery, PO Box 5560, Boroko

Peru

Archaeological Museum
Calle Tigre 165, Cuzco

Archaeological Museum of Trujillo University
Calle Bolivar 466, Trujillo

Brüning Archaeological Museum
Calle 2 de Mayo 48, Lambayesque

Museo Nacional de Antropologia y Arqueologia
Plaza Bolivar, Pueblo Libre, Lima

Rafael Larco Herrera Museum
Avenida Bolivar 1515, Pueblo Libre, Lima

Poland

Asia and Pacific Museum
ul Nalczowska 40, Warsaw

Portugal

Museum of Overseas Ethnography
Rua das Portas de Santo Antao, Libson

Spain

Museo de las Américas
Avenida de los Reyes Catolicos, Cuidad Universitaria, Madrid 3

Museo Etnologico
Paseo de Santa Madrona, Parc de Monjuic, Barcelona 08004

Switzerland

Museum für Völkerkunde
Augustinergasse 2, 4051 Basel

Museum für Völkerkunde
Zurich

Turkey

Bursa Turkish and Islamic Art Museum
Bursa

Mevlana Museum
Konya

Topkapi Sarayi Muzesi
Istanbul

United Kingdom

Cambridge Museum of Archaeology and
 Anthropology
Downing Street, Cambridge CB2 3DZ

Fitzwilliam Museum
Trumpington Street, Cambridge CB2 1RB

Horniman Museum and Library
London Road, Forest Hill, London SE23 3PQ

Leicestershire Museum and Art Gallery
New Walk, Leicester

Manchester Museum
University of Manchester, Oxford Road, Manchester, M13 9PL

Museum of Mankind
6 Burlington Gardens, London W1X 2EX

Petrie Museum of Egyptian Archaeology
University College London, Gower Street, London WC1E 6BT

Pitt Rivers Museum
South Parks Road, Oxford OX1 3PP

Royal Scottish Museum
Chambers Street, Edinburgh, EH1 1JF

Victoria and Albert Museum
Cromwell Road, London SW7

Whitworth Art Gallery
University of Manchester, Oxford Road, Manchester, M15 6ER

United States of America

Alaska State Museum
Whittier Street, Juneau, AK 99811

American Museum of Natural History
79th Street and Central Park West, New York, NY 10024

Museum of Fine Arts, Boston
465 Huntington Avenue, Boston, MA 02115

Field Museum of Natural History
Roosevelt Road at Lake Shore Drive, Chicago, IL 60605

Harvard University Art Museum
Harvard University, Cambridge, MA 02138

Los Angeles County Museum of Natural History
900 Exposition Boulevard, Los Angeles, CA 90007

Metropolitan Museum of Art
Fifth Avenue, New York, NY 10028

Millicent Rogers Museum
Taos, NM 87571

Mingei Museum of International Folk Art
4405 La Jolla Village Drive, San Diego, CA 92122

The Museum of Indian Arts and Culture
710 Camino Lejo, Santa Fe, NM 87501

The Museum of International Folk Art
706 Camino Lejo, Santa Fe, NM 87501

Palace of the Governers
North Plaza, Santa Fe, NM 87501

Peabody Museum of Archaeology and Ethnology
11 Divinity Avenue, Cambridge, MA 02138

Peabody Museum of Natural History
Yale University, 170 Whitney Avenue, New Haven, CT 06520

Peabody Museum of Salem
161 Essex Street, Salem, MA 01970

Robert H. Lowie Museum of Anthropology
103 Kroeber Hall, University of California, Berkeley, CA 94720

San Diego Museum of Man
1350 El Prado, San Diego, CA 92101

San Francisco Craft and Folk Art Museum
Fort Mason Centre, Building A, San Francisco, CA 94123

Smithsonian Institution
1000 Jefferson Drive SW, Washington, DC 20560

Textile Museum
2320 S Street NW, Washington, DC 20008

University Museum
University of Pennsylvania, 33rd & Spruce Street, Philadelphia, PA 19104

Wheelwright Museum
704 Camino Lejo, Santa Fe, NM 87501

USSR

Peter the Great Museum of Anthropology and Ethnology
3 Universitethaya Nabererezhnaya, Leningrad

International Auction Houses

Many auction houses will value and sell tribal and folk art often in biannual or more frequent specialist auctions, and many have branches in other countries and in provincial towns.

France

Ader Picard Tajan
12 Rue Favart, Paris 75002
Tel: 42 61 80 07

Germany

Ketterer
Brienner Strasse 25, D-8000 Munich 2.
Tel: 089 591181

Rippon Boswell
Friedrichstrasse 45, D-6200 Wiesbaden
Tel: 06121 372062

Switzerland

Galerie Koller
Ramistrasse 8, 8024 Zurich
Tel: 01 475040

Ineichen
C.F. Meyerstrasse 14, 8002 Zurich
Tel: 01 2013017

United Kingdom

Christie's
8 King St., St. James's, London SW1Y 6QT
Tel: 0171 839 9060

Phillips
7 Blenheim St., London W1Y 0AS
Tel: 0171 629 6602

Sotheby's
34/35 New Bond St., London W1A 2AA
Tel: 0171 493 8080

United States of America

Butterfield and Butterfield
220 San Bruno Avenue, San Francisco CA 94103
Tel: 415 861 7500

Christie's East
219 East 67th St, New York, NY 10021
Tel: 212 606 0400

Grogan & Company
890 Commonwealth Avenue, Boston MA 02215
Tel: 617 266 4200

Phillips
406 East 79th St, New York, NY 10021
Tel: 212 570 4830

Robert W. Skinner
Route 117, Boston, MA 01451
Tel: 617 779 5528

Sotheby's
1334 York Avenue, New York, NY 10021
Tel: 212 606 7000

Dealers, Importers and Services

In this section, the names and addresses of dealers from all over the world are listed, together with the services they offer (e.g. cleaning and repairing) and the kinds of artifacts stocked. Obviously it is not possible to list everybody, but we have tried to give details of well-established houses and traders, as well as some more unusual and specialist galleries and businesses. It is advisable to call before you visit a dealer or showroom – some are only available by appointment, and it is always worth checking opening times.

Key to services and types of artifacts stocked:

Imp.	Importer	N Am.	North America
Ret.	Retailer	S Am.	South America
W.	Wholesaler	N Af.	North Africa
Manu.	Manufacturer	Anat.	Anatolia
Rep.	Repairs	Cauc.	Caucasus
A.	Antique	Pers.	Persia/Iran
O.	Old	Afgh.	Afghanistan
N.	New	Indon.	Indonesia

Australia

Nazar Rug Galleries Pty Ltd.
583 Military Road, Mosman,
New South Wales 2088
Tel: 02 9692659/02 3311505
Imp. Ret. W. Rep.; A.O.N.; Anat. Cauc. Pers. Afgh.
A well-established business which does expert repairs and valuations.

Austria

Herbert Bieler
Erlaufstrasse 25/8, A-2344 Ma. Enzerdorf
Tel: 0223 623 9562
Imp. Ret.; A.O.; Anat.
Two exhibitions per year of primarily old and antique kilims, and domestic weavings.

Hannes Boesch,
Hans Sachs Gasse 7, A-8010 Graz,
Tel: 0316 78730
Ret. Rep.; A.O.; Anat. Cauc. Pers. Afgh.

Galerie Safor,
Naglergasse 29, A-1010 Vienna
Tel: 0222 533 3289
Ret. W.; A.O.; Anat. Cauc. Pers.
Dealing with outstanding and antique carpets and kilims.

Galerie Sailer,
Wiener Philharmonikergasse 3, A-5020 Salzburg
Tel: 0043 662 846483
Imp. Ret. Rep.; A.; World
Only antique kilims, Oriental tapestries, North American Indian textiles.

Beate von Hartem,
Burggasse 24/12, A-1070 Vienna
Tel: 0222 933 0493
Expert textile repairs.

Belgium

Coppens Tribal Art,
Grote Peperstraat 69, 2700 Sint-Niklaas (Antwerp)

Tel: 03 776 99 39
Imp. Ret. W.; A.; Indon. Africa
Fifteen years' experience importing and specializing in
Bornean and Sumatran textiles.

Geert Keppens
Ruilare 54, B-9130 Zeveneken, Lokeren
Tel: 091 559 617
Imp. Ret. W. Rep.; A.O.; Anat. Cauc. Pers. Afgh.
Travels frequently to the Middle East and Central Asia.

Pierre Loos
17 Impasse Saint-Jacques, Grand Sablon, B1000
Brussels
Tel: 322 514 0209

Etienne Roland,
Noville Les Bois, B-5068 Fernelmont
Tel: 328 183 4005
Imp. W.; A.O.; Anat. Cauc. Pers.
A selection of textiles for collectors, antique dealers,
decorators and interior designers.

Herman Vermeulen,
Kraanlei 3, B-9000 Ghent
Tel: 091 24 38 34
Imp. Ret. W. Rep.; A.O.; Anat. Cauc. Pers.
More than twelve years' travelling experience in
Anatolia.

Canada

George Brown Antiquarian
P.O. Box 363, Station Q, Toronto, Ontario, M4T 2M5
Tel: 416 964 9134
Ret.; A.O.; N Am.
Specialist in books concerning, and art and material
culture of, the North American Indian tribes.

Country Furniture,
3097 Granville, Vancouver V6H 3J9
Tel: 604 738 6411
Ret.; O.N.
Accessories and trifles for the selective shopper.

Frida Crafts
39, Front St East, Toronto, Ontario M5E 1B3
Tel: 416 366 3169
Ret.; O.N.
Handicrafts from Africa, Latin America and Asia.

Sharanel Inc.,
763 Woodbine Ave, Toronto, Ontario M4E 2J4
Tel: 416 694 1399
Imp. Ret. W.; O.N.; Afgh.
Travels to Central Asia to buy, sells to trade and retail.

Vernacular,
1130 Yonge St, Toronto, Ontario M4W 2L8
Tel: 416 961 6490
Ret.; O.N.
Specializing in kilims, masks, tribal arts and textiles.

Woven Gardens,
1451 Sherbrooke St West, Montreal H3G 2W4
Tel: 514 937 6273
Ret.; O.N.
Wide selection of floor coverings, kilims, ethnic and
antique artifacts.

France

Apamée
3 Rue Maitre Albert, 75005 Paris

Tel: 46 34 04 40
Imp. Ret.; A.; Anat. Cauc. Pers. Afgh.
Antique kilims and carpets.

L'art Turkmene,
26 Rue Auguste Comte, 69002 Lyons
Tel: 78 38 21 54
Imp. Ret. W. Rep.; A.O.; Anat. Pers. Afgh.

Asher Eskenazy
35 Rue de l'Arbalète, 75005 Paris
Tel: 43 36 25 21

Galerie AK Kurt,
72 Rue du Cherche-Midi, 75006 Paris
Tel: 42 22 10 49
Imp. Ret.; O.N.; Anat. Pers.
The owners visit Turkey each year to buy kilims, car-
pets and textiles.

Galerie Kartir,
11 Rue Bonaparte, 75006 Paris
Tel: 43 26 90 28
Imp. Ret. W.; A.O.; Pers.
Art and textiles of the Middle East.

Gerard Hadjer,
22 Rue Drouot, 75009 Paris
Tel: 48 24 96 67
Imp. Ret. W. Rep.; O.A.N.; Anat. Cauc. Pers.
Dealer in arts and textiles.

Haga,
22 Rue de Grenelle, 75007 Paris
Tel: 42 22 82 40
Ret.; A.; World
Textiles of the Orient and Europe a speciality.

Germany

Galerie Antiker Kunst,
Oberstrasse 110, 2000 Hamburg 13,
Tel: 45 50 60/47 63 72
Ret.; A.
Fine dealer in ancient art including Coptic textiles. By
appointment.

Peter Hoffmeister,
Rosenauer Strasse 20, D-8635 Dorfles-Esbach,
Tel: 09563 3538
Rep.

Koken,
Esslingerstrasse 14, 7000 Stuttgart
Tel: 0711 233416
Imp. Ret.; A.O.N.; Anat. Pers. Afgh.
Hand-woven home furnishings from Anatolia through
to the East.

Ilona-Marie L. Lemberg-Richtermeier,
Atelier und Werkstatte, Schulterblatt 1,2000
Hamburg 6
Tel: 040 439 15 26
Rep.; A.; S Am.
Restoration and conservation of Coptic and pre-
Columbian textiles. Maxim is 'Sew, not glue'.

Galerie Neiriz,
·Kurfürstendamm 75, 1000 Berlin 15
Tel: 030 882 3232
Imp. Ret. W. Rep.; A.; Anat. Cauc. Pers.
A private kilim collector who sells antique pieces in
four exhibitions each year.

Galerie Ostler,
Ludwigstrasse 11, D-8000 Munich 22
Tel: 089 285 669
Ret. W.; A.; Anat. Pers.
Their focus is weaving as art.

Alfred Walter,
Cremon 35, Hamburg 11
Tel: 040 2802306
Handwashing, restoration and conservation.

Italy

The Carpet Studio,
Via Monalda 15/R, 50123 Florence
Tel: 055 211423
Ret.; A.; all but mostly Anat.
Primarily a specialist in antique carpets and textiles;
also has small selection of kilims.

Luciano Coen,
65 Via Margutta, 00187 Rome
Tel: 06 678 3235/679 0321
Ret.; A.; Anat. Cauc. Pers.
Stocks a few and very selected antique kilims. His Swiss
wife speaks fluent English and German.

Eskenazi,
15 Via Montenapoleone, 20121 Milan
Tel: 02 700020
Ret.; A.O.; Anat. Cauc. Pers.
Dealer and exhibition organizer in rugs, kilims and
textiles from Asia.

Ghalibaf,
40 Corso Vittorio Emanuele, Turin
and 19 Via Cavour, Alessandria
Tel: 011 539303/531146
Imp. Ret. Rep.; A.O.; Anat. Cauc. Pers.
A large choice of antique and prestigious carpets and
kilims.

Kilim Arte & Antichita,
Via Fama, 15, 37121 Verona
Ret.; A.O.
Kilims and textiles.

The Kilim Gallery,
Via di Panico 8, 00186 Rome
Tel: 06 68 68 963
Imp. Ret.; A.O.N.; Anat. Cauc. Pers.
Kilim specialist.

Il Mercante D'Oriente,
Corso S Anastasia 34, 37121 Verona
Tel: 045 594 152
Ret. Rep.; A.O.N.; Anat. Cauc. Pers.
Buys and sells tribal and village textiles.

Daniele Sevi,
6 Via Fiori Chiari, 20121 Milan
Tel: 02 87 61 69
Ret.; A.O.; Anat. Cauc. Pers.
Carpets, rugs, and kilims; also European carpets.

Dario Valcarenghi,
6 Via F. Corridoni, Milan
Tel: 02 54 83 811
Imp. Ret.; A.O.; Anat.
A large collection of antique and old kilims.

Luxembourg

Galerie Interferens Pilscheur
26 Bvld de Petrasse, L-2320, Luxembourg
Tel: 352 403 095

Mexico

ARIPO
Garcia Vigil 809, Oaxaca, Oaxaca 68000
Telex: 018835
Traditional crafts from the nine regions of Oaxaca.

Chimalli
Garcia Vigil 513-A, Oaxaca, Oaxaca 68000
Local crafts.

Ex-convento de Santo Domingo
Sna Jolobil Gift Shop
Calzeda Lazaro Cardenas No. 42, Apartado Postal 191,
29240 San Cristobal de Las Casas, Chiapas
Tel: 967 8 26 46
Costumes, textiles and ceremonial artifacts from sur-
rounding villages.

La Mano Magica
Alcala 204, Oaxaca, Oaxaca 68000

Mari Olguin
Apartado Postal 921,
Oaxaca, Oaxaca 68000
Tel: 951 589 06
Textiles, wood and tin folk art.

Multi Export SA de CV
Amberes No. 21, Codigo Postal 06600, Mexico D.F.
Tel: 533 61 303032
A selection of pre-Columbian reproductions, papier-
mâché, wall hangings, ceramics and glassware.

Victor's Artes Regionales
111 Calle Porfirio Diaz, Oaxaca, Oaxaca 68000
Tel: 951 611 74
Local art.

Yalalag,
Alcala 104, Oaxaca, Oaxaca 68000
Papier-mâché, clay, wood and tin figures, textiles and
ceramics.

Netherlands

D.W. Kinebanian,
Heiligeweg 35, Amsterdam
Tel: 020 267019
Ret. W.; A.O.; Anat. Cauc. Pers. Afgh.
Traditional family business specializing in antique and
old kilims and carpets.

Saskia Wessel,
Overtoom 19, Amsterdam
Imp. Ret.; A.O.N.; Afgh.
A collector and retailer of ethnic artifacts from Asia.

Portugal

De Natura,
162a Rua da Rosa, 1200 Lisbon
Tel: 1 366081
Imp. Ret.; A.O.N.; Anat. Cauc. Pers. Afgh.
A gallery selling fine oriental art and kilims.

Spain

Puerto Galera,
Dr. Roux, 30, Torre, Barcelona 17
Tel: 205 05 12

Sweden

J.P. Willborg AB,
Sibyllegatan 41, 114 42 Stockholm
Tel: 08 7830265/7830365
Imp. Ret. W. Rep.; A.; Anat. Cauc. Pers.
Antique textile gallery.

Switzerland

Alt Amerika, Arts Primitifs
Neumarkt 21, 8001 Zurich
Tel: 01 251 9118
Ret.; A.O.; S Am. Africa
African and old Peruvian textiles and objects.

Djahan Orientteppiche,
Freilagerstrasse 17, Zollfreilager, CH 8043 Zurich
Tel: 01 491 9797
Imp. W.; A.O.N.; Anat. Cauc. Pers.
A well-established firm renowned for their great col-
lection of kilims.

Galerie Kistler Dekor KI AG,
Bernstrasse 11, 3250 Lyss
Tel: 032 84 44 33
Imp. Ret. W.; A.O.; Anat. Cauc. Pers. Afgh.
Nomadic art gallery.

Graf & Raaflaub Ag/Ltd,
Rheingasse 31/33, 4005 Basel
Tel: 061 25 33 40
Imp. Ret. Rep.; A.; Anat. Cauc. Pers.

Nomadenschätze,
Weyrmuhle, 5630 Muri/AG
Tel: 057 44 42 18
and at Kirchgasse 36, 8001 Zurich
Tel: 01 252 5500
Imp. Ret.; A.O.; Anat. Pers. Afgh.
Tribal flatweaves, rugs, textiles and jewelry.

Ali Shirazi,
Zollfreilager Block 1, Kabin 337, Postfach 159,
CH 8043 Zurich
Tel: 01 493 1108
Imp. W.O.; A.O.; Pers, Afgh.
A collection of unusual nomadic pieces.

Teppich Stettler AG,
Amthausgasse 1, 3011 Bern
Tel: 031 21 03 33
Imp. Ret. Rep.; O.N.; Anat. Cauc. Pers. Afgh.
An enterprise specializing in nomadic and cottage
rugs, kilims and bags.

United Kingdom

Aaron Gallery,
34 Bruton Street, London W1X 7DD
Tel: 0171 499 9434/5
Imp. Ret. W.; A.O.N.
Islamic and ancient art.

Peter Adler,
191 Sussex Gardens, London W2
Tel: 0171 262 1775
Ret.; A.O.; Africa, Oceania

Specialist dealer in the textiles and sculpture of West
and Central Africa and Oceania.

Meg Andrews Antique Costumes & Textiles,
20 Holly Bush Lane, Harpenden, Herts AL5 4AT
Tel: 01582 460 107
Ret.; A.; World
Decorative costumes a speciality.

J.L. Arditti,
88 Bargates, Christchurch, Dorset BH23 1QP
Tel: 01202 485414
Ret. Rep.; A.O.N.; Anat. Cauc. Pers.
Old Oriental rugs, runners and kilims bought and sold,
cleaning and restoration service.

Sara Bamford,
Wapley Barn, Staunton-on-Arrow, Leominster,
Herefordshire, HR6 9LQ
Tel: 01544 267849
Ret. Rep.; A.O.; Anat. Cauc. Pers. Afgh.
Restorers, cleaners and repairers with an interesting
collection of rugs and kilims.

David Black Oriental Carpets,
96 Portland Road, London W11 4LN
Tel: 0171 727 2566
Ret. Rep.; A.N.; Anat. Cauc. Pers.
Long-established collector and dealer of antique kilims
and dhurries. Author and publisher of many books on
kilims and textiles.

Carpet Export Import Company,
Room 1 – The Music Room, 1-7 Davies Mews,
London W1Y 1AR
Tel: 0171 629 6078
Imp. W.; A.O.N.; Anat. Cauc. Pers. Afgh.
An all-embracing company with cleaning and restora-
tion services available.

The Country House Partnership
96 Northwick Business Centre, Blockley, Nr Moreton-
in-Marsh, Gloucestershire GL56 9RF
Tel: 01386 700303
Kilim-covered furniture.

Chandni Chowk,
1 Harlequins, Paul Street, Exeter, Devon EX4 3TT
Tel: 01392 410201
Imp. Ret. W., A.O.N.; Anat. Pers. Afgh. India. Indon.
A comprehensive gallery of old tribal art

Coats Oriental Carpets
4 Kensington Church Walk, London W8
Tel: 0171 937 0983
Ret. Rep.; A.; Anat. Cauc. Pers. Afgh.
A small specialist shop dealing in the more rare and
esoteric examples of village and tribal weaving.

Sue Deakin,
7 Averling Road, High Wycombe, Bucks.
Tel: 01494 448215
Kilim and carpet repairer.

de Quorum Lifestyle,
11 Colville Terrace, London W11 2BE
Imp. W.; N.; India
Twice yearly collections of decorative Indian hangings
and rugs; made to order service available.

Designers Silks – Lucy Coltman
Netting Cottage, Netting Street, Hook Norton, Near
Banbury, Oxfordshire OX15 5NP
Tel: 01608 730011

Specialist importer and dyer of silk yarn for repairers and embroiderers.

Fantasia Designs,
20A Conduit Mews, London W2 3RE
Tel: 0171 402 6278/370 0917
Imp. W.; O.N.; India
Importer of old and new Indian decorative textiles.

Christopher Farr Handmade Rugs,
115 Regents Park Road, Primrose Hill,
London NW1 8UR
Tel: 0171 586 9684/9685
Ret.; A.N.; Anat. India. Africa
Antique and new rugs and textiles a speciality.

John Gillow Oriental Textiles,
50 Gwydir Street, Cambridge CB1 2LL
Tel: 01223 313 803
Imp. Ret.; A.O.N.; India, Indon.
Peripatetic for six months a year in South and South-East Asia, collecting textiles, especially embroideries.

Daphne Graham,
1 Elystan St., London SW3 3NT
Tel: 0171 584 8724
Ret.; A.O.; Anat. Pers.
Specializing in antique and decorative kilims, new floral kilims, cushions and kilim-upholstered furniture. Also flatweaves from Eastern Europe.

Graham & Green,
4 Elgin Crescent, London W11
Tel: 0171 727 4594
Ret.; A.O.N.; World
An eclectic selection of beautiful objects from all over the world.

Joss Graham Oriental Textiles,
10 Eccleston St., London SW1 9LT
Tel: 0171 730 4370
Imp. Ret.; A.O.; World
A constantly changing selection of tribal and folk textiles and other artifacts from all over the world.

David Hartwright Ltd,
Unit 15c, Farm Lane Trading Centre, 101 Farm Lane,
London SW6
Tel: 0171 381 3276
Rep.; A.O.N.; World
Cleans and restores all types of textiles.

Alison Henry
29 Bramley Road, Worthing, West Sussex BN14 9DS
Tel: 01903 212270
Repairs carried out personally by experienced trained weaver.

J.P.J. Homer Oriental Rugs,
'Stoneleigh', Parabola Road, Cheltenham, Glos GL50 3BD
Tel: 01242 234243
Ret. Rep.; A.O.; Pers.
Sale and repair of antique rugs, saddlebags, runners and occasionally kilims.

Jonathan Hope,
20 Roland Gardens, London SW7
Tel: 0171 373 3704
Imp. Ret.; A.O.; Indon.
A well-known Indonesian textile specialist. Open by appointment.

Paul Hughes,
3A Pembridge Square, London W2 4EW
Tel: 0171 243 8598
Imp. Ret. W. Manu. Rep.; A.O.N.; S Am. Africa. Indon.
Specializes in ancient textiles as well as more contemporary West African and Congo weavings. Open by appointment.

Tessa Hughes,
Denmark Lodge, Crescent Grove, London SW4 7AG
Tel: 0171 627 2145
A.; India
Private dealer open by appointment.

Alastair Hull,
The Old Mill, Haddenham, Ely, Cambs CB6 3TA
Tel: 01353 740577
Imp. Ret. W.; O.N.; Pers. Afgh. Indon.
Travels frequently to Afghanistan and Iran buying kilims to sell from his home and from exhibitions and tribal art galleries.

Indigo
No. 3 Gabriel's Wharf Market, 56 Upper Ground,
London SE1 9PP
Tel: 0171 401 2597
Imp. Ret.; A.O.N.; India

Kathryn Jordan,
19 Bailbrook Lane, Swainswick, Bath BA1 7AH
Tel: 01225 331 858
Rep.; A.O.N.; World
Restoration, conservation, cleaning, estimates and advice.

The Kilim & Nomadic Rug Gallery,
5 Shepherds Walk, London NW3 5UL
Tel: 0171 435 8972
Ret. Rep.; A.O.; Anat. Pers.
A dealer who travels extensively around Anatolia seeking old and unusual kilims.

The Kilim House,
951/953 Fulham Road, London SW6 5HY
Tel: 0171 731 4912
and
The Kilim Warehouse,
28A Pickets St., London SW12 8QB
Tel: 0181 675 3122
Imp. Ret. W. Rep.; A.O.N.; Anat. Cauc. Pers. Afgh.
A well-known importer of Anatolian kilims, with an interesting gallery in an unusual location.

Christopher Legge Oriental Carpets,
25 Oakthorpe Road, Summertown,
Oxford OX2 7BD
Tel: 01865 57572
Imp. Ret. W. Rep.; A.O.N.; Anat. Pers. Afgh.
Buyers and sellers of all types of Oriental rugs, also offering valuation and cleaning services.

Debbie Lewin,
19 Charlwood Place, Pimlico, London SW1
Tel: 0171 821 5143
Rep.; A.O.
Restoration, conservation, cleaning, mounting and framing of textiles.

Liberty plc,
210/220 Regent Street. London, W1R 6AH
Tel: 0171 734 1234
Ret.; A.O.N.; S Am. Anat. Pers. Afgh. India. Indon.
A well-known store.

Martin & Frost
83 George St., Edinburgh EH2 3EX
Tel: 0131 225 2933
Ret. Rep.; O.N.; Anat. Afgh.
Quality house-furnishers with a specialized Oriental rug and carpet department with knowledgeable staff.

Moroccan Rugs and Weavings,
5A Calabria Road, London N5 NJB
Tel: 0171 226 7908
Imp.: A.O.N.; N Af.
Viewing by appointment. 5-day exhibitions twice a year.

Garry Muse,
26 Mostyn Gardens, London NW10
Tel: 0181 969 5460
Ret.; A.; Anat.
Rare Anatolian kilims and rugs.

Oriental Rug Gallery
42 Verulam Road, St Albans, Herts AL3 4DQ
Tel: 01727 41046
Imp. Ret.; O.N.; N Af. Anat. Pers. Afgh.
Carpets and kilims, valuations and repairs.

Orientis,
Abbey Corner, Digby Road, Sherborne, Dorset
Tel: 01935 816 479/813 274
Ret. Rep.; A.O.N.; Anat. Pers. Afgh.
Oriental textiles and costumes.

Indar Pasricha Fine Arts,
3 Shepherd Street, London W1Y 7LD
Tel: 0171 493 0784
Ret.; A.; Anat. Pers. India
Islamic fine arts.

Rau,
36 Islington Green, London N1
Tel: 0171 359 5337
Imp. Ret.; A.O.; Pers. Afgh.
A long-established collector and traveller.

Rufus Reade,
40 Pilrig St., Edinburgh EH6 5AL
Tel: 0131 554 1078
Imp. Ret.; O.N.; Anat.
An Anatolian kilim exhibitor.

Gordon Reece Gallery,
Finkle St., Knaresborough, Yorks HG5 8AA
Tel: 01423 866219/866502
Ret. Rep.; O.N. Anat. Cauc. Pers. Afgh.
An ethnic gallery with eight different exhibitions each year, and a large permanent kilim stock.

Clive Rogers Oriental Rugs,
22 Brunswick Road, Hove, Brighton, Sussex BN3 1OG
Tel: 01273 738257
Imp. Ret. W. Rep.; A.O.N.; Anat. Cauc. Pers. Afgh.
Carpet and kilim dealer, importing new, natural-dyed Anatolian rugs. International commission agent, valuations and restorations.

Philippa Scott,
30 Elgin Crescent, London W11 2JR
Tel: 0171 229 8029
Ret.; A.; N Af. Anat. Pers. India
Collector and writer who deals and consults privately. Open by appointment.

David Seyfried,
759 Fulham Road, London SW6 5UU

Tel: 0171 731 4230
Kilim-covered floor stools and furniture.

Ron Simpson Textiles,
Grays Antique Market, 138 Portobello Road, London
W11
Tel: 0171 727 0983
Ret.; A.; N Am. India
Antique and decorative textiles. Collector and organizer
of textile exhibitions.

Sussex House
63 New Kings Road, London SW6 4SE
Tel: 0171 371 5455
Imp. Ret.; A.O.; Anat. Cauc. Pers. Afgh.
Finely made carpet and kilim cushions, bags, stools,
ottomans and cabinets.

Thames Carpet Cleaners Ltd,
48–56 Reading Road, Henley-on-Thames,
Oxon RG9 1AG
Ret. Rep.; A.O.
Specialist in cleaning and restoration of Oriental rugs,
tapestries and silks.

Thornborough Galleries,
28 Gloucester St., Cirencester, Glos GL7 2DH
Tel: 01285 2055
Ret. W. Rep.; A.; World
Vegetable-dyed kilims of special merit among the main
stock of antique carpets.

Upholstery Techniques
Stanway Grounds, Broadway Road, Stanway, Chel-
tenham, Gloucestershire GL54 5DR
Tel: 01242 69414
Kilim-covered furniture.

Linda Wrigglesworth Chinese Textiles,
Grays in the Mews, 1-7 Davies Mews, London W1Y
1AR
Tel: 0171 408 0177
Ret.; A.; China
Specialist dealer in antique Chinese court costumes and
textiles.

United States of America

Adraskand Inc.,
15 Ross Avenue, San Anselmo, CA 94960
Tel: 415 459 1711
Ret. Rep.; A.O.N.; Anat. Cauc. Pers. Afgh.
Sales and exhibitions of antique tribal and village rugs,
kilims and textiles. Has stock of new but traditional
Anatolian kilims

Amatulli Importer Inc.,
568 Main Avenue, Norwalk, CT 06851
Tel: 203 849 1400
Imp. Ret. W.; A.O.N.; Anat.
A vertically integrated Oriental rug company.

American Indian Collection
P.O. Box 1375, Blue Jay, CA 92317
Tel: 714 337 6672
Ret.; A.O.; N Am.
Pre-1950s American Indian art.

Amerind Art Inc.,
1304 12th Street, Santa Monica, CA 90401
Tel: 213 395 5678
Ret. A.; N Am.
Run by the private dealer and collector of Navajo tex-
tiles Tony Berlant, co-author of *Walk in Beauty*.

Anahita Gallery,
P.O. Box 1305, Santa Monica, CA 90406
Imp.; A.O.; Afgh.
Direct importer of Central Asian textiles, kilims, art and
jewelry. Obscure collectors' kilims a speciality.

R. Anavian & Sons,
421 East 72nd St, New York, NY 10021
Tel: 212 879 1234
Ret. W. Rep.; A.O.; Anat. Cauc. Pers. Afgh.
Dealers in fine Oriental rugs, kilims and antique tex-
tiles.

Michael Andrews Antique Oriental Rugs,
2301 Bay St 302, San Francisco, CA 94123
Tel: 415 931 5088
Ret. W.; A.; S Am. Anat. Pers.
Open by appointment.

Antique Carpet Gallery,
533 S.E. Grand Avenue, Portland, OR 97214
Tel: 503 234 1345
Ret. W. Rep.; A.O.; World
A gallery specializing in old and antique pieces, with an
emphasis on natural dyes and good condition.

The Antique & Decorative Textile Company,
254 West 73rd Street, New York, NY 10023
Tel: 212 787 0090
Ret.; A.; S Am. Anat. Pers. India
Run by Frank Ames, author of *The Kashmir Shawl*. Open
by appointment.

Jeff Appleby
Rt 3, Box 470 A/, 100 Cortez Place, Escondido,
CA 92025
Tel: 619 480 4455
Ret.; A.; S Am. Indon.
Rare textiles to be seen by appointment.

Arcade Gallery
2200 Bodega Avenue, Petaluma, CA 94952
Tel: 707 762 8448
Ret.; A.; Africa
Long-established African specialists open by
appointment.

Ariana Oriental Rugs,
211 King St, Alexandria, VA 22314
Tel: 703 683 3206
Fine antique and semi antique rugs, textiles, kilims
and jewelry.

Asia Minor Inc.,
801 Lexington Avenue, New York, NY 10021
Tel: 212 223 2288
Imp. W.; A.O.N.
Primarily kilim dealers, also selling carpets and
tapestry.

J.R. Azizollahoff,
303 Fifth Avenue, Suite 701, New York, NY 10016
Tel: 212 689 5396
Ret. W.; A.O.N.; Anat.
A dealer and consultant in mainly vegetable-dyed
Anatolian carpets and kilims.

Bellas Artes,
Canyon Road, Santa Fe, New Mexico
Tel: 505 983 2745
584 Broadway, New York City, New York
Tel: 212 274 1116
Ret.; A.O.; World

An interesting gallery juxtaposing contemporary fine
arts and crafts with decorative textiles.

Berbere Imports,
144 South Robertson Boulevard, Los Angeles,
CA 90048
Tel: 213 274 7064
Imp. Ret. W. Rep.; A.O.N.; Anat. Cauc. Pers. Afgh.
Importers of rugs and kilims whose distinguishing fea-
tures are truly ethnic design, colour and weave, and
large size.

Steve Berger Bolivian Weavings,
904 Irving Street # 220, San Francisco, CA 94122
Tel: 415 753 0342
Ret.; A.; S Am.
A large and historic collection of Bolivian textiles may
be seen by appointment.

David Bernstein Fine Art,
737 Park Avenue, Appt 11B, New York, NY 10021
Tel: 212 794 0389
Ret.; A.; S Am. Africa. Indon.

James W. Blackmon Antique Textiles,
PO Box 25, Olema, CA 94950
Tel: 415 669 7411
Imp. Ret. Rep.; A.; S Am. Africa. Anat. Pers.
Appraises, lectures on, cleans, conserves and sells anti-
que textiles.

Luna Blanca/Lauren Rickey
Los Angeles, California
Tel: 213 394 5889
Mexican textiles, folk art, music and photographs.
Open by appointment.

Judith Bronowski Fine Folk Art
PO Box 1491, Pacific Palisades, CA 90272
Tel: 213 459 2227
Mexican wood carvings and papier-mâché figures.

Jacques Carcanagues,
21 Green Street, New York, NY 10012
Tel: 212 431 3116
Imp. Ret. W.; A.O.N.; Anat. Pers. Afgh.

Tukey Cleveland
Santa Fe, New Mexico
Tel: 505 982 6454
Folk art old and new. Open by appointment.

Davis Gallery
3964 Magazine Street, New Orleans, LA 70115
Tel: 504 897 0780
Ret.; A.O.; Africa
Tribal art from West and Central Africa.

Douglas Dawson Gallery,
814 N Franklin, Chicago, IL 60610
Tel: 312 751 1961
Imp. W.; A.O.; World

Mort Dimondstein
749 Longwood Avenue, Los Angeles, CA 90005
Tel: 213 939 4962
Ret.; A.O.; Africa. Oceania
Open by appointment, a dealer specializing in the
sculpture of the tribes of Africa and Oceania.

Double K Gallery
318 N. La Cienega Blvd, Los Angeles, CA 90048
Tel: 213 652 5990
Traditional and contemporary American folk art, from

whirligigs and weathervanes to esoteric carvings. Also furniture, textiles, pottery, tramp art, and paintings from the 1920s to the 1960s.

George Fine Kilims
One Cottage Street, Easthampton, MA 01207
Tel: 413 527 8527
Imp. Ret.; A.O.; Anat.
Traveller of Anatolia collecting kilims for designers, retailers and collectors.

Folklorica – NYC
89 Fifth Avenue, New York, NY 10003
Tel: 212 255 2525
Imp. Ret. W.; A.O.N.; S Am. Africa. Indon.
A gallery of primitive art.

The Folktree
217 South Fairoaks Avenue, Pasadena, CA 91105
Tel: 818 795 8733
Specializes in folk art from the Americas in general. Also items from Africa, Indonesia, Thailand and China. Wood and clay, sculpture, ceramics, textiles, clothing, masks, jewelry and books.

The Folk Tree Collection
199 South Fairoaks Avenue, Pasadena, CA 91105
Tel: 818 793 4828
Rugs, furniture, contemporary and North American folk art, antiques, Asian art, paintings. Changing monthly exhibits of local and folk artists.

Four Winds
310 Broad Street, Nevada City, CA 95959
Tel: 916 265 9021
A range of wood carvings, pottery and jewelry.

Larry Frank
PO Box 290, Arroyo Hondo, NM 87513
Tel: 505 776 2281
North American Indian and New Mexican Spanish colonial art. Open by appointment.

Frederico
1522 Montana Avenue,
Santa Monica, CA 90403
Tel: 213 458 4134
Ret.; A; N Am. Latin Am.
Mexican and American Indian artifacts a speciality.

Cora Ginsberg
819 Madison Ave 1A, New York, NY 10021
Tel: 212 744 1352
Ret.; A.
Antique costumes and textiles from America and Asia. Open by appointment.

Renate Halpern Galleries Inc.,
325 E 79th Street, New York, NY 10021
Tel: 212 988 9316
Ret.; A.O.; World
Open by appointment.

Jonathan S. Hill Ethnic Textiles,
PO Box 40616, San Francisco, CA 94110
Tel: 415 647 9399
Imp. Ret. W.; A.O.; S Am.
Textiles of the Andes and Himalayas.

Indian Art Center,
Box 2560, Gallup, NM 87305
Tel: 505 863 6948
Ret. W.; O.N.; N Am.
South-West American Indian arts and crafts.

Interwerks,
PO Box 7417, Dallas TX 75209
Tel: 214 521 8544
W.; A.O.N.; Anat.
Direct wholesaler to interior designers and architects.

Jerrehian Brothers,
25 Station Road, Haverford, PA 19041
Tel: 215 896 0900
Ret. Rep.; A.O.N.; Anat. Pers.

L. Kahan Gallery
560 Broadway Suite 508, New York City, NY 10012
Tel: 212 966 1138
Ret.; A.O.; Africa.
Well-established dealer in African art.

Kate
808 11th Street, Santa Monica, CA 90403
Tel: 213 393 6343
Eclectic mixture of both old and new folk art: whirligigs, sculpture, bottlecap folk art, pottery, furniture, purses, frames, etc.

Stephen King Oriental Rugs,
Boston Design Center, 660 Summer St., Boston, MA 02210
Tel: 617 426 3302
W.; A.O.; Anat. Cauc. Pers. Afgh.
Sales through designers and architects of antique and new carpets and kilims.

Kilim,
150 Thompson St, New York, NY 10012
Tel: 212 533 1677
Imp. Ret.; A.O.; Anat. Cauc. Pers.
Specialists in old and antique kilims, saddlebags, prayer kilims, runners and tribal kilims in all sizes.

Le Souk Gallery
1001 East Alameda, Santa Fe, NM 87501
Tel: 505 989 8765
Imp. Ret.; A.O.; N Af.
Berber arts a speciality. Open by appointment.

La Luz de Jesus
7400 Melrose Avenue, Upstairs, Los Angeles, CA 90046
Tel: 213 651 4875
A wild and eclectic collection of folk and tribal art from all over the world, examples vary from Jamaican voodoo flats to Tibetan singing bowls.

Maqam/Dennis R. Dodds,
PO Box 4312, Graver's Lane, Philadelphia, PA 19118
Tel: 215 438 7873
Ret.; A.; Anat. Pers.
Author, lecturer and dealer in antique textiles.

Krikor Markarian,
151 West 30th St, Room 801, New York, NY 10001
Tel: 212 629 8683
W. Rep.; A.O.; Anat. Cauc. Pers.
Small and room-size antique collectable rugs and kilims, and restoration and hand-cleaning service.

Martin & Ullman Artweave Textile Gallery,
310 Riverside Drive, New York, NY 10025
Tel: 212 864 3550
Ret. Rep. W.; World
Specialists in ancient textiles who also conserve and mount textiles. Open by appointment.

Davis Mather Folk Art Gallery
141 Lincoln Avenue, Santa Fe, NM 87501

Tel: 505 983 1660
Imp. Ret.; N.; N Am. Latin Am.
New Mexican animal wood carvings, Mexican and native American folk art.

Marian Miller Kilims,
148 East 28th St., New York, NY 10016
Tel: 212 685 7746
Imp. Ret. W.; A.N.; Anat. Cauc. Pers.
Antique kilims, with a selection of new Anatolian kilims.

Stephen A. Miller Oriental Rugs Inc.,
212 Galisteo St, Santa Fe, NM 87501
Tel: 505 983 8231
Ret. Rep.; A.O.N.; Anat. Cauc. Pers. Afgh.
Comprehensive selection in all sizes, representing major weaving centres of the world.

Mohr Textile Arts,
125 Cedar Street, New York, NY 10006
Tel: 212 227 1779
Ret.; A.O.; World (except N Am.)
Open by appointment.

Mokotoff Asian Arts,
Place des Antiquaires, Gallery #88, 125 E 57th Street, New York, NY 10022
Tel: 212 751 2280
Ret.; A.; Africa. India.
Primarily Chinese textile dealer.

Mount Vernon Antiques
Box 66, Rockport, Massachusetts
Tel: 508 546 2434
Ret. Rep. W.; A.; N Am.
Specializes in quilts, hooked rugs and clothing.

Ken Nelson
PO Box 200, Tres Piedras, NM 87577
Tel: 505 758 7826
Mexican folk art, textiles and jewelry. Open by appointment.

Nomad
279 Newbury Street, Boston, MA 02116
Tel: 617 267 9677
Folk art, textiles, jewelry, clothing, folk music.

Nonesuch Gallery
1211 Montana Gallery, Santa Monica, CA 90405
Tel: 213 393 1245
19th- and 20th-century decorative arts, American folk art, American Indian artifacts, cowboy relics, arts and crafts, pottery, weavings, paintings and jewelry.

O'Bannon Oriental Carpets,
5666 Northumberland St, Pittsburgh, PA 15217
Tel: 412 422 0300
Ret.; A.O.N.; Anat. Cauc. Pers. Afgh.
A personal interest in village rugs from Anatolia, but tries to offer the best rugs available from all areas.

Obatu – Afshar Inc.,
311 West Superior, Suite 309, Chicago, IL 60610
Tel: 312 943 1189
Ret.; A.O.; Pers.
A gallery for kilims, specializing in antique and old flat-weaves from Persia.

Oddiyana
432B Melrose Avenue @ Heliotrope, Los Angeles, CA 90029
Tel: 213 664 1826

Old Taos
108 Teresina Lane, Taos Plaza, Taos, NM 87571
Tel: 505 758 7353
American Indian, Mexican, Spanish colonial and cow-boy arts.

James Opie Oriental Rugs Inc.,
214 SW Stark St, Portland, Oregon
Tel: 503 226 0116
Ret.; A.; Pers.
Weavings and kilims from southern Iran have long been the speciality of this store.

Origins,
135 West San Francisco, Santa Fe, NM 87501
Tel: 505 988 2323
Imp. Ret.; A.O.N.; World
A gallery of folk art to fantasy.

Outside-In
6909 Melrose Avenue, Los Angeles, CA 90038
Tel: 213 657 6369
20th-century American folk and 'outsider' sculpture, paintings and furniture.

Pace Primitive
32 East 57th Street, New York, NY 10022
Tel: 212 421 3688
Ret.; A.; Africa & Himalayas

The Pillowry, New York
19 East 69th St, New York, NY 10021
Tel: 212 628 3844
Imp. Ret. W. Rep.; A.O.; Anat. Cauc. Pers. Afgh.
A world-wide collection of kilims, rugs, needlepoint, trappings and textiles. Specialists in work on uphol-stery, hassocks and pillows.

The Pillowry, Los Angeles
8687 Melrose Avenue, West Hollywood, CA 90069
Tel: 213 657 5790
Imp. W.; A.O.; Anat. Cauc. Pers. Afgh.
A collection of flat-weaves, Navajo rugs, saddlebags, ethnic and formal textiles, and pillows.

El Pueblo de Los Angeles Historic Park (Olvera Street)
845 North Alameda Street, Los Angeles, CA 90012
Tel: 213 625 5045
A street of colourful Mexican flavour, selling arts and crafts of Central America.

Quilt Gallery
1611 Montana Avenue, Santa Monica, CA 90403
Tel: 213 393 1148
Fine antique American quilts, hooked rugs, ethnic and folk art, and American paintings.

Robertson African Arts,
36 W 22nd Street, New York, NY 10010
Tel: 212 675 4045
Ret. W.; O.; Africa
Open by appointment, this is a very large gallery of African Art.

The Rug Collectors Gallery,
2460 Fairmont Boulevard, Cleveland Heights,
OH 44106
Tel: 216 721 9333
Ret.; A.O.; Anat. Cauc. Pers. Afgh.
Specialists in fine, old and antique rugs and kilims with artistic merit.

Sakrisabz,
Penn's Market, Rt 202, Old York Road Store, No. 20,

Lahaska, Pennsylvania
Tel: 215 794 3050
Imp. Ret. W.; A.; Afgh.
Direct importers of antique kilims, textiles, brasswork and carvings from Central Asia.

Alfred L. Scheinberg Inc.
230 W 76th Street Penthouse B, New York, NY 10023
Tel: 212 595 6340
Ret.; A.; Africa
West African dealer open by appointment.

Shaver Ramsey Oriental Galleries,
2414 East Third Avenue, Denver, CO 80206
Tel: 303 320 6363
Imp. Ret.; A.O.N.; Anat. Pers. Afgh.
A vast collection of kilims, from the antique, classic and collectable, to the more modern and decorative.

Paul S. Shepard,
3026 E. Broadway, Tucson, AZ 85716
Tel: 602 326 4852
Ret. W.; N Am.
Pre-Columbian and American Indian textiles.

Mark Shilen Gallery,
201 Prince Street, New York, NY 10012
Tel: 212 777 3370
Ret., A.O., Anat. Pers. Afgh.
All types of tribal weavings, but strong emphasis on kilims.

Silkroute,
3119 Fillmore St., San Francisco, CA 94123
Tel: 415 563 4936
Imp. Ret. Rep. W.; A.O.N.; Anat. Afgh.

Sonrisa
8214 Melrose Avenue, Los Angeles, CA 90046
Tel: 213 651 1090
Folk and contemporary art showing Los Angeles artists influenced by a Mexican aesthetic. Mostly furniture, ceramics and graphics.

Southwest Textiles,
PO Box 1306, Corrales, NM 87048
Tel: 505 898 5058
Ret. W.; O.; N Am.
Navajo, Hispanic and Pueblo textiles.

Sun Bow Trading Co.,
108 Fourth St NE, Charlottesville, VA 22901
Tel: 804 293 8821
Imp. Ret. W. Rep.; Anat. Pers. Afgh.
Source acquisition of tribal and nomadic textiles and rugs from Konya to Kashgar.

Tamor Shah,
3219 Cains Hill Place N.E., Atlanta, GA 30305
Tel: 404 261 7259
Imp. Ret. W.; A.O.; Afgh.
Fine antique and semi-antique rugs, kilims, tapestries, embroideries, costume and lace.

John Bigelow Taylor,
162 East 92nd St, New York, NY 10128
Tel: 212 410 5300
High-quality photography of kilims, carpets, textiles and works of art.

Mary Taylor,
99 Bank St, New York, NY 10014
Tel: 212 242 3652
Restorer of fine antique kilims.

Textile Arts Inc.,
1571 Canyon Road, Santa Fe, NM 87501
Tel: 505 983 9780
Ret. Rep.; A.; World
Specializes in museum-quality textiles from around the world. Gallery owner Mary Hunt Kahlenberg is author of several textile books. Co-author of *Walk in Beauty*.

Edwin E. Thomas
Tribal And Ethnic Art, Box 214, Rancho De Taos,
NM 87557
Tel: 505 758 9373
Author, lecturer, collector and dealer of pre-Columbian art and folk art. Open by appointment.

Trocadero Textile Art,
1501 Connecticut Avenue, N.E. Washington, DC 20036
Tel: 202 328 8440
Imp. Ret. W. Rep.; A.O.N.; Anat. Cauc. Pers. Afgh.
A large collection of kilims bought from source.

Turkana Gallery,
125 Cedar Street, Penthouse, New York, NY 10006
Tel: 212 732 0273/516 725 4645
Imp. Ret. Rep.; A.O.; World
Primarily a kilim dealer. Open by appointment.

Umbrello,
8607 Melrose Avenue, Los Angeles, CA 90069
Tel: 213 655 6447
and at
701 Canyon Road,
Sante Fe, NM 87501
Tel: 505 984 8566
Imp. Manu. Ret.; A.O.N.; N Am. S Am.
A gallery for South-West American and Mexican home furnishings. Facsimile Navajo rugs made in Mexico a speciality.

Vilunya Folk Art
Charles Square, 5 Bennett Street, Cambridge MA 02138
Tel: 617 661 5753
Folk art, textiles, jewelry, clothing, folk music.

Helene Von Rosentiel Inc.,
382 11th Street, Brooklyn, NY 11215
Tel: 718 788 7909
Rep.; A.O.N.; World

John and Suzan Wertime,
PO Box 16296, Alexandria, VA 22302
Tel: 703 379 8528
Ret.; A.; Pers.
Specialists in small, outstanding nomadic weavings for the connoisseur and collector.

James Willis Gallery
109 Geary Street (At Grant) 2nd Floor, San Francisco,
CA 94108
Tel: 415 989 4485
Ret.; O.; Africa, Indon. Oceania.
Long-established dealer in sculpture.

Woven Legends Inc.,
922 Pine St, Philadelphia, PA 19107
Tel: 215 922 7509
Imp. Ret. W. Rep.; A.O.N.; Anat. Cauc. Pers.
A constantly changing selection of fine antique and modern kilims.

Bibliography

Periodicals
Available world-wide by subscription

Arts d'Afrique Noire (quarterly) B.P. 24, Arnouville 95400, France Tel: (1) 39 87 27 52

African Arts J.S. Coleman African Studies Centre, UCLA, Los Angeles, California 90024, USA Tel: 213 825 1218

Hali (textiles) Hali Publications Ltd, Kingsgate House, Kingsgate Place, London NW6 4TA, UK Tel: 071 328 9341

Oriental Rug Review, Beech Hill Road, Meredith, New Hampshire 03253, USA Tel: 603 279 5574

Books and Catalogues

Aboriginal and Oceanic Decorative Art, National Gallery of Victoria, 1980

African Art Frank Willett, 1971

African Art in the Cycle of Life R. Sieber and R.A. Walker, 1987

African, Pacific, and Pre-Columbian Art, Indiana University Art Museum, 1986

African Textiles J. Picton and J. Mack, 1979

Ancient Peruvian Textiles Ferdinand Anton, 1987

Animal Regalia Moira Broadbent, 1985

Art and Decoration of Central New Guinea Barry Craig, 1988

ART/artifact Centre of African Arts, 1988

Artesanos Mexicanos Judith Bronowski, 1978

Art of Indonesia Fritz A. Wagner, 1959

Art of Oceania A. Bühler, 1969

Art of Oceania, Africa, and the Americas Museum of Primitive Art, 1969

Arts and Crafts of Mexico Chloë Sayer, 1990

Arts and Crafts of Rajasthan A. Nath and F. Wacziarg, 1987

Arts and Crafts of Turkestan Johannes Kalter, 1984

The Arts of Islam Hayward Gallery, 1976

Asian Puppets UCLA Museum of Cultural History, 1979

Aymara Weavings L. Adelson and A. Tracht, 1983

Caravans to Tartary Roland and Sabina Michaud, 1985

The Care and Preservation of Textiles K. Finch and G. Putnam, 1985

Carpet Magic Jon Thompson, 1983

Consideration for the Care of Textiles and Costumes Harold F. Mailand, 1980

Contemporary African Arts Maude Wahlman, 1974

Court and Village Merrily Peebles, 1981

Courtyard, Bazaar, Temple: Traditions of Textile Expression in India K.F. Hacker and K.J. Turnbull, 1982

The Craft of the Weaver A. Sutton, P. Collingwood and G. St. Aubyn Hubbard, 1982

The Crafts of Indonesia Joop Ave (ed.), 1988

The Decorative Arts of Africa Louise E. Jefferson, 1974

Divine Kingship in Africa W. Fagg, 1978

Double-Woven Treasures from Old Peru A. Cahlender with S. Baizerman, 1985

Dowries from Kutch Vickie Elson, 1979

The Dyer's Art: Ikat, batik, plangi Jack Lenor Larsen with A. Buhler, B. and G. Solyom, 1976

Embroidered Textiles Sheila Paine, 1990

Ethnic and Tourist Arts Nelson H.H. Graburn (ed.), 1976

Ethnic Sculpture M. McLeod and J. Mack, 1985

Expressions of Belief Suzanne Greub (ed.), 1988

Flat Woven Rugs of the World Valerie S. Justin, 1980

Flat Woven Textiles Cathryn Cootner, 1981

Folk Art of the Americas August Panyella (gen. ed.), 1981

From the Bosporus to Samarkand: Flat Woven Rugs A.N. Landreau and W.R. Pickering, 1969

From the Far West: Carpets and Textiles of Morocco P.L. Fiske, W.R. Pickering and R.S. Yohe (eds.), 1980

Golden Sprays and Scarlet Flowers: Traditional Indian Textiles Marie-Louise Nabholz-Kartaschoff, 1986

The Guide to the Painted Towns of Shekhawati Ilay Cooper, 1988

Harmony by Hand P. Houlihan, J.L. Collings, S. Nestor and J. Batkin, 1987

A History of Textile Art Agnes Geijer, 1982

I Am Here A.H. Whiteford, S. Peckham, R. Dillingham, N. Fox and K.P. Kent, 1989

Ikats from South-East Asia Jonathan Hope, 1977

Ikats: Woven Silks from Central Asia The Rau Collection, 1988

Indian Costumes from Guatemala Krystyna Deuss, 1981

Indian Crafts D.N. Saraf, 1982

Indonesian Textile Techniques Michael Hitchcock, 1985

Kilim, Cicim, Zili, Sumak Belkis Balpinar Acar, 1982

Kilims Yanni Petsopoulos, 1980

Latin American Brocades: Explorations in Supplementary Weft Techniques S. Baizerman and K. Searle, 1980

Lions and Tigers and Bears, Oh My! C. and D. Mather, 1986

Living with Decorative Textiles Nicholas Barnard, 1989

Living with Kilims A. Hull and N. Barnard, 1988

Master Dyers to the World Mattiebelle Gittinger, 1982

Masterpieces of Primitive Art D. Newton, 1980

Mexican Masks Southwest Museum, 1988

Mexico Michael D. Coe, 1984

Mola Art Capt. Kit. S. Kapp, 1972

Native America Christine Mather, 1990

Native Arts of North America Christian F. Feest, 1980

Nigeria's Traditional Crafts Alison Hodge, 1982

Nuristan L. Edleberg and S. Jones, 1979

Otavalo Lynn Meisch, 1987

Pacific Art Royal Scottish Museum, 1982

Patchwork Pamela Clabburn, 1983

Patterned Threads: Ikat Traditions and Inspirations Lotus Stack, 1987

Patterns of Life: West African Strip-Weaving Traditions Peggy Stolz Gilfoy, 1987

Peruvian Pottery George Bankes, 1989

Polynesian Barkcloth Simon Kooijman, 1988

Polynesians Ben Burt, 1981

The Potter's Art in Africa W. Fagg and J. Picton, 1978

Pre-Columbian Art F. Anton and F.J. Dockstader, 1968

The Primary Structure of Fabrics Irene Emery, 1980

Primitive Art L. Adam, 1940

Primitivism in Twentieth-Century Art William Rubin, 1984

Pueblo Indian Textiles Kate Peck Kent, 1983

The Qashqai of Iran Lois Beck, 1986

Shoowa Design: African Textiles from the Kingdom of Kuba Georges Meurant, 1986

Soloman Islanders Ben Burt, 1981

Spanish-American Blanketry Harry P. Mera, 1987

The Spirit of Folk Art Henry Glassie, 1989

Splendid Symbols: Textiles and Tradition in Indonesia Mattiebelle Gittinger, 1979

The Techniques of Rug Weaving Peter Collingwood, 1976

Textiles and Weaving Structures Peter Collingwood, 1987

Textiles in Archaeology John Peter Wild, 1988

Textiles of Baluchistan M.G. Konieczny, 1979

Textiles of Indonesia Indonesian Arts Society, 1976

Textiles of the Kuna Indians of Panama Herta Puls, 1988

Threads of Life: A private collection of textiles from Indonesia and Sarawak Dr Monni Adams, 1981

Threads of Tradition: Textiles of Indonesia and Sarawak Joseph Fischer, 1979

Traditional Art of Africa, Oceania and the Americas The Fine Arts Museum of San Francisco, 1973

Traditional Indian Crafts of Gujarat Julia Nicholson, 1988

Traditional Indian Textiles J. Gillow and N. Barnard, 1991

Traditional Textiles of Tunisia Irmtraud Reswick, 1985

Tradition and Creativity in Tribal Art Daniel P. Biebuyck (ed.), 1969

Tribal Rugs Jenny Housego, 1978

Tribes Peter Marsh, 1988

Tulips, Arabesques and Turbans: Decorative Arts from the Ottoman Empire Y. Petsopoulos (ed.), 1982

Turkish Flat Weaves W.T. Ziemba, A. Akatay and S.L. Schwartz, 1979

The Unappreciated Dhurrie Steven Cohen; D. Black and C. Loveless (eds.), 1982

Walk in Beauty: The Navajo and their Blankets M.H. Kahlenberg and A. Berlant, 1977

The Weavers of Ancient Peru Mo Fini, 1985

Weaving Arts of the North American Indian Frederick J. Dockstader, 1977

West African Narrow Strip Weaving V. and A. Lamb, 1975

Woven Air: The Muslin and Kantha Tradition of Bangladesh Whitechapel Art Gallery, 1988

Glossary

abr Persian word meaning 'cloud'; a general term for ikat.

adire (Yoruba, Nigeria) Name given to the deep-blue resist-dyed cloth.

adze Simple chopping-action wood-carving tool.

ajarakh Block-printed cloth from northern India, worn by Muslim men as turbans.

asasia (Ashanti, Ghana) Silk cloth for royalty and notables woven using a complex supplementary weft-patterning technique on a three-heddle drag loom.

bandha The resist-binding of yarn before weaving known also as 'ikat'.

bandhani (s), **bandhana** (pl) The Gujarati word for the resist technique of tie-and-dye.

bulto Mexican figurine.

chakla (Gujarat, India) Square dowry cloth, usually embroidered, initially used as a cover, then hung in the home as an auspicious emblem.

chapan Warm, padded robe of Central Asia.

charpoy Wood-framed, rope-bound bed found in Hindustan.

chaupad A game from the Indian subcontinent.

chief blanket Early type of blanket worn as clothing and woven by Navajo Indian women.

dhorkra Indian smithy.

dhurrie (Hindi and Urdu) Flat-woven cotton floor-cover.

drag loom Very simple, narrow looms used by the Ewe and Ashanti tribes of Africa to weave 'kente' cloth.

eye-dazzler A design composition of a textile – usually a Navajo rug, kilim or dhurrie – that is dominated by a single, central motif, shimmering with bright colour.

geringsing Double-ikat cotton cloth from the village Tenganan Pageringsingan in Bali.

ghajeri Flat-woven rug from Central Asia made up of narrow strips (tent bands) of warp-face patterned cloth.

gokh A small stone shrine placed beside doorways of houses in northern India.

hampatong Wooden representations of tribesfolk in Indonesia.

hanbel Flat-woven woollen rug/blanket, made by the Berber of North Africa.

haveli Palaces or mansions of wealthy landlords in northern and western India.

hinggi Man's ceremonial mantle of Indonesia.

huipil South Mexican and Guatemalan Indian blouse made up of panels of decorated and plain cloth.

ikat From the stem of the Malay-Indonesian word 'mengikat' meaning to bind, tie or wind around, 'ikat' refers to cloth patterned by the resist-dye technique before weaving.

jali Openwork wooden shutter of India.

kachina Supernatural figures of the Zuni Indians, believed to bring rain, game, happiness and prosperity.

kantha Traditional Bengali embroidery-decorated quilt.

karmara Metal-craftsman of India.

katab Meaning 'to cut up'; this is an Anglo-Indian term for the appliqué technique and appliquéd textiles.

kendi Indonesian clay or ceramic water vessel.

kente (Ashanti, Ghana) General term for strip-woven cloth of Ghana, worn as a wrap.

keris Personal ceremonial dagger of South-East Asia.

kilim Flat-woven rug or rug woven without a knotted pile.

lota Personal water vessel of India.

milagro ('miracle') Metal folk artifact of Central America.

mola Kuna word for cloth. A panel of reverse-appliqué cotton cloth used as a blouse decoration.

Mukkur Town in southern Afghanistan, home to kilim-weaving gypsies (the Koochi).

ndop Carved wooden royalty figures from Zaire.

olla Coiled basket made by Apache women.

pantelho Tortilla bag of Central America.

parath Wooden food serving and preparing bowl/board from India.

Pendleton trading blanket Blanket from Pendleton woollen mills, Oregon, produced for native Americans.

poro African secret society mask.

rebozo Fringed ikat-decorated shawl of Central and South America.

refajo Guatemalan Indian wrap-around skirt.

retablo Mexican painted panel.

rukorsi Persian, square stove and oven flat-woven cloth.

sarape, serape Traditional North American Indian clothing wrap.

sarong Malay tubular garment which is wrapped about the body.

shigra Vegetable-fibre carrying basket of the Andes.

ship cloth Textile of Indonesia depicting a boat.

vicuna Wild and rare cameloid. Its hair is used to make Bolivian and Peruvian textiles.

vigango Kenyan wooden grave-marker depicting the life of the deceased through pictorial narrative.

wayang golek Wooden puppets from Java and Bali.

wayang kulit Shadow puppets of hide from Java and Bali.

yucca Leaves used to make baskets by the Pueblo Indians.

yurt Central Asian circular tent made of felt covers and willow staves.

Index

Numerals in italics refer to illustrations